FORMS OF PERSUASION

THE PUBLISHER GRATEFULLY ACKNOWLEDGES THE GENEROUS
SUPPORT OF THE PUBLISHER'S CIRCLE OF THE UNIVERSITY OF
CALIFORNIA PRESS FOUNDATION, WHOSE MEMBERS ARE:

ARIEL AISIKS / INSTITUTE FOR STUDIES ON LATIN AMERICAN ART (ISLAA)
GIFFORD COMBS
THE DIDO FUND
MARCY AND JEFFREY KRINSK
MICHELLE AND BILL LERACH
MARJORIE RANDOLPH
RAY AND WYN RITCHIE EVANS FOUNDATION
PETER WILEY

THE AUTHOR GRATEFULLY ACKNOWLEDGES THE SUPPORT
OF THE RICHARD D. AND MARY JANE EDWARDS ENDOWED
PUBLICATION FUND TOWARD THIS VOLUME.

# FORMS OF PERSUASION

Art and Corporate Image in the 1960s

Alex J. Taylor

UNIVERSITY OF CALIFORNIA PRESS

University of California Press
Oakland, California

© 2022 by Alex J. Taylor

Cataloging-in-Publication Data is on file at the Library of Congress.

ISBN 978-0-520-38356-2 (cloth : alk. paper)

Printed in China

30   29   28   27   26   25   24   23   22   21
10   9   8   7   6   5   4   3   2   1

*For Michele*

# CONTENTS

# ACKNOWLEDGMENTS

**CORPORATE PATRONAGE REQUIRES** an understanding of art that exceeds the work of a single author. This book also bears the traces of the many collaborators who have helped me make sense of this history. At the University of Oxford, where this research began, I acknowledge the support of the Clarendon Fund, the Rae and Edith Bennett Travelling Scholarship, the James Fairfax Oxford Australia Fund, and the Isaiah Berlin Fund. I benefited from the advice of Craig Clunas and Alastair Wright in the Department of History of Art, and Linda Scott in the Saïd Business School. Most of all, I am grateful for the mentorship of Geraldine Johnson, and I thank her for her intellectual precision and boundless energy.

Much of this project took shape when I was a predoctoral fellow at the Smithsonian American Art Museum, where I benefited from the input of a brilliant cohort whose contribution to the development of the project was enormous. Thanks to the staff at SAAM (in particular the indefatigable Amelia Goerlitz, but also Tiarna Doherty, Anne Evenhaugen, Virginia Mecklenberg, and Denise Wamaling) and at the Archives of American Art (including Marisa Bourgoin and Elizabeth Botten) for their assistance. As a postdoctoral research fellow at the Tate, I was grateful for the support of

Jennifer Mundy, Celia White, and especially Christopher Griffin. Thanks to everyone at the Terra Foundation for American Art for these and other opportunities. I would also like to thank the Center for Sales, Advertising and Marketing History, Duke University; the Special Collections Research Center, University of Chicago; the Center for the History of Business, Technology and Society, Hagley Museum and Library; and the Getty Research Institute for travel grants that further assisted my project.

Work from this book was presented at the Andy Warhol Museum, the Institut national d'histoire de l'art, the University of Glasgow, the University of Southern California, and the University of Sydney, and I thank the organizers of these events for the opportunity to share my research. At these presentations, and elsewhere, I have been appreciative for the suggestions of many scholars but would especially like to acknowledge Natalie Adamson, Jo Applin, Anna Arabindan-Kesson, Nadya Bair, Judith Barter, John Blakinger, Alan Braddock, Maggie Cao, David Peters Corbett, Sophie Cras, John Curley, John Davis, Melody Barnett Deusner, Erika Doss, Amanda Douberley, Seth Feman, Blake Gopnik, Jennifer Greenhill, Anthony Grudin, Mona Hadler, Mazie Harris, Patricia Johnson, Mark Ledbury, Emily Liebert, Christine Mehring, Angela Miller, Marina Moskowitz, Bibiana Obler, John Ott, Erin Pauwels, AnnMarie Perl, Alistair Rider, Caroline Riley, Deirdre Robson, Vanessa Schwartz, Jennifer Sichel, Catherine Spencer, Amy Tobin, Hélène Valance, Robin Veder, and Tatsiana Zhurauliova. An earlier version of chapter 7 appeared in *Corporate Patronage of Art and Architecture in the United States, Late 19th Century to the Present* (Bloomsbury, 2019), and I am grateful to its editors, Melissa Renn and Monica Jovanovich. Thanks to Andy Petretti for assisting in Genoa, Lieke Wouters for assisting in Zevenaar, and Farouk Ophaso for his unstinting hospitality in Washington, DC.

I am fortunate to have landed in a research environment as stimulating as the University of Pittsburgh. Thanks to Drew Armstrong, Gretchen Bender, Maria D'Anniballe, Alyssa DiFolco, Josh Ellenbogen, Shirin Fozi, Linda Hicks, Holger Hoock, Sahar Hosseini, Alison Langmead, Michelle McCoy, Tom Morton, Chris Nygren, Mina Rajagopalan, Ana Rodríguez Castillo, Karoline Swiontek, and Anne Weis for their collegiality and support. Jennifer Josten, Barbara McCloskey, Kirk Savage, Sylvia Rhor, and Terry Smith each helped me refine this book, and I am grateful for their close readings and thoughtful suggestions. I have also benefited from discussions about this project with Pitt graduate students and would like to especially acknowledge Colleen O'Reilly and Isaiah Bertagnolli. Thanks to Kate Joranson and the staff of the Frick Fine Arts Library for their help. At the University of California Press, sincere thanks to Jessica Moll, Elisabeth Magnus, Teresa Iafolla, Claudia Smelser, Nola Burger, and especially Archna Patel for their expert guidance in bringing this book to publication.

My husband Matthew Sousa has lived through most of this research, and I thank him for his love, humor, and patience with the peculiarities of academic work. Many of my discoveries and ideas have first been tested on Matthew, so his intellectual contribution to the project is considerable. Thanks to all of my family for their support. This book is dedicated to my mother Michele, the most creative businessperson I know.

# INTRODUCTION

The Culture Sell

A man walked into the spacious lobby of a Park Avenue building, worked his way thru a maze of paintings and asked the receptionist: "What gallery is this?"

"This sir," she replied, "Is the Pepsi-Cola company."

*CHICAGO DAILY TRIBUNE*, 1961

**L**URED BY THE PROMISE OF A PUNCH LINE, we are instead served the cold sparkle of public relations. Like so much of what passes for news, this anecdote from the early sixties sounds very much like something concocted by a publicist, even what we might now call an "advertorial" or "sponsored content." Its author was certainly not going to miss the opportunity to plug the prestigious address of Pepsi-Cola's gleaming new "world head-quarters," designed by Skidmore, Owings & Merrill and dedicated in February 1960. And even if our apocryphal visitor did overlook the company's name that was sprawled across the foyer wall, his misrecognition was more than just an excuse to demonstrate the company's good taste. To momentarily confuse a multinational cor-poration for a modern art gallery was precisely the kind of shift in perception that was essential to sophisticated consumer marketing in the 1960s. Pepsi-Cola could not merely be a carbonated beverage, nor its maker just a company. It had to stand for something more.

For Pepsi-Cola and many other large corporations, articulating these intangible meanings coalesced around the idea of corporate

image, a term that began to dominate design, marketing, and public relations practices in the late 1950s.[1] "Corporate image—or corporate personality," explains one of the period's many marketing and management texts on the subject, is "merely the picture which your organization has created in the minds of your various publics."[2] It was a concept that seemed both new and timeless, simple and infinitely multifaceted. "Esthetic elements and nonverbal symbols . . . say things about a product or a store that could never be said in words," explained Pierre Martineau in *Motivation in Advertising* (1957).[3] According to Martineau, the "affective meanings and subjective imagery" of such approaches promised nothing less than "permanent brand loyalty."[4] Crucially, corporate image extended beyond straightforwardly visual forms like logos and advertising layouts, and indeed beyond consumer marketing itself, to encompass the wider range of ways that business could "communicate effectively with its various publics in the discharge of its rapidly proliferating responsibilities to the larger society."[5] Building the corporate image was about trying to sell more stuff, for sure, but it was also more broadly understood as a means to help secure the long-term social and political legitimacy of the large-scale corporation.

This book explores how, in the 1960s, works of art contributed to such efforts to shape the corporate image. My study reconstructs a series of case studies that span the interactions between postwar art and the advertising, public relations, lobbying, and personnel strategies of big business. In the 1960s, Pepsi-Cola was one of many companies to operate exhibition spaces in their corporate headquarters. Many firms bought or commissioned artworks to display inside their offices and factories, while others hosted artists in residence. Some reproduced art in their advertisements and annual reports and profiled it in press stunts and photo ops. Their promotional art exhibitions toured across the country and around the world. Even when these encounters were fraught, or were regarded to have failed, they left an indelible impression on 1960s art and culture. Both tax advantages and the investment potential of art in a booming market, itself buoyed by business purchases, undoubtedly contributed to the boom in corporate art patronage in this period. But it was still the potential of art to shape the corporate image that I argue was the prime concern for these companies and the "persuasion industry" professionals that advised them.[6] Through such activities, works of art were drawn into the expansive efforts of business to shape consumer behavior and influence social and political discourse, bolstering the standing of corporate enterprise in a global market.

Over the past decades, scholars of "corporate modernism" have provided rich accounts of the contributions of big business in fields such as architecture and design.[7] Modern art is crucial to the stories they tell, but corporate patronage itself remains a subject "conspicuously absent from the art historical canon," as the authors of a recent edited collection observe.[8] This is especially true in histories of modern and contemporary art, where corporate capitalism is still often understood as a corrupting influence, the antithesis of a properly radical avant-garde. Research into the capitalist

engagements of the 1960s counterculture has certainly helped complicate such clichés, as has scholarship exploring artistic engagement with the systems of Cold War technocracy.[9] Some art historians have even begun to reveal the generative power of capitalism for the 1960s avant-garde.[10] Here, I seek to recover the direct engagements between 1960s art and the promotional machinery of corporate capitalism. Far from sovereign statements of independent creativity, or emancipatory expressions of resistance against the cultural norms of midcentury society, the artworks I describe might be better understood as advertorials of sorts. Like Pepsi-Cola's gallery, they also stood for something more.

To be clear, my focus is on not just any kind of profit-seeking business interested in art—which could include galleries, most museums, and indeed artists themselves—but rather large-scale, increasingly multinational, and usually shareholder-owned corporations like Pepsi-Cola, a company to which I will return throughout this introduction. Such corporations were characterized by complex managerial hierarchies, multi-industry interests through diversification and conglomerate structures, and sophisticated bureaucratic systems for managing policy, strategy, labor, distribution, sales, and marketing. Many of these traits date, in varying degrees, from the late nineteenth century, but it was in the postwar decades that they reached their full potential, assuming the pinnacle of their international scope and complexity in the so-called golden age of capitalism. In this form, corporations would become the most powerful social and cultural force of the second half of the twentieth century—an influence that art and artists were engaged to help secure.[11]

## CONTEXTUALIZING COMMERCIAL PATRONAGE

This history is far from unique to the 1960s. The cliché of corporate patrons as modern-day Medici might lend a patrician aura to frequently more pragmatic business decisions, but it does at least register the continuities of this field with the longer intersections between the histories of art and capitalism. Nevertheless, this is also an essentially modern story, as the rise of the mass media and mass markets vastly expanded the communicative possibilities of art patronage. Since the late nineteenth century, photography and other seemingly "rational" forms of realism would become especially essential to capitalism's imagery, helping to represent and reproduce the forms of organization and efficiency upon which it relied.[12] Works of fine art would find a unique niche in the visual cultures of consumer persuasion, first in the artistic bill posters of early outdoor advertising and eventually in other forms of prestige advertising that reproduced fine art to, as T.J. Jackson Lears has put it, "surround mass-produced goods with an aura of uniqueness."[13] Michele Bogart's landmark *Artists, Advertising, and the Borders of Art* (1995) has surveyed this field as it came to operate across the full gamut of commercial visual cultures in early twentieth-century America, showing how such claims to the category of "art" not only functioned as a "means of acquiring authority and influence in their fields and in the broader culture"

but also ultimately reinforced the construction of a modernist avant-garde premised on its separation from commercial concerns.[14]

Pepsi-Cola had, in fact, played a significant role in this history. Bogart's study concludes with a section on Pepsi-Cola's wartime art competitions from which works by modern American painters, such as Stuart Davis and Max Weber, were used to illustrate promotional calendars. For Bogart, this represents the "one last prominent advertising campaign of the 1940s" that remained committed to the convergence of fine and commercial art.[15] "By the end of the 1950s," she writes, "advertising commissions for 'fine art artists' had all but dried up."[16] There was indeed a shift away from fine art in advertising as television campaigns took the creative lead, but this should not be mistaken to mean that the relations between art, business, and the persuasion industry changed into anything so simple as an arrangement of "separate spheres." Instead, my study will suggest that such engagements expanded beyond the limits of the advertisement into the more affective, amorphous, and dispersed field of corporate image making.[17]

Like many consumer brands, Pepsi-Cola had begun to shift from product-centric marketing efforts to a more expansive personality-based approach characteristic of corporate image campaigns in the late 1950s. "Once this brand stopped trying to be an economy cola and moved to establish a distinctive product image, sales soared," records one marketing commentator of the company's efforts to project a more modern, elevated brand personality.[18] Pepsi-Cola shifted its account to BBDO in 1960, hiring photographers such as Bert Stern and Irving Penn to help cultivate a more natural, youth-oriented image for the product, one that was, as the company boasted, "exciting without being frantic, a look that was highly artistic but at the same time as real as life itself."[19] Works of art might then have disappeared from Pepsi-Cola's advertising, but as the company promoted a "gallery director" from the ranks of its public relations department, modern art became one of many forms of cultural production it used to cultivate a vivid, authentic corporate image.

Although my study focuses on painting, sculpture, and other works of "fine art," it is important to acknowledge that these were only a small slice of the creative practice—including music, theater, literature, film, television, and more—drawn into the field of corporate image making. Sometimes, the results defy classification. Take, for instance, the enormous swirling wave of twenty-five thousand Christmas tree ornaments designed by Robert Brownjohn for the Pepsi-Cola foyer in December 1959 (fig. 1). This giant curlicue of candy-colored ribbon installed to mark the arrival of Pepsi-Cola's gleaming new architectural jewel box appears to have been the company's first lobby display. Brownjohn's wave of lurid iridescent spheres danced across the foyer like a Disney fantasy, disregarding the building's restrained crystalline geometry. The motion of viewers around the object further animated its multicolored sparkle as it reflected light from both the grid of ceiling lights above and the high-gloss white floor. This was at least as much a sculpture as it was seasonal decor: a sprawling installation that transformed

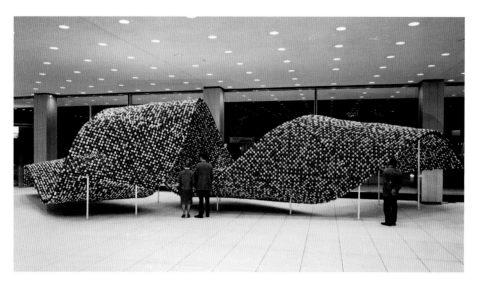

cheap plastic ornaments into a spectacular branding gesture and required neither product nor promotion to achieve its experiential image of buoyancy and sparkle.

To situate this object among its sculptural contemporaries helps reinforce the shared genetics of modern art and commercial design. In Brownjohn's case, such relations originated at Chicago's "New Bauhaus," where his student design of an undulating plastic ribbon of tactile spots and grids is known from its inclusion in László Moholy-Nagy's *Vision in Motion*.[20] As it swoops across the floor and bounds into the air, the enveloping effects of his Pepsi installation certainly echo those achieved in Herbert Ferber's landmark *Sculpture as Environment* (1961) installed at the Whitney Museum a year later (fig. 2). There are, of course, many differences between such works, but both anticipate the shift from objects to spaces that would define the decade's sculptural legacy. Brownjohn's object also preempts the large, eye-catching abstractions that would begin to permanently ornament New York's other fishbowl foyers, such as Beverly Pepper's *Contrappunto* (1963), commissioned for the entry to the United States Plywood Corporation (fig. 3). *Contrappunto* might be more formally contained than either Ferber or Brownjohn's curlicues, but as a hidden motor turned its suspended upper loops, its animated abstraction also chimed with the lobby's immersive Muzak soundtrack.[21] Like Brownjohn, Pepper cited the influence of Moholy-Nagy on her early practice (encountered, in her case, through classes with György Kepes), but her first career as an art director in New York advertising agencies must also have sharpened her perception of modernism's marketing potential.[22]

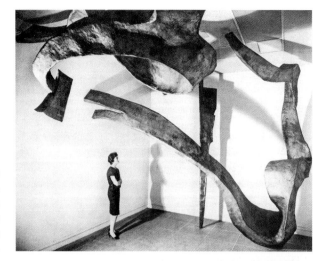

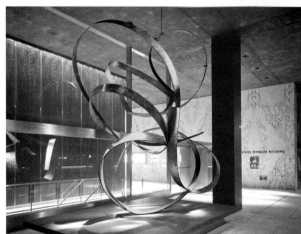

By the 1960s, blurring the boundaries between art and advertising could itself serve persuasive ends. When Pepsi-Cola displayed award-winning advertisements for a 1962 exhibition, for example, the promise that visitors could watch television commercials "uninterrupted by crass entertainment" was not just a tongue-in-cheek inversion of mass media critique; it also sought to affirm the expressive force of consumer culture itself.[23] More fundamentally, the persistence of such cultural distinctions could help camouflage the contours of corporate strategy. Critic Stuart Preston might then have thought that the exhibition *Twenty Young French Painters* (1963) seemed "incongruously sheltered in the gleaming, Muzak-reverberating hall of the Pepsi-Cola building," but his judgment failed to register that this exhibition was—on the heels of the company's new bottling agreement with French manufacturer Source Perrier—barely less commercial than the company's displays of declaredly commercial art.[24] Given the

importance of Latin American markets to Pepsi-Cola, the same could be said of the interactive abstractions of Lygia Clark or the early pop constructions of Marta Minujin, both artists for whom Pepsi-Cola exhibitions represented their first New York City showings.[25] Whether displaying folk carvings from Puerto Rico, crafts from the Philippines, or modern paintings from the Congo, these displays were all invariably tied to the company's ever-fluctuating relations with the international governments and licensees upon which global expansion relied.

As large corporations began to behave more like countries—the "Republic of Pepsi-Cola," quipped one journalist in 1965—corporate image programs equally sought ever-wider expressions of social relevance and legitimacy.[26] This was why Pepsi-Cola's public relations department, responsible for the company's image-building activities in the arts and beyond, claimed that its goal was to create "subtle but beneficial interminglings of Pepsi sociability with the nation's life."[27] Sometimes this comprised entirely predictable elaborations of the red, white, and blue of the Pepsi-Cola brand identity, such as the exhibition *The American Flag* (1962), drawn from the Library of Congress collection to show the "many imaginative uses" of the flag in the history of advertising.[28] But how should we understand the decision to host *Guns*, another 1962 exhibit that showcased two hundred firearms lent by the Winchester Gun Museum and that began with an image of the Pepsi logo peppered with bullet holes? Critic Brian O'Doherty thought the show was a "reminder of a more gracious age when killing was a more polite and personal matter," but within a few years his joke, and indeed, the exhibition, would surely have been unthinkable.[29] In seeking to locate their products at the center of everyday life, and to animate their brand with all of the complex identity of a real person, corporations necessarily had to engage with the tumultuous social and political contexts that surrounded them. By the end of the decade, as the example of Pepsi-Cola will so unmistakably suggest, it didn't always seem worth the trouble.

While the activities of corporate art patrons in the 1960s have not yet received a dedicated historical study, several accounts of corporate involvement in the arts since the 1970s have been published in the last two decades.[30] Unlike the direct interactions between artists and companies that characterized earlier practices, such activities were increasingly controlled—especially in the United States, but eventually elsewhere around the world too—through the auspices of museum sponsorship. Like the earlier decline of art in advertising described by Bogart, such a shift was far from complete, but the rising prominence of these institutionally brokered unions did help the borders between art and business appear to remain intact. The desirability of this separation is fundamental to the accounts of Mark Rectanus's *Culture Incorporated: Museums, Artists and Corporate Sponsorships* (2002) and Chin Tao Wu's *Privatising Culture: Corporate Art Intervention since the 1980s* (2003), books that take a critical perspective on the operation of museum sponsorship as an effort to use cultural capital to legitimize corporate power and, ultimately, privatize the sphere of art.[31]

Scholars advancing such perspectives rarely detail the specifics of the encounter between artists and patrons and have even less to say about its influence on works of art themselves.[32] Such condemnations of the corporate exploitation of art can, in my view, too readily romanticize the undiluted and uncorrupted culture of an imaginary past. As Erika Doss has observed, "Artists who desired visibility and recognition depended on some form of patronage, be it private, public or corporate. And such patronage usually involved some degree of compromise; 'complete' aesthetic freedom was more often ideological fiction than social fact."[33] The inevitability of such accommodations seems to me a more useful framework than models of "recruitment" or "co-option." In seeking to understand the direct engagements of art and business as they unfolded within the social fabric of everyday life, I regard their relations in more ambivalent terms, proceeding on the contrary belief that art has long constituted its forms in relation to trade, consumption, reproduction, and mass media. Building on a now-rich field of scholarship that has revealed the mutuality and confluence of fine and commercial art, high and low, I treat such categories not as fixed or opposing positions but as an infinitely graded "continuum of visual production," as Patricia Johnson has termed it, an unstable terrain within which artists continually calibrate and recalibrate their practices.[34]

My approach also owes less to the many accounts of the organization of modern and contemporary art markets than it does to what I regard as the more nuanced scholarly approaches to patronage in earlier periods. In particular, I concur with Francis Haskell's conclusion that the transactions between artist and patron do not suggest "the existence of underlying laws which will be valid in all circumstances."[35] In his work on seventeenth- to nineteenth-century art, Haskell pays close attention to the "mechanics" of patronage and the status of the artwork as "a form of social and financial investment."[36] Michael Baxandall goes further still in demonstrating the centrality of the patron's influence in the form of the artwork itself. He famously treats Renaissance patrons as "clients," demonstrating how their requirements and interests profoundly shaped the appearance of Italian Renaissance painting. Elsewhere, Baxandall shows how early modern artists mimicked their patrons' commercial strategies by adopting subcontracted production and branded styles to bolster their businesses.[37] In these and other writings by Haskell and Baxandall, and in more recent scholarship that has absorbed their lessons, patronage emerges as a sharp lens through which to see the entanglement of works of art in the dynamics of the commercial world and the long history of consumer marketing.[38]

Each of my chapters embeds particular artworks within their corporate histories. Beginning with the artworks that most visibly engage with the iconography of big business in the 1960s, Part 1 is titled "Repackaging Pop" and considers the role of pop art for the packaged consumer goods industry. Chapter 1 explores the inexplicably little-known commercial relations between Andy Warhol and the Campbell Soup Company. Reconsidering the implications of Warhol's famous appropriation of the image of the

company's product, I suggest that pop represented a paradoxical force for its corporate subjects: at once an exciting marketing opportunity and a problematic interference with their control over their own brands. Chapter 2 examines the pop commissions of the Container Corporation of America, a paperboard packaging and design firm. Focusing on paintings produced by Warhol and James Rosenquist for the company's advertisements, I explore how these canvases bear the traces of their patron's efforts to shape the meanings of the works they commissioned. Chapter 3 surveys the foray of tobacco giant Philip Morris into this field. Considering the portfolios of pop prints commissioned by the company and its public relations agency Ruder & Finn under the direction of influential publicist Nina Kaiden, I examine how the production and exhibition of these works powerfully register the company's marketing imperatives, including its interest in the visual effects of packaging and the need to work around new regulatory restrictions on cigarette advertising. All three of these companies were seeking to build global brands in the 1960s, and throughout this section I highlight the cultural dimensions of their internationalizing enterprises.

In Part 2, titled "Abstraction at Work," I focus on the role of art within the workplace, moving away from particular works of art to consider instead corporate art collections as a multidimensional unity, carefully planned environments designed to shape corporate image. Chapter 4 considers the artworks selected for the offices of Chase Manhattan Bank in New York. Here, I argue that the collection juggled contradictory goals: balancing executive tastes with corporate identity and countering the drive for efficiency with the individualistic and humanistic values that the company understood modern art to exemplify. Chapter 5 examines the collection of large abstract paintings commissioned for the Turmac Tobacco Company factory, the Dutch manufacturer of Peter Stuyvesant cigarettes. My account of the history of this collection, the role of European integration in its formation, and its subsequent international tours to Canada and Australia explores the public relations and personnel functions it served for an expanding multinational brand.

In the third and final section of the book, "Marketing Materials," I turn to the industrial patronage that I suggest buoyed the status of steel as a sculptural material in the 1960s. Steel is only one of the industries that turned to modern art as a kind of product placement vehicle, but its engagements had an unparalleled impact not only on the material meanings of postwar sculpture but also on the self-image of its makers. Chapter 6 examines the residency of a group of international sculptors in the factories of Italian steel giant Italsider in 1963, recovering the context of postwar Italian reconstruction and industrial change that shaped the works of Alexander Calder, Beverly Pepper, and David Smith made in Italsider's factories. Chapter 7 examines U.S. Steel's involvement in creating Pablo Picasso's monumental public sculpture for the city of Chicago from the company's proprietary alloy marketed under the brand name Cor-Ten. Finally, chapter 8 considers Richard Serra's 1969 residency at Kaiser Steel in Fontana, California. Reconstructing Serra's fraught relations with Kaiser staff to

complicate his identification with the figure of the steelworker, I reinterpret his temporary sculptural installations as materializations of the collapse of this company and, more generally, of the idea that artists might directly contribute to the shaping of a corporate image.

This is a diverse territory to cover, but by considering a range of patrons, sectors, styles, and, albeit to a necessarily more limited extent, international contexts, I aim to provide a synthetic account of 1960s art that puts patronage at the center of its history. At the same time, I also want to examine works of art themselves, regarding their material form as essential evidence for understanding their engagements with corporate image and the persuasion industry. My selective focus on many well-known artworks (beginning with Warhol's *Campbell's Soup Cans* and ending with Serra's *Skullcracker* series) is not intended to reinforce the canons of American art with which it mainly conforms, but rather to avoid the trap of presenting the corporate art phenomenon as a matter of only marginal significance for the established artistic legacies of the decade. Indeed, the fame of many of the artworks I consider reflects the efforts of business to promote them, interests that are frequently embedded within their received histories. Here, I am especially interested to shine a light on agents other than artists who shaped the form and meanings of these works: the art directors, advertising creatives, public relations advisers, and other such producers of commercial culture whose very power so often depended upon the maintenance of their public invisibility.

In positioning artworks as something more than the stuff of individual creation, I seek neither to diminish their significance as works of art nor to deny the agency of their named creators. But as David Nye notes in his pioneering study of photography at General Electric, the corporation's "very mode of operation places a structural limit" on assumptions about individual authorship.[39] It is thus crucial to attend to the varying degrees of collaboration and control within which specific works were made and circulated. Commissions differ from competitions, for instance, and both significantly differ from company purchases of existing works. While I regard all of these situations as forms of patronage that shaped corporate image, I have tried to not smooth over their practical differences. Some of my case studies were chosen because of the availability of corporate archives. I have also made considerable use of sources from the popular press, reading between the lines of such sources (often closely based on press releases) to reconstruct the persuasive agendas they advance. Works of art themselves can sometimes round out this correspondence in visual terms, providing material evidence of the strictures of patronage in both their content and their form.

The international orientation of corporations makes it impossible, in my view, to strictly limit my subject to the art or artists of a particular nation. My focus is thus primarily on companies then based in the United States, but I have sought to engage with the international artistic and commercial contexts their businesses involved. To

further suggest the multidirectional dynamics of this field, I devote sections to Dutch and Italian firms, and these case studies were selected not only for their exemplary status among 1960s corporate art patrons but also for the multinational imagination that they reveal. My scope is therefore motivated less by the idea of a global art history than by the conditions of postwar commerce, the complex multinational supply chains and marketing strategies that, in the 1960s, American corporations developed to pursue global expansion. Indeed, these companies could, on occasion, even take credit for the purported international triumph of postwar American art, boasting that it was their "aesthetic and financial support that has helped to make this leadership possible."[40] This is an exaggeration, but the cultural and economic influence of the United States in Europe ensured by the Marshall Plan did provide important conditions for the global circulation of American art. And as scholars of the "cultural Cold War" have begun to recognize, this history was commercial as well as ideological: waged on billboards and in supermarkets and, as works of art were drawn into its system of consumer choice, in museums and art magazines as well.[41]

While it is important to recapture the genuine and mutual enthusiasm for collaboration between artists and corporations that ran through much of the sixties, many of the examples I recount focus on particular moments of friction within these relations. Such disputes help clarify the motives of artists and executives alike by raising the veil of PR spin by which the reception of these projects was, for the most part, so effectively managed. Smoothing over problems was what business did best, but the works of art explored here often manage—sometimes quite unwittingly—to document the complexities of the commercial imperatives within which they were entangled.

## THE POLITICS OF PERSUASION

In 1959, economist John Kenneth Galbraith delivered a lecture at New York's Museum of Modern Art (MoMA) that helps articulate the socioeconomic frameworks that would come to underpin the field of corporate art patronage in the following decade. Galbraith explained to his audience that "improving economic well-being requires an increasingly close relationship between the artist and economic life."[42] Alluding to the problems he had already described in *The Affluent Society* (1958), Galbraith argued that "artistic perception is as necessary to the modern manufacturer of consumers goods as engineering skill." The aesthetic standard of American products had "fallen below both European standards and our own tastes," he suggested. America's weakened balance of trade therefore manifested the failure of business to pay attention to modern art. "The businessman, having accommodated himself to the scientist in the course of accommodating himself to the twentieth century," he declared, "must now come to terms with the artist."[43]

In a more general sense, corporate enterprise would become obsessed with creativity in the 1960s, and a burgeoning management literature would imagine its expertise as a kind of humanist art. The advertising business would cast its innovations as

nothing less than a "creative revolution."[44] At one level, this was a matter of prestige. "A businessman who reads *Business Week* is lost to fame," Galbraith noted in *The Affluent Society*. "One who reads Proust is bound for greatness."[45] The cultural interests of corporate liberals sought to consolidate the position of the multinational corporation at the very center of human civilization and to combat the persistent reputation of American business as materialistic and uncultured. "Business—the great soulless corporation," summarized one journalist, "is being looked to more and more as the source of the wealth and power and taste to support the projects . . . which the rest of our civilization neglects."[46]

Artists too recognized this shift. Many were enthusiastic about the possibility of working with large-scale corporate enterprise, even if they and their interpreters later disavowed such interests. After the prescriptions of state-sponsored schemes in the thirties and forties, and the restrictions of McCarthy-era political persecution in the fifties, the idea of stable patronage from American business was far from an unattractive prospect.[47] Further, as Bogart and Doss both point out, the focus of many left-wing artists on reaching the masses found renewed, if reconfigured, utility in the field of mass marketing.[48] Disillusioned with the trope of the marginalized artist (though, as always, still happy enough to deploy its clichés) and fed up with the risks of making art "on spec," artists began to see big business as a viable pathway to achieve professional stability, a change manifest in the pronounced valorization of corporate identity among many artists of the period.[49] Advertising and merchandising had long provided paying work to writers and creatives of all varieties, and even for those who eventually rejected the profession (or suppressed the history of their involvement in it), the techniques they learned were not easily forgotten. And as art history and criticism were assimilated by public relations discourse, modern art itself would become necessarily shaped by press releases and other forms of spin-doctoring.

The interest in image making that brought business and artists together corresponded with a broader public visibility for the techniques of the persuasion industry. The first edition of Pierre Martineau's *Motivation in Advertising* (1957) featured a generically modern dust jacket with an abstract design of three intersecting curving lines. By 1971, when his volume was reprinted as a cheap paperback, these wavy curves had proliferated into the wafting smoke of a cigarette, a psychedelic tangle of luridly colored shapes and fragmentary images (fig. 4). This is an illustration that metaphorically condenses a decade of advertising but also confirms the Medusa-like image of the persuasion industry itself as seductive but dangerous. By the end of the 1960s, consumers came to recognize that the pervasive, intermingled impressions of mass marketing were swirling around everything they consumed. Repositioned for a readership beyond the professional marketers it had so influenced in the late 1950s, Martineau's book was repackaged for a public fascinated by the images they too understood to be manipulating their behavior. As Daniel Boorstin explained in his acutely perceptive book *The Image: A Guide to Pseudo-events in America* (1961), "The more we know about

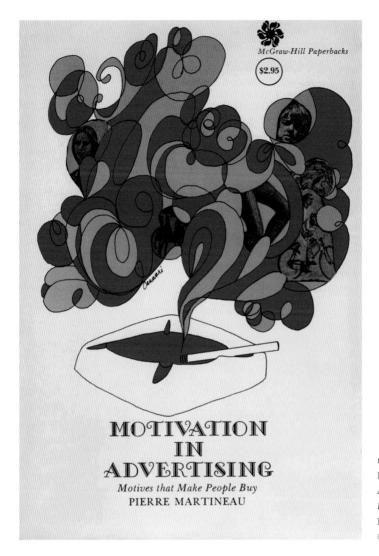

FIGURE 4

Pierre Martineau, *Motivation in Advertising: Motives that Make People Buy* (1957; repr., New York: McGraw-Hill, 1971), cover design. © McGraw Hill.

the tricks of image-building, about the calculation, ingenuity, and effort that have gone into a particular image, the more satisfaction we have from the image itself. The elaborate contrivance proves to us that we are really justified (and not stupid either) in being taken in."[50]

Above all, however, it was Vance Packard's *The Hidden Persuaders* (1957) that had sparked popular interest in the tricks of the advertising business. Providing mainstream exposure for the techniques of Martineau and others, the book reignited the consumer activism of the Depression era and focused new attention on the industry's alleged manipulations of human psychology and vision.[51] Not only did the book give impetus to a host of new consumer regulations, but it also sharpened artistic

perceptions of such practices.[52] Packard followed this best seller with a steady stream of books that considered the impact of business culture on American behavior. These included his account of American class barriers in *The Status Seekers* (1959) and his tract against consumer excess and "planned obsolescence" in *The Waste Makers* (1960).[53] Packard's books shed new light on the impact of commercial values on the possibility of a fulfilling and democratic society, and their claims are echoed in the work of countless social critics and commentators of the period. While his books are breezy and occasionally sensationalist, their period significance to sixties arts and letters should not be underestimated.[54]

Packard's critiques of business were a key influence on the more profound attack on the "corporate system" mounted by the New Left in the 1960s.[55] The Students for a Democratic Society's *Port Huron Statement* (1962) was a landmark articulation of such beliefs. "Government influence is marginal to the . . . basic structure of distribution and allocation which is still determined by the major corporations with power and wealth concentrated among the few," explained this foundational treatise.[56] Such attacks on business and its values provide a crucial background for this study and remain central to contemporary criticisms of unchecked corporate power, but such activists were more moderate than is sometimes assumed. Initially, at least, the Students for a Democratic Society, as one historian has put it, "aimed not to destroy capitalism, but to reform it."[57] It is within this constructive and liberal spirit that the widespread artistic enthusiasm for corporate collaboration in the early to midsixties should also be understood.

Even if by 1960 it was possible to claim that business "never enjoyed a more favorable climate of public opinion," corporate threats to a free society remained part of a well-established folklore of capitalism.[58] From the perspective of business this was a matter of combating fears of not only bigness and monopoly but also cultural irrelevance. One executive worried about the "bland image" of big business, complaining that even those who thought highly of a company "don't so much as write a postcard if the government threatens to break up its corporate structure."[59] Emerging concerns over the dehumanizing effects of corporate organization and increasing attention to corporate disregard for health and the environment required further rebuttals. As historians Kenneth Lipartito and David Sicilia observe, the postwar corporation faced a "host of new challenges to its reputation, and responded in ways that reached well beyond the earlier techniques."[60] Above all, the widespread impacts of Packard's critique of the manipulations of the persuasion industry itself meant that, as the editor of the *Harvard Business Review* observed in 1960, "advertising is obviously suffering from (to use one of its own favorite new words) 'image' trouble."[61] As the following chapters will show, all of these concerns were ones that works of art could help mitigate.

It was also in the 1960s that ideas like "corporate citizenship" and "corporate social responsibility" emerged as frameworks for the image problems faced by big business. Richard Eells's *Corporation Giving in a Free Society* (1956) was among the first efforts to

argue for a strategic approach to corporate engagement with social and community interests. Calling for a "new philanthropy" that would exceed the paternalism of earlier efforts, Eells argued that "corporate enterprise has a paramount duty to fight for the survival of a basically healthy social pattern that liberates man's creative energies, and to combat the suffocating forces of mandated conformity."[62] In 1960, Eells moved from his role in public relations at General Electric to a teaching position at Columbia University, where he would become one of the most prominent advocates for corporate social responsibility.[63] His study *The Corporation and the Arts* (1967) helped draw cultural programs into this model, claiming that "since the artist's freedom to create is just as essential as the businessman's freedom to innovate," both "have a vital interest in maintaining a free society."[64]

This softer, kinder "new capitalism" remained, of course, unavoidably self-interested.[65] As President Johnson's administration expanded social programs into ever-widening spheres of public life, corporate engagement with culture thus also served as an ideological salvo against what big business perceived as dangerously interventionist tendencies in Washington. Corporate efforts to wrest control of culture from new public agencies like the National Endowment for the Arts (created in 1965) and state arts councils represented a defense of free enterprise ideals, a kind of preemptive strike against other kinds of government intervention that could more directly affect the bottom line.[66] It was in this context that business leaders founded lobby groups such as the Business Committee for the Arts (created in 1967) to help demonstrate the capacity of companies to play a leading role in arts and culture.[67] In cultivating a corporate personality, works of art helped naturalize corporate personhood. More pragmatically, exhibitions and events also provided a credible excuse for matters of commerce to be broached with politicians and other power elites, with cultural events providing a congenial context—then as now—for the serious business of lobbying and other such cocktail hour negotiations.

The idea that corporations should contribute to the smooth functioning of society—including its arts and culture—gained considerable traction throughout the 1960s. But the idea also had its detractors. For economist Milton Friedman, the rhetoric of corporate social responsibility was nothing less than a dangerous Trojan horse for socialism. "There is one and only one social responsibility of business—to use its resources and engage in activities designed to increase its profits," he argued in *Capitalism and Freedom* (1962).[68] Friedman allowed for the fact that, in practice, the doctrine of social responsibility could serve as a cloak for activities that were justified on other grounds, such as tax deductibility or employee satisfaction. However, "Businessmen who talk this way," he later wrote, "are unwitting puppets of the intellectual forces that have been undermining the basis of a free society these past decades."[69] Corporate social responsibility was thus, in his view, anything but harmless spin: "In the present climate of opinion, with widespread aversion to 'capitalism,' 'profits,' the 'soulless corporation' and so on, this is one way for the corporation to generate

goodwill as a by-product of expenditures that are entirely justified in its own self-interest. . . . This may gain them kudos in the short run. But it helps to strengthen the already too prevalent view that the pursuit of profits is wicked and immoral and must be curbed and controlled."[70] If Friedman represented the most vocal conservative adversary of corporate social responsibility, many in the art world would come to suspect the motives of corporate art patronage for different reasons. In the late 1960s and 1970s, leftist artists and critics began to attack the hegemony of powerful museums like MoMA with a new vehemence, especially targeting their powerful boards as evidence of an institutional subservience to the values of a corporate elite.[71] Outside the United States, American corporate expansion had itself come to be viewed by some as a new kind of imperialism, and the promotion of American art as one means by which local styles were being subjugated by a nexus of private and state interests. Coca-colonization had become one shorthand for this charge, and critics frequently understood the global homogenization of postwar art in equivalent terms.[72] "Modern art, like bottled soft-drinks, glass-box office buildings, hit tunes, cities drowned in automobiles and other manifestations of modern civilization[,] has become the same the world over," reported one art critic in 1964.[73] As conservative ideologues attacked the premises of corporate art programs from the right, the Left no less came to understand such initiatives as—to borrow Friedman's terms from the seemingly opposing position—"undermining the basis of a free society." Such a position would come to find its most prominent moral conscience in the art world whistleblowing of Hans Haacke, the genesis of whose artworks within the interconnecting fields of conceptual art and corporate patronage provide the focus for my conclusion.

## CONTESTING THE SIXTIES

By exploring the interactions between art and business in the 1960s, this book also hopes to begin to unsettle the exaggerated position of resistance and counterculture in the decade's histories. In even the most sophisticated art historical accounts, the tumult of the late sixties has tended to define the character of the entire decade. Here, by way of example, is Rosalind Krauss: "Throughout the 1960s, youthful ideals measured against official cynicism created a collision course that eventuated in the uprisings of 1968" and "immediately affected the art world as well."[74] Such master narratives underpin a wide variety of approaches. In distinguishing the "upsurge of oppositional politics" in the sixties from the fifties, for example, Alex Potts claims the decade to have been "more demonstratively libertarian and allied with an activist public stance often directed against the art market and established institutions of art."[75] As a result, he suggests, "A radical individualism combined with a democratically oriented anti-establishment politics again became a real possibility." By the late 1960s and early 1970s, such values culminated, by his account, in the belief that "a new, genuinely radical form of art could develop . . . that might resist, or even subvert, the reifying and consumerist tendencies of modern capitalism."[76] Such accounts risk obscuring the rather messier ideological

configurations of the period, including the flourishing forms of corporate capitalism that should be counted among the decade's most powerful legacies.

From the present vantage point, to rewrite the histories of the sixties, more than half a century later, is also to grapple with the incompleteness of the progressive social change that it promised. Historians have argued, for example, that 1960s counterculture was, in fact, "complicit in many of the elements of society it criticised," suggesting that its critiques ultimately catalyzed consumer society and strengthened capitalism's power.[77] There is still much for art history to learn from such perspectives. As Philip Ursprung has rightly argued, "The attempts by many to identify American art in the 1960s with the counterculture, the New Left, or the widespread protests against the Vietnam War are no more than wishful thinking and completely overlook the considerable efforts of these artists to be accepted into the mainstream."[78] My account, though no less partial or partisan than those it seeks to challenge, similarly seeks to complicate the tendency to imagine the decade's art as unequivocal expressions of dissent.

The pervasive claims for the "radicality" of 1960s avant-gardes, and the vague political parallels this identification often involves, risk limiting art historians (and museum curators) to a celebratory cataloging of oppositional practices with insufficient attention to their contradictions. Such accounts too frequently accept the stated politics of artists, ignoring the rose-tinting of their often-retrospective recollections, and the frequent omission of the kind of commercial endeavors described in this book. The history reconstructed here does, of course, confirm the darkening political tumult of the late sixties, but the shifts from Kennedy-era optimism to the confrontations of 1968 unfold with rather less inevitability than the mythologization of the latter moment as an explosion of dissent might suggest. While the epochal social changes that flourished in the late sixties all undoubtedly left their mark on the art of the decade, and some make their influence felt in my study, this book offers a corrective for an art history too often content to exclude art's more complex relations to the victories of capitalism, and in so doing, to mask its own underlying allegiances to the mores of middle- and upper-class taste.

## CORPORATE COLLAPSE

What is clear, however, is that by the early 1970s the once-widespread enthusiasm for business-art collaboration was on the brink of collapse, at least in the multiplicity of forms that it had taken in the previous decade or so. Nowhere was this more spectacularly evident than in the field of art and technology. Indeed, it was a Pepsi-Cola initiative that represented one of the field's most high-profile breakdowns.[79] In late 1968, Pepsi commissioned the New York–based collective Experiments in Art and Technology (E.A.T.) to design a high-tech new media spectacle for the company's pavilion at Expo '70 in Osaka. Having sponsored Disney to create the "It's A Small World" attraction for the 1964–65 New York World's Fair, Pepsi already recognized the marketing potential of such multisensory and interactive experiences. "A good exhibit,"

the company's exhibitions director had explained in 1966, should create "a maze of intimacy from the sounds, smells, and feeling of its product. It should create a world which entraps the audience."[80] Produced by artists and scientists under the leadership of E.A.T. founder and former Bell Laboratories staffer Billy Klüver, the artwork comprised a computerized sound and light environment contained within a giant reflective dome (fig. 5)—as though one could now step inside the reflective spheres of Brownjohn's installation in Pepsi-Cola's foyer. The exhibit was originally called the Pepsi Sensosphere until someone realized that, ominously, "senso" sounded like the word for "war" in Japanese.[81]

Klüver had long been a vocal propagandist for collaborations between artists and business. In a meeting with Washington bureaucrats in 1966, for instance, he suggested that federal arts funding would be better handled by the Small Business Administration than the Smithsonian, arguing that artists had more in common with entrepreneurs than museums.[82] But he would also become somewhat more wary of the promises made for corporate art patronage. In a 1968 talk at the Museum of Modern Art, Klüver sought to dispel the idea that artists offered business much in the way of commercial value.[83] "Artists cannot be used as a source of new ideas," he said. "There are already too many profitable ones in industry." He also voiced a word of warning about the value of art as a public relations tool. "In many cases," he pointed out, "the company prefers not to have its name associated with the project." Above all, he recognized, corporations did not want to "trust its public relations or publicity to a situation they don't control, like the art world." Referencing Galbraith's lecture from a decade earlier, Klüver claimed that in fact, artists rather than executives had turned out to be the ones driving the proliferation of collaborative projects: "Galbraith described industry's involvement in the arts in his talk here ten years ago in terms of industry as the old-type arts patron, which would now become interested in art as it became financially secure and affluent. It was maybe too early in 1959 to see that in fact the moving force in changing the relationship between the arts would not be the affluent, secure, art-collecting industry, but the artist himself."[84] Klüver's message to business was simple: it must, he declared, "accept the artist on his own terms."[85]

When the industry publication *Soft Drink Review* reported on E.A.T.'s collaboration with Pepsi in 1968, however, it was clear that—for this company, at least—art was not really the point. Instead, the trade journal recorded that E.A.T. was commissioned to "explore new and effective ways to appeal to young people around the world" and achieve "new and revolutionary environmental communication techniques."[86] Pepsi had itself played a vital role in fashioning the popular image of sixties counterculture in the youthful and mildly rebellious individualism of its "Pepsi Generation" campaign, and it was in line with such messaging that the pavilion would be promoted.[87] "There's a beat that's bouncing from telstars to transistors, binding a new world of the young," the copy buzzed. "Gathered by one beat to one place, promoting understanding, friendship and peace. . . . It's a youth revolution you'll witness at the International

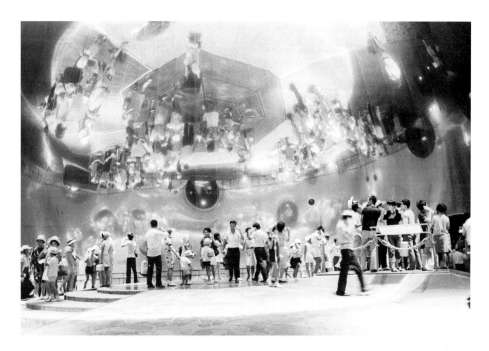

Youth Palace . . . the Pepsi Pavilion at EXPO '70."[88] This wasn't just spin into which art was unknowingly recruited. Given that E.A.T. itself described the pavilion as offering "choice, responsibility, freedom and participation," it is not difficult to see how the artists' concept itself engaged with the values of their patron's brand.[89] When critic Harold Rosenberg cited the Pepsi Pavilion and other "Chamber of Commerce-sponsored happenings" to argue that contemporary artists risked becoming "Madison Avenue idea men," his accusation came with the benefit of experience: he also worked as a part-time public relations consultant for the Advertising Council of America.[90]

As the Pepsi Pavilion neared completion, however, its problems mounted. In New York, the Guerrilla Art Action Group protested E.A.T. for its production of "the baubles of capitalism," while the underground press reported rumors "that the whole pavilion might be destroyed by Japanese student protesters."[91] The final preparations in Osaka were particularly luckless: a workman rigging the lights ripped the mirrored foil dome, and a sculpture broken during construction had to be removed. On the opening day, thirty audio headsets were stolen. Theatrical fog had to be turned off when it leaked into the restaurant next door. Above all, Pepsi's local bottlers were entirely unimpressed by the experience itself. Despite massive budget overruns, the installation remained unstable in operation, a sparse and experimental affair that lacked the spectacle they had anticipated and didn't appear to sufficiently promote

their product. "The Pepsi Generation gap is wider than anyone could have foreseen," reported the *Village Voice* in June 1970, as word of the dispute got out.[92] According to the sympathetic account of critic Barbara Rose, "The Pavilion was not the monument to American enterprise and advertising the Pepsi-Cola company bargained for, but an unexpected and subtle work of art."[93]

On April 20, 1970, Pepsi terminated their contract with E.A.T., kicking the artists out of the pavilion and replacing their avant-garde program with activities of a more obviously promotional bent. As one Pepsi executive wrote to Klüver: "I told you I didn't want any art exhibit and that's just what you've given me. Art is not going to sell Pepsi-Cola, and Pepsi-Cola is not going to sell art."[94] Embattled from all sides, the possibilities of corporate art patronage narrowed and in the decades ahead came to favor the blue-chip acquisitions of existing works and the more defined parameters of sponsored museum exhibits. The reputation of E.A.T. never recovered from the debacle, and their briefly commanding position in the New York art world fizzled almost overnight.[95] And as Pepsi abandoned its barely ten-year-old skyscraper for a secluded compound in the suburbs, the company turned to ostensibly "safer" forms of art detached from the conflicts of urban America, surrounding the pastoral acreage of their new headquarters with an expansive sculpture garden.[96] But for a decade or so, artists and executives had sat around the same tables, looking for common ground in the making of persuasive images, the business in which they both specialized.

# REPACKAGING POP

**AS ARTISTS TURNED TO THE SUPERMARKET** for inspiration, it is little wonder that packaged goods manufacturers paid close attention to the rise of pop art. What is less well known, however, is the extent to which these companies and their advertising agencies began to hire pop artists to help promote their products and build their brands. It is easy to imagine that pop artists were perfectly suited for the persuasion business, but, as we shall see, these encounters were anything but uncomplicated. This section explores the engagement of the Campbell Soup Company, Container Corporation of America, and Philip Morris with pop in the mid-1960s. My account is primarily concerned with works that Andy Warhol and James Rosenquist made for these three companies, but it also explores commissions by artists including Jim Dine, Marisol, Mel Ramos, Larry Rivers, and others to reconstruct the possibilities and problems that pop art posed for its patrons in the business of packaged consumer goods.

Much of the most influential scholarship on pop art of the past decades has focused on reclaiming its critical politics, exploring its relation to the social disruptions of the mid- to late 1960s. While it has been important to recover such political entanglements, one should not lose sight of pop art's driving interest in the world of mass-produced commodities. The direct relations between pop and consumer brands have remained somewhat neglected, perhaps a topic that has simply seemed too apparent to merit closer investigation.[1] Given the manifold transformations of media, materiality, and scale that such works almost always involved, the incorporation

of consumer brands into pop art should not be taken at face value. To suggest, for example, that "the inclusion of . . . specific corporations in Pop art works was due to their predominance in the consumer environment" too readily accepts these images as neutral reflections of the world in which pop artists lived.[2] Given the involvement of pop artists in commercial practice—designing advertisements, painting billboards, or decorating shop windows, for example—the presence of commercial imagery in their artworks is far from an impartial representation of American culture. Nor should the reincorporation of pop back into consumer culture as a key style craze of the mid-1960s be excluded from our understanding of the movement's history. There are obvious distinctions between these two fields of cultural production, but to ignore their relationships would be to elide the widespread embrace of consumer objects that pop art came to include within its cultural remit.

It is also a mistake, however, to necessarily regard pop's participation in the strategies of big business as a capitulation to its authority—in the words of one scholar, "an artistic stamp of approval on the American status quo."[3] As much as the corporate involvement in works such as these might favor the latter position, pop's participation in the persuasion industry was more equivocal than it at first might appear. Pop art might frequently look like packaged goods, and it was sometimes closely aligned with their manufacturers, but it does not always do what it says on the tin. The idea of packaging had itself become a prime metaphor for critics to dismiss certain forms of modern art and architecture as superficial efforts to attract the consumer's eye, aligned (directly or otherwise) to the tactics of salesmanship and, therefore, the goals of big business.[4] To make artworks that directly engaged with packaged goods was then to confront such discourses head on. By looking closely at particular works of art directly involved in the intersection between art and business, this section seeks to confirm the persistently ambivalent attitude of pop to its commercial sources.

For those responsible for marketing consumer products, pop's appeal derived not only from its familiar content but from its style, harking back to the illustrative commercial art modes lost to an age of color photography and television advertising. But with the nostalgia of such references also came risks. For its corporate patrons, pop could expose the more disreputable aspects of mass marketing, tactics that had inspired a string of high-profile journalist exposés and, as a result, new consumer protection regulations. As the cycles of consumer obsolescence and waste came under increased scrutiny in the 1960s, pop art risked drawing attention to the kinds of manipulations that big business preferred to obscure. Where abstraction might align with a corporate image of modernity and progress, the unmistakably "hard sell" content of pop risked foregrounding the baser commercial imperatives that "soft sell" cultural patronage was meant to hide. By the same token, the support of pop art from big business could help reinforce the authority of consumer taste and strengthen corporate commitments to the democracy of an unregulated free market.

Through high-profile advertising campaigns and widely touring exhibitions, corporations played a significant role in the international promotion of pop, creating a global art movement through the same means that they were simultaneously creating global consumer brands. In this sense, pop art was an especially conspicuous manifestation of the alleged Coca-colonization of American culture. As advertising agencies and public relations firms grappled with language and cultural variations required for new international markets, and the diminished oversight of licensing and affiliate agreements, pop art tested the tolerance of consumer brands to cede control of their image in an expanded, multinational marketplace. More often than not, corporations' engagement with pop artists required careful controls and equally careful efforts to disguise their interventions in order to preserve the appearance of artistic independence. That the corporate patrons of pop were also among those who turned to their lawyers to deal with the trademark infringements it involved is a telling instance of this field's contradictions.

The extent to which pop art celebrates or criticizes the visual cultures of mass consumption still remains a fundamental question for its interpretation, but my account emphasizes the coexistence of both impulses at once. In these projects, I argue, pop artists can be seen to reckon with the marketing and communications goals of their corporate patrons, making artworks that fulfilled these strategic imperatives but, simultaneously, sought to assert their creative independence from the same. These are works that exemplify the contradictions of pop art and reveal just how insufficient it would be to understand its attitudes toward consumer capitalism to be anything so simple as either complicit or critical. In the contacts between pop and business reconstructed here, we see artists and executives actively engaged in the content and meaning of the images they were creating, negotiating a precarious compromise between commercial and artistic imperatives. These frictions remain visible in the works of art themselves.

# 1

## TRADEMARKING CAMPBELL'S SOUP

---

I N 1963, ANDY WARHOL took a commission to illustrate a feature story on consumer trademarks for the cover of the business and finance section of the *New York Herald Tribune*. Previously unacknowledged in Warhol scholarship, this drawing, and the article with which it engages (fig. 6), provide useful clues for understanding Warhol's engagement with consumer brands and the companies that made them in the mid-1960s. Titled "Big Case over lower case," the article refers to the lobbying efforts that the United States Trademark Association directed toward the publishers of the Merriam-Webster Dictionary, among other adversaries, over the representation of consumer brand names in its new edition. As the article explains, the prospect of a brand becoming a household name might have been great for sales, but it also brought with it the serious risk that its name would slip into generic "lower case" use and thus no longer be a trademark under corporate control.[1]

The three-page feature details a range of trademarks that had suffered this fate, such as cellophane and aspirin, and those forced

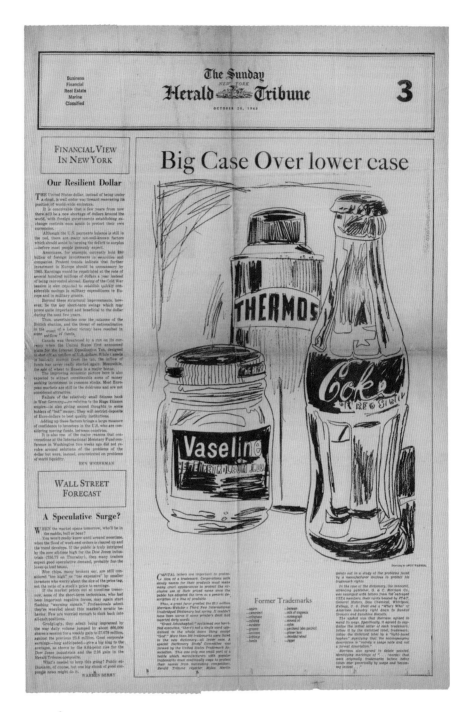

FIGURE 6

Andy Warhol, clipping ("Big Case Over lower case," *New York Herald Tribune,* October 20, 1963), 1963. The Andy Warhol Museum, Pittsburgh; Founding Collection, Contribution The Andy Warhol Foundation for the Visual Arts, Inc. 1998.3.10264. © 2020 The Andy Warhol Foundation for the Visual Arts, Inc. / Licensed by Artists Rights Society (ARS), New York.

to aggressively fend off such linguistic co-option, like Formica and Kleenex. Finally, the article celebrates Coca-Cola as the "long-time champ in staving off public theft of its gold-mine trade name," detailing the various strategies by which the Coca-Cola Company kept control of its trademarks.[2] Judging by his illustration, Warhol fully absorbed the article's content. His drawing brought together, with only casual regard for perspective and scale, one brand from each of the scenarios the report outlined—the Thermos Bottle, a former trademark lost by its corporate owner in a 1958 legal battle with a competitor; Vaseline, whose manufacturer had pursued a strategy of brand extensions beyond the category of petroleum jelly in order to avoid the same fate; and finally Coca-Cola, whose success in controlling its trademarks loomed over all others. In this context, it is significant that Warhol's drawing creatively unifies the brand's Spencerian script logo with its truncated name Coke, the word that was at such risk of becoming a generic term. Below Warhol's improvised logotype, the only example of its kind, Warhol includes the letters REG—a reference to the public notice of "trademark registered" by which the Coca-Cola Company sought to protect its brand from the kind of mischief that Warhol's revision represents.

Warhol's engagement with consumer trademarks in this article helps us understand the variations across his most famous branded subject: the Campbell's Soup can. The first series of these iconic works (fig. 7), made in late 1961 and early 1962, could hardly foreground their commercial source more blatantly. Far from "exact, hand-painted copies that are faithful reproductions of the original," as they have on occasion been described, these works evidence many variations from their branded source.[3] The images differ in scale and format and in some instances show cans with peeling labels, price tags, and opened lids. Traced onto the canvas via a projector, they remain inescapably handmade: the name of each flavor wobbles tentatively around the label, while the rubber-stamped row of fleur-de-lis all but ignores the supposedly curved surface of the can. Warhol decorates the center of most versions with a plain yellow disc, an abstracted stand-in for the intricate gilded medallion that the Campbell Soup Company had won at the 1901 Paris Exposition.[4] As Cécile Whiting has accurately summarized, such works "treat the label as shapes, colors, and forms, not valuable consumer information."[5]

When Warhol returned to the soup can subject in 1964 (fig. 8), his approach is subtly but significantly different. The fleur-de-lis are more illusionistically depicted as if they were disappearing around the edges of the can. The medallion is rendered in black and gold to suggest the intricate details of the original. Rather than hand-painting thirty-three soup varieties on a small scale, Warhol now prints just one at almost twice the size as most of the early versions—selecting Tomato Soup as its sole subject, whose flagship status would be reinforced by his reuse of the same screens for several other works.[6] In one rarely observed detail from this second series of works, at the upper left corner of the can, Warhol includes two overlaid crossed circles, the registration device used by printers to ensure that colors line up accurately—a quality

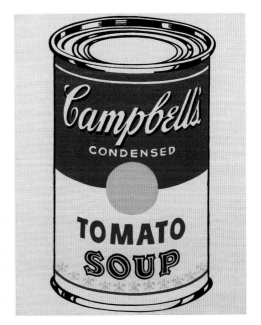

that so many of Warhol's other screen prints happily eschew.[7] Warhol referred to these works as being in "real colors" and described his use of specially mixed and metallic paints, interests that suggest the concern for accuracy and realism that characterized his return to the soup can subject.[8]

The increased concern for the accurate presentation of the Campbell's Soup trademarks in these works is not just the result of Warhol's move from painting to screen printing. It also reflects the impetus for Warhol to begin this second series of cans: a $2,000 commission from the Campbell Soup Company itself. This episode, strangely neglected in the voluminous scholarship dedicated to these works, is the central focus for this section.[9] Warhol had already been in touch with the company from the outset of the series, requesting an inventory of its available flavors, a list he used to determine the thirty-two cans in his 1962 exhibition at the Ferus Gallery in Los Angeles. Not only did Warhol's strict observation of the company's product line as the basis for his series favor commercial over artistic logic, but the accurate showcasing of their range also served to foreshadow the promotional potential of his subject.[10] His dealer, Irving Blum, certainly recognized the possibilities. "I contacted Campbell's by letter," he later described. "I suggested they buy the paintings and give them as gifts to 32 different museums—as a promotional gesture on their part."[11]

The commercial implications of Warhol's use of a high-profile trademark were not lost on period critics either. In a 1962 interview, critic David Bourdon compared Warhol's homage to Campbell's Soup with Stuart Davis's reference to the "57 Varieties" trademark in his 1957 mural commission for the Pittsburgh-based H.J. Heinz

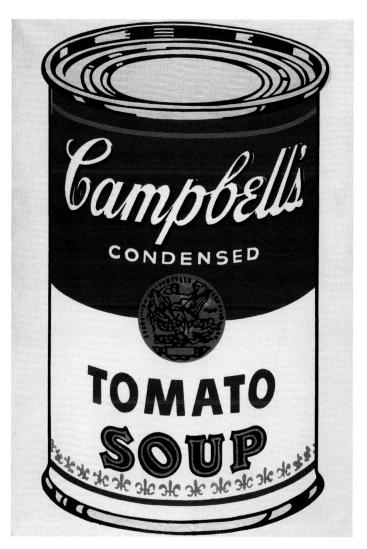

Company.[12] "Why didn't I think of that?" exclaimed Warhol in an interview with Bour-
don, as though Heinz's more extensive flavor range made this brand instantly more
appealing. Warhol had experimented with his hometown brand of Heinz, including a
series of 1962 drawings in which their iconic ketchup bottle appears alongside the
Campbell's can, but there was more to be made from his posture of feigned surprise.
"The H.J. Heinz Co. probably sends Stuart Davis all '57 Varieties' every year, besides
having paid him for the mural," Warhol speculated. "Do you know that the Campbell
Soup Co. has not sent me a *single* can of soup?"[13] He repeated the complaint in a 1963
interview: "Not even a word. Isn't that amazing? If it had been Heinz, Drew Heinz
would have sent me cases of soup every week."[14]

In such statements, Warhol walks a delicate line. While he makes it clear that his first series of soup cans did not involve corporate support, he also foregrounds the promotional functions his subject matter could accommodate. Such possibilities were evident from the outset of the pop movement and the central position of his work in its public reception. A 1962 cartoon in the *New Yorker,* for instance, showed a critic telling the sculptor of a giant headache pill that "if the modern museum doesn't snap it up . . . the Bufferin people will."[15] The presence of Campbell's Soup paintings in the background of this cartoon's fictional studio makes it clear that the cartoonist had Warhol in mind. Warhol's eye on commerce seems, at this stage, to have been more equivocal: he also told Bourdon that he preferred that the Campbell Soup Company not know about his works "because the whole point would be lost with any kind of commercial tie-in."[16] Such a statement seems to favor a critical reading of Warhol's relationship to consumer culture. But as real Campbell's Soup cans became central to Warhol's promotional repertoire—a souvenir to sign for fans, or a prop for publicity shots—Warhol's attitudes would be complicated by the attention he thought he was owed by his corporate muse.

By 1964, Warhol's attention to the Campbell's brand paid off. "Your work has evoked a great deal of interest here at Campbell Soup Company," the product marketing manager William MacFarland eventually wrote to the artist in a May 1964 letter. "I have since learned that you like Tomato Soup," he continued, so "I am taking the liberty of having a couple of cases . . . delivered to you at this address." With relations between artist and corporation initiated, more significant discussions followed. In August, Warhol's assistant Billy Linich wrote back to MacFarland to see if the company was interested in purchasing one of Warhol's new wooden sculptures, a Campbell's Tomato Juice carton.[17] The correspondence was directed to E. Marshall Nuckols Jr., who replied that the company had "of course, followed the 'Campbell Experience in the World of Art' as you describe it." But Nuckols was less keen to blur the lines between art and advertisement. "If Campbell were to sponsor or display these works in any way, however, it might interject an element of commercialism into the whole program that would detract from their acceptance as works of art."[18]

This did not, however, preclude internal uses of Warhol's art by the company. In early October, another senior company official wrote to Ivan Karp, assistant director of Leo Castelli Gallery, to confirm a more substantial transaction: an order for a Warhol painting, required on a three-week turnaround, commissioned as a gift for their outgoing chairman of the board Oliver Willits: "This is to confirm our conversation by phone today in which Campbell's Soup Company commissioned Mr Warhol to do a painting of a can of Campbell's Tomato Soup on a plain neutral background similar to the painting he did in 1962 called 'Campbell Tomato Soup Can.'"[19] Several implications of the commission are worth addressing. It is clear that Warhol's return to the Campbell's Soup can theme after more than two years resulted from a commission from the product's manufacturer. Although he had stated his personal preference for

tomato soup in interviews, it was also at the request of the corporation that the commissioned picture should depict their best-selling flavor. Warhol's choice to make the work with a photographic silkscreen—even though his corporate patron required only a single painting—foreshadows his reuse of these screens in subsequent versions of the subject as much as it reflects his patron's likely preference for the hard, smooth edges of mechanical reproduction, and Warhol's anticipation of their desire for an accurate presentation of its trademarks.[20]

As Warhol well knew from his experience in the commercial art sphere, the accurate reproduction of a brand's visual characteristics was no minor matter. In the case of Campbell's Soup, Anthony Grudin has shown how the product was positioned as a "sign of good taste," especially among the working-class consumers for whom national brands represented quality and were inexpensive luxuries promising social elevation.[21] Such issues were central to an article titled "Memorable Packages," published in the trade magazine *Industrial Design* in 1960 and preserved in Warhol's archives.[22] The article laments the "trend toward anonymity" in modern packaging. Serving as "a reminder of a time when design was achieved neither by depth probing nor by committee," Campbell's Soup was among the brands celebrated for retaining their Victorian "finishing swirls," "exposition medals," and "heraldic devices."[23] As the antithesis of the anonymous supermarket commodity, the decorative features of the Campbell's Soup can (the medallion, the fleur-de-lis) were central to its traditional, wholesome image. Consistent expression of these aesthetic cues was of the highest priority to Campbell Soup Company. As a 1964 textbook on the international expansion of American business noted, the company had resorted to paying "bonuses for exact reproduction" of their trademarks.[24] Warhol's commission paid close attention to the accurate representation of Campbell's visual identity in order to comply with such requirements.

The relationship between Warhol's art and the corporate context for which it was produced also extends beyond such marketing activities. As labor historian Daniel Sidorick has shown, Campbell's growth under the leadership of Oliver Willits and William Murphy had involved eliminating many of the "hand operations long necessary in the production of soups."[25] In 1964 alone, the company made some three hundred changes to its production processes designed to increase productivity, often by replacing workers with machines.[26] There were aesthetic goals for this automation too. In 1962, the company introduced a new electronic measurement system for grading the color of tomatoes, one of many processes introduced to improve the visual consistency of its products.[27] As the company expanded internationally in the early 1960s, it was particularly concerned to ensure tomatoes' "uniform color and flavor though grown in different climates."[28] If automation helped the company improve plant efficiency and product consistency, however, it also posed serious labor relations problems. It was in part to combat the company's troubled relationship with its workforce that the public relations firm Newsom and Company was charged with "creating a stronger and clearer impression of the company's personality," efforts designed not

only to improve sales but also to preemptively secure public favor in case of union action.[29] It is striking that the choice of Warhol's art for Willits's departure gift unified the interconnected interests in efficient, machine-like production and carefully managed brand image that had defined Willits's own leadership of the company.

Correspondence suggests that the Campbell Soup Company wished to keep control of any news concerning Warhol's commission. William C. Parker, the company's director of public information, had asked that the gallery keep the commission under wraps. "We would appreciate it if all publicity concerning this painting be withheld until after November 20," he wrote, as Warhol's work was to be presented as a surprise to the outgoing chairman Willits on the evening of November 19.[30] That such publicity never seems to have eventuated reinforces the sense that this private commission was not to be confused with the business of consumer marketing. The only press that Campbell's appears to have generated appeared in the company's own magazine and seems to confirm its ambivalence toward the swell of attention that Warhol had brought to their brand. Titled "Campbell's Soups on Canvas," the one-page, 130-word feature details how "reproductions of our soup cans" were on display at "famous museums and galleries around the world."[31] As if to reinforce their legal ownership of the trademarks that Warhol was making his own, the artist's name is excluded from the main article, included only in the caption of the photograph of the dinner at which it was presented. Even this image (fig. 9) diminishes the presence of Warhol's work—positioning the commissioned canvas at the end of the formal banquet table, beyond the suited men, fine china, and elaborate floral centerpiece, pushing the supermarket packaging upon which both pop art and this company relied as far into the background as possible.

The reference to Campbell's trademarks being on display "around the world" is noteworthy. Like many American corporations, Campbell Soup Company had aggressively diversified its product lines and pursued international expansion since the 1950s, and protecting their trademarks abroad became a significant concern. One episode from the period helps capture the corporate anxieties that this issue would provoke. In 1965, the United States Trademark Association's press office widely publicized the trademark scam of Robert Sancier Aries, an exiled chemistry professor. Aries had bought the unregistered trademarks for more than three hundred brand names in Monaco and attempted to sell them back to American corporations. "It is theoretically possible for Dr. Aries to open a bank bearing the name 'Chase,' for example, in Monaco," explained an outraged lobbyist to the *New York Times*.[32] It was not for nothing that Aries was establishing a sideline in scientific art authentication at the same time as his trademark scam made headlines. Both fields depended on incontestable ownership and authenticity, and both promised profits to those with the power to validate (or fake) brand-name signifiers.[33] For art and business alike, international markets were making it increasingly difficult to keep control of one's trademarks.

By the mid-1960s, the burgeoning visual culture of pop required that Campbell's grapple with the implications of a wide range of threats to its brand. In November

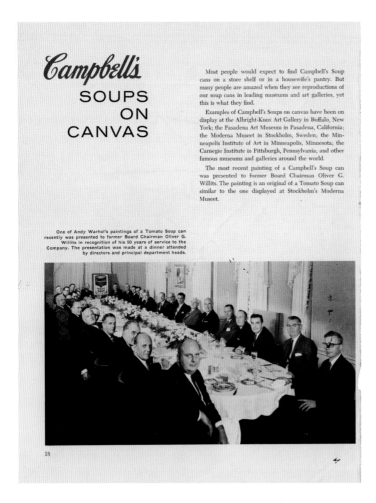

**Campbell's**
## SOUPS
## ON
## CANVAS

Most people would expect to find Campbell's Soup cans on a store shelf or in a housewife's pantry. But many people are amazed when they see reproductions of our soup cans in leading museums and art galleries, yet this is what they find.

Examples of Campbell's Soups on canvas have been on display at the Albright-Knox Art Gallery in Buffalo, New York; the Pasadena Art Museum in Pasadena, California; the Moderna Museet in Stockholm, Sweden; the Minneapolis Institute of Art in Minneapolis, Minnesota; the Carnegie Institute in Pittsburgh, Pennsylvania; and other famous museums and galleries around the world.

The most recent painting of a Campbell's Soup can was presented to former Board Chairman Oliver G. Willits. The painting is an original of a Tomato Soup can similar to the one displayed at Stockholm's Moderna Museet.

One of Andy Warhol's paintings of a Tomato Soup can recently was presented to former Board Chairman Oliver G. Willits in recognition of his 50 years of service to the Company. The presentation was made at a dinner attended by directors and principal department heads.

18

FIGURE 9

Clipping ("Campbell's Soup on Canvas"), 1964. The Andy Warhol Museum, Pittsburgh; Founding Collection, Contribution The Andy Warhol Foundation for the Visual Arts, Inc. TC11.108.1.15.6. © 2020 The Andy Warhol Foundation for the Visual Arts, Inc. / Licensed by Artists Rights Society (ARS), New York.

1964, Campbell's legal department issued new "Trademark Guidelines" to its advertising agencies worldwide, reminding them to include the "registered trademark" statement in all print advertising, and suggested that it even be spoken in radio advertisements.[34] Warhol's imagery was, I think, a prime source of their anxiety. In 1966, United Wallpaper capitalized on the pop trend by releasing a pattern that featured both the Campbell's and Brillo Box brands, absorbing the soup brand into the field of pop's campy celebration of lowbrow supermarket products.[35] In the field of pop fashion, $15 shift dresses by youth label Crazy Horse "decorated with a great big picture of a can of Campbell's Soup" appeared in *Life* magazine in February 1965.[36] It seems unlikely that the company provided permission for such tongue-in-cheek reproductions that drew their fashionable currency from Warhol's use of the Campbell's brand, expanding his own relatively limited (if high-profile) trademark infringement into a much wider field of profitable consumer goods.

Campbell's was not the only company grappling with the rapid reabsorption of pop into the same mass culture sources, especially comic books and consumer packaging, from which it had appropriated.[37] One company that specialized in such products was Pop Arts Inc., founded by Maurice Greenberg. Established in 1966, within two years it had licensed more than 150 labels, including Heinz, Pepsi, and Kleenex, to make branded pillows, placemats, and other homewares. "At first the manufacturers weren't sure," explained Greenberg. But very soon, they "started getting letters asking us to use certain brand names. The manufacturers wanted us."[38] As trade journal *Advertising Age* reported, the company had "gotten free ads into more than 1,000,000 homes," where the items functioned as "365-day-a-year billboards."[39] Several advertising agencies sought to capitalize directly on the pop trend too. Handman & Sklar established their "Pop Art Forever" division to sell reprints of a Lichtenstein imitation used in a coffee advertisement, while Fladell, Winston, Penette Inc. advertised and sold prints offered by its "Pop Art Portraits" subsidiary. Within three weeks, they sold more than four thousand posters at $3.98 each. It "might make more money in 1965 than the agency," its representatives told *Advertising Age*.[40]

Other companies tried to manage the complexities of the pop trend by avoiding artworks altogether. Pepsi-Cola had used its foyer gallery to launch *Vernacular America: Sources of Pop Art* in mid-1964 but, after opening the exhibit to a room of artists and curators, immediately canceled it—sensing an imminent backlash to their showcase of visual culture "sources" that had "inspired Pop artists," yet was missing any actual works of art.[41] By the mid-1960s, the threat inherent in pop's unlicensed uses of trademarks was compounded by the fact that the movement itself was beginning to lose its fashionable sizzle. "The admen are now trying to . . . get out of the gimmick business quick," the *New York Herald Tribune* reported. "It makes them nervous—what with the subtleties of in and out and pop and op these days, a man can't depend on whether he'll sell to the outs because it's pop or to the ins because it's out."[42] This also had serious implications for the avant-garde credentials of pop. As Blake Gopnik has rightly summarized, the "triumph of Pop Art in the culture at large wasn't the sign of success it might seem; it sealed Pop's doom as serious art."[43]

In response to the explosion of cheap pop-styled consumer paraphernalia, Campbell Soup Company had itself attempted to leverage the new meanings of its brand. For a 1967 consumer sales promotion, the company advertised that it would give customers "The Souper Dress" in return for sending the company $1.00 and the labels from two different kinds of soup. The disposable shift was decorated with four rows of Campbell's Soup Cans (fig. 10), its flattened red, black and yellow grid serving as something of a pop rejoinder to Yves Saint Laurent's celebrated Mondrian collection from 1965 and the numerous knock-offs it too had inspired.[44] Campbell's efforts to profit from the visual culture of pop did not merely seek to convert Warhol's artistic capital into a tactic for sales promotion. More strategically, it should also be regarded as a tactic to reestablish control over its intellectual property by marking out the

production of mass-produced pop paraphernalia as being within their own promotional remit and making it clear to other producers of pop-styled products that their brand was off-limits.

That the Souper Dress is sometimes mistaken as Warhol's own work is appropriate given his own contribution to disposable pop fashion.[45] In November 1966, Brooklyn department store Abraham & Strauss advertised that Warhol would appear in-store for a "happening" to promote disposable paper dresses made under the "Wastebasket Boutique" brand.[46] The shift dresses were made from Kaycel, a new nylon-reinforced paper produced by the Kimberly-Stevens Corporation and launched a few weeks earlier at the New York Premium Show—a trade event for businesses seeking low-cost promotional giveaways like the Souper Dress.[47] For the assembled crowd, Warhol had

Gerard Malanga screen-print the word "Fragile" onto a dress modeled by Nico (fig. 11). Like the mailing package of an overzealous sender, Warhol's intervention declared the ephemerality of the garment, which could not be washed or dry-cleaned. Given that Warhol's creations were to be donated to the Brooklyn Museum, where their intended ephemerality would be undercut, Warhol's motif was also a gesture that mischievously announced the low-grade disposability of the product he had been hired to elevate.[48]

Warhol's embrace of disposable consumer products would eventually attract the ire of Campbell's lawyers. The poster for his 1966 exhibition at Boston's Institute of Contemporary Art took the novel form of a brown paper shopping bag (fig. 12) decorated with an image from Warhol's *Colored Soup Cans* series.[49] The bag was silkscreened by newly established art publisher Poster Originals, which, in addition to allowing its use by the ICA, widely advertised the bag's sale as a "multiple" for $5.[50] In early 1967, Campbell Soup Company threatened legal action against the poster's manufacturer, requesting that their production and distribution of the bag be "stopped immediately." "As we hope you realize, the label that you reproduced contains our trademarks which are extremely valuable to our operation and are our Company's exclusive property," the company's legal counsel advised Poster Originals. "We are very concerned about them appearing on any commercial products without our consent."[51]

Poster Originals' response, dated three days later, was prompt if condescending. Furnished with the details of Campbell's Warhol commission of two years earlier by Leo Castelli Gallery, their lawyer's response to Campbell's relished the revelation. "We

FIGURE 12

Andy Warhol and Guild Paper Products, Inc., *Campbell's Soup Can (Tomato)*, 1966. Screen print on shopping bag. 24 × 17 in. The Andy Warhol Museum, Pittsburgh; Gift of David M. Gilson, 1994.1. © 2020 The Andy Warhol Foundation for the Visual Arts, Inc. / Licensed by Artists Rights Society (ARS), New York.

were rather surprised at your letter since your Company has been aware of the use of the tomato soup label for a number of paintings by the artist, Andy Warhol," wrote their attorney, and "The Company had no objection to this use and, in fact, rather approved of the idea." In any case, the lawyer claimed, taking a philosophical turn, the so-called shopping bags were no such thing: that they were "printed on a shopping bag rather than a more conventional form was not intended to change its character as a work of graphic art." "Anyone who acquired a shopping bag," Poster Originals' lawyer dryly informed the soup manufacturer, "would be very pained if any member of his household were actually to use it as a shopping bag."[52] Nothing further seems to have come of Campbell's complaint.

Poster Originals' lawyer had understood the crux of the problem: for Campbell's, the use of the brand in Warhol's artworks was one thing, but the production of a shopping bag was entirely too close to the business of packaged consumer goods. Branded shopping bags were precisely the kind of thing that Campbell's themselves might need to make. The nature of the image exacerbated the transgression. As Campbell's lawyers described it, the bag featured a "large fanciful reproduction." Warhol's *Colored Soup Cans* series were made, ironically, using the same screens created for Campbell's own commission. With their self-consciously garish palette, barely legible contrasts, and frequently off-register execution, *Colored Soup Cans* flagrantly disregards the rules of the Campbell's brand.[53] In the case of the paper bag for the ICA, a paper fold runs straight through the product name, and the label design would be only further deformed if the bag was opened for use. Just as the reproduction of their brand on a shopping bag transgressed the borders between art and commodity that Campbell's wished to regulate, Warhol's brazen treatment of the brand of his patron revealed the fragility of the corporate image and served as a perverse visual insult to the company's demands for brand integrity.

Warhol was not a stranger to such legal disputes. In 1966, he had settled a claim from Patricia Caulfield over his use of her photograph for his *Flowers* series.[54] In May 1967, the general counsel of the Coca-Cola Company also targeted Warhol's use of their trademarks. In this case, Warhol had created *You're In/L'eau d'Andy*—a series of silver spray-painted Coca-Cola bottles filled with cheap perfume.[55] The cease-and-desist letter arrived a little over a week after the series' first showing at a group exhibition in Philadelphia. "We must object to the use of our famous bottle for Coca-Cola as a container for your cologne," wrote the company's general counsel John D. Goodloe. "Its use as a container or a cologne constitutes a flagrant infringement and competition."[56] With Warhol's punning brand name, it cannot have helped that *You're In* took aim at the kind of hip youth marketing slogans that Coca-Cola specialized in, but it was the reuse of actual bottles that was the fundamental issue. The reference to "competition" here is significant: Coca-Cola's letter cites Section 43AA of the Lanham Trade-Mark Act, which concerns the false labeling or packaging of products that will "enter into commerce." Coca-Cola can hardly have failed to notice Warhol's earlier use of their brand in artworks, or to understand that these objects were also sold for profit, but it was

Warhol's use of their trademarks to sell a consumer product that made *You're In* so intolerable. Warhol told the *Philadelphia Inquirer* that he "didn't expect the company to react that way," but such press coverage quickly capitalized on the dispute, pointing out that Coca-Cola's actions had inadvertently turned *You're In* into "a collector's item."[57]

Even when companies invited Warhol to contribute to promotions, his responses could upend their expectations. Asked by Hallmark to decorate a Christmas Tree for an exhibition of celebrity designs in their Fifth Avenue Hallmark Gallery in 1964, Warhol provided no Campbell's Soup Cans or silver spray paint, choosing instead to present the exhibition's only undecorated tree—a plain spruce entirely bare of the ornamentation on which Hallmark's business thrived. Here, the critical edge of Warhol's famously blank affect could not be clearer. The contribution of the artist Marisol, a friend of Warhol's, to a Hallmark's 1967 Christmas exhibit was even more perverse. Marisol presented a traditionally decorated tree "sleeping" on a Victorian bed. "Trees cry when they're cut," Marisol explained of her installation, which she claimed depicted a tree dreaming of its former life in the forest.[58] A reportedly teary Marisol told the *New York Times* that she did not "believe in Christmas trees for herself because she thinks it's cruel to chop them down."[59] For a sculptor known for her figurative sculptures made from wood, Marisol's anguish over the plight of trees was an unavoidably eccentric performance. Replacing holiday cheer with mourning, her gesture provided an awkwardly dark message for a paper products company. Recruited into the machinery of promotion but destabilizing its expectations, both Marisol and Warhol's contributions to this exhibit exemplify the unpredictable messages that pop artists could present to their corporate patrons.

Warhol's continued engagement with the Campbell's Soup can in the mid-1960s should be understood within this broader field of the consumer cultures of pop, a field that required consumer goods companies and their agencies to grapple with the impact of artistic works on their corporate image. Even if advertising commissions for artists had declined, it does not seem right to claim that Warhol's engagement with commercial imagery occurred "just at the point when advertisers themselves were largely turning their backs on art, when debates over the artist's relationships were becoming, from the advertiser's perspective, a dead issue."[60] These were issues with considerable currency in the field of consumer marketing. And while the details of Warhol's Campbell's commission were, for the most part, unknown to period observers, there was certainly gossip that something more was at stake. For instance, in 1968, a *New York Times* reporter wrote offhandedly—and without naming names—of the "really, truly, or at least almost, fantastic artist who has been put under a subterranean contract with Campbell's Soup."[61] Campbell's gift of a case of soup to the artist was even reported in the press, prompting writer Peg Bracken to consider whether other artists could "get part of their support from businessmen, in return for pushing their products."[62]

In 2014, Campbell's public relations department staffer William Parker insisted that the company "received many press inquiries as to whether or not the company

had any commercial connection with Mr. Warhol, and the reply was always an emphatic 'no.'"[63] A letter from Parker to Random House Publishing, sent in August 1967, confirms that the company and its representatives had long toed this line. "Now and then we have been asked by some serious student of art, an art critic, or a journalist whether or not our company subsidized Mr. Warhol's work. . . . I think you should have it on record there that the company has not attempted to influence Mr. Warhol in any way. So far as we know, all his selections of commercial products as art subjects have been entirely his own."[64] Similar distancing efforts are evident from the other side. When Warhol's gallery representative Ivan Karp acknowledged the commission, he also assiduously downplayed its significance. Asked directly whether the Campbell Soup Company had reacted to Warhol's use of their brand, Karp confidently responded that "they think very little about it." Describing the company's staff as "a staid, conservative people," he informed his audience that "for three years, after Mr. Warhol glorified tomato soup . . . [they] said nothing."[65] Karp acknowledged the commission but framed it in such a way as to substantiate the company's lack of interest. "Recently they gave their retiring president one of Andy's paintings as a going away gift," he admitted, neglecting to specify the subject of the painting, let alone the circumstances of its production as a corporate commission. "And if I may judge by the expression on the old man's face . . . there is nothing he wanted less."[66]

Perhaps most surprising of all is Warhol's silence on the matter, even given his own famously impassive persona. For any other artist, this might not be unusual—the disavowal of corporate collaboration characterizes many accounts of 1960s art practice. And when it suited Warhol, he seems to have capitalized on his contacts at the company. In 1965, for instance, he "wheedled actual labels out of the Campbell's Soup Company," for a variety of flavors, on which he then printed invitations for his exhibition at the University of Pennsylvania.[67] But the sense that the Campbell's commission itself was something to be swept under the rug provides a stark counterpoint to Warhol's later famous embrace of "business art" in the Factory. In an oft-cited passage from *The Philosophy of Andy Warhol*, such attitudes crystallize into a creative philosophy:

> Business art is the step that comes after Art. I started as a commercial artist, and I want to finish as a business artist. After I did the thing called "art" or whatever it's called, I went into business art. I wanted to be an Art Businessman or a Business Artist. Being good in business is the most fascinating kind of art. During the hippie era people put down the idea of business—they'd say, "Money is bad," and "Working is bad," but making money is art and working is art and good business is the best art.[68]

Understood through this account of his journey from commercial art to "capital-A" Art to "business art," Warhol's 1964 Campbell's commission represents a transitional moment, describing an artist under the temporary spell of those "hippies" for whom

working and making money was so deplorable, and not yet willing to risk his new avant-garde credentials by "selling out." It had not been so long since Warhol had employed separate assistants for his commercial and fine art output, regarding the former as his "secret profession," so much so that he "concealed any evidence of commercial art activities" when art world visitors came to his studio.[69] Warhol never abandoned his practice as a commercial artist, but by early 1966, when he placed an advertisement in the *Village Voice* offering to "endorse" the wide range of products that he required for the Factory (as his studio was by then known), Warhol's decision to unify these separate spheres seems to have been made up. Collaborating with big business would become central to his practice, and he would work for anyone who would pay for his services.[70]

Warhol's eventual embrace of "business art" is, of course, uniquely enthusiastic. Most artists who participated in collaborative projects in the 1960s evidence a more persistent ambivalence to the restrictions set by their corporate patrons. By the end of the decade, self-consciously avant-garde artists became much less likely to openly boast of their commercial projects, fearing that the diminished status of this field would threaten their credibility. But the problematic implications of business-art collaborations were no less sharply felt among the ranks of corporate marketing and public relations personnel. The branded subject matter of pop might seem to make its commercial application relatively straightforward, but in practice it tended to make the meanings of branded content all the more hotly contested. For the Campbell Soup Company, Warhol's realism was both flattering and disturbing—and Warhol actively played with both possibilities. His works, and the visual culture they spawned, represented an exciting opportunity for corporate public relations and product marketing, but also a troublesome intervention into the image of valuable consumer brands.

# 2

## CONTAINER CORPORATION'S ART DIRECTION

**W**ARHOL'S FASCINATION FOR PACKAGING finds a more cryptic expression in a small and all-but-ignored group of pictures from the early 1960s.[1] The title for these works may be the benign-sounding *Corporate Trade Ad* (1963) (fig. 13), but it is their evasion of advertising aesthetics that sets them apart from his other treatments of consumer products. In the key picture of the series, an arrangement of twelve panels features screen prints of what seems to be a random selection of items: a lemon, a plant, a hammer, a wine glass, a coffee cup, a chair, a bunch of celery, some strawberries, the windscreen of a Volkswagen, what appear to be some pill bottles, a can of tomato paste, and a nylon stocking. With such unremarkable objects, the effect is entirely less captivating than Warhol's screen printing of similar panels for his well-known commissioned portrait *Ethel Scull 36 Times* (1963), also painted on the same cheerful array of colored canvases. *Corporate Trade Ad* is a painting of consumer products, but its forgettable assortment of oddities wholly lacks the sizzle of the Scull portrait and seems even further

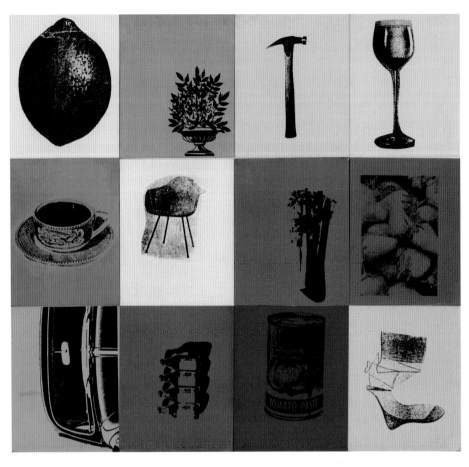

removed from the high-impact supermarket labels of his iconic Campbell's Soup cans and Brillo boxes.

Given the context for which Warhol produced this painting, its avoidance of such iconic consumer brands initially seems even more surprising. The work was commissioned by America's leading packaging manufacturer, the Container Corporation of America (CCA). Paperboard accounted for three-quarters of all packaging production in this period, and as self-service supermarkets and consumer demand for conveniently portioned products boomed through the 1950s, Container Corporation was among its most successful producers. But it was not boxes that Container Corporation was best known for. As the company's founder Walter Paepcke had put it in 1954, cardboard packaging was "of almost complete indifference to the business men, investors,

prospective employees and leaders of public opinion who were our audience."[2] Understanding this had prompted Paepcke to pioneer the use of art in advertising, commissioning works from dozens of high-profile modern artists and designers.[3] Along with his wife Elizabeth, Paepcke played a pivotal role in fostering a taste for modernism among the American business elite, a mix of culture and commerce that elevated Container Corporation to a uniquely rarified position among the ranks of interwar American industrial enterprise.[4]

This was, of course, more than just enlightened patronage. As Paepcke's Bauhaus-trained design consultant Herbert Bayer wrote, the Container Corporation's art programs had "to be justified within the context of a business plan."[5] Art helped capture the attention of their target market, connecting the qualities of "originality, imagination and taste" with "similar qualities in our organization."[6] Container Corporation's approach prefigured the shift from marketing focused on the factual description of product benefits to the more institutional focus that would come to characterize corporate image marketing. However, this aesthetic differentiation was not just a matter of brand. It also served to dramatize the aesthetic orientation of the company's business. Container Corporation's profits were to be made, not from yards of raw paperboard, but from the added value of design—the development of packages conceived to grab consumers' attention before they noticed the competition.

Warhol had secured his commission as part of a shift in Container Corporation's advertising strategy, long handled by the agency N.W. Ayer & Son, a pioneer of art in advertising practices in the interwar years.[7] After Paepcke's death in 1960, the company became nervous about the overly lofty tone of its corporate image. "We didn't object then, and we don't now, to having people think well of us because they like our ads," explained Ralph Eckerstrom, the company's design director. "But we also wanted them to remember that we make paper and plastic packages in all shapes and sizes and are ready and eager to do business with them."[8] A new series of advertisements was required: one that would not abandon the company's artistic approach but would be more "marketing oriented." "We want to talk about other things in addition to design—our marketing, our machinery, research and the materials we use," Eckerstrom summarized.[9] *Advertising Age* recognized the significance of the change, reporting that it would be a paradoxically "revolutionary idea for so distinctive a pioneer in image-building to be running mundane advertising discussing such prosaic subjects."[10]

Container Corporation's advertising had long divided industry commentators. For Pierre Martineau, it exemplified the power of institutional advertising to capture a corporate personality, in their case "a style-and-design company . . . not just another production company manufacturing containers at any price." Further, as he explained in *Harvard Business Review,* the influence of Container Corporation's approach meant that "the number of hitherto staid corporations that feature abstract art and symbols in their corporate messages has assumed the proportions of a major shift in advertising style."[11] In Rosser Reeves's *Truth in Advertising* (1961), by contrast, Container Corporation's

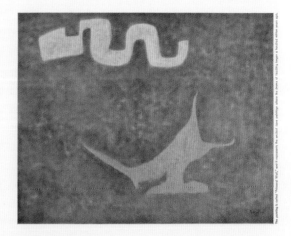

FIGURE 14
"A Teacher Affects Eternity . . .,"
promotional poster, Great Ideas of
Western Man series, Container
Corporation of America, 1959.
Agency: N.W. Ayer & Son.
Featuring William Baziotes,
*Primeval Wall*, 1959. Container
Corporation of America
Collection, Special Collections
Research Center, University of
Chicago Library.

approach served as his example of overly creative brand image advertising that had become entirely unintelligible. Confused by the praise of his peers toward the company's 1959 advertisement featuring a painting by William Baziotes (fig. 14), he tested the ad with customers to confirm his skepticism: 100 percent of the people did not understand the picture, and 85 percent of the people did not grasp what the advertisement itself was trying to say.[12] Even as David Ogilvy, one of the leaders of the so-called creative revolution, praised Container Corporation's advertisements, he also recommended against the use of nonrepresentational images. "Abstract art does not telegraph its message fast enough for use in advertisements," he wrote in 1963.[13]

To balance the artistic alignments of its corporate image with a desire for more straightforward marketing of its business, Container Corporation found its answer in Warhol, commissioning his work as part of Eckerstrom's new strategy. The objects in *Corporate Trade Ad* are therefore no meaningless miscellany. As Warhol's patron later described, the diversity of the work's subjects "illustrates the many products packaged

by CCA."[14] Proofs of the advertisement reveal that, just as Warhol seems to have modified his visual strategy to comply with the needs of his patron, the advertising agency had to alter its copy to suit Warhol's work. Under the headline "For Protection Action CCA," the proof of the advertisement read: "Without a tear, dent, scratch or rip describes the way your product will reach the retail shelf. Not the markdown counter."[15] Faced with Warhol's decidedly scrappy and irregular-looking images, N.W. Ayer & Son changed the final copy execution. The published version that appeared in *Business Week* and *Modern Packaging* opened instead with a question: "Does your package promise to preserve, defend, guard, shield, shelter, house, care for, present—and sell your product?"[16] Its unrelenting list of verbs not only matched the bland repetitions of Warhol's art but, by shifting the emphasis from the state of packaged products on arrival to the qualities of the invisible package itself, also avoided the potential for Warhol's scrappy imagery to be interpreted as an indictment on the quality of his patron's product.

In its 1962 annual report, Container Corporation had favored even more protracted descriptions of the products they packaged: "Ammunition, automotive parts, bakery goods, beer, building materials, canned foods, caps and closures, cereal products, chemicals, china and pottery, clothing, coffee, tea, cocoa, confectionery, cosmetics, dairy products, explosives, electric products, frozen foods, fruits and vegetables, furniture, glass products, hardware, household goods, linen and towels, liquor and wine, machines and parts, matches, meat products, personal accessories, petroleum products, pharmaceuticals, publishers, printers, radio products, rubber goods, soaps and cleansers, soft drinks, spices, sporting goods, sugar and salt, textiles, tobacco products, tools, toys and games, vegetable products."[17] An array of tiny pictograms illustrates this long list, each symbolizing a type of product—a full page showing gridded rows of icons depicting the company's vast remit (fig. 15). It is not known if Warhol saw such sources. But with its serial presentation of generic products and tabular arrangement, the work he produced closely followed the communications strategy of his patron.

Such modes of visualizing the company's business dodged the problems of reproducing real packaging, including the need to seek permission from manufacturers and the risk of offending clients whose brands weren't represented. Further, the absence of other company names ensured the primacy of Container Corporation's own brand. Elsewhere in the company's 1962 annual report, images of actual paperboard packages were limited to those in their blank, unprinted form. Warhol's screen-printed products were also applied to "blanks"—as he would later term his monochrome panels—and repeatedly declare their printedness, without any attempt to disguise the cut edges of the advertising imagery from which they were sourced (fig. 16). Helping to distance the company from the commercial imagery on which its business depended, such images emphasized the useful products, rather than the wasteful layers of packaging in which they were increasingly contained. In observance of such strategies, Warhol's artwork, despite the commercial context for which it was produced, pursues a comparatively uncommercial approach to the presentation of consumer goods.

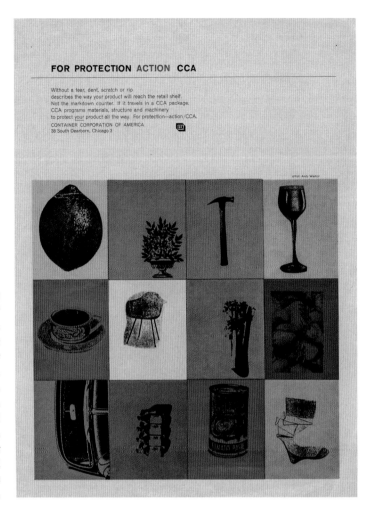

FIGURE 15
"For Protection Action CCA,"
Container Corporation of America,
1963. Advertisement. Agency:
N.W. Ayer & Son. Featuring Andy
Warhol, *Corporate Trade Ad,* 1963.
The Andy Warhol Museum,
Pittsburgh; Founding Collection,
Contribution The Andy Warhol
Foundation for the Visual Arts,
Inc. T656. © 2020 The Andy
Warhol Foundation for the Visual
Arts, Inc. / Licensed by Artists
Rights Society (ARS), New York.

It is especially significant that Warhol avoids representing any brand names in his picture. Most prominently, he blurs the brand name on a can of Hunt's Tomato Paste, either by heavy inking or by overexposure of the screen. In the panel beside it, the labels on a row of small bottles are each carefully masked. Another version of *Corporate Trade Ad* (fig. 17) features twelve more panels not included in the Container Corporation's version of the work—perhaps units that Warhol, or his patron, rejected. (They certainly appear even more roughly executed, with murkier background colors and several less readily identifiable subjects.) Here, a pack of Gold Medal Flour, then sold under the Betty Crocker brand, is so lightly screened that its label text is all but invisible. A can of Morrell Pride Ham has the manufacturer's name prominently redacted, perhaps by a strip of tape on the screen.[18] The brand name of another unidentified bottle in the bottom right corner is again excised—

PRODUCT AREAS SERVED BY CONTAINER CORPORATION OF AMERICA: AMMUNITION, AUTOMOTIVE PARTS, BAKERY G

BUILDING MATERIALS, CANNED FOODS, CAPS AND CLOSURES, CEREAL PRODUCTS, CHEMICALS, CHINA AND POTTER

COFFEE, TEA, COCOA, CONFECTIONERY, COSMETICS, DAIRY PRODUCTS, EXPLOSIVES, ELECTRICAL PRODUCTS, FROZEN F

AND VEGETABLES, FURNITURE, GLASS PRODUCTS, HARDWARE, HOUSEHOLD GOODS, LINENS AND TOWELS, LIQUOR

MACHINES AND PARTS, MATCHES, MEAT PRODUCTS, PAINT, VARNISH, PAPER PRODUCTS, PERSONAL ACCESSORIES,

PRODUCTS, PHARMACEUTICALS, PUBLISHERS, PRINTERS, RADIO PRODUCTS, RUBBER GOODS, SOAPS AND CLEANSERS,

SPICES, SPORTING GOODS, SUGAR AND SALT, TEXTILES, TOBACCO PRODUCTS, TOOLS, TOYS AND GAMES, VEGETABL

FIGURE 16

*Annual Report*, Container Corporation of America, 1962. Inside front cover. Source: Angelo Bruno Business Library, University of Alabama.

this time, it appears, by obscuring its letters in the photosensitive emulsion before printing.[19]

In both *Corporate Trade Ad* works, Warhol's effacing of branded products is so consistent in its application, and so inconsistent with his other consumer imagery of the period, that its correspondence with the communicative tactics of his patron can hardly be accidental. But as much as Warhol's erasures obey Container Corporation's strategy to represent products rather than packages, they also expose it.[20] His struck-out and scratched-off brands provide a visible trace of the demands that his patron placed on their commission, actively or otherwise.[21] Warhol's compliance with his patron's desire to avoid the representation of branded packages was contradictory, quickly followed by the reverse strategy—just as, the following year, he would negate his attention to the integrity of the Campbell's brand by

producing the same image in over-the-top colors and printing it on mass-produced shopping bags.[22]

We should also remember that it was at this time that Warhol began producing his sculptures of supermarket cartons (fig. 18), reproducing as sculptures the exact kind of printed boxes manufactured by the Container Corporation. In its earlier sales promotions, the company showcased its product stacked in the very abundance that Warhol's sculptures could themselves be arranged to produce (fig. 19). Container Corporation had, in fact, manufactured boxes for the Brillo Manufacturing Company of the type Warhol would copy.[23] James Harvey, the designer responsible for the Brillo box design, had reportedly considered bringing legal action against Warhol. That Harvey was an abstract painter—one who distinguished between his commercial and

artistic works more rigidly than Warhol—directly brought into question the status of Warhol's creation. But as Michael Golec notes, Harvey "had no grounds to claim an infringement on his creative property," as the company owned his design.[24] Brillo's decision not to litigate was almost certainly the result of their ambivalent attitude toward Warhol's appropriation and the opportunities it represented for their brand.

Indeed, Brillo's advertising personnel directly engaged with pop art, if not with Warhol himself. For a 1965 exhibition titled *Yes Art* at New York's Fitzgerald Gallery, a parody of the pop phenomenon intended as a "kind of humorous protest against the promotional aspect of art today," the Brillo brand loomed large.[25] The company provided real Brillo boxes for the gallery to sell, and the wife of a Brillo staffer contributed an embroidered rendition of the company logo. In a photograph for *Advertising Age,* Brillo's advertising manager and account executive posed in the gallery with their package rendered increasingly iconic by the pop phenomenon.[26] In the United Kingdom, Brillo even briefed their agency J. Walter Thompson on Warhol and pop art, an

"artistic trend gaining popularity in the USA."[27] By participating in the pop art craze, consumer brands and their agencies sought to capitalize on its promotional potential but also attempted to take control of the new meanings the movement was producing for their brands.

Across the more than one hundred art commissions instigated by the Container Corporation, it is clear that the company imposed rigorous constraints over the artworks used to represent its business. While the appearance of artistic freedom was essential to the credibility of Container Corporation's strategy, and such claims have been repeatedly cited in subsequent scholarship, the regulation of the art it commissioned was thorough and sophisticated.[28] Where Warhol's *Corporate Trade Ad* registers the requirements of the corporation in its explicit reference to items requiring packages or already packaged, most of the artworks commissioned by the company in the 1950s and 1960s were for its "Great Ideas of Western Man" advertisement series, placed in *Time*, *Business Week*, and other national magazines. Juxtaposing philosophical quotations with contemporary works of art, these advertisements remained

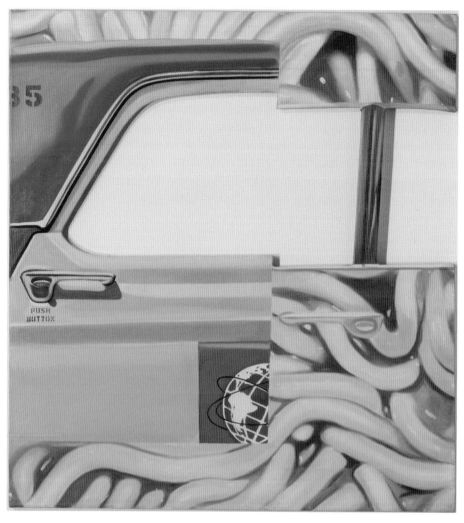

proudly disconnected from the business of boxes—elevating the corporation above mere matters of commerce. But as a careful examination of James Rosenquist's 1965 commission (fig. 20) for the "Great Ideas" series helps demonstrate, even these apparently autonomous and noncommercial images were shaped by the imperatives of corporate strategy.

The very decision to theme the series around "Great Ideas of Western Man" spoke to the Container Corporation's corporate image, positioning the cardboard box as one

of civilization's most momentous ideas. This was exactly the sort of hyperbole the company would propagate elsewhere: paperboard boxes were "nothing short of a revolution," the company would claim, and had "done as much to change the quality of American life as rural electrification or the internal combustion engine."[29] Great ideas and modern art would both help reinforce the profound cultural consequence of disposable boxes. Rarely had advertising been so self-consciously highbrow; "Copywriter: Francis Bacon" was how one industry annual credited a 1963 print advertisement, as though the Renaissance philosopher were himself on retainer.[30] These were advertisements that, at least at first, had to appear to advertise nothing. As one commentator put it, they were "99 per cent editorial."[31] In writing to potential artists, N.W. Ayer & Son went so far as to claim that they included "no advertising on the page. The quotation is printed in suitable type, and there is a small signature of the Container Corporation of America."[32]

Signed by the company as much as by the artist, the elevated positioning of the "Great Ideas" series required art to occupy an equally lofty moral framework, one in which the free expression of the artist was declaredly unsullied by commercial interference. "What would happen if an advertiser ever had the courage to give artists totally free rein—and then actually used their work in its advertisements?" asked *American Artist* in 1966. "What would happen if no stipulations were ever made as to medium, subject, technique or style?" Container Corporation, it claimed, toeing the company line, was "doing exactly that."[33] As John Massey, the company's director of marketing and communications, later emphasized, perhaps a little too vehemently: "The artists were and are free to interpret the quotations assigned to them in any way they want. Over the years, we have never given them any instructions or directions. . . . What you see is a true and unfettered expression of the artist's own feelings, with no influence from the Container Corporation whatsoever."[34]

Yet in the selection of the artists alone, the company already controlled the kinds of images it would receive. Many were, in fact, illustrators and graphic designers, practitioners accustomed to working to brief and altering designs at the client's request. And while some of the advertisements tended toward geometric and typographic designs, they rarely embraced complete abstraction. Josef Albers was among the artists whose "Great Ideas" proposals were deemed by the company's design consultant Herbert Bayer to be too abstract to be suitable.[35] "It is very difficult to do something today with modern art that makes sense," Bayer admitted to *Advertising Age*. "So much of it has become non-communicative. . . . We found it difficult to use good art—advanced art—and yet say something."[36] Bayer later lamented that the dominance of abstraction made it "more and more difficult to find good artists interested in . . . a commission coming from industry," a problem that registered the growing antiestablishment posture of postwar American art, as much as it revealed Bayer's own beliefs in an art tethered to corporate goals, remaking Bauhaus ideals to the more pragmatic tastes of American business.[37]

In this context, pop was a welcome relief. As Bayer saw it, pop meant that it was "no longer taboo" for artists to work within a representational mode.[38] Bayer worked for Container Corporation until 1965, and along with his former colleagues at N.W. Ayer & Son, the rise of pop provided a new legitimacy to the figurative imagery they already preferred.[39] It is no coincidence that realism was crucial for Container Corporation's supermarket packages too, and the company also turned to works of art to demonstrate their skills in printing packages. "Container Corporation of America is currently engaged in compiling a limited-edition recipe portfolio," wrote a company representative to art dealer Edith Halpert in 1962. Seeking artworks painted in a "magic-realist or trompe l'oeil" style, the project sought to "show customers and potential customers the possibilities of fine printing on quality paper board manufactured for food products."[40] Printed reproductions of realistic artworks helped showcase the technical abilities of printed boxes to vividly conjure—and often magically enhance—their concealed contents.

Packaging created product prestige through both visual and material means, and Container Corporation was not the only company in this field to take advantage of the natural fit between art and print promotion. The Mead Corporation's Annual Painting of the Year competition, established initially as an amateur prize in 1955, eventually attracted artists including Ed Ruscha and Robert Rauschenberg, and high-profile judges like museum directors Lloyd Goodrich and René d'Harnoncourt, and even, in 1960, Marcel Duchamp.[41] Mead distributed printed reproductions of artworks and produced lavish catalogues printed on "outstanding Mead papers and cover stock." From 1961, the American Federation of Arts would tour the works, as Harris put it, for the "indoctrination of The Mead Corporation and its literally thousands of employees and key sales groups and executives as a sales tool."[42] By 1963, the competition's management was being handled by the public relations agency Ruder & Finn, fast emerging as a specialist in such corporate art initiatives.[43] Favoring museums "in markets that are important to us," Mead's art program became a multichannel vehicle to showcase high-quality printed images that helped sell consumer products and, in so doing, the paper stock upon which this business relied.[44]

If Container Corporation chose Rosenquist for his realism's communicative relevance to packaging industry customers—a preference that, as we shall see, had its limits—it tried to influence the form of his art in other ways too. In October 1964, an art director from N.W. Ayer & Son wrote to Rosenquist's dealer Leo Castelli to outline the terms of the assignment. Despite promising that there was "no format or restrictions to consider," the art director specified the desired size of the painting and the price he was willing to pay: five by six feet of painting for $3,000.[45] Leo Castelli informed the art director that $3,000 would only get him four by five feet of painting, to which he agreed, but the interest in the size of the work is notable. Given that the work was to be reproduced on a magazine page, their concern to secure work on a larger scale than required for reproduction confirms the corporation's parallel interest in building a valuable collection of works that could be used in offices and touring

exhibitions—activities that substantially extended the value of the corporate invest-ment in art.[46] By the end of the 1960s, Container Corporation's touring exhibition of the "Great Ideas" works had been shown in over fifty venues across the United States and had toured to international venues in Europe and Latin America where the com-pany sourced raw materials and operated manufacturing plants.[47]

As with the other commissions in the series, the quotation on which Rosenquist's work was to be based was assigned to the artist. He was also asked to supply a "written interpretation" that explained the meaning of his work.[48] The company consistently reserved the right to reject a picture if it failed to illustrate the quotation to its satis-faction, in which case the work would be returned, and a fee to cover only "basic expenses" paid. These quotations were of the utmost importance to Container Corpo-ration, and it had not hesitated to reject works on the basis that they failed to com-municate the meaning of the allocated text. For instance, in 1961, a work by Marisol, who had been commissioned to respond to a Thomas Jefferson quote, was rejected for not being "sufficiently pertinent" to the supplied text.[49] Even Le Corbusier had been rejected when he submitted a drawing that was thought to have "absolutely nothing to do with the quotation."[50] The quotations provided an important way for Container Corporation to regulate the content of the artworks it commissioned.[51]

Some high-profile artists recognized the need to keep the company's demands in check. When Belgian surrealist René Magritte was commissioned to undertake his first commission for the "Great Ideas" series in 1958, for example, the company offered to send another quotation if the one supplied did not appeal but was careful to stipulate that the artist could not choose his own. Magritte agreed to the John Milton quotation supplied but had his legal adviser push back on the company's other demands. "I am not a 'publicity' artist (with what that implies: projects, modifications, technical dis-cussions, revised projects etc.)," he wrote. "In certain cases, I can sell to a company the right to reproduce one of my works—if the manner in which the reproduction is used . . . is acceptable to me. . . . If for example, one of my pictures was to be repro-duced on a big Coca Cola advertisement, I would refuse to sell the reproduction rights." Magritte's anxiety about the company's use of art was such that he further insisted that these rights pertained only to the use of his picture in the "Great Ideas" series. "Container Corporation would not be buying the right to reproduce the picture on cardboard boxes," he stipulated, fearful that his art would become more directly used on the product he understood it was helping to promote.[52]

The sheer hubris of the "Great Ideas" concept also makes the origins of these quo-tations worth considering. Mortimer Adler, editor of the Great Books of the World, chose them from the 163,000 file cards covering 102 Great Ideas compiled for the *Syntopicon*, an index dubbed "the Baedecker to 30 centuries of Western Thought."[53] When Paepcke secured Adler's assistance on the project, the *Syntopicon* was nearing completion, making designation of the Container Corporation advertisement series as the "Great Ideas of Western Man" serve as a kind of cross-promotion for his own pub-

lication.[54] Adler's approach to the Western canon consistently sought to package its insights as tools for self-realization and personal success.[55] Paepcke himself had participated in Adler's so-called Fat Man Class, a philosophy class for businessmen at the University of Chicago in the 1930s, and it was on this model of humanist education for corporate executives that he had founded the Aspen Institute for Humanistic Studies in 1950. Adler also developed the curriculum for Aspen's "executive seminars," selecting readings that would be germane to the "problems and issues that confront the citizens of an industrial, free-enterprise, capitalistic democracy."[56]

Adler's selections for Container Corporate advertising were no less ideological. Reproduced in magazines like *Fortune* and *Business Week,* they may have presented his client as an enlightened cultural statesman, but they were never at odds with the ideology of free enterprise. Fundamentally, then, Container Corporation was selling capitalism itself, finding its principles validated throughout the history of philosophy and taking responsibility for their propagation. It is not at all right to claim that Paepcke's "radically commercialized Bauhaus venture" was "purged of all political and ideological implications concerning artistic intervention in collective social progress."[57] To the contrary, Paepcke's engagement with artists and intellectuals was closely tied to the ideals of liberal capitalism, and progress was its most important product. While writings by Marx were read at the "Executive Seminars," Paepcke explicitly decided to exclude him from the "Great Ideas" advertisements, fearful that his name alone would give the wrong political impression.[58] Years later, the quotation by the late Supreme Court justice Louis Brandeis chosen for Rosenquist, and printed above the image of the painting in the resulting advertisement and poster (fig. 21), maintained these imperatives: "That margin between that which men naturally do and that which they can do is so great that a system which urges men to action and develops individual enterprise and initiative is preferable in spite of the wastes that necessarily attend that process."[59] Billed in the advertisement as a proposition about "democracy," its subject is more properly capitalism, or, at the very least, the two are conflated. Louis Brandeis's proposition was, ironically, taken from his 1912 speech against monopolies, but out of context, it reads as an almost unconditional endorsement of free enterprise. Brandeis had, in fact, been a fervent critic of "cut-throat competition" between corporations and the consumer manipulation and monopolistic tendencies it produced, views that shaped his design of the Federal Trade Commission.[60] Here, however, Brandeis sounds rather more unequivocal in his support for free enterprise, and it is not by accident that the quotation was allocated to Rosenquist. N. W. Ayer & Son art director Edward Warwick later remembered that "tremendous time went into the matching up of quote and artist," and the selection of Rosenquist was characteristically strategic.[61] Given the imagery of consumer excess that characterized Rosenquist's work, this quotation preemptively controlled the critical dimension of his art. No matter what unpleasant debris capitalism leaves behind, the quote seems to argue, the ambition and competition it fuels make its "wastes" worthwhile.

that margin between that which men naturally do and that which they can do is so great
that a system which urges men to action and develops individual enterprise and initiative is preferable
in spite of the wastes that necessarily attend that process

louis d. brandeis on democracy
artist: james rosenquist
great ideas of western man    one of a series

container corporation of america

As the country's leading packaging supplier, such a claim was clearly in Container Corporation's interests. But Rosenquist's response to this perspective was more complicated. In the unpublished statement that he wrote for the company to explain his painting, Rosenquist cast the "wastes" of Brandeis's quotation in more specific terms: "My idea of the surplus of society is that there seems to be such an abundance at this period that a human being hardly becomes involved with the material waste of democracy. For instance, an automobile or container comes off the assembly line. . . . Eventually it winds up in the junk heap, so that the process becomes automatic."[62] Here, Rosenquist designates both the automobile and the container as equally destined for the scrapheap, using the very business name of his corporate patron to epitomize the

FIGURE 22
James Rosenquist in a paper suit, 1966. Photo: © Steve Schapiro / Corbis via Getty Images.

epoch of planned obsolescence and disposability that he explained was the subject of his painting.

Rosenquist is grappling here not only with the social impacts of the commodity culture upon which his patron relied but also with the reputation of pop art itself as a passing consumer fad. "I suspect these canvases come with built-in obsolescence," wrote critic Henry Seldis of the pop "trend" in 1963. "Question is whether you will be able to trade them for new models when this drastic post-abstract-expressionist reaction had run its course."[63] Rosenquist incorporated such criticism into his own practice. "I sort of feel like a paper bag," was how he explained his decision to wear a paper suit on several occasions. "Something that might end up in the garbage tomorrow."[64] In one instance, not long after his Container Corporation commission, Rosenquist performed this disposable identity by posing in this outfit with blank cardboard boxes (fig. 22). In the mid-1960s, pop and op seemed to come and go with such startling speed it was impossible not to see the parallels with yo-yos and hula hoops.[65] Vance Packard's critique of "planned obsolescence" in *The Waste Makers* (1960) had famously detailed how automobile companies used changes in design and styling to stimulate consumer desire, but his critique also helped further popularize and propagate these techniques. At one marketing conference, Packard was himself called upon to explain to food manufacturers how they could make their products "catch the eye" of the shopper.[66]

Like pop artists, Packard was not alone among cultural critics to find a ready audience for their insights on consumerism in the ranks of business itself. Consider the example of Marshall McLuhan, hired to deliver a lecture for the Container Corporation in late 1966. Countercultural intellectual Theodore Roszak would cite this episode as evidence that McLuhan had let Madison Avenue types "off the hook with respect to any kind of social or cultural responsibility," but this doesn't quite capture the contradictions of his consultancy.[67] For their part, Container Corporation had already transformed his "medium is the message" mantra into their advertising claim that "the package is the product."[68] They also probably imagined that McLuhan would approve of their work with modern artists. In *Understanding Media* (1964), he had claimed artists could give "the artistically perceptive businessman a decade of leeway in his planning."[69] And yet McLuhan's speech for the company barely concealed his contempt for the "massive garbage apocalypse" he understood to be the impact of their products. His advice was, in short, for America's most famous packaging company to find another line of business.[70]

The packaging industry faced even more serious attacks in Washington. Since the early 1960s, Michigan Senator Philip Hart had vigorously lobbied to introduce "truth in packaging" regulations. "In the design room," he complained in one editorial, "attractiveness is often emphasized at the expense of fact, while motivational researchers scamper about whispering secrets in everybody's ears."[71] For a 1963 stunt, Hart posed with the package of a frozen cherry pie (its brand name redacted, much like those in Warhol's picture), counting the cherries it contained to reveal the discrepancy between its pictured and actual contents (fig. 23). Such criticisms directly threatened the Container Corporation design business. When Hart asked a represent-

ative from the company to provide testimony at an early hearing on packaging and labeling practices, the response came from the company's lawyers: the Container Corporation would answer his questions "only under subpoena."[72]

Business mounted an extensive lobbying campaign against the Fair Packaging and Labeling Act before it was finally passed in 1966. William Murphy, president of Campbell Soup Company, was among the most vocal opponents of the legislation, arguing that "government regulations in advertising and packaging were poor substitutes for the consumer's free choice."[73] The emphasis on "individual enterprise and initiative" that the Container Corporation chose for Rosenquist's commission not only advanced the broad interests of free market capitalism but echoed the terms by which big business sought to argue against a raft of impending regulations. The release of Ralph Nader's exposé *Unsafe at Any Speed: The Designed-In Dangers of the American Automobile* (1965), which argued that the escalation of highway deaths could be directly linked to the prioritization of automotive styling over car safety, made the broader demands of consumer advocates for increased regulation seem even more urgent.

Packaging and cars were, that is to say, two of the most prominent fields in debates over consumer regulation in the mid-1960s, and Rosenquist's explanation of the picture to the Container Corporation confirms the purposefulness of his pictorial juxtaposition of "an automobile or container." Rosenquist's composition alludes to techniques essential to the Container Corporation business, such as die-cut windows designed to provide a glimpse of the interior of a package, or more often, printed images that made such contents look rather more appetizing than they really were. We might also note that Rosenquist has identified his slithering subject to be Franco-American Spaghetti, a brand manufactured by the Campbell Soup Company—and therefore something of a rejoinder, perhaps, to his pop art competitor's most famously co-opted canned goods.[74] Rosenquist's reconceptualization of the metal skin of a car door to be concealing its vulnerable innards of precooked spaghetti might even suggest something of Nader's horrifying exposé, but its composition also hinges on the central question of period debates about consumer packaging: that is, the degree to which packages reveal or conceal their contents.

Rosenquist's decision to represent differing window profiles and door handle shapes in his two overlaid planes reiterates the tactics of planned obsolescence, as though the outer shell of the door panel represented the superficial skin used to restyle an old model. By making his subject a taxi, however, he also presents a design that seems rather more immune to change, shielded from the drives of consumer desire by its generic status. There is a related contradiction at work in Rosenquist's use of the shaped canvas. Adopting this tactic at the same time as Frank Stella and other abstract painters were experimenting with its avant-garde possibilities, Rosenquist uses the technique to present nothing less paradigmatically tied to the traditions of representational art than the frame of a window. The result allows Rosenquist to forcefully point toward the picture's context of display, to the wall of the gallery or museum, or,

in the case of the Container Corporation, to the blank paper of the printed page. The picture's most puzzling disjunction is the edge between Rosenquist's representation of the car door and the spaghetti, where the encounter between two window profiles undoes the work's layered illusion of inside and outside. Collapsing its pictorial planes into one, Rosenquist's canvas foregrounds the fundamental instability and manipulability of consumer images that was at the heart of the "truth in packaging" fracas.

Nevertheless, the quotation that Container Corporation supplied to Rosenquist tried to resolve his work's ambiguities, and the broader social criticisms of the packaging business into which it tapped, and instead ensure that his art appeared to support the business of his patron. But Container Corporation's control of Rosenquist's work was not limited to simply this discursive framing: further investigation shows that the company also exerted more direct pressure on the content of his painting. A photograph of the picture held in the Leo Castelli Gallery records (fig. 24) shows the painting as it was first sent to the company. At the top of the taxi door, Rosenquist had painted the text "Super Operating Corp." As careful as ever to ensure that it managed the meanings of its commission, Container Corporation's advertising agency questioned the brand-name reference. "We are interested to know whether the stencil lettering on the door, 'Super Operating Corp.' is actually in existence," art director Edward Warwick from N.W. Ayer & Son asked in May 1965, "Somehow or another we feel that we have seen it."[75]

Super Operating Corporation was, in fact, a very real taxi company. Perhaps someone recalled its name from news earlier in the decade, when it was charged with unfair labor practices by the National Labor Relations Board for threatening to fire employees who joined the union.[76] But it is more likely that the familiarity of Super Operating Corporation derived from its direct connection to the patronage of pop art: this was the fleet of 130 cabs operated by the high-profile collector Robert Scull.[77] Rosenquist's success had been closely tied to Scull's collecting, from his very first sale in 1961 to the sensational purchase of *F-111* in 1965. In his *Portrait of the Scull Family* (1962), Rosenquist had also included taxi imagery—with another car door and fragments of stenciled signage.[78] Nor was this the only reference to Rosenquist's patrons in the picture's iconography. The text "push button" on the door of the taxi (which does not seem to have been a feature on New York taxis) surely references Rosenquist's own *Pushbutton* (1960–61), one of several early canvases purchased from Rosenquist's studio by Italian collector Giuseppe Panza. The cropped image on the door of the taxi is the *Unisphere*, the giant globe produced by U.S. Steel that became the logo for the 1964–65 New York World's Fair. At the time of his Container Corporation commission, Rosenquist had been contracted to produce one of the ten mural panels for the exterior of the Fair's New York State Pavilion.[79] By including coded references to his most prominent customers in a picture made for another, Rosenquist invites the attentive viewer to consider how the content of his art might be influenced by its patronage. These are the hidden messages that Rosenquist sought to sneak into Container Corporation's advertising.

Container Corporation seems to have caught only the most obvious of Rosenquist's references to his other patrons. Learning that the text referenced Scull's business name, N.W. Ayer & Son asked Rosenquist to seek written permission for its use.[80] This was more than a matter of trademark infringement. Disrupting Container Corporation's desire to achieve, through art, a status above mere matters of business, Rosenquist's design subtly put patronage at the very center of the picture. The inclusion of a business name in the picture itself not only transgressed Container Corporation's desire for

images that looked like art rather than advertising but also competed with the company's own deliberately discreet "Great Ideas" tagline—and the function of their logo as a "signature." Scull was nothing if not pleased to receive cultural recognition, and he unsurprisingly agreed to the inclusion of his company's name in the picture.

Backed into a corner, N.W. Ayer & Son wrote to Leo Castelli: "Despite the fact that Mr. Scull very kindly gave us his permission to retain the 'Super Operating Corp.' on the side of the door in Rosenquist's painting, our client has asked that it be removed or changed to a non-existent corporation. Our good client thinks that the name is great, but they do not want to mix this kind of realism in with their art."[81] Container Corporation may have chosen Rosenquist for his realism, but "this kind of realism" was not what it was looking for. Less ambiguous than Rosenquist's evocation of the scrapheap or "truth in packaging," or his reference to his World's Fair commission, the presence of Super Operating Corporation's name threatened to overshadow—especially with its superlative modifier—the prominence of the similarly generic name of Container Corporation itself. Rosenquist's references to his other patrons undermined the appearance of aesthetic autonomy desired by Container Corporation and, in the case of Scull's taxi company, confused two businesses whose public identities were both inextricably, though rather differently, linked with contemporary art.

For Container Corporation's advertisements to be effective, the images they contained had unmistakably to declare their status as independent art objects. As *American Artist* reported in 1966: "In selecting the artists, and in evaluating the quality of their completed work, the primary question before the committee is 'How good is it as art?' Apparently, the problem of making a painting 'which might not be any great shakes as a work of art but which would make a great ad' simply cannot occur in this series."[82] There was no more persuasive advertisement than one that didn't look like an advertisement. Sometimes, this was a matter of stylistic approach, favoring painterly and handmade artworks that declared their difference from slick advertising illustrations. For one commissioned work, for example, the Container Corporation told Philip Guston's dealer, "We strongly wish that the artists employ a vignette shape as it has proved over the past that the completed page looks less commercial."[83] Making its advertisements appear uncommercial was of the highest importance for the credibility of Container Corporation's strategy. In the case of both Warhol and Rosenquist, a key problem seems to have been the presence of other brand names. By competing with the intended messages of advertisement (whether marketing message or, more substantively, corporate ideology), and confusing the singular voice of Container Corporation, the textual references to other companies in their works threatened to compromise the effectiveness of the advertisements for which these artworks were destined.

Four days after receiving N.W. Ayer & Son's letter, Rosenquist agreed to repaint the work. Given his earlier experience painting billboards, this was not unfamiliar territory.[84] His whereabouts made it especially difficult to refuse Container Corporation's request. He was an artist in residence at the Aspen Institute, the think tank founded

by Walter Paepcke at the same time as the "Great Ideas" series. Rosenquist sat at the seminar table alongside prominent businessmen-collectors like Larry Aldrich and John Powers, entertaining the otherwise corporate group with his "freewheeling, free association conversation about art."[85] The presence of Paepcke's widow Elizabeth, who played such a central role in Container Corporation's art programs, could also hardly be ignored, nor could the attendance of a manager from Container Corporation's design and market research laboratory.[86] Rosenquist at first agreed to replace the real taxi company name with a made-up one, but eventually he simply chose to paint over it entirely.

The influence that Container Corporation wielded over artworks could reflect the company's sensitivities about more weighty issues than matters of art patronage or even the problems of the packaging industry. Larry Rivers also refused Container Corporation's request to produce a sketch, insisting instead on producing a finished work for the commission.[87] As with Rosenquist, Rivers's realism appealed to the agency's predetermined ideas about what kind of an artwork it wanted: "We would be particularly interested in his executing one of his sketchy figurative subjects and being able to combine it with a brushed in (written) phrase," wrote N.W. Ayer & Son art director Walter Reinsel.[88] Supplied with a Lord Acton quotation on minority rights to illustrate, Rivers delivered *Identification Manual* (1964), which includes civil rights leaders and skin-lightening cream among its complex imagery. In this case, Container Corporation simply never included the artwork in an advertisement. As one executive later recalled, this decision was made for fear of offending the management of the company's southern paper mills, whose notoriously discriminatory labor practices lasted until the late 1960s.[89] "It had some racial connotations to it," Massey recalled, "and there was some real concerns about some of our management who were sensitive to that from the south, Alabama and Mississippi, where we had some of our big paper mills . . . so they just raised all kinds of hell."[90]

It was thus not simply that art could appear to transcend the commercial motives of business, but that it was meant to also distract from the conflicts faced by corporate enterprise.[91] While it is difficult to know how many artworks were rejected or artists excluded, it is clear that Container Corporation imposed strict controls on more sensitive subjects. An earlier example demonstrates that the company was not beyond blatant manipulation of the works it received. When Leon Karp included a Ku Klux Klan figure in the iconography of his 1951 commission to illustrate a Thomas Hobbes quote on war and peace, the final advertisement simply cropped out the offending half of the work.[92] In the name of corporate image, promises of artistic freedom could be easily set aside.

In the case of Rosenquist's painting, however, tensions over its altered content would not end with the picture's completion. In 2003, a representative of the artist wrote to the Smithsonian American Art Museum (to which the Container Corporation had donated its collection in 1984) concerning the title of the picture: "The lengthy

Justice Brandeis quote is definitely not the title of the work," the representative advised on Rosenquist's behalf. "The work is titled *The Friction Disappears*."[93] Despite its absence in any of the correspondence concerning the original commission, or in any of the exhibitions and reproductions of the work since its creation, this new appellation was adopted at the artist's request. In one swift maneuver, Rosenquist subtly inscribed the picture's corporate intervention, and the problematic text that had been deleted on the request of his patron, into the very identity of the work. The passage of time further helped the artist's cause: the thin layer of yellow paint over the offending passage of the picture has begun to degrade, making the obscured text partially visible to the attentive viewer. With the meaning and content of his artwork subject to the controls of his patron, Rosenquist's retitled picture reasserts the circumstances of its production, quietly pushing back against the myriad controls exercised by its patron.

# 3

## THE BOLD NEW TASTE OF PHILIP MORRIS

————

"**AS SLIPPERY, AGREEABLE AND CONVENTIONAL** as an ad man at a client's party" was how a critic in *Artforum* described James Rosenquist in 1964.[1] The sketch could almost serve as a caption for Rosenquist in a publicity photograph from the following year (fig. 25), in which he and the visiting British pop artist Peter Phillips present their work to George Weissman, the president of Philip Morris International. The photograph promoted 11 *Pop Artists*, a set of prints that the company had commissioned for a promotional touring exhibition. The project was the initiative of Philip Morris's new public relations firm Ruder & Finn. Beside the boldly branded portfolio, another, more iconic graphic identity is visible. Tiny, but instantly recognizable by its bold chevron design, a pack of Marlboro cigarettes is artfully placed on the table, the executive's own little masterpiece. Brought together by art and tobacco in the sleek Park Avenue offices of Philip Morris, the three corporate propagandists accompany their moment of aesthetic contemplation with a cigarette.

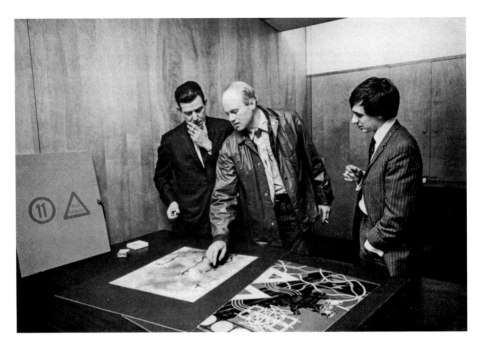

FIGURE 25
George Weissman, president of Philip Morris International, in meeting with James Rosenquist and Peter Phillips, 1965. 11 *Pop Artists: The New Image*, Munich: Galerie Friedrich + Dahlem. Photo: © Estate of Guy Gillette.

A "corporate image" advertisement introduced in 1965 and placed in industry trade magazines for several years even more blatantly demonstrates the connection that the company sought to forge between good taste in art and good taste in cigarettes (fig. 26). Titled "The Fine Art of Flavor," Leo Burnett Company's print execution displayed Philip Morris brand packs on an artist's palette hovering over a silky background, like an array of aesthetic choices awaiting the discriminating taste of the consumer.[2] Such parallels were so favored by Philip Morris staff that one of the company's consultants, who thought that "the equating of modern packaging with modern art is the basis for many marketing weaknesses," felt compelled to assert that "art galleries and art masterpieces are not relevant in the supermarket."[3] For Weissman, however, the equivalences between artist and executive, artworks and consumer products, provided a compelling marketing metaphor. "We are businessmen, not artists," he wrote, "but as manufacturers of mass consumer products we are intrigued by art forms which cut across intellectual and cultural barriers, appealing to people of every type and from every place."[4] In the 1960s, Philip Morris's diversification into new forms of marketing was matched by its diversification into new kinds of consumer products—from razor blades and chewing gum to plastic packaging and printing. Cigarettes were to be just another consumer product among many, and pop art another mass marketing tactic.

The fine art of flavor

PHILIP MORRIS INCORPORATED 🛡️ *Makers of America's finest cigarettes*

FIGURE 26
"The Fine Art of Flavor," Philip
Morris Incorporated, 1966.
Advertisement. Agency: Leo
Burnett Company. Source: Blue
Book of Automatic Merchandising,
National Automatic Merchandising
Association.

Like Container Corporation, Philip Morris turned to pop for its communicative potential. Nina Kaiden, Ruder & Finn's director of fine arts, later glossed her pitch to the cigarette company in a press interview: "Look, this is pop art. It says something! Share it with the people from whom you reaped. By making art exhibitions available to them you give part of what you reaped back in another form."[5] The project's motivations were, of course, more complex than Kaiden's sound bite admits. But the enthusiasm for pop as an art movement that "says something" and that "gives back" to consumers in "another form" registers the value of consumer recognition of pop art's sources, as well as its avant-garde transformation. To persuade Weissman of the project's merits, Kaiden had taken him from his Park Avenue office by taxi to Rosenquist's Broome Street studio.[6] Rosenquist could have even showed his potential patron examples of his paintings that referenced Philip Morris advertising.[7] He later told an interviewer that although he "used to know Madison Avenue advertisers," he never liked them: "Bunch of jerks. 'Hey, man, what you hipped on now, man? What's the latest?' Screw them."[8] Whatever he

discussed with Philip Morris representatives, the studio visit sealed the deal. "I am delighted to learn from Leo Castelli that you will be part of the Pop Art graphic project we are developing for Philip Morris," Kaiden wrote to Rosenquist in June 1965. Packaged with the letter—probably sent to all participating artists—was a selection of Philip Morris cigarettes. "Not that we're trying to indoctrinate you or anything," Kaiden joked in her correspondence, in a nervous nod to the moral minefield Rosenquist was entering.[9]

As 11 Pop Artists was being planned, the marketing of cigarettes was front-page news. In January 1964, after almost a decade of mounting evidence, the surgeon general had officially confirmed the link between cigarette smoking and cancer. Within days, the Federal Trade Commission (FTC) flagged its intention to curb deceptive advertising practices and require warning labels on packages. The impact was immediate: sales plummeted, and in January alone the sales loss was estimated at $45 million.[10] Over the following three months, Americans smoked thirteen billion fewer cigarettes.[11] By April, fearful of FTC intervention, the tobacco industry released its own Advertising Code—limiting claims about youth, health, and virility, but above all seeking to demonstrate its capacity for self-regulation.[12] The tactic worked: by the time Congress finally legislated on warning labels in July 1965, it was more sympathetic to the industry, exempting advertising from displaying health notices and preventing any government agency from making further rulings on cigarettes for four years.

It was at the outset of this challenging situation that, in early 1964, Philip Morris hired Ruder & Finn to lead its public relations.[13] The art programs led by Nina Kaiden were but one strand of a wide variety of activities designed, in the face of impending restrictions, to combat negative perceptions of the industry and create new vehicles for the promotion of cigarettes.[14] Many of these attempted to counter health concerns about smoking and position Philip Morris for competitive advantage in an unstable market context. In late 1964, for instance, Ruder & Finn coordinated a twenty-city tour by psychologist Dr William Dunn, who gave talks on the taste-testing methods at the Philip Morris Research Center in Richmond, Virginia.[15] Finn's business partner William Ruder had worked with George Weissman earlier in his career and in the early 1960s had taken leave from his role at Ruder & Finn to work as the assistant secretary of commerce in Washington. Ruder not only led the Philip Morris account but supported the lobbying and advocacy activities of the company through his involvement with the Tobacco Institute, the Washington-based lobby group established to defend the "individual rights of smokers."[16]

Founded in 1948, Ruder & Finn's cofounder David Finn had begun his career working for the American Artists Group, an art reproduction firm that produced greeting cards and prints.[17] By the end of the 1950s, the company had grown into one of New York's biggest public relations firms, specializing in creating the kind of newsworthy promotions that Daniel Boorstin would lampoon as "pseudo-events" in The Image: A Guide to Pseudo-events in America (1961). For Johnson & Johnson, for instance, Ruder & Finn created "Emergencies Don't Wait Week" to help drive sales of first aid supplies, while for the Chemstrand Corporation, a division of Monsanto Chemical, they would mount a New

York fashion show to promote a new acrylic fiber.[18] Expanding first through a network of national partners and then through a range of international affiliates, Ruder & Finn would also become a leading public relations agency for tourism boards, trade groups, and ultimately foreign governments, eventually renowned for, in the words of one journalist, their expertise in "revolutionary and counter-revolutionary publicity packaging."[19]

In the mid-1960s, Ruder & Finn turned to contemporary art for several clients seeking to resist increased government regulation. Alongside her work for Philip Morris, for example, Nina Kaiden contributed to the Outdoor Advertising Industry Association's response to the Highway Beautification Act of 1965, passed under the influence of Lady Bird Johnson, which sought to limit the proliferation of billboards and junkyards on the nation's highways. The following year, Kaiden coordinated a series of billboard designs from contemporary artists Stephen Antonakos, Helen Frankenthaler, Milton Glaser, Ernest Trova, and Jack Youngerman. "The winning design will be displayed, not as countryside clutter, but in the commercial zones of cities—where it would be seen by the greatest number of potential museum visitors" and where it could help "brightening up a drab cityscape," noted *Art in America* of the initiative.[20] This was not just about championing the industry's cultural patronage but also about emphasizing the public value of billboards. Most of the designs were safely abstract, but the proposal of graphic designer Milton Glaser more frankly delivered on the public relations effort to refresh the image of outdoor advertising by assembling a collage of scenic landscapes—the very vision that billboards were criticized as obscuring.[21]

The commercial vulgarities of pop were strategically excluded from Ruder & Finn's campaign for the outdoor advertising industry, but the movement's validation of commercial aesthetics remained a useful lobbying tool. Seeking to defend highway billboards from government oversight, the vice president of the National Advertising Company warned his colleagues that "President Johnson might just as well go one step further and outlaw pop art along with billboard[s] and auto junkyards."[22] "Who is to say that a highway sign is not an art form?" he asked. "Even . . . the remains of old cars . . . have come to be regarded by some authorities as true art forms when mounted on pedestals." His speech warned that government taste making was a dangerously slippery slope: "If fundamental rights can be trampled upon by the Federal government in the name of an abstract concept such as 'beauty' why cannot other personal tastes and responses be legislated. . . . Why cannot certain kinds of advertising, certain kinds of magazines, certain kinds of television shows, certain kinds of movies be abolished and made unlawful on the ground that their effect is not considered 'beautiful' by some?"[23] Not only did pop flatter the visual cultures on which consumer culture relied, but its transgressions could help assert the democracy of consumer taste—and help business argue against government regulation of the free market. Ruder & Finn had successfully used this strategy in earlier work for the Comic Book Association of America, for whom they helped fend off censorship in the late 1950s amid concerns over the influence of comic books on juvenile delinquency. These were ideas that they would equally apply to their work for Philip Morris.[24]

Some media outlets held up 11 *Pop Artists* as evidence that Philip Morris was "engaged in activities which indicates they feel responsibility for correction of damage, if not for the blight itself."[25] The project was among those that enabled David Finn to claim that the tobacco industry represented "one of the outstanding examples of social responsibility in American industry."[26] A more thorough understanding of the outcomes that Philip Morris sought from its associations with contemporary art is legible from archival documents concerning an unrealized project in 1966. Art International: U.S.A. was planned to be a six-week art fair, conceived by Finn and publisher Harry Abrams, and optimistically pitched as New York's answer to the Venice Biennale. Its venue was to be the recently opened New York Coliseum, another of Ruder & Finn's clients.[27] In September 1966, Philip Morris's account executive at Ruder & Finn sent a seven-page proposal to Weissman: "We have assurances that the phrase 'made possible by a grant from Philip Morris' (or we can use Marlboro or Benson & Hedges or whatever brand or company we choose) will be identified with every public announcement of the exhibition. . . . Furthermore, both the President of Philip Morris and the President of Philip Morris International can become members of the Board of Art International, Inc. and act as spokesmen for the project. This will further identify it with Philip Morris."[28] As Ruder & Finn explained, the exhibition would help Philip Morris reach the "intellectual and civic leaders" who were "the most influential people in America."[29] The importance of such positioning for big tobacco was emphasized in a subsequent report by the agency. This study recommended that the company invest in "corporate sponsorship of educational television and public service events, to win the support of those who have been most antagonistic to the industry: the intellectual community."[30] Philip Morris's interest in the leaders that the cultural sphere could reach is also made clear by an internal memo about the project sent by George Weissman. "Roger Stevens," the founding chairman of the National Endowment for the Arts, "has assured Ruder & Finn that 'Art International' would receive U.S. Government support and that President Johnson may personally lend his identity as Honorary Chairman, just as the president of Italy is the Honorary Chairman of the Venice Biennale."[31] Facing a crisis in the future of its business, Philip Morris hoped that art could—through such events—deliver favor across all levels of the American power elite.

When George Weissman spoke at the "Business and the Arts" conference hosted by the New York Board of Trade and *Esquire* magazine in March 1966, he framed Philip Morris's support of the 11 *Pop Artists* project around the social responsibilities of the corporation. "The passion of the giant private patron, the emergence of the corporation as the controller of an enormous new medium of worldwide communications, the growing awareness of corporations' potential and responsibility for enlightenment, the ever-widening scope of the corporation's horizons," he prophesied, "these are the factors that will cement the lasting relationships with the arts."[32] It was high-minded rhetoric, and it had traction: the following year, Philip Morris (along with the Container Corporation) would receive prizes from the "Business in the Arts" awards that stemmed from this inaugural conference.

The more practical reasons for Philip Morris's sudden interest in art were clear to at least some in the audience. One attendee at the conference recalled that Roy Moyer of the American Federation of Arts, the agency that organized the tour of Philip Morris's pop prints to sixteen venues around the country, "remarked privately . . . that Weissman neglected to say that this is a way of getting the corporate name into areas where cigarette advertising is forbidden."[33] Ruder & Finn records reiterate this imperative, expressing high hopes for the public relations growth that would be presented "as opportunities for straight-forward cigarette advertising may grow more restricted."[34] Art, in other words, was being understood as new and unregulated media space. Eventually, even Weissman would be unabashedly frank about the status of art as an advertising vehicle. Exhibitions, he told a journalist in 1971, are "a lot cheaper than taking full-page ads saying how good we are. Particularly now when tobacco companies are having a difficult time communicating on radio and TV, these projects offer an excellent way for us to communicate that we are an innovative company."[35]

The idea of innovation was crucial to the corporate image of Philip Morris, which saw itself as an industry upstart whose creative marketing and product development had given it the edge over its larger competitors. As Weissman told an interviewer in 1968, "We can't hit the big boys head on. . . . We just don't have the financial resources. So we have to hit them where they ain't. . . . As a small company, whatever we have done has been through innovation."[36] An article on the company's first arts project echoed such spin: "The dynamism of business depends primarily on innovation, and the artist proceeds along similar lines."[37] The idea that, as critics Elena and Nicolas Calas would put it, "the businessman who patronises experimental and pseudo-experimental artists may well recognise in the endeavour of enterprising artists the aesthetic version of his gambling spirit" became a mainstay of corporate art rhetoric in the late sixties, connecting avant-garde modernism and business through their shared drive for innovation and progress.[38]

For Philip Morris, such values closely aligned with the discursive requirements of cigarette marketing. "We believe that it is our obligation to represent not only that which is tested and traditional in society but that which is new and experimental," Weissman wrote of the pop art commission.[39] Smoking was to be, at once, a sign of strident independence and the height of up-to-date fashionability. The ideological implications of such rhetoric were made especially clear in one article on the commission, which explained, "In short, the company feels that only so long as individual ideas and freedoms are cherished will the atmosphere in which the free enterprise system flourishes be cherished and preserved. Those who create new products and those who create new artforms have identical stake in this system: competitive creativeness."[40] Free choice was central to big tobacco's arguments against regulation, the ideological handmaiden to its insistence that smoking was not addictive. No longer could Weissman complain, as he had in a 1954 speech, of the "medical propaganda being directed against the cigarette industry" and the "prohibition, regulation and strangulation" perpetrated by government agencies,

or claim that his company would "stop business tomorrow" if it thought smoking was harmful.[41] But art could, superficially at least, help to absorb some of smoking's now-indubitable risks. Philip Morris's desire to preserve the individual freedoms of cigarette smoking, both as an expression of free choice and as itself the work of the free enterprise system, found its "identical stake" in the risk-taking of the avant-garde. "Any commercial venture has its risks. We wanted to do something no one else has done," Weissman would claim of an art project later in the decade. "You can't always play it safe. It would have been easy for us to get together a group of Rembrandts."[42]

Philip Morris may have liked the image projected by risky avant-garde projects, but the controls the company imposed on art and artists were no less rigorous than at Container Corporation. In fact, it was Philip Morris's stipulation that "they did not want the cigarette company's name used in connection with art that might prove controversial" that seems to have caused the Art International U.S.A. project to be shelved.[43] These tendencies were already in evidence in 11 Pop Artists, no matter how much the idea of pop—with its familiar and richly communicative realistic imagery—might have appealed to the consumer marketing minds at Philip Morris. In what seems to be its first, rather more conservative foray into the arts, in 1964, consumers were certainly meant to recognize the "stars of Philip Morris sponsored programs"—including Carol Burnett, Jackie Gleason, and the cast of Gilligan's Island—whose portraits the company commissioned Famous Artists School instructor Alfred Chadbourn to paint.[44] The pop style may even have reminded them of the Duke Handy cartoon strip that advertising agency N.W. Ayer & Son had developed to promote Philip Morris products to young male smokers in the late 1950s.[45]

As much as pop art could evoke the consumer-friendly images of advertising, the prints in the 11 Pop Artists portfolio proved more challenging for a corporation so accustomed to having complete control over its self-representations. From the beginning of the pop project, changes to the list of artists provide evidence of the mounting anxieties. Kaiden consulted with museum directors from around the country for suggested participants, as much gauging ever-shifting art world tastes as initiating contact with potential exhibition venues.[46] Originally titled 10 Pop Artists, in mid-1965 the project had a slated list of artists that included Allan D'Arcangelo, Roy Lichtenstein, James Rosenquist, Andy Warhol, John Wesley, Tom Wesselmann, Allen Jones, Bob Stanley, Mel Ramos, and Gerald Laing. One key modification to this list is telling: Stanley was removed, probably because of the erotic content of his images, and was replaced with Peter Phillips.[47] The final addition of Jim Dine was suggested by Rosa Esman, who was coordinating the production of the portfolios. In September, the project title was finally changed to 11 Pop Artists to reflect the full roster of contributing artists.[48]

As others have noted, several of the prints included references to smoking—but one should not too quickly judge the works to serve in any straightforward way as promotions for their patron.[49] Period critics shared the concern: "Art once removed from a commercial product assumes a once-removed-from commercial intent when

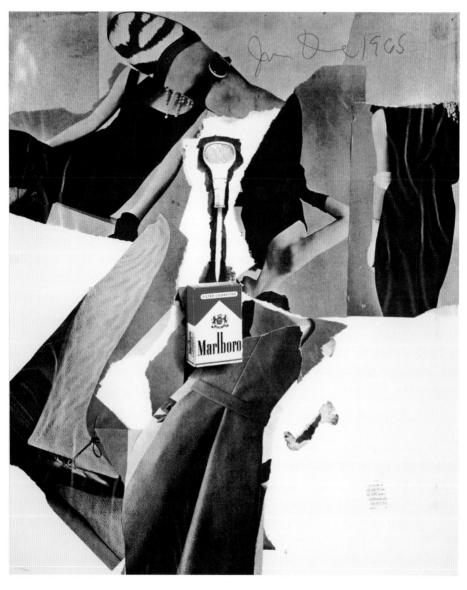

sponsored by a commercial company," concluded one critic of the project.[50] However,
the tone of the works was far from consistent, and even those prints that seem to align
with the requirements of Philip Morris advertising are, on closer inspection, rather
less affirmative than they might seem at first glance. Jim Dine's *Awl* (1965) (fig. 27)
centered on an illusionistic image of the Marlboro pack (the only part of the otherwise

monochrome work screen-printed in color), immortalizing its iconic design in art without the distracting health warning it would very soon be required to display. "We didn't ask the artist to do that," a Philip Morris spokesperson said of Dine's work when it was displayed at the Smithsonian Institution. The journalist noted, however, that "it was clear that as he looked at it that he was pleased by that particular print."[51]

With its background of torn female bodies, and the sharply pointed tool of the work's title pointing at the cigarettes as though they were the perpetrator of the violence of its background image, Dine's presentation of his patron's brand is more disturbing than it might seem at first glance. Dine's source imagery came from the July 1964 issue of *Vogue*, elegant black-and-white photographs of the latest fashions taken by Irving Penn and Guy Boudin. In *Awl*, Dine ripped these pages apart to produce a faceless and mutilated body as the background for his illusionistic reproduction of the Marlboro pack.[52] It does not seem quite right to regard Dine's print as anything so simple as product placement. Similarly ambiguous is his second print *Throat* (1965), in which the cowboy imagery of the Marlboro brand materializes in the form of a red paisley kerchief, laid out below a cut-out fragment of a women's craned neck, but titled so that it unavoidably reminds the viewer of the anatomy beneath her skin and, in so doing, the cancer to which it was vulnerable.

Perhaps the most blatant example of artistic incorporation of the patron's brand in the portfolio is Mel Ramos's *Tobacco Rose* (fig. 28), which centers on a buxom nude perched on a Philip Morris package.[53] Ramos's image fulfills the striptease implicit in the company's 1955 campaign promoting the brand's new package design: "Pardon us while we change our dress," read its headline (fig. 29). Ramos inflates such sexist and, by the mid-1960s, passé equivalences between woman and package, and the phallic associations of the cigarette itself, to their most burlesque extreme. Rendered in a sickly shade of yellow, the pose of this postcoital pinup partially masks the brand name, cropping it to a suggestive "Phil Mor"—as if the "Phil" she straddles were a satisfied male customer, or more obliquely, as if to promise that smokers of the brand will "feel more." Such allusions were risky territory for the cigarette industry, whose own code forbade advertisements that "represent that cigarette smoking is essential to social prominence, distinction, success or sexual attraction."[54] Advertiser efforts to "establish a causal relationship between sex and smoking" were precisely the territory that the new regulatory regime was forcing the industry to abandon, relegated to history along with smoking doctors and athletes.[55] The underlying tactics persisted, of course, but by the mid-1960s were absorbed within imagery defined by a more subtle, allusive approach.

While Ramos's later claim that Philip Morris dictated the brand of cigarettes in *Tobacco Rose* might be correct, it should not be mistaken for their approval of his imagery. One critic had connected Ramos's imagery to "pre-code comic book covers," and this suggestion of an unregulated media space rightly captures the risks of such imagery.[56] In the context of mid-1960s tobacco regulation, Ramos's print flagrantly

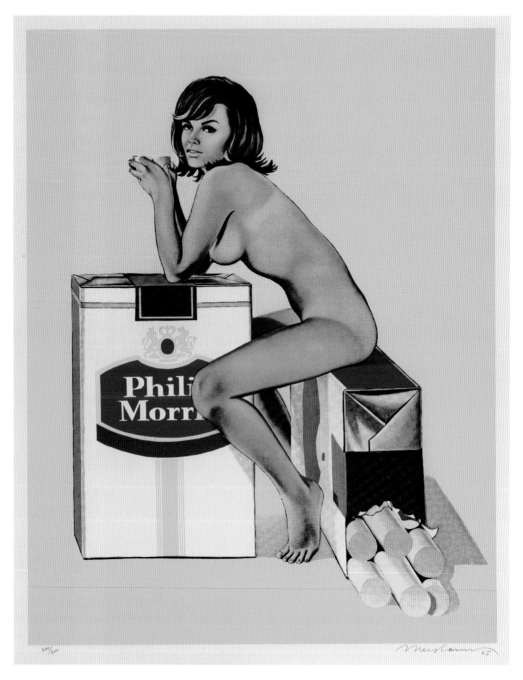

FIGURE 28

Mel Ramos, *Tobacco Rose,* from the portfolio *11 Pop Artists,* vol. 2, 1965. Screen print, 28 × 22 in. Gift of Philip Morris Incorporated. Smithsonian American Art Museum, Washington, DC / Art Resource, NY. © 2020 Estate of Mel Ramos / Licensed by VAGA at Artists Rights Society (ARS), NY.

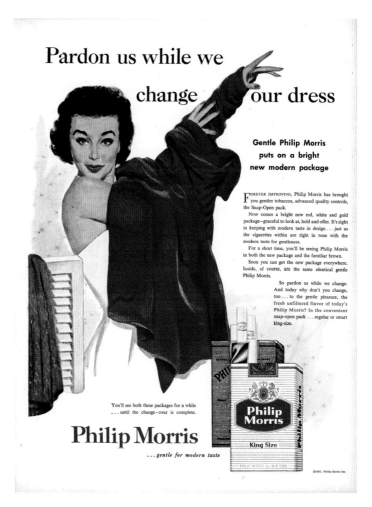

laid bare the industry's most unscrupulous marketing techniques. Perhaps they can even be understood to foreshadow feminist critiques of the same through the sheer outrageousness of their objectifying sexism.[57] Direct corporate intervention is more evident in another Ramos print, which was to depict another pouting nude pressed against a giant tube of Colgate toothpaste. This work's title was originally to be *Gardol Gertie,* a reference to the special "Gardol" formula highlighted in the brand's advertisements.[58] With the risk of potential trademark infringement over the use of the Colgate brand—a risk to which Ruder & Finn would have been attuned, given that Colgate-Palmolive had also been a client—Ramos's edition had to be overprinted so that the text on the tube could be changed from COLG to COMF on each print in the edition, and retitled with the fictional brand moniker *Miss Comfort Crème* (fig. 30).[59] Centered on a darker metallic ground, Ramos's cropped framing suggests something of the peep show imagery upon which he drew. "Miss Comfort Crème turned out very

FIGURE 30

Mel Ramos, *Miss Comfort Crème*,
from the portfolio 11 *Pop Artists*,
vol. 3, 1965. Screen print. 40 × 30⅛
in. Gift of Philip Morris Incorpo-
rated. Smithsonian American Art
Museum, Washington, DC / Art
Resource, NY.
© 2020 Estate of Mel Ramos /
Licensed by VAGA at Artists Rights
Society (ARS), NY.

successfully," Esman wrote to Ramos in February, "and I know it was an unwelcome chore to do away with Gardol Gertie. Until I learn that Comfort Crème is a little publicized product of Lever Brothers I rest easy!"[60]

Once the 11 *Pop Artists* prints were prepared for exhibition, the corporation's anxieties over their content became increasingly apparent. Despite their interventions in Ramos's works, both *Miss Comfort Crème* and *Tobacco Rose* were cut from the show.[61] These were not the only notable exclusions. Warhol's three prints of Jacqueline Kennedy were all pulled. If, as Thomas Crow has argued, these works exposed "the reality of suffering and death" beneath the mass-produced image, it is not difficult to understand why they so disturbed their corporate patron.[62] The industry had just succeeded in lobbying for references to "death" to be removed from the label warnings mandated by the Cigarette Labeling and Advertising Act (1965), replacing them with the more tepid warning "Cigarette smoking may be hazardous to your health."[63] The

THE BOLD NEW TASTE OF PHILIP MORRIS          **79**

pall of death unavoidably hung over their brands: "Marlboro Country" had, according to the *Village Voice*, recently become teen slang for a cemetery.[64] The exhibition opened just as the labeling requirement went into effect in January 1966, so Warhol's darker subject matter was not the kind of upbeat, carefree imagery that Philip Morris hoped pop would deliver.

As with efforts to seek approval from Robert Scull for Rosenquist's Container Corporation commission, Ruder & Finn asked Leo Castelli to seek approval for Warhol's images from Jacqueline Kennedy. "I spoke with Ivan Karp about a question which has been raised by the Philip Morris lawyers," Kaiden wrote to Leo Castelli in November 1965. "Due to the strict codes applied to the tobacco industry and their tremendous sensitivity to any criticism that they might exploiting some art form for their own benefit, the use of Mrs Kennedy's pictures without her approval has been questioned."[65] Kaiden arranged for a set of proofs to be sent to the president's widow. "Philip Morris has seen and approved the Warhol prints," her letter claimed, "but has asked that we request your consent."[66]

The terms here are revealing: even given the complete lack of cigarette imagery in Warhol's works, their "approval" and subsequent restriction were drawn into the discourse of the looming advertising restrictions. Conflating Warhol's exploitation of Jacqueline Kennedy's image with its own use of his art, Philip Morris's anxieties concern the nature of the company's patronage as much as they do the subject of Warhol's prints. In December, Castelli confirmed that he had spoken with Kennedy's secretary and that "Mrs Kennedy has indicated that she had no objection against Andy Warhol's silkscreens being circulated in America or anywhere else under the auspices of the Philip Morris Company."[67] But such clearance was never going to be enough to mitigate the public relations risks. Ruder & Finn issued a low-key statement the day before the exhibition opened in New York to announce that Warhol's three serigraphs would be omitted, replaced instead by two lithographs brighter in color and mood: *Liz* (1965) and *Flowers* (1965). "We didn't want anyone in the United States to think a tobacco company was exploiting the widow of the former president," Richard Warner, the senior vice president of Ruder & Finn, told an Associated Press reporter.[68]

The same article also summarily noted that "two nudes by Tom Wesselmann also will be dropped from the American exhibit," as though the risqué subject matter sufficiently explained the exclusion.[69] If Ramos's prints were cut for the same reason, his name was not mentioned. Wesselmann's third print did not show a nude, but it was titled *TV Nude* (1965), and while it was included in the initial presentation of the show at the Virginia Museum of Fine Arts, it too was missing from the catalogue published for the American Federation of the Arts (AFA) gallery opening in New York in February 1966.[70] Finally, and without any mention, one of John Wesley's prints was cut: the only one of his three provocative images of women in which the figure's breasts were not hidden by a bikini top. In total, nine of the thirty-three commissioned prints were dropped from the show. While Kaiden could still declare, in a pro forma press release

provided to venues, that the "artists were given free rein to create their original graphics"—ignoring the intervention that forced Ramos to reprint over the unlicensed brand on his work—it hardly mattered when so many works simply disappeared from public view in the resulting exhibitions.[71]

Many of the more explicit prints remained in international exhibitions of the prints, as though less regulated markets allowed for a more liberal approach. The sponsorship of these exhibitions was often adjusted to suit local requirements. When the prints were exhibited across Canada by Philip Morris affiliate Rothmans of Pall Mall, they were described as having been "commissioned by Benson and Hedges."[72] In Venezuela, Philip Morris's local affiliate Tabacalera Nacional presented *11 Pop Artists* with the assistance of the US Embassy and the United States Information Agency. Lichtenstein was flown in to meet with local artists for an event at the American cultural center and to conduct interviews with television and press reporters.[73] In the United Kingdom, Philip Morris's razor brand Ever-Ready Personna sponsored the show.[74] Across these and other international presentations, *11 Pop Artists* became a defining source for American pop's international reception. The widespread availability of these works meant that they played an important mediating role in the European reception of American pop art. Whereas the larger, usually hand-painted and sometimes sculptural works remained less easily seen outside New York, the prepackaged compilation of these flat, printed images for international circulation further served to reinforce the shared values between pop art and the mass-produced global brands it helped promote.

The most significant change that the *11 Pop Artists* project endured was its subsequent reconceptualization under the title of *Pop and Op* for an extended American tour. In mid-1965, Ruder & Finn hurriedly purchased an additional thirty-five prints by Josef Albers, Ellsworth Kelly, Bridget Riley, Frank Stella, Victor Vasarely, and others for Philip Morris. Max Kozloff (previously one of pop art's most strident critics and, later, an equally vocal opponent of art as corporate propaganda) rewrote his catalogue essay to explain the exhibition's new stylistic indecision, stretching to emphasize the formal similarities between the "two kinds of art" included in the final exhibition.[75] As the press release issued by the American Federation of Arts in early 1966 described, these works completed "the up-to-date representation of artists currently working within these two trends."[76] This bet-both-ways maneuver reinforces the importance of being up-to-date for Philip Morris. While in mid-1965 pop remained fashionable, by the end of the year its sheen was beginning to wear off, and as the mass-market imitation of op art escalated, it is not surprising that Philip Morris worried about looking behind the times. As an earlier marketing report for the company outlined, staying "in advance of trends" in the "youthful, style-setting or style-discerning market of the future" was crucial, ensuring that its marketing initiatives would appeal to the smokers of tomorrow.[77] The stylistic conjunction of *Pop and Op* cast the success of modern art movements as a matter of consumer choice.

Unlike the problematic realism of the pop commissions, the new op acquisitions were abstract but could also be connected to the discourses of cigarette marketing. "These works may at first seem unfamiliar and as has been said uncomfortable," the catalogue introduction for a 1968 exhibition of the same works for an exhibition in Australia described, "but, once their flavour has been tasted, then the alert spectator should find that he or she is wishing for more. This is, of course, a common experience in so many aspects of everyday life where one must first overcome the unfamiliar and even distasteful before find new and lasting pleasures."[78] It is difficult to even read the latter phrase without hearing the voiceover artist for a cigarette commercial. Philip Morris's incorporation of op art into its promotional repertoire sought to use its effects as a further means to capture the ineffable sensations of smoking.

The retinal effects of abstract art further resonated with the visual regime of cigarette package design at Philip Morris. "New forms of design and imagery are essential to the continued health of our own company," Weissman wrote, with no apparent irony, in the introduction to the *Pop and Op* exhibition.[79] The aesthetic decisions of Philip Morris were central to the identity of the products, as one designer explained, because "cigarettes are anonymous, they derive their differences from the perceptual stimuli surrounding them."[80] Packages were of paramount importance to the cigarette business, and aesthetic judgement was crucial for its design orientation. As design firm Loewy and Snaith explained, cigarette packages had to establish an "instantly recognizable, believable difference in quality and performance between yours and competitive products."[81] Form, shape, and color were at the very heart of the identity of their products. "Graphics are very important here," a Philip Morris staffer would later explain, noting "people here were already concentrating on shapes, colors, lines" before the company turned to fine art.[82]

Philip Morris's approach to packaging undoubtedly informed their taste for modern art. In the mid-1950s, Weissman oversaw the redesign of the Marlboro and Philip Morris brands, assembling a team of consultants to produce a "modern colorful package with maximum brand identification and visual recognition."[83] For the latter rebrand, code-named "Project Mayfair" to foil nosy competitors, the designs of Egmont Arens (fig. 31) were tested according to "color intensity and graphic visibility . . . to establish proper angles of recognition for cartons and the best-retained cartouche forms."[84] Albert Kner, head of the Design Laboratory of the Container Corporation, was retained to study the recognition speed and memorability of the graphic identities, using "hidden cameras activated by photo-electric cells, one-way mirrors, ocular measurement, and other devices . . . to check customer reactions."[85] The psychological and physiological effects of designs were studied by art historian turned corporate color consultant Louis Cheskin (fig. 32), who posed with Weissman as they inspected color swatches, as always, cigarette in hand.[86] The result of such efforts was high-contrast packages in primary colors often arranged in shield- and flag-like formations, and it is no accident that other photographs show an American flag among the color swatches

FIGURE 31 ◀

Egmont Arens pointing to chart tracing development of Philip Morris package design, 1955. Photographer unknown.
Source: *Package Design for Self-Selling* (New York: Philip Morris Incorporated, 1957). Egmont Arens Papers, Special
Collections Research Center, Syracuse University Libraries.

FIGURE 32 ▶

Dr. Louis Cheskin and George Weissman inspect Philip Morris design samples, 1955. Photographer unknown.
Source: Louis Cheskin, *How to Predict What People Will Buy* (New York: Liveright, 1957), rear cover.

and pack designs on the design table.[87] "Marlboro Country" was more than just a met-
aphor; the brands these boxes would send into global circulation sought the same
symbolic resonance and loyalty as the nation itself.

This rigorous testing regime sought to understand consumer preferences and asso-
ciations for color, shape, and line in ways not dissimilar to the conventions of formal art
analysis. When market researcher Elmo Roper was retained by Philip Morris to survey
the opinions of design professionals, his targets included "a professional artist and art
director" and "a lady who is in the industrial design department section of the New
York Museum of Modern Art."[88] The MoMA curator was probably Mildred Constantine,
an adviser to the International Design Conference at Aspen from 1961 until 1964 and an
associate of Container Corporation's Egbert Jacobson.[89] "The aesthetic quality of the
package, as of other artifacts," she had written for *The Package* (1959) exhibition they
co-curated, "is the result of a conscious effort to organize materials and functions into
clear shapes and relationships, with a due concern for their effect on the eye."[90]

Following such formalist principles, the pack designs of Philip Morris sought to
achieve "retina retention" with simple geometric shapes, strong gestalt profiles, and
searing color—much like the effects that would come to be favored by abstract paint-
ers like Kenneth Noland and Alexander Liberman in the early 1960s. ("The hard edge
is too handy for spearmint gum," was how the ever-irreverent Larry Rivers character-
ized the affinity between abstract painting and consumer packaging around this
time.)[91] We might detect such continuities in some of the Philip Morris pop prints

themselves: see, for instance, the partial representation of the Philip Morris brand as viewed on an acute angle in Ramos's *Tobacco Rose,* reduced to a series of abstract blobs and yet still legible as the same brand as its frontally oriented counterpart. This is precisely the kind of "corner of the eye" viewing that packaging designers sought to capture in the competing visual stimuli of the supermarket aisle.

The prints of British artist Gerald Laing might initially seem the least pop of the *11 Pop Artists* portfolio, but in this context, his references to the aesthetics of midcentury graphic design are perhaps the most closely observed of all the participating artists. Laing was interested in the borders between abstract art and consumer marketing, and with Peter Phillips (the other British artist included in the portfolio) had recently produced a "hybrid" artwork determined by the preferences of consumers, performing as market researchers to interview more than one hundred critics and curators in order to statistically design its form.[92] Laing's *Compact* (1966) (fig. 33) channels the most avant-garde tendencies of sixties graphic design, something like the geometric logos of Elaine Lustig Cohen that branded the *11 Pop Artists* portfolio itself. Two vertical red ribbons frame this mirror image form, bending into a sinuous, pinched bulb shape in silver mylar foil. Like many of his works from this period, Laing's designs distill the Art Nouveau revival of mid- to late 1960s psychedelia, extracting archetypal, even minimalist forms from its florid excess.[93] In another print, *Slide* (1966), an angled bar of reflective silver mylar bends into a vertical zip, like a wiggling trail of cool, blue smoke.[94] Both look like graphic designs awaiting logos and other typographic elements. Just as Container Corporation's designers sought to control the sequence of the eye across the surface of a package, Laing's abstractions achieve something of the same gestalt profiles and directional thrusts that were essential to effective packaging design. In Caracas, Venezuela, where *Slide* was displayed alongside the rather more literal visual punch of Roy Lichtenstein's *Sweet Dreams, Baby!* (1965) (fig. 34), the commercial relevance of Laing's slippery position between pop and hard-edge abstraction is unmistakable. None of his prints were excluded from the *Pop and Op* exhibition.

James Rosenquist's first print for the portfolio is the work, however, that most directly tackles the paradoxes of the project. *Circles of Confusion* (1965) (fig. 35) combines both pop and op characteristics, melding the branded consumer imagery and eye-catching abstraction on which Philip Morris packaging relied. The powdery, sherbet-hued surface of the work is a clear homage to the work of Rosenquist's friend and fellow Aspen Institute artist in residence Larry Poons, whose work was among the op prints added for the American tour. As Rosenquist later described, the work's title refers to the glowing orbs of light produced when bright highlights in a background are deliberately shot out of focus, a technique used by commercial photographers to create an otherworldly aura for product images.[95] Within this shimmering optical field, Rosenquist repeats the florid circular logo of another troubled corporation of the 1960s, General Electric (GE).[96] Like Rosenquist's Container Corporation picture, *Circles of Confusion* thus slyly includes the brand name of one company in the commission

FIGURE 33

Gerald Laing, *Compact,* from the portfolio *11 Pop Artists*, vol. 1, 1966. Screen print and collage. Gift of Philip Morris Incorporated. Smithsonian American Art Museum, Washington, DC / Art Resource, NY. © Estate of Gerald Laing / Bridgeman Copyright.

for another. Perhaps he even knew that General Electric, the nation's fourth-biggest corporation, was also on Ruder & Finn's client roster. In any case, the juxtaposition cleverly suggests the corporate nature of postpainterly abstraction, linking the repetitive visual impression of the logotype with the optical effects of 1960s abstract painting.

FIGURE 34

Roy Lichtenstein in front of *Sweet Dreams, Baby!*, 1965, at the opening of the exhibition *Pop Art: La nueva imagen* at Centro Venezolano Americano, Binational Center, Caracas, Venezuela, 1966. Photographer unknown. © Estate of Roy Lichtenstein. Also featuring Gerald Laing, *Slide,* 1966. © Estate of Gerald Laing / Bridgeman Copyright. Courtesy The Roy Lichtenstein Foundation Archives.

The tensions between abstraction and figuration and between art and advertising that characterized Philip Morris's early forays into avant-garde practice find their more conservative counterpart in another little-known Philip Morris art scheme, whose unequivocal embrace of realist art suggests the less risky path that corporate art projects could take. In 1967, the company was planning a major exhibition of the popular painter of the American West Frederick Remington, a show to feature over one hundred works and be wholly "underwritten by Philip Morris."[97] Ruder & Finn had proposed the project to the National Collection of Fine Arts (NCFA), in Washington, D.C. The museum had recently exhibited the *11 Pop Artists* portfolio it had been given and had accepted a donation toward the costs of US representation at the 1966 Venice Biennale from the company (fig. 36).[98] It was a relationship the museum wished to cultivate. "The occasion was quite important to the National Collection," wrote the NCFA's John Latham of the donation "because Philip Morris commissions many exhibitions of contemporary art and we hope to be on the receiving end of some of them for our permanent collection."[99] Something of this intersection between state and commercial interests is validated by the publicity photo for the check presentation, staged before Thomas Moran's *The Grand Canyon of the Yellowstone* (1872)—an artwork itself inextricably tied to the government's colonization and promotion of the American West, the myths upon which the company's flagship Marlboro brand would so forcefully draw.

FIGURE 35

James Rosenquist, *Circles of Confusion,* from the portfolio *11 Pop Artists,* vol. 1, 1965. Screen print on paper, 23⅞ × 20 in. Gift of Philip Morris Incorporated, 1966. Smithsonian American Art Museum, Washington, DC, / Art Resource, NY. © 2022 James Rosenquist Foundation / Licensed by Artists Rights Society (ARS), New York. Used by permission. All rights reserved.

The following year, Philip Morris launched a national advertising campaign for the Remington Masterpieces. This set of four reproductions, delivered in a cardboard tube disguised as a giant cigarette, was offered for $1.50—but orders were required to include the bottom of a (presumably consumed) Marlboro pack. While this promotion capitalized on the relationship between Remington's imagery and the Marlboro brand,

FIGURE 36
Robert W. Norris, left, director of community relations, Philip Morris International, presents a check to David W. Scott, director, National Collection of Fine Arts, 1966. Photographer unknown. Record Unit 320, Box 14, Folder 8, Smithsonian Institution Archives, Image # 94 9292.

the exhibition itself remained unrealized. Under Kaiden's direction, Ruder & Finn's art activities remained largely oriented toward contemporary art, but this advertising promotion suggests the more conservative directions that corporate art projects could take. For Philip Morris, the Remington idea was eventually reincarnated as *Frontier America: The Far West*, a 1975 touring exhibition whose images, as one reviewer noted, "tend to corroborate the romantic and macho vision of the West brought to us by John Ford and Randolph Scott."[100]

Such a turn away from avant-garde practice is evident in the late sixties activities of other companies considered in the last three chapters. At the Campbell Soup Company, the problematic brand images produced by Andy Warhol were counteracted by the company's move, in 1967, to amass a $250,000 collection of antique soup tureens.[101] Favoring pieces with eighteenth-century aristocratic connections, the resulting touring exhibition and eventual corporate gallery sought to emphasize the class associations of soup by "recalling an era when formal dining was a more highly studied art."[102] According to company president William Murphy, the purpose of the collection was nothing less specific than to "counteract the bad image given [to] his products when Andy Warhol

painted a famous pop art picture of Campbell Soup Cans." Warhol's own image was a matter of particular anxiety for this stalwartly traditional company. "You know what kind of a sex life that man has," said one Campbell's executive about the artist, explaining the need to "counteract the bad image" that pop art had produced for their brand.[103]

Container Corporation's art programs also became increasingly product-centric. While the "Great Ideas" series continued in scaled-back form, two projects exemplified how art might promote cardboard boxes better than Warhol or Rosenquist's works. In 1967, Container Corporation collaborated with New York's Museum of Contemporary Crafts on an exhibition of paper sculpture, garments, furniture, and even housing. Titled *Made with Paper,* the exhibition boasted that paper itself was the "medium of ideas" and constructed a concrete poem of sorts from eighty-seven instances where paper was mentioned in the works of William Shakespeare.[104] The show was extended to the foyer of the Time-Life Building, an undeniably print-focused context that sealed the critic John Perreault's view that it represented "mainly a paper commercial."[105] By the time Container Corporation participated in the Los Angeles County Museum of Art's Art and Technology program in 1969, producing a giant walk-through structure assembled from 4,500 polygon-shaped folded forms by sculptor Tony Smith, art was—at least for the company—a grand showcase for its expertise in the mass manufacture of cardboard boxes.[106]

The liaison between pop art and the corporation in the mid-1960s suggests how consumer businesses carefully controlled their engagement with the arts, favoring the communicative flexibility and ideological openness of abstraction over the realistic representational modes that they had, initially, found so appealing about pop. By 1968, one management text would dismiss a taste for pop art (along with the use of "the latest catchphrases" and a propensity for "group activities" and "meetings") as the trappings that workers used to create a false image of creativity.[107] Pop artists too, on the whole, fell out of love with the possibilities of working with business. "We became all weird about corporations," Rosenquist writes in his autobiography, regarding them as perpetrators of "all kinds of nefarious deeds."[108] Or here is Allan D'Arcangelo, another of the artists commissioned to contribute to the Philip Morris portfolio: "We are forced to walk a thin line between corruption and ourselves," he explained in 1970. "Artists don't need patrons and patrons don't need artists."[109] But it wasn't always this way. The commercial contexts to which pop artists contributed not only are crucial to understanding the particular artworks produced within these often-complex circumstances but played a pivotal role in shaping how these artists imagined the economic and social role of their practice.

# ABSTRACTION AT WORK

**IN THE LATE FIFTIES AND EARLY SIXTIES,** major corporations began to assemble large-scale collections of modern art that were understood to improve the lives of employees and enrich their corporate image. In the following two chapters, I consider the interconnected and sometimes contradictory imperatives behind the pioneering art programs of Chase Manhattan Bank and Turmac Tobacco Company, two of the largest and most widely publicized corporate collections of the period, and prominent exemplars for many other companies in the decades ahead. I explore why these firms integrated modern art into their offices and factories and how they promoted this endeavor as evidence of their enlightened leadership, positive employee relations, and progressive brands. The prominence of artists like Mark Rothko and Jean Dubuffet might make the artworks at Chase Manhattan more familiar to art historians than those at Turmac, but both examples demonstrate the global orientation of these companies. Reconstructing the contributions of architects, designers, and advisers such as curator Dorothy Miller and critic Herbert Read, I also explore the development and interpretation of these collections and show how their overall communicative program was as carefully composed as the individual objects they contained.

Collections like those of Chase Manhattan and Turmac both fundamentally responded to criticisms concerning the dissatisfaction of the postwar wage worker. These businesses came to understand works of art as a way to provide some measure of individual expression missing from the modern workplace, and the gestural

forms of abstract painting seemed to be an effective means to offset the dehumanizing effects of the modern office and factory. "The very slapdash ebullience of the paintings creates a welcome contrast to severe, rigorously detailed interiors," reported *Fortune* magazine in 1960. "Businessmen ... have found that abstract paintings can, in fact provide a sense of emotional release, and may give the beholder a thin grip on humanity in a business-machine world."[1] A report from 1962 was more specific, if cautious, in its recommendations. "The 'humanizing' influence of painting," it advised, "may not wholly offset automation equipment you install but it will have a softening effect."[2]

Such ideas built, I think, upon the compensatory claims made for abstract art by many of its most prominent advocates. One might recall, for example, Alfred Barr's suggestion that modern art was "an embodiment of the freedom which we all want but which we can never really find in everyday life with its schedules, regulations and compromises."[3] In "The Liberating Quality of Avant-Garde Art" (1957), Meyer Schapiro mounts a more extended argument for abstract expressionist painting as a reprieve from the monotony of modern work. The "frustrations and emptiness that arise from the lack of spontaneity and personal identification in work," he explained, had stimulated abstract painters to embrace the messy and the accidental in ways that no other worker could, producing art that was "a means of affirming the individual in opposition to the contrary qualities of the ordinary experience of working."[4] Setting aside Schapiro's more fundamental critique of the alienation of postwar labor, such an account imagined abstract art to provide the human values lacking from the modern workplace. The complementary notion that modern artists themselves represented the opposite of the modern worker—"one of the few remaining individualists in the age of organization man," as one critic put it—contributed to a pervasive framework that imagined modern art to provide the satisfactions that modern work could not.[5]

The burgeoning taste for abstract art among corporations in the 1960s followed their earlier recognition of the productive aesthetics of modern architecture. As Clement Greenberg saw it, the success of modern architecture had derived, in large part, from the "growing realization on the part of industrial experts that cheerfulness and comfort can be as essential to efficiency as the more literally functional qualities of a building."[6] For Greenberg, the fact that "some number of people now get an immediate satisfaction from the decors in which they work" represented "at least one gain for high culture under industrialism."[7] In "The Case for Abstract Art" (1959), Greenberg further proposed painting and sculpture as an "antidote" for the inadequacies of industrial society. The disinterested contemplation of abstract art, he contended, was a "self-cure and self-correction" for a culture that "devotes more mental energy than any other to the production of material things and services," a world in which "we are all too busy making a living."[8]

Such recuperative claims provided a robust framework by which modern art could demonstrate "the human side of enterprise," to borrow the title of a best-selling management text of the period.[9] This made it possible to perceive even the most insular forms of abstract art as media of communication that, like the bold new logos and

visual identity programs being adopted by corporate enterprise in the 1960s, would make a vivid, immediate impression on the viewer. Just as Greenberg called for artworks that revealed themselves fully in the "instantaneous shock of sight," corporate patrons often favored artworks whose clarity and legibility were consistent with other forms of corporate communication.[10] This was especially relevant in the global sphere, where the "topos of abstraction as an international language" was echoed by the communications requirements of multinational business seeking to transcend barriers of language and culture.[11]

As abstract art was conceptualized by its patrons as a kind of communications tool, it was also invariably drawn into the centralized planning and management for which the postwar corporation was so often criticized.[12] Corporate interests in modern art, argued business journalist Chris Welles in 1966, were thus contributing to a "new world of centralized aesthetic planning" by which companies sought to impose "complete—if not tyrannical—control."[13] Under such regimes, employee aesthetic preferences were a matter of corporate scrutiny and evaluation. As one executive explained in 1966, modern art could thus serve as "a subtle but powerful discipline within the corporation, a kind of unofficial quality control mechanism."[14] Paradoxically, then, such efforts to achieve aesthetic control coexisted with the idea that modern art might humanize the experience of modern work and soften the image of business. At both Chase Manhattan and Turmac Tobacco Company these contradictory impulses shaped the composition of their corporate collections and informed the social functions that midcentury patrons imagined modern art to serve.

# 4

## CHASE MANHATTAN'S EXECUTIVE VISION

**"D**AVID ROCKEFELLER DEFINITELY WANTS ROTHKO,**"** reads a Western Union cablegram sent by Museum of Modern Art (MoMA) curator Dorothy Miller to the art dealer Sidney Janis in June 1960.[1] The message confirmed the purchase of Mark Rothko's *White Center* (*Yellow, Pink and Lavender on Rose*) (1950) (fig. 37), a canvas that would dominate the entry to Rockefeller's executive suite at Chase Manhattan for decades to come (fig. 38). Rothko's dazzling yet tranquil painting allowed its owner to display the kind of sophisticated aesthetic judgment that defined so many forms of elite consumption in postwar America. It also connected Rockefeller to a network of other wealthy collectors who had already expressed their faith in advanced American painting by acquiring Rothko's work.[2] These conglomerate associations were further extended by the artwork's status at the top of the bank's multilayered art program, the top rung in an arrangement of abstract paintings working together to cultivate a modern, progressive corporate image. Using Rothko's picture as a departure point, this chapter will explore the delicate balances

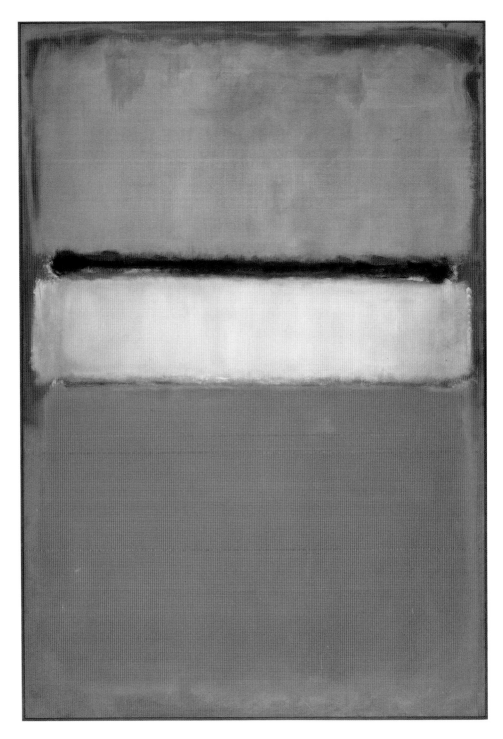

FIGURE 37

Mark Rothko, *White Center (Yellow, Pink and Lavender on Rose)*, 1950. Oil on canvas, 81 × 55½ in. Private Collection. © 1998 Kate Rothko Prizel & Christopher Rothko / Artists Rights Society (ARS), New York.

between individual expression and corporate hierarchy that Chase Manhattan Bank's pioneering art collection negotiated over the course of the 1960s.

Rockefeller's own judgment of Rothko's work was rather less definite than the cable confirming its purchase might suggest. "Miller told me about it and urged me—if not insisted—that I acquire it," he later recalled. "Up until that time, I had preferred figurative paintings and found it difficult to adjust to the abstract works of the New York School."[3] When works from his personal collection were shown alongside other Rockefeller family collections for a 1959 fundraising exhibition, David's tastes were characterized as the "most conservative" of his brothers.[4] Less than a year later, his purchase of *White Center*—the first abstract painting in his collection—unequivocally confirmed his faith in the advanced forms of modernism so essential to the reputation of MoMA's founding family.

Rockefeller paid $8,500 for *White Center*; in 2007, he sold the work for a record-breaking price of $72 million.[5] The fact that Rockefeller acquired the picture for his personal collection at all, rather than for the corporate collection of the bank headquarters where it would be installed, ironically seems to have been the result of Rothko's own persistent efforts to control the fate of his works. As the sale was being finalized, Dorothy Miller wrote to Rockefeller's assistant: "When David looked at the painting at the gallery . . . no mention was made of the possibility that the Bank might eventually have the picture. There is great demand at present for Rothko's pictures and he sells very few. I felt sure that because of certain views he has he would be well pleased to have one of his paintings in David Rockefeller's collection, but I was uncertain that he would be willing to sell to the bank simply because he is rather 'sticky' about where his pictures hang."[6] Rockefeller's private acquisition ensured, Miller continued, that "no question of the Bank will come up at present with the artist or the Janis Gallery." And even if the subterfuge was temporary, Miller understood that it would be "easier to approach the problem of the artist's reaction to the possible use of the picture in the Bank once the picture has been purchased by David."[7] Deferring news of the commercial context for which the picture was destined to be used, Miller's strategy capitalized on Rothko's apparent preference for private over corporate patronage but in retrospect also reveals just how blurry these distinctions could become.

As Miller undoubtedly knew, the sale of *White Center* occurred in the wake of what became Rothko's most famous and ultimately aborted commission for a commercial space. In June 1958, Rothko was contracted to decorate a dining room for the Four Seasons Restaurant in the Seagram Building.[8] In late 1959 or early 1960, apparently dissatisfied with the idea of his works appearing in such an exclusive space ("the most expensive restaurant ever built," boasted one period source), Rothko withdrew from the commission.[9] Such an action did not, however, preclude other corporate uses of his art: Seagram's also owned Rothko's *Brown and Blacks in Reds* (1957) (fig. 39), a work they hung at the threshold of the company's fourth-floor reception, around the corner from a backlit display of Seagram's liquor bottles.[10] This same "glowing mood painting" represented

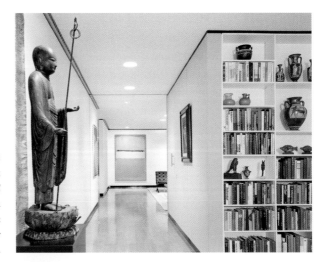

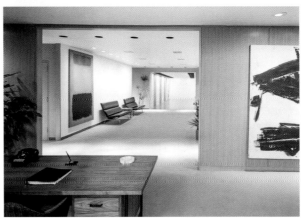

Seagram's at the Whitney Museum's *Business Buys American Art* exhibition in March 1960 and was reproduced in *Fortune* magazine to demonstrate the company's role in the "corporate splurge in abstract art."[11] Rockefeller's acquisition tied both company and collector to the burgeoning patronage networks of 1960s corporate modernism.

Despite the risk of Rothko's disapproval, Rockefeller's acquisition of *White Center* was almost immediately drawn into Chase Manhattan's image-building activities. Less than a month after the work's purchase, the canvas was a last-minute addition to the *Paintings on Loan from the Chase Manhattan Bank* exhibition at the Albright Art Gallery in September 1960, its private ownership undistinguished from the rest of the newly assembled corporate collection.[12] Rockefeller posed with *White Center* for the Buffalo press (fig. 40), confirming critic Paul Goodman's quip that Rothko's canvases were beginning to be treated like "backgrounds that make people look good."[13] That was certainly the desired effect when photographer Bruce Davidson used the same

ALBRIGHT GUEST — David A. Rockefeller, brother of Gov. Rockefeller, poses before one of the paintings from his own collection during visit to the Albright Art Gallery last night. The painting is currently on display there. *C-E*

FIGURE 40

David Rockefeller with Mark Rothko, *White Center (Yellow, Pink and Lavender on Rose)*, 1950, unidentified clipping, September 1960. Source: Gordon M. Smith Papers, Albright-Knox Art Gallery Archives. Image courtesy the Albright-Knox Art Gallery Archives © 1998 Kate Rothko Prizel & Christopher Rothko / Artists Rights Society (ARS), New York.

painting for a *Vogue* fashion shoot in 1962, along with other works at Chase Manhattan.[14] In both cases, it would be easy to understand such photographs to undermine Rothko's art, as has been argued of the earlier appearance of Jackson Pollock's *Lavender Mist* in *Vogue,* but they should also be understood to have enriched its reception.[15] Here, Rockefeller stands as the front man for Rothko's infinite depths, the alignment of his confident gaze repeating the dominant horizontal of its composition. "Chase Manhattan," explained the bank's statement on the collection, "wanted its new offices to reflect the present and even anticipate the future. For this reason, the bank deliberately sought the work of artists whose approach is future-looking."[16] For Rockefeller, then, Rothko's painting envisioned the infinitely expanding horizons of high finance, a field for the mastery of his corporate vision.[17]

As Rockefeller placed his bets on the future of modern art, his own future was up for grabs too. In January 1960, the retirement announcement of Chase Manhattan Bank president John McCloy opened the top job for Rockefeller. In this context, Rothko's *White Center* stood as an expression of his faith in the prospects for more than just his career or the company. "One of our members told David Rockefeller that if capitalism has such good taste it has a great future," commented a member of a foreign trade delegation after a 1963 visit to Rockefeller's office.[18] Understood in these terms, Rockefeller's Rothko also represented a defense against the alleged materialism of American business itself, criticisms that Rockefeller declared, in a 1960 interview, to

have been "used too often and unjustly to criticize our society."[19] Engaging with the modernist avant-garde helped big business directly counter such criticisms. "Ironically that very materialism which, according to popular prediction in some quarters, will cause our final downfall, has in truth acted as America's cultural patron saint," reported critic Katharine Kuh in a 1961 article on the bank's collection.[20]

There was also something about Rothko's art that seemed especially suited to the imaging of corporate status. When architectural critic Ada Louise Huxtable ranked the visible expressions of executive hierarchy in November 1960, she explained that the "teak table and the Rothko are available at the top," and "farther down the line it is the metal desk and the good print."[21] Another "well-known decorator" suggested that the presence of an abstract painting in an office demonstrated that "this man knows what's 'in' today and what will be 'in' tomorrow, and will back his knowledge to the hilt." In line with Rockefeller's own projected promotion, the same article claimed that modern art could help predict "which vice president is going to be the next president"—at which point he was likely to trade up to "an original Mark Rothko."[22] With their subtly differentiated hierarchies so effectively conjuring the "prestige gradation" that sociologist C. Wright Mills claimed to define white-collar status at midcentury, Rothko's stacked compositions sat on the top rung of the corporate ladder.[23]

Regardless of Rothko's own interests, the formal suitability of his art for the executive suite was redoubled by the effects it produced. As art historian Sarah Rich has demonstrated, the widespread reception of Rothko's paintings as "soothing" tied them to an expansive period discourse around stress relief, especially "as a necessary antidote to . . . the tensions of office labor."[24] This claim understood the emptiness of his pictures as a relief for overstimulated eyes and offered the sensations of blurred vision as a relaxation technique. With its warm, luminous energy, *White Center* was especially suited to such palliative fantasies.[25] According to critic Dore Ashton, Rothko's increasingly brooding palette of the late 1950s was, indeed, an effort to combat the misinterpretation of the "effusive yellow, orange and pinks" in earlier works like *White Center,* an effort to prove that he was "never painting luxe, calme and volupté."[26] The artist's new works might have eschewed such uplifting dawn hues, but Rockefeller's acquisition from a decade earlier ensured the suitability of this painting within the therapeutic framework so useful to the corporate context.[27]

Inside the stacked monolith of Chase Manhattan's headquarters, the formal resonance of Rothko's canvas with its architectural container was further emphasized by the presence of John Marin's *Midtown New York* (1928) on the facing wall of the entry to Rockefeller's executive suite.[28] This composition, featuring a silvery, stepped skyscraper fringed by scaffolding and emerging from a stripe of brown tenements, had served as the background for an earlier portrait of Rockefeller (fig. 41). "I had been working at Chase Manhattan . . . and was very interested in urban development in New York," he later recalled of the Marin watercolor, so "this picture of a building under

FIGURE 41

Portrait of David Rockefeller, ca. 1955. Photographer unknown. David Rockefeller Family Photographs, Box P179, Folder 254, Courtesy Rockefeller Archive Center. Featuring John Marin, *Midtown New York,* 1928. © 2020 Estate of John Marin / Artists Rights Society (ARS), New York.

construction had a definite appeal for me."[29] Because Marin's work depicted construction at Rockefeller Center, the landmark redevelopment project overseen by his father John D. Rockefeller Jr., the work had an even more personal connection. Crucially, this was the site of the family's most troubled patronage experience: the censorship of Diego Rivera's 1933 mural for its anticapitalist iconography, as Mary Coffey has written, "a foundational episode in the modern history of art censorship and corporate arts patronage.[30] David Rockefeller was sixteen at the time and seems to have absorbed its implications.[31] "From this point forward capitalists would no longer dream in public," writes art historian (and abstract painter) Robert Linsley of the affair, and "if they hoped to make use of art to reinforce their values in the public sphere, they would have to find a different kind of art."[32] In the wake of the Rivera debacle, Rothko's abstraction fit the bill.[33]

The recurrent connections between Rothko's art and executive self-imaging outlined here left their mark on art criticism too. In 1961, for example, soon after the Seagram's fiasco, critic Michel Butor conjured the image of an executive basking in the reflected glow of Rothko's paintings, a businessman who misunderstood these paintings as "a simple instrument of comfort" that wouldn't "disturb us in any way during our business conversations" but will "help impress our customers from Kansas City or even from Europe."[34] For Butor, Rothko's paintings ultimately withstand such a misreading, but the necessity to address their corporate appeal is telling. Critic Hilton Kramer was even more scathing in the conclusions he drew from the presence of Rothko's work in Rockefeller's office:

Go through the new Chase Manhattan bank tower in lower Manhattan ... with its air of being the perfectly designed, luxurious, air-conditioned concentration camp of the future. Look at the way Mark Rothko and the other movie stars of the New York School ease your way into this anonymous, faithless future, and see if you can ever again read an essay proclaiming Rothko's spiritual serenity and esthetic heroism with quite the same feeling. Under the fluorescent lights, with the pink typewriters purring along, it is just nice—pleasantly, harmlessly, powerlessly nice—to encounter a large, soft yellow or brown or grey-purple rectangle floating before one's eyes. There it is—comfortable, easy, undemanding, completely forgettable, an ornament of power by virtue of its financial cost, but an ornament that leaves that power unquestioned in any human terms.[35]

The idea that it was the emptiness of abstract art that made it so well suited to the needs of big business would become a repeated refrain in accounts of corporate collections in the years ahead. "Chase Manhattan bank has lately found that in its avoidance of touchy subjects, there is nothing safer for its flock of customers," explained painter Balcombe Greene in 1966. "Once past the notion that art must represent something, no one can take offense at abstraction."[36] Critic John Canaday reported a similar sentiment in his summary of the bank's first decade of collecting in 1971: "The subject matter, if any, of business-collected art must be noncommittal. Abstract art of the sixties, removed from life as it was, was the perfect product."[37]

Such perspectives chime with the strategic ambiguity that was so essential to image-based marketing appeals. "An image is ambiguous," Daniel Boorstin explained in his book *The Image* (1961). "It floats somewhere between the imagination and the senses, between expectation and reality. In another way, too, it is ambiguous, for it must not offend. It must suit unpredictable future purposes. . . . It must be a receptacle for the wishes of different people."[38] This wasn't just theoretical: Boorstin further observes how advertising campaigns were using deliberately blurred photographs and "fuzzy outlines" to "make it easier for the viewer to see whatever he wished to see." For Boorstin, all of this brought to mind more avant-garde forms of contemporary image making. "In advertising, as in painting," he observed, "the non-representational technique is apt to become more popular, to give the viewer ample scope for his unpredictable but always exaggerating expectations."[39]

As much as abstraction provided business with a malleable communications tool and avoided some of the political associations of American realism, it was anything but empty of symbolic significance. Abstract art represented a rich field upon which complex, compound meanings could be projected. Corporate uses of these works were formulated with the input of the artists, critics, and curators with whom they engaged and were elaborated through highly considered contexts of display. As Rothko's *White Center* helps suggest, the integration of modern art into the workplace capitalized on

the rich associative capacity of abstract art and its potential to transform the image of those who basked in its reflected glow.

## A FRIEND FOR ABSTRACTION

Rockefeller's purchase of Rothko's *White Center* built upon the use of modern art already established at Chase Manhattan's midtown branch in the lower floors of an Emery Roth & Sons skyscraper at 410 Park Avenue. Completed in October 1959, the branch was designed by Skidmore, Owings & Merrill architects J. Walter Severinghaus and Gordon Bunshaft with interior designer Davis Allen. Here Rockefeller and Miller selected some twenty works of art to install throughout the branch. This scheme represented the foundation of Chase Manhattan's collection, providing a model for integrating modern art into the bank's newly constructed downtown headquarters that would eventually extend to branches and offices around the world. As the collection developed over the subsequent decade, Chase Manhattan would cast abstraction as an essential ingredient for the modern office.

Abstraction dominated the Park Avenue branch, including two works each by abstract painters Theodoros Stamos, James Brooks, and Jack Youngerman and sculptor Dmitri Hadzi.[40] In a letter to Miller sent soon after the branch opened, art collector Guy Weill described his encounter with the collection, delighting in the way that, for instance, Lawrence Calcagno's *Earth Legend VI* (1959) (fig. 42) was positioned such that it seemed to be "greeting you as you step out of the elevator."[41] This red abstracted landscape ran from ceiling to floor, so precisely sized that it is difficult to believe that the size of the canvas was not stretched to order, reinforcing the picture's window-like effect and balancing an adjacent yellow curtain. As Weill's description attests, modern painting and sculpture like this seemed to humanize the banking experience: "The cool and efficient, nearly soulless, atmosphere of a business place has been eroded and enriched by the paintings and sculptures. Instead of the usual desk and drape area each space gains new dimension and individuality by the works of art incorporated therein. Business interiors in our era of conformity and mass production usually lack individuality, which here at Chase Manhattan they gain through the use of the collection of art."[42] Major commissions from Alexander Calder and Sam Francis furthered such effects. Both artists had provided small studies for the bank's approval, so their abstraction was a foregone conclusion, but how should we understand the effect of these works in the branch? Suspended above the open desks and swivel chairs, Calder's twenty-foot sculpture (fig. 43) dramatized the generous double height of the main banking hall and the airy modernism of its design. "Nowhere on the main floor is there a teller's cage in sight," noted the *New York Times,* an absence emphasized by Calder's airborne iron construction, as though banking's old structures had broken free and taken flight.[43] "The bank's customers can stroll inside the gleaming new office, glance appreciatively at the mobile, and then go about their chores of borrowing money, signing checks and depositing savings," described another visitor to the

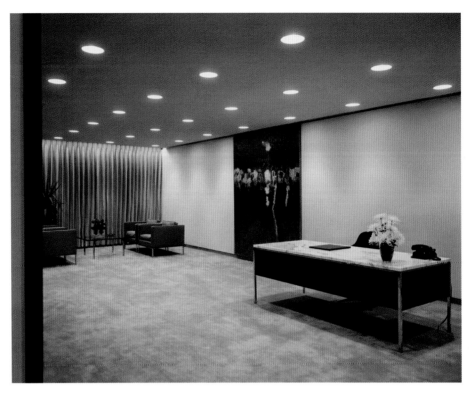

FIGURE 42

Chase Manhattan Bank, 410 Park Avenue, 1959. Photo: © Ezra Stoller/Esto. Featuring Lawrence Calcagno, *Earth Legend VI*, 1959. © Courtesy the Estate of Lawrence Calcagno.

branch.[44] The unrestricted movement of Calder's sculpture helped reinforce, as such period descriptions suggest, the unconventional openness and transparency of the banking space by providing fleeting moments of distraction without interrupting the flows of the branch whose activities it reproduced in abstract form.

The thirty-eight-foot painting by Sam Francis commissioned for the more private fourth floor of the branch (fig. 44) can be understood in related terms. In mid-1959, Miller took Rockefeller, Bunshaft, and probably Chase Manhattan president John McCray to Francis's studio to see the work in progress.[45] "I felt it would be a good idea for them to meet the artist," Miller recalled. "Francis was a very seductively interesting young man and could also talk about his work."[46] Although there is no record of their discussion, contemporary accounts help conjure how Francis might have explained his painting to the bank's representatives. According to a 1960 article by Yoshiaki Tono, who had shared his studio while the mural was under way, Francis put "violent colors at the two extremities and a blank area in the middle" to emphasize the dramatic "dialogue" between the opposing colors on either side.[47] The following year, Tono described the mural among a group of New York works that turned the "white

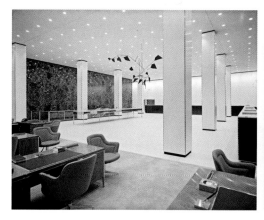
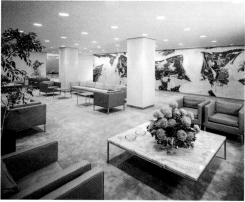

FIGURE 43 ◀

Chase Manhattan Bank, 410 Park Avenue, 1959. Photo: © Ezra Stoller/Esto. Featuring Alexander Calder, *Untitled*, 1959. © 2021 Calder Foundation, New York / Artists Rights Society (ARS), New York.

FIGURE 44 ▶

Chase Manhattan Bank, 410 Park Avenue, 1959. Photo: © Ezra Stoller/Esto. Featuring Sam Francis, *Untitled*, 1959. © 2021, Sam Francis Foundation, California / Artists Rights Society (ARS), New York.

space in the center into a forum for dialogue."[48] Such descriptions chime with Francis's own descriptions of the human significance of his increasingly centripetal compositions. "The space at the center of these paintings is reserved for you," he later wrote in his journal.[49]

The idea that the shapes in Francis's painting stage a kind of dialogue, or that its blank passages provide the space for its viewers to do the same, chime with the practical aspirations of the room for which it was designed. Although this was called a "board room," the bank boasted that it featured "no conventional board room table."[50] Instead, it was filled by groupings of sofas, club chairs, and coffee tables, all designed to "stress the unconventional air of informality."[51] Such ambitions aligned with Francis's loosely arranged shards of color, forms in flux that appeared to separate and recombine at will. Scaled to fill the longest wall of this eccentric meeting space, and even appearing to permeate the surrounding rooms through their coordinating splashes of gold silk and red wool upholstery, Francis's mural provided the unifying backdrop for a total environment designed to cultivate an image of free and open exchange of ideas—and money.

Francis later described his Chase Manhattan mural as "a butterfly caught in a trap," apparently dissatisfied by the low ceiling and pillars that constrained its view.[52] This is also a suggestive description of the polychrome wings that sprawl from the white central spine of the picture, and the sense that its forms compete against the restrictions of its setting. An account of the work by art historian Robert Rosenblum, a later adviser to the bank's art program, further emphasizes this tension. Rosenblum describes the "almost volcanic upheaval and irregularity" of the work as a field within which "no

shape or contour obeys any rule but disobedience to geometry and to predictable pattern," a "deliberate rebellion against the modular, rectilinear tyranny of any modern office building."[53] Just as Calder's mobile for Chase Manhattan was understood as "a foil to the computer," Rosenblum claimed Francis's work as "a welcome oasis in a business world of computer precision."[54] Both artworks amplified the human possibilities of the open spaces of the branch and helped distract from the underlying technologies that represented their antithesis.

As the 410 Park Avenue branch was unveiled, the construction of Chase Manhattan's sixty-four-story downtown headquarters at One Chase Manhattan Plaza was well under way. There the human impact of automation was an unavoidable concern: following the merger of Chase National with the Bank of Manhattan in 1955, the planned consolidation of staff into a single new building sought to integrate the "personnel and operations of these two large institutions, each with a strong personality and a distinct culture."[55] New underground spaces allowed the bank to apply "assembly-line" methods to banking, implementing a new central computerized check-processing facility.[56] Within a year of the building's completion, the company could reduce its manual labor requirements and implement an ongoing time measurement program to reduce office jobs through efficiency savings.[57] Such changes were an important context for the acquisition of art, as the bank's description of the art program explained: "In a period where there is continued physical growth and an increasing stress on mechanization in many fields of bank operations, it is of special importance to provide a warm and human atmosphere in which to work. No simpler or more direct way of expressing management's awareness of the emotional needs of its employees suggested itself than the visual enrichment of their working environment."[58] The new headquarters brought together 7,500 employees previously spread across a range of buildings, and only 150 were to have private offices; the rest combined in office pools designed to "shift and reshape themselves frequently." These early open-plan offices were designed to have a minimum of columns to improve functional flexibility and save space, because, as one critic noted, "A desk can be put where there might have been a column."[59] Works of art mollified such rigorous efficiencies. The "visual enrichment" of the office through the art program sought, according to J. Walter Severinghaus, to "provide a pleasant place for employees where they can do their jobs happily. . . . Hopefully, if we have done a good job, you will have less labor turnover and better productivity."[60] Art historian Harriet Senie later wrote that Gordon Bunshaft viewed artworks "as a benefit to employees akin to Blue Cross and vacations," and this attitude seems to be one shared by many key players in the formation of the Chase Manhattan collection.[61]

Chase Manhattan's art program also helped reshape the bank's image among consumers. In *The Hidden Persuaders* (1957), Packard described how advertising agencies and motivation researchers had begun to analyze and counter the "fear factor" associated with interacting with banks.[62] Rockefeller was acutely aware of this problem.

"The old attitude of bankers used to belittle and terrify prospective customers," he told a journalist in 1963. "Probably a large segment of the public still looks on bankers as stuffy and conservative."[63] In 1960, Chase Manhattan's advertising agency Ted Bates and Co. introduced a new slogan for their client to combat such perceptions: "You've got a friend at Chase Manhattan."[64] By shifting its advertising efforts almost entirely to television, the bank was rapidly repositioned from a "stodgy wholesale bank catering mainly to other corporations" into a ubiquitous consumer brand with a welcoming, accessible personality.[65] Managed by the bank's public relations team, the art collection was closely allied to such efforts, particularly the desire to demonstrate "the bank's awareness of human values as exemplified by the emotional impact of the works shown . . . to emphasize the basic fact that banking is, above all, a personalized activity depending on human relations, on mutual understanding, and trust."[66]

Alongside the warm handshake of "human values," however, Chase Manhattan was also in the process of a literal overhaul of their brand identity, a process that resulted in the debut of the bank's now-iconic octagonal logo in November 1960. Developed by design firm Chermayeff and Geismar, and originally including both multicolor and one-color versions, this symbol was one of eight designs proposed to the company. Designer Tom Geismar thought any of them "might have worked equally well."[67] Avoiding the problems of a logo based on their building ("not easily identifiable because of the great number of other rectangular shaped buildings," notes one strategy document) or their monogram (which might preclude a future "change in the bank's name"), the abstract mark was conceived to work equally well "seen from a distance or print in small size."[68] Yet in a flyer titled "Our New Symbol of Service" that launched the design to staff (fig. 45), it was not abstraction's flexibility that was the focus. Rather, this flyer noted the dense and elaborate symbolism of the new logo: its "strong feeling of motion and activity," its suggestion of "a single unit made up of separate parts," and its implication of "growth from a central foundation."[69] This most simple of shapes—according to Rudolf Arnheim, the first abstract corporate logo in America—became an analogy for the bank's planning and strategy, visualizing organizational structure, even embodying corporate history.[70] Responding to the launch of the mark, one advertising executive even praised the bank for providing what they regarded as "an explanation such as many of us would be glad to have when viewing most abstract art."[71] Like the artworks installed in its branches and offices, the logo became a lesson in the multifarious symbolic possibilities of modernist abstraction.

Alongside the development of its new brand, Rockefeller turned his attention to assembling the art collection for the bank's downtown headquarters at what would become known as One Chase Manhattan Plaza by bringing together a larger committee of experts from across the city's museums: Alfred Barr and Dorothy Miller from MoMA; James Johnson Sweeney, formerly of MoMA and the Guggenheim Museum; Robert Hale, from the Metropolitan Museum of Art; Perry Rathbone from the Museum of Fine Arts in Boston; and the building's architect Gordon Bunshaft from Skidmore,

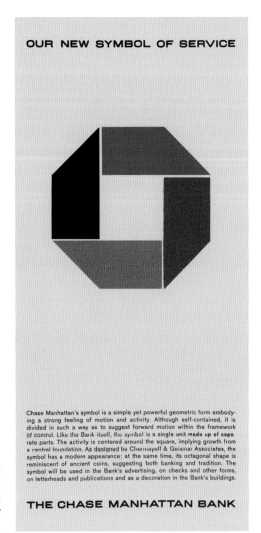

OUR NEW SYMBOL OF SERVICE

Chase Manhattan's symbol is a simple yet powerful geometric form embody-
ing a strong feeling of motion and activity. Although self-contained, it is
divided in such a way as to suggest forward motion within the framework
of control. Like the Bank itself, the symbol is a single unit made up of sepa-
rate parts. The activity is centered around the square, implying growth from
a central foundation. As designed by Chermayeff & Geismar Associates, the
symbol has a modern appearance; at the same time, its octagonal shape is
reminiscent of ancient coins, suggesting both banking and tradition. The
symbol will be used in the Bank's advertising, on checks and other forms,
on letterheads and publications and as a decoration in the Bank's buildings.

THE CHASE MANHATTAN BANK

FIGURE 45
"Our New Symbol of Service," Chase Manhattan
Bank flyer, ca. 1960. Designed by Chermayeff &
Geismar. Dorothy Miller Papers, Archives of
American Art, Smithsonian Institution.

Owings & Merrill. Miller was tasked with arranging works from galleries and studios around New York to be brought to the bank for the committee's consideration, with the hope that she would be "selective at the source" so that they did not have to waste time "turning down bad things that should not have come up."[72] As a photograph of an early meeting illustrates, Miller's prescreened artworks were presented in a steady procession before the selection panel and evaluated like contestants in a beauty contest (fig. 46).

The committee operated under rigorously bureaucratic procedures. More than one hundred works were often viewed in a single meeting. Committee members scored each on a scale between 0 (low) and 3 (high).[73] At the conclusion of the meeting, individual tallies were combined, and those that achieved more than an agreed-upon min-

imum score were purchased.[74] This threshold varied depending how many committee members were in attendance at a meeting: if seven were voting, for instance, the maximum score an artwork could achieve was 21, and works scoring a combined total of 11 or over would be purchased. This impersonal game of numbers favored paintings with a visual immediacy, absorbing formal judgment into the efficient quantifications of banking. In Rockefeller's case, Miller delighted in the development of his critical vision. "His eyes rapidly became attuned to modern art and it was impressive to watch," she recalled of his participation in these meetings. "Soon he was easily picking out the best works."[75]

Because the art committee had "a comparatively small budget allocation and a large amount of wall space to cover with it," the art committee focused on "abstract paintings—usually done on a large scale—by contemporary painters" whose "reputations have not yet grown sufficiently" for their prices to be out of reach.[76] In other words, they needed works at a substantially lower price per square foot than Rothko and his ilk, but still providing something of these individualistic, expressive effects. As a result, Chase Manhattan helped buoy the market for the so-called second-generation abstract expressionist paintings just as the movement was fading from critical favor. ("Abstract expressionism is on the wane," one visitor quipped in 1963, "and it is comforting to feel that the Chase Manhattan bank is going to be stuck—just like the rest of us.")[77] From the Betty Parsons Gallery, for example, Chase Manhattan purchased twelve works of art between October 1959 and March 1961, ten of which were abstract paintings with an average price of about $3,000.[78] As Miller trawled the galleries and studios of New York discussing the bank's requirements and selecting works, it is difficult to believe that these preferences did not encourage dealers—and in turn artists—to make more of the kind of large, boldly expressive, and often warm-hued abstractions that this high-profile patron wished to purchase at such an unprecedented quantity.[79]

The committee's decisions were also keyed to the spatial requirements of the Chase Manhattan headquarters, where Gordon Bunshaft used them to "dramatize vistas and axes" and "vitalize spatial dynamics."[80] To facilitate such planning, early decisions were made before the large blueprints of the building unrolled on the floor (fig. 47).[81] Potential artworks were divided into four size groups, and these categories were scrupulously tracked in collection inventories to allow works to be matched to the requirements of particular locations.[82] "Twice a year we may decide we need fourteen paintings four feet square," a bank curator later explained.[83] Such requirements also influenced the format of purchases: larger works in public areas such as corridors and elevator foyers tended to be portrait in format so that they could extend from floor to ceiling, while paintings or prints in private offices tended to be smaller landscape or square formats suitable for installation behind desks and above bureaus.

In the committee's first year, the committee acquired more than one hundred artworks. It is difficult to generalize across the entire collection, but some sense of its scope is worth describing. As was the case at 410 Park Avenue, the majority of major

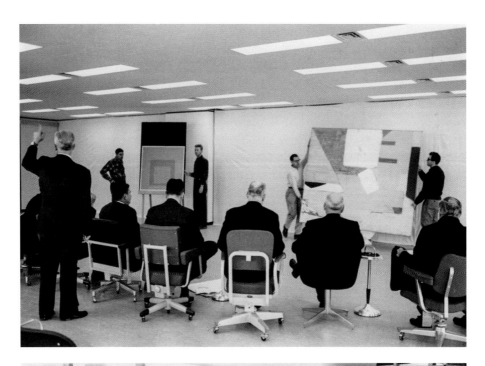

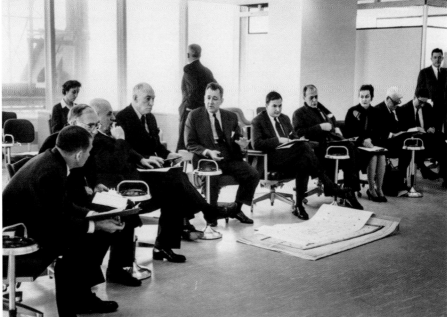

FIGURE 46 ▲

Chase Manhattan Bank Art Committee, 1960. Unknown photographer. Gordon Bunshaft architectural drawings and papers, Department of Drawings & Archives, Avery Architectural and Fine Arts Library, Columbia University.

FIGURE 47 ▼

Chase Manhattan Bank Art Committee, 1960. Unknown photographer. Gordon Bunshaft architectural drawings and papers, Department of Drawings & Archives, Avery Architectural and Fine Arts Library, Columbia University.

purchases were large abstract paintings, including works by Afro (Basaldella), Elmer Bischoff, James Brooks, György Kepes, David Lund, Conrad Marca-Relli, Joan Mitchell, Georges Mathieu, Kyle Morris, Kenzo Okada, Pierre Soulages, Hedda Sterne, Kumi Sugai, Esteban Vicente, and Jack Youngerman. Multiple purchases of works by Brooks, Guerrero, Sugai, Marca-Relli, Okada, and Youngerman confirm that they seemed particularly suited to the bank's requirements, installed as they often were in public corridors and prominent meeting rooms. When geometrical abstractions by the likes of Josef Albers and Fritz Glarner were chosen, they tended to be smaller in scale and served as energizing punches of color dotted throughout the building. Adolph Gottlieb's *The Crest* (1959) (fig. 48), one of the company's most expensive early purchases, captures the visual effects of many early acquisitions. Ultimately installed in a midtown branch, Gottlieb's picture provided warmth and expressive intensity but delivered these effects with a visual immediacy that had, as Lloyd Goodrich and John Baur had claimed of this artist's work in 1961, "the impact of a sledgehammer."[84]

To plan the placement of pictures, Skidmore, Owings & Merrill built scale models of standard floors of the Chase Manhattan headquarters and then constructed a series of sample rooms to test layouts at full size. Artworks were included in these plans. For an early installation of a reception area (fig. 49), for instance, José Guerrero's *Fire and Apparitions* (1956) was selected as an exemplar for the bank's growing collection of large abstract paintings.[85] With its blazing, energetic gestures in red and brown, Guerrero's picture seemed so well suited to the bank's requirements that it was hung and photographed in several different bank locations over the coming years (see also, for instance, fig. 54).[86] Critic Emily Genauer rightly recognized that "art objects of timid size, pale palette or subtle theme" that would "fail to have an impact on a transient audience" were at significant disadvantage for corporate patronage.[87] Across early acquisitions such as the Guerrero picture, along with prominently installed abstractions by Pierre Soulages, Joan Mitchell, and Kumi Sugai, the predominance of high-contrast works in red, white, and black is noteworthy, as it underlines the bank's demand for both chromatic warmth and graphic impact in their art acquisitions.

Chase Manhattan's art program would also support the bank's expansion into new international markets. Over the 1960s, the bank opened some sixteen international branches in Africa, South America, Europe, and Australia and developed a range of subsidiary and affiliate arrangements to further establish a global presence.[88] Works of art were bought and commissioned for many of these branches and helped garner cultural capital for the state support required for their establishment. When Nigerian leader Nnamdi Azikiwe visited Rockefeller in 1959 to promote industrial investment in advance of independence, the pair posed before a model of Calder's mobile planned for the Park Avenue branch.[89] Two years later, international press coverage of the opening of Chase Manhattan's branch in Lagos focused on its cast concrete relief by émigré art teacher Paul Mount and local artist Festus Idehen, a work inspired by Benin bronzes but "in keeping with modern architecture and making full use of new materials."[90] The

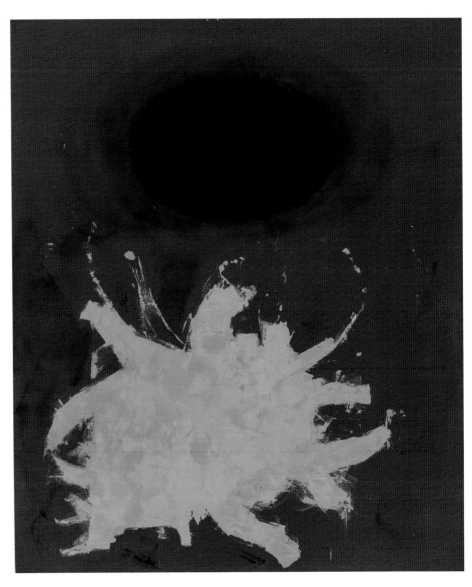

flow of art and material culture moved in the opposite direction as well. In one instance, Nigerian representatives presented examples of "ancient Nigerian money" for Chase Manhattan's numismatic display in New York's Rockefeller Center.[91] Works of art provided a congenial context to show the global economic exchanges so essential to the bank's success.

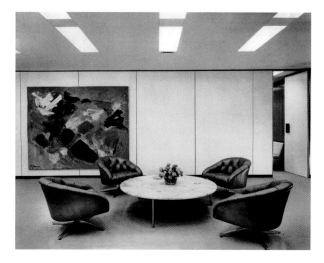

By the mid-1960s, the need to identify works of modern art for international branches became a key focus for the New York–based art committee. "In a departure from the usual method of presentation," note the minutes from a 1966 meeting discussing acquisitions for Paris and London branches, "the works under consideration were submitted in the form of projected slide transparencies."[92] When committee member Perry Rathbone was later sent to Europe to assess the impact of the art collection in these contexts, he reported that "wherever I went, both at home and abroad, I found almost without exception that the managers were sensitive to more than the stated advantages of the program—the decoration and enrichment of their premises. They were alert to the subtler meaning and implications of the Chase Manhattan involvement with art—as image forming, as advertising."[93] Like Rockefeller's *White Center,* the presence of art in the bank's foreign branches further served to counter perceptions of American materialism. "The European image of an American bank is one governed by a Texas type with ten-gallon hat and big cigar: the materialistic oil man," reported the branch manager in Paris. "The art involvement of Chase Manhattan destroys this comic image, which is very important in a foreign bank. Art creates a more receptive atmosphere."[94]

Rockefeller himself played an active role in the internationalization of Chase Manhattan's art program. "By the time I retired from Chase I had made some forty-four trips to fifteen countries of Latin America," he later recalled. "Whenever I had a chance I would visit local art galleries to get a feel for the work that was being done, and I bought a number of paintings over the years, sometimes for the bank and sometimes for myself." Rockefeller's collecting was closely tied to his business relationships. In 1965, he gave a work by Sam Francis to Brazilian media magnate Assis Chateaubriand on a visit promoting Latin American free trade, and the following year he had MoMA staff dispatch prints by Jasper Johns and Richard Hamilton that had recently been on

display at the museum as a gift to President Ferdinand Marcos of the Philippines, a client of the bank.[95]

Through Barr and Miller, MoMA was a crucial partner in the bank's strategy. In an early committee meeting, for instance, works from Miller's recent *16 Americans* exhibition were sent directly from the museum to the bank for the committee's consideration.[96] On at least one occasion, Chase Manhattan acquired artworks directly from the museum's collection. "We're going to some of the museums to see if they have duplicate material that we might pick up at a reasonable price," Rockefeller told a journalist in 1960, without any suggestion of impropriety.[97] This proposal was realized in 1965, when the bank was sent a selection of twenty-five prints from the MoMA collection for its consideration. Of these, the bank purchased eight works, including "duplicate material" by Marc Chagall, Henri Toulouse-Lautrec, Giorgio Morandi, Jean Arp, and Pablo Picasso.[98] Such practices were not limited to prints. Rockefeller purchased works for his own collection in the midst of bank art committee meetings, and, on occasion, works from his own collection were presented to the committee as potential purchases.[99] Such practices reveal the extent to which Rockefeller's leadership of Chase Manhattan's art holdings blurred the borders between museum, corporate, and private collecting regardless of their differing regulatory status.

If such activities seem somewhat improper, in retrospect they were ones whose financial implications were, it should be said, of minuscule significance to either the banking giant or Rockefeller himself. One period source does suggest that, for accounting purposes, the bank treated its artworks as "decorations and furnishings, and thus a depreciable asset"—but this claim is at odds with the escalating value of the works in the collection that it so assiduously tracked.[100] Indeed, the bank was so confident of the collection's investment value that it intended to donate paintings to museums as they increased in value.[101] "It is my belief that additional funds will be accumulated through a program for giving certain works of art away to public museums," Miller explained, "thus enabling the Bank to add to its collection."[102] Rockefeller had become the chairman of the MoMA board in 1962, and perhaps Miller anticipated that the museum's collection might itself benefit from the bank's donations. Gottlieb's *The Crest* (1959) seems to be one of the few pictures donated in this way, although it was given to the Whitney rather than MoMA. Certainly, the bank did not wish to lose money on their collection, and the idea that its costs could be self-sustaining must have appealed. Even if many of these works did dramatically increase in value over the decades ahead, their use for Chase Manhattan was never just a matter of making money—something that the bank hardly needed modern art to achieve.[103]

The dominance of abstract art at Chase Manhattan was not, it should also be said, without its internal critics. In a February 1960 meeting, bank president John McCloy pointedly requested that the art committee consider "more historical paintings," and in the March meeting he complained of the "continuing tendency toward the abstract" among the works preselected for the committee.[104] Such resistance was significant

enough to be incorporated into the art program's strategy, which noted that a "complete reliance on contemporary art" would be a "serious mistake, suggesting a narrowness of interest, or, worse, a desire to be merely fashionable."[105] The purchase of less expensive historical prints and works of decorative art superficially helped address such concerns, and in June 1960, interior designer Ward Bennett was dispatched to Europe to acquire more material of this type. Dorothy Miller carefully limited the scope of Bennett's acquisitions. When Miller asked Stefan Munsing, the cultural officer at the American Embassy in London, to assist Bennett's visit, she requested that he "steer him to the decent galleries of the artists themselves who are not doing abstract work."[106] Demarcating abstraction from the historical and decorative artworks understood as part of the bank's décor rather than art collection, Miller's instructions sought to ensure that high modernism remained the responsibility of the art committee on which she herself sat, and further reinforced New York as its proper marketplace.

Bennett was himself known for his eclectic style and tolerance for diverse tastes, qualities that made him ideally suited to conduct interviews with the 130 senior staff at the bank to identify items that "would reflect each executive's work area of personal interests."[107] As a result of these interviews, an executive in the legal department was supplied a caricature of judges by Honoré Daumier, while one responsible for the African market received artifacts from that continent. Another in accounting received a decorative abacus.[108] A map of ancient Rome provided a suitably imperial backdrop for an executive in charge of international operations.[109] Such expressions of staff individuality bolstered the promise that "no two offices were alike," adding infinite variation to the thirty fabrics, five types of marble, and 2,400 basic types of furniture, which the bank boasted—as always, calculator in hand—"offered as many as 56,000 possible variations."[110] Accordingly, the company explained, "The art in each of their offices stands as a personal expression of the man [sic] who works in it."[111] The art program benefited from Bennett's efforts at individualization, even if the emphasis on abstraction by Rockefeller's art committee paid little heed to staff preferences.

The question of staff tastes for abstraction does seem to have been a matter of corporate concern. "Every one of these one hundred and sixteen vice-presidents knows very well that David is hipped on this abstract art," records one 1960 article on the collection. "So would you think they'd all belly up to have an abstract expressionist painting to hang on their wall?"[112] According to this source, however, relatively few staff embraced the presence of abstract painting. And yet the bank's publicists still promoted instances to the contrary. *Time* magazine thus reported that "an executive vice president who insisted that all he wanted was a print of the port of New York has—and highly prizes—a fiery black and red abstraction by Jack Youngerman."[113] As a bank representative later boasted, "We've found in interviewing officers that although some may at first express a preference for very traditional art, they often change their opinions and opt for more modern work after they become acquainted with them."[114]

Such efforts stood in stark opposition to the testing regimes that had been derided in William Whyte's *The Organization Man* (1956), a book that had reported that the guidelines of Sears, Roebuck and Company regarded an interest in art among executives as "detrimental to success."[115] The new possibilities for abstract art to be drawn into the field of executive evaluation are vividly captured in a 1962 cover of the *New Yorker* (fig. 50) by illustrator Charles Saxon, which dramatizes the uncertain reaction of an executive to a newly installed fiery abstraction. Two suited aesthetic technocrats, one apparently holding a pad of graph paper, stand ready to assess the response of the executive as an abstract painting arrives in his office.[116] The perspective of the blue-collar workers who install the painting seems irrelevant to the executive's judgment, but as they elevate the object that is meant to elevate him, it also somehow frames and repeats his own skeptical stare. The resemblance of Saxon's cartoon to the widely reproduced images of abstract painting in the offices and corridors of Chase Manhattan is no accident. These images, and the narratives about the bank and its executives that they were used to communicate, represented the most sustained media presentation of modern art in the workplace and the ideals of individual expression and aesthetic leadership that 1960s business would pioneer.

A couple of months before the *New Yorker* illustration, Rockefeller himself had appeared alongside the impression of a Pierre Soulages painting on the cover of *Time* magazine (fig. 51). Here, Henry Koerner's impressionistic handling absorbs a contemplative Rockefeller into a total environment of painterly modernism. The border of red in Soulages's canvas reiterates *Time* magazine's iconic frame, while its reflected image across the arc of the boardroom table, the scene over which Rockefeller presides, stamps its own brand of creative work into the space of the executive. Acknowledging that "few Chase executives try to understand their boss's artistic acquisitions," the magazine's article quotes Rockefeller's defense of modern art as a form of executive stress relief: "They might not mean anything to you now, but if you look at them for three or four days, you will find them very soothing."[117] As Koerner's painting helps suggest, Rockefeller's corporate vision became inseparable from the abstract paintings before which he was so often depicted.

In response to the criticisms of McCloy and others, the art committee did make some concessions to realist painting, selecting canvases by Fairfield Porter and Walter Murch, along with works of veristic surrealism by artists such as Kay Sage and Paul Delvaux. However, such works were mainly modest in scale and price and were rarely installed in prominent locations. As far as more contemporary forms of realism were concerned, isolated works by Robert Indiana and Larry Rivers were the limit of the bank's acceptance of pop. A Jasper Johns print was among the early purchases, though as one of his *Numbers* series, its content presumably aligned with the preoccupations of the banker in whose office it was installed. At the very least, it resonated with the numerical mindset of the bank's art committee. The committee rejected Warhol's

FIGURE 50

*New Yorker,* November 17, 1962, cover. Illustration: Charles Saxon, *New Yorker* © Conde Nast.

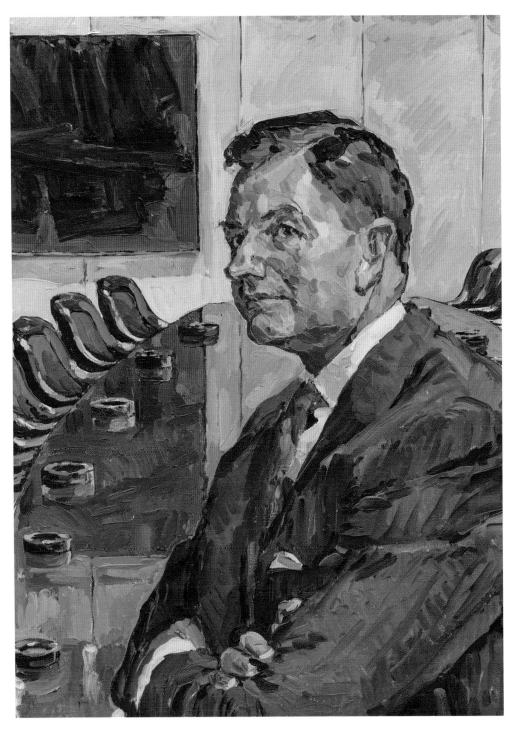

FIGURE 51

Henry Koerner, *David Rockefeller*, 1962. National Portrait Gallery, Smithsonian Institution, Washington, DC. Gift of David Rockefeller. © Henry Koerner Estate.

FIGURE 52

Jason Seley, *Untitled (Triptych)*, 1964. Welded steel, 78 × 78 in. Collection: JPMorgan Chase. Photo: Dorothy Miller Papers, Archives of American Art, Smithsonian Institution.

*Flowers* (1964); Miller scored it 0 out 3 points.[118] As Miller later admitted, the broad exclusion of pop helped to ensure that the collection could remain "an antidote to commercialism."[119]

As much as abstraction humanized Chase Manhattan, then, it also used culture to camouflage, even counteract, the commercial imperatives of banking. These were boundaries that one particular acquisition brought to the fore. In the mid-1960s, the bank acquired a rippling chrome construction by sculptor Jason Seley and installed the work on a prominent wall in a lower-level entry to One Chase Manhattan Plaza (fig. 52). As Chase employees on their lunch hour gathered to inspect the work, "a stir of protest" swept the crowd.[120] Seley's art, they realized, was made from nothing more than scrapped automobile fenders. Rockefeller's colleague George Champion demanded the removal of the work, and the episode became a symbol for the underlying tensions between the bank's two senior executives.[121] Perhaps it was the banality

of Seley's material that caused the controversy, or simply the fact that its abstraction was suddenly revealed to be little more than junk. Some might even have understood the work as a corrosive critique of consumer waste and recognized its incongruity in the foyer of a bank so closely connected to the easy credit that drove the same. Where the bank's art collection usually deployed modernism to smooth over the tensions between culture and commerce, Seley's work brought them into high relief and did so in a public foyer of the bank's headquarters. These were tensions that would only become more fraught by the end of the decade.

## FIGURING THE PUBLIC

Chase Manhattan also sought to embody its corporate image on the plaza of its new downtown headquarters through a monumental sculpture commission. While the tensions between human values and spatial efficiency that characterized the bank's use of art inside the building were mainly balanced across the collection as a whole, this proved more challenging to achieve within a single work of art. Over some fifteen years, the bank and its art committee considered more than a dozen proposals from major American and international sculptors for the site before finally committing to Jean Dubuffet's *Groupe de quatre arbres* (1972) (fig. 53). This final section of the chapter considers how this long-delayed commission negotiated the requirements of Chase Manhattan's corporate image, moderating the alienating effects of the high-rise office while navigating the complex social entanglements of the corporation at the end of the 1960s.

It is useful here to briefly outline the context for the construction of One Chase Manhattan Plaza. Following the merger of Chase National with the Bank of Manhattan in 1955, Rockefeller was charged with planning the bank's new downtown headquarters. Working with real estate mogul William Zeckendorf to assemble several adjoining blocks, Skidmore, Owings & Merrill designed a shimmering skyscraper set on a large open plaza. The design was completed in early 1956, and like the Seagram Building already under construction, it eschewed the stepped "wedding cake" designs by which New York property developers used setbacks to maximize usable space within the zoning code. Instead, the plan took advantage of an obscure planning loophole that allowed buildings that occupied no more than a quarter of the site to be built to an unlimited height.[122] To make this possible, the city planning commission gave unprecedented approval for closure of the stretch of Cedar Street between William and Nassau streets to be absorbed into the bank's "superblock" in return for land that would widen the surrounding sidewalks. Such an arrangement pointed the way forward to the 1961 New York Zoning Resolution, the new planning code that would allow increased building heights in exchange for the provision of public space and, in so doing, forever transform the New York City streetscape.[123] One Chase Manhattan Plaza was, as architectural critic Paul Goldberger would later explain, "the box all the others came in."[124]

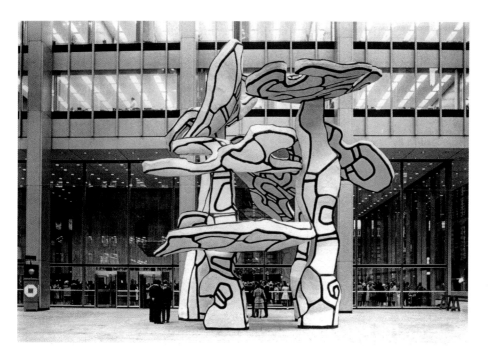

FIGURE 53

Jean Dubuffet, *Groupe de quatre arbres,* 1969–72. One Chase Manhattan Bank Plaza. © 2020 Artists Rights Society (ARS), New York / ADAGP, Paris.

Public art was one way to demonstrate the "public-ness" of the building's plaza used to justify the increased building height, and this was a claim that MoMA would help strengthen. For a 1957 exhibition of corporate architecture, curator Arthur Drexler exhibited the bank's architectural model to showcase the "trees and sculpture" that would make the site a "pleasant oasis in the urban canyon."[125] Chase Manhattan's plaza thus served as a microcosm of the broader promises of urban renewal. "The objective of the bank is not only to provide ample space for the bank's present needs and future expansion," the company explained, "but also to benefit downtown New York and the city as a whole."[126] In 1958, Rockefeller had spearheaded the creation of the Downtown-Lower Manhattan Association, a group of corporate and real estate interests seeking to revitalize the area. As a centerpiece for this initiative, Chase Manhattan's new headquarters helped ignite the vast construction program that would transform Lower Manhattan throughout the 1960s, in large part, thanks to the financing offered by the bank itself.[127]

Isamu Noguchi was the first artist to contribute to this plan. Hired initially as a consultant to produce a $3,500 study for the site in 1956, Noguchi then received a fee of $15,000 to design a circular garden below the plaza.[128] When the plaza finally opened in 1964, Noguchi's design featured an undulating terrain of cobblestones and sculptural

FIGURE 54

Isamu Noguchi, *Sunken Garden*, 1961–64. Photo: Arthur Levine. Courtesy of Levine Family. Source: Museum of the City of New York. © 2020 The Isamu Noguchi Foundation and Garden Museum, New York / Artists Rights Society (ARS), New York.

rocks recessed into a circular well (fig. 54). This may well have provided "meditation space in the midst of urban frenzy," but it also served the more practical goal of providing light to the enormous basement floors that ran under the plaza.[129] As Nicholas Machida has rightly observed, Noguchi's sunken garden "implicated art in the logic of zoning."[130] The effort to commission a monumental sculpture for the southeast corner of the plaza was, by contrast, more closely tied to the requirements of corporate image. Indeed, the relationship between the logo and this sculpture was long-standing. As design firm Chermayeff and Geismar had begun to develop the bank's new logo in 1959, executives considered their possible relationship. "The company had recently commissioned sculptures for its new headquarters," designer Tom Geismar recalls. "Perhaps, one of the executives proposed, one of these sculptures could form the base of the corporate mark." Geismar may well have ignored the suggestion, but it is one that helps indicate the extent of the symbolic burden pinned on this "thematic sculpture," a turn of phrase through which the bank further reiterated such ambitions.[131]

All of this might help explain why the bank rejected Alexander Calder's first proposal for the site, the welded sheet-bronze *Three Legged Beastie* (1959) (fig. 55). Calder's angled geometries were to be included in the exhibition of the bank's collection at the

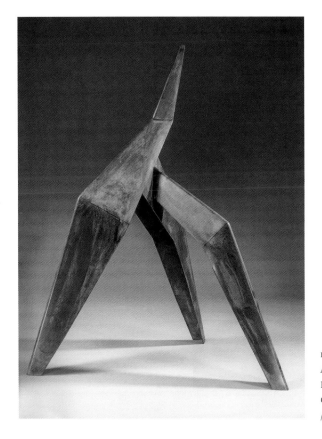

Albright Art Gallery in September 1960, but the work was pulled from the selection at the last minute. "We were a bit premature in showing you the Calder stabile study in bronze. . . . Until this piece is fully discussed, we do not feel that we can offer the piece for display."[132] Given that Geismar recalls that initial resistance to the abstraction of his own logo design prompted executives to propose that the planned artwork might provide a more "figurative" solution, it seems likely that the competing proposal of Alberto Giacometti had emerged as the bank's preferred choice.[133] Bunshaft had sent a model of the site to Giacometti in 1956, before Calder was engaged to produce his proposal, and had followed up with a visit to the artist's studio in January 1957.[134] In his *Projet pour la Chase Manhattan Plaza*, Giacometti suggested a group of three different figures: one walking man, one standing woman, and one head (fig. 56). It is not clear if Giacometti presented these three miniscule gilded bronzes (the tallest is just four inches high, including its base) to the New York committee, but their uniquely small size does suggest that they were intended for a scale model, able to be moved around the miniature mock-up like chess pieces.

The very idea of these figural forms rising from massive blocks of gold on the forecourt of New York's richest bank provides a startling contrast to Giacometti's now

firm alignment with the imagery of postwar alienation. For a time Giacometti lost interest in the project, and some art historians have interpreted his inability to complete the project to confirm his art's incompatibility with the corporate context.[135] But when he was brought to New York for the first time to see his MoMA retrospective in 1965, his interest in the Chase Manhattan project was, in fact, reignited.[136] The account of James Lord, a friend who accompanied the artist to the site, vividly captures this enthusiasm:

> In the taxi he wanted to make a detour to see the Chase Manhattan Bank plaza. . . . He was instantly excited by the problem of creating a sculpture powerful enough to dominate without being effaced by the enormous mass. He strode the space in all directions, researching the best space for such a sculpture. The more he gazed at that wide empty space in front of the building, the more excited he became. That same night, at midnight, he insisted on returning to the Chase Manhattan Bank Plaza, with his wife Annette, and a friend; for one hour, in the cold deserted plaza, he examined the diverse positions and proportions that the sculpture should have, demanding of his friend that he remain immobile here and there to judge the effect.[137]

Striding back and forth—just like, one imagines, his gaunt sculptural figures—Giacometti reportedly returned to the site several times, even using "poles and measuring devices" to judge the proper height for the work. This sustained spatial reckoning led Giacometti to conclude, according to another account, that the plaza called for a sculpture about twenty-six feet in height.[138] Giacometti died before his proposal could progress any further, but to picture his figures at this scale on the forecourt of Chase Manhattan not only complicates conventional art historical understandings of his practice but helps confirm the connections between the bank's corporate image and the goals of humanist modernism, yoking this artist's universalizing imagination to the equivalently expansive ambitions of a mass market brand.

Over the decade or so that the bank and its art committee struggled to identify a viable sculpture for the plaza, and as many of the world's most prominent sculptors produced maquettes engaging with the bank's site—including several rounds of concepts developed by Calder and Henry Moore, and multiple proposals from Isamu Noguchi, William Zorach, Dmitri Hadzi, and Francesco Somaini—several key problems emerged.[139] The bank was committed, it seems, to securing a famous sculptor for the site and appears to have entered into discussions with less prominent figures with limited enthusiasm. Big-name brands called for big-name artists. Tensions between abstraction and figuration that the bank only tenuously balanced across its collection as a whole became more fraught when the bank was faced with the challenge of commissioning a single representative sculpture. The desire for a work that would humanize the severe geometry of modernist architecture favored a work that used more organic forms, and whose color would be legible against its glass and aluminum facade. Finally, it was understood that the work needed to hold its own against the monumental glass and aluminum curtain wall of the building and somehow also relate to the human scale that the plaza was supposedly designed to provide.

The latter challenge became increasingly tricky as the public value of urban plazas, once considered so self-evident, began to be called into question. In *The Life and Death of Great American Cities* (1961), Jane Jacobs had damned the redevelopment of urban space into regulated "super-blocks and park promenades, wiping away all nonconforming uses, transforming it to an ideal of order and gentility so simple it could be engraved on the head of a pin."[140] Even modernist architects began to admit that planning had failed to address "human scale" and "person to person" interaction, laying particular blame on the "leftover voids between gigantic boxes, where sparsely sprinkled adults and children are equally ill at ease."[141] As windswept urban plazas began to look less and less like expressions of corporate social commitment, "public" sculpture acquired even greater significance in the effort to animate such voids.

As if these challenges were not enough, the bank's art committee still had to suggest sculptors for other Chase Manhattan branches. For the forecourt of a new Skidmore, Owings & Merrill–designed branch in San Juan, Puerto Rico, for instance, they again struggled to suggest an appropriate artist. After considering works by abstract

Opening of One Chase Manhattan Plaza, 1964. Photo: Herman Hiller. LC-2016652069. New York World Telegram and Sun Photograph Collection, Prints and Photographs Division, Library of Congress.

sculptors including Clement Meadmore, Harry Bertoia, Richard Stankiewicz, and others (the kind of "straight-edge" sculptors that Barr ruled out for the New York commission), the committee dodged the problem entirely.[142] "It had originally been planned to use a large outdoor sculpture work at Hato Ray," record the minutes from a May 1969 meeting. "Mr. Bunshaft, however, suggested the use of a black cube with the bank symbol on four sides, and the Committee approved this suggestion."[143] At One Chase Manhattan Plaza, a giant logo also served as a kind of aesthetic placeholder for the unrealized sculpture, its bold geometry counterbalancing Noguchi's circular void (fig. 57). Art historian Amanda Douberley has suggested that abstract sculpture became, in the 1960s, "an overt symbol of the corporation, much like a logo or a trademark," and such connections further confirm that logos could indeed serve as art's cheaper and more easily managed substitute—although, and especially given the presence of other commercial tenants in the Chase Manhattan building, one that was ultimately unable to contain the more open-ended symbolism that an ostensibly autonomous work of public sculpture could provide.[144]

In January 1968, having ultimately decided against a second proposal from Henry Moore, Rockefeller wrote to Miller that the bank was "again in need of a sculptor and a sculpture."[145] Once again, the answer came from MoMA, whose forthcoming Jean Dubuffet retrospective included new proposals for monumental sculptures. Stripped of the corrosive surfaces of *art brut,* Dubuffet's recent works were whimsical linear

abstractions in mainly black on white, more like the ludic doodles of a dreaming office worker than gritty urban graffiti.[146] After some years of occasionally fraught negotiations, the bank finally announced Dubuffet's commission in late 1970.[147] The satisfaction with the sculpture it had so uncompromisingly defined seems to have reflected more a faith in its suitability for the site than an interest in its inherent sculptural qualities. "This work will harmonize with the scale of the building and offer a fanciful contrast to the severe lines of the surrounding environment," Rockefeller explained at a press event that displayed the maquette before a scale backdrop of the building (fig. 58).[148] Its open form cultivated relations between skyscraper, sculpture, and the people that interacted with both. "One of the most important qualities of this sculpture is that people may walk through and investigate the work, rather than simply view it from a distance," explained Bunshaft of the work.[149] Tellingly, the work bears more than a passing resemblance to the tiny mushroom-shaped sculptural placeholders that were used on Skidmore, Owings & Merrill's 1959 model of the building (fig. 59).[150] In its scale, color, shape, composition, and subject matter, Dubuffet's work delivered forms that the bank's art committee had been trying to realize for more than a decade.

Chase Manhattan had promised "trees and sculpture" for the plaza, and Dubuffet effectively provided both at once. The sense that his design, like a gnarled plant able to withstand any kind of pruning, could be cut or extended without compromising its formal logic appeared to offer a flexibility that the proposals of other sculptors lacked. This sense of variable form had practical ramifications too, allowing the prefabricated sections of the monument to be shipped across the Atlantic and put back together, just like the jigsaw puzzle it so resembled. If *Groupe de quatre arbres* provided the vegetation that critics of corporate space alleged it sapped, its forms also provided a more fundamental image of growth itself. To this end, the sculpture might direct our imagination to organic processes, but it ultimately provides their synthetic surrogate instead, rendered cheerfully familiar, even graspable, by the artist's plasticine shapes and cartoonish outlines. Installed as the World Trade Center neared completion, in the heart of the financial district that Rockefeller's initiatives had so fundamentally transformed, Dubuffet's sculpture provided an eccentric contrast to the skyscraper's gridded rationality, and a kind of delirious fantasy of never-ending growth, gleefully unconstrained by the laws of nature.

The artist himself would confirm the work's relation to the self-image of finance capitalism. In *Chase Manhattan News*, the company's internal magazine, a cable from Dubuffet was quoted as evidence of his support of the bank's goals: "There is no other place I would have found more desirable than the impressive Chase plaza to locate this monument. . . . It is in such a place that a manifestation of the spirit has its greatest effect; an affirmation of its special quantities, its animation, its power."[151] Brought to New York for the work's unveiling in October 1972 (fig. 60), Dubuffet further expressed his support for the business of his patron. "I could not have hoped for a place better

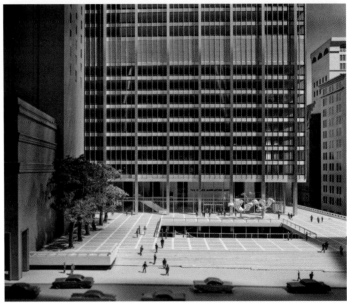

suited to this monument, austerely intellectual in concept, than the plaza where it stands today, a site richly distinguished by the high intensity activities which take place here," he explained. "This plaza, and the prodigious buildings which rise above and surround it, are the dramatic illustrations of an extraordinary celebration of reason, logic and calculation."[152] Dubuffet cannot but have been aware of the contradiction between such values and his famously antiestablishment attitudes. Taming the wilder embrace of spontaneity and mental instability that had characterized his earlier works, *Groupe de quatre arbres* stood as a kind of corporate allegory for the feverishly "high intensity activities" by which the bank and its workforce cultivated the unrestrained growth of American capitalism.[153]

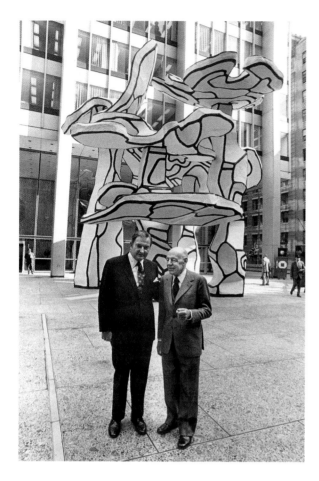

For critic Harold Rosenberg, the Chase Manhattan commission necessarily toppled the "myth of Dubuffet's radicalism," anticultural claims evacuated "in the embrace of one of the world's largest banks."[154] But what of Giacometti, or the other sculptors that sought to secure the commission, or indeed the art inside the building? To what extent should this context define these works? And how should an engagement with one patron define an artist's broader practice? What is essential, I think, is to recognize the unavoidability of such accommodations to the motives and meanings produced by corporate patronage. To cast Dubuffet's work as a kind of "revolutionary pantomime," as Rosenberg puts it, is necessarily to also confront this posture to be more fundamental to much of the art of the 1960s, even as it grappled with contradictory political drives.[155] The eventuality of their collision was one that poet Randall Jarrell had, with extraordinarily specific foresight, all but predicted. "If we have the patience (or are given the opportunity) to wait until the West has declined a little longer," he wrote in a 1957 essay, "we shall all see the advertisements of Merrill Lynch, Pierce, Fenner, & Smith illustrated by Jean Dubuffet."[156]

The apparent contradiction of a self-professed antiestablishment rebel collaborating with the epitome of corporate capitalism echoed tensions playing out within a much larger cultural field. By the mid-1960s, Chase Manhattan's headquarters were the focus for mounting political friction concerning the social responsibilities of the corporation. Its plaza had been the site for several protests, some by the Students for a Democratic Society and others against the bank's financial stake in apartheid South Africa.[157] Recruiters from Chase Manhattan faced protests when they visited university campuses, and branches in Europe and South America had been the target of anti-American bombings.[158] In late 1969, protesters who "blamed large U.S. corporations for the war in Vietnam" set off a bomb one floor below Rockefeller's office in the Chase Manhattan headquarters. (Surveying the debris, the *New York Times* noted that a Georges Braque lithograph "appeared untouched.")[159] The target of such actions was not just the bank but corporate America itself, as the bombers' letter explained:

> The giant corporations of America have now spread themselves all over the world, forcing entire foreign economies into total dependence on American money and goods. Here at home these same corporations have made us into insane consumers, devouring increasing quantities of useless credit cards and household appliances. We work at mindless jobs. Vast machines pollute our air, water and food. Spiro Agnew may be a household word but it is the rarely seen men like David Rockefeller of Chase Manhattan, James Roche of General Motors and Michael Haider of Standard Oil who run the system behind the scenes.[160]

Rockefeller understood the seriousness of these attacks. "It is scarcely an exaggeration to say that right now American business is facing its most severe public disfavor since the 1930s," he told an audience of businessmen in 1971.[161] Artists were entangled in such mounting criticisms—and not just because their works of art had played a role in the preemptive defense of Chase Manhattan's image. In June 1969, the organization Artists Against the Expressway had mobilized against the proposed downtown freeway that threatened New York's downtown loft studios. Protesting the "real estate interests" and "formidable banking influence" behind the project, the invitation was signed by Donald Judd on behalf of more than a dozen artists and dealers.[162] Their meeting was planned for the MoMA auditorium, but "when the museum received word that some of its trustees would be attacked" the museum withdrew permission to use the space.[163] Barnett Newman called for artists to directly lobby Rockefeller, as "a lover of art" as well as "the most vocal advocate of the Expressway," to choose sides. "He should have the opportunity to declare," Newman told the meeting, "whether he has some feeling for the artists who made the art as well as the art."[164] Backing for Newman's suggestion came from some unlikely quarters. MoMA curator Arthur Drexler, who had worked with Chase Manhattan on several projects, offered his support. "I

will join you in any march or demonstration including going to David Rockefeller's
office," he volunteered.[165]

By the end of the decade, Rothko's *White Center* might have maintained its position
at the top of the bank's aesthetic hierarchy, but Rockefeller also sought to engage with
a more diverse range of American art and artists. In August 1969, for example, Rock-
efeller redirected the bank's art committee efforts to organize a benefit sale for Har-
lem's new Studio Museum.[166] Chase Manhattan guaranteed the sale's success by
agreeing to purchase any unsold works for their own collection, safe in the knowledge
that their staff and committee had already vetted them, and indirectly benefiting from
artists' benefit sale pricing.[167] However much this effort sought to "reflect the bank's
interest in fine art and in the problems of New York's minority groups," as the *Wall
Street Journal* reported in January 1970, it also necessarily exposed the challenging
politics of their conjunction.[168] According to Faith Ringgold, Chase Manhattan had
briefly intended to acquire her *Black Light Series #10: Flag for the Moon: Die Nigger*
(1969) (fig. 61) until its representatives realized that the final two words of its title
were contained in the painting's flag design. The racist slur is hidden in plain sight, a

test of the viewer's attentiveness—and one that the practiced speed of the bank's habits of looking evidently failed. "At first glance, it appeared to be an appropriate one for the collection," Ringgold has recalled of the incident, as though the bank's hasty judgment almost saw the painting installed downtown behind the desk of a director of government relations, or a vice president of national expansion.[169]

Chase Manhattan's rejection of this picture, an episode that the artist has retold several times, confirms how her layered, camouflaged polemic disturbed the kind of instantaneous aesthetic impressions upon which the bank's collection was premised, and perhaps even the social equivalents of such judgments. (Even as Rockefeller declared the bank's commitment to minority hiring, he complained of Black and Puerto Rican youth "who have only the vaguest idea what constitutes punctuality and proper attire.")[170] Ringgold's encounter with Chase Manhattan cuts to the core of her painting's trenchant critique of systemic racism disguised beneath the bunting of patriotism, declaring as it does that Black lives were the ultimate cost of putting man on the moon. As America's war on poverty was trumped by the space race, Ringgold was not alone in her perspective. "I can't pay no doctor bill (but whitey's on the moon)" was how poet Gil Scott-Heron put it in his 1970 spoken word track. In Ringgold's painting, this was the message that the bank initially failed to see, and that once they did, they couldn't bear to confront.

Still, Ringgold persuaded her prospective patron to return to her studio to select an alternate work. "Finally, they decided on a painting depicting six faces in varying shades of dark, a subtle statement of black people's multiethnic heritage," Ringgold explains. "Since they didn't know it was titled *Six Shades of Black*, they likened it to the color spectrum of America, and suggested calling it *Untitled*. I renamed it *The American Spectrum* and received $3,000, my first formidable sale."[171] Disclosing the bank's preemptive effort to silence the title of her work, an action rendered so utterly impossible by the textual content of the work they had first selected, Ringgold's revised title provided the ambiguity that her patron required. But her action—especially through its subsequent disclosure—should also be understood to smuggle the politics of her practice into the bank's collection under the guise of its misperceptions.[172]

Many of the artists who provided work for the Studio Museum benefit also attended a black-tie gala to celebrate ten years of the art program, an event at which Gottlieb was photographed chatting with Rockefeller and at which a who's who of the New York art world socialized with a bevy of bank executives. "What made the evening unusual was the presence of so many name painters . . . in the corporate headquarters of a bank," observed the *Washington Post*.[173] Among their ranks was Louise Nevelson, who had also been listed among the sponsors of the Artists Against the Expressway group. But it was reports that Calder, Rivers, Motherwell, and others had "either declined at the last minute or failed to show up" that implied unspoken frictions. Such absences were not the usual stuff of social reporting, and they served to imply more substantive rejections.

This souring of relations was all relatively new. In his 1963 book on the architects Skidmore, Owing & Merrill (SOM), for example, Henry-Russell Hitchcock could credibly claim that "most independent painters today, I suspect, would rather have their pictures hung in an SOM executive office than in Wright's Guggenheim Museum."[174] And, even if this represented no more than a tactic to reach modernism's West Fifty-Third Street headquarters, ambitious artists did write to Miller asking to be put forward for the Chase Manhattan collection, no doubt recognizing its fundamental curatorial entanglement with major museum collections.[175] But just as the status of MoMA would appear less stable by the late sixties and early seventies, Chase Manhattan's use of art to communicate its commitment to "human values" no longer seemed quite so harmless. If Dubuffet bore the brunt of this realization, it was a predicament with which many other artists also had to grapple.

# 5

## A PASSPORT FOR PETER STUYVESANT

**I**N OCTOBER 1968, A FEW MONTHS after the strikes and pro-
tests that had brought the city to a standstill, David Rockefeller
arrived in Paris to promote his own vision for the future of
capitalism. Speaking at a financial industry forum, he used his visit
to advocate for "a broad free-trade area among nations that would
agree to phase out industrial tariffs over a period of years." For
Rockefeller, these ambitions extended beyond the liberalization of
trade between Europe and the United States. "I believe that 'Atlan-
tic' should be defined with sufficient geographical elasticity to
embrace Japan, Australia and other nations," he explained. "Over
time it might well embrace all industrial nations."[1] This global
thinking is also evident, around the same time, in the attention he
seems to have paid to the art collection of the Turmac Tobacco
Company, a Dutch cigarette manufacturer. Like the collection at
Chase Manhattan Bank, Turmac's engagement with modern
painting provided a striking case study for Rockefeller's lobbying
work with the recently founded Business Committee for the Arts.

FIGURE 62

View of Turmac Tobacco Company, ca. 1968. Photo: © Paul Huf / Maria Austria Instituut. Color Print,
10½ × 7⁵⁄₁₆ (26.6 × 18.5 cm). Collector Records, 81. The Museum of Modern Art Archives, New York. Digital Image
© The Museum of Modern Art/Licensed by SCALA / Art Resource, NY.

In a way, this initiative was using abstract painting to materialize the free trade future
he was so eager to promote.

Just before Rockefeller left for Europe, he had his assistant return an installation
shot of the collection he had borrowed from MoMA director Bates Lowry (fig. 62).[2] As
this image shows, Turmac's collection hung not in boardrooms or executive offices, as
at Chase Manhattan, but from the broad steel girders of their manufacturing plant. In
the upper right of this photograph, a large pink and red abstraction by British painter
Peter Coviello hovers like a giant eye over the bays of mainly female machine opera-
tors who transformed imported tobacco into rolled cigarettes. In this section, I explore
the early history of this collection to recover its commercial utility for Turmac's labor
relations and brand promotion. Through the collection's touring exhibitions through-
out Europe, and in Canada and Australia, I further examine its role in cultivating the
internationalist image of Peter Stuyvesant, one of several cigarette brands that Tur-
mac licensed and manufactured.

The elevated view of Paul Huf's photographs of the collection, taken from a mezza-
nine of supervisory offices that looked out over the factory floor, rightly alludes to the

Alexander Orlow and commissioned artists at the Turmac Tobacco Company, 1960. Collection Liemers Museum, Zevenaar. Photo: © Paul Huf / Maria Austria Instituut. Featuring Peter Bischof, *Raumproblem mit dem kleinen Kreis* (*Lebensfreude*), 1960. Courtesy Peter Bischof.

dynamics of observation in which these paintings were implicated. The program was in part conceived for its effects on the personnel who would look up at these artworks as they worked—or, perhaps, for the effects of the artworks looking down at them. Huf had documented Turmac's collection from its inception. His photograph of the collection's inauguration in July 1960 shows Turmac director Alexander Orlow alongside the thirteen artists engaged to produce gigantic paintings for the factory (fig. 63). In the background of this Dutch group portrait for an age of mass production, it is an abstract painting by Peter Bischof that dominates, the structure and speed of his giant abstraction as unmistakably modern as the machines above which it hovers. As Turmac's press release described, Bischof's arresting black and white artwork was among those that aimed to eliminate "the greyness and routine that is sometimes prevalent in the daily workplace."[3]

In line with such ambitions, Turmac asked artists to make works responding to the theme of *levensvreugde*—the "joy of life."[4] This was a promise on which press coverage of the collection's unveiling elaborated. The artworks sought "to give more job satisfaction," explained one Rotterdam newspaper.[5] Drawing on the example of William

Morris and other late nineteenth-century models for elevating worker taste, as well as on more recent Productivist and Bauhaus examples, Turmac turned to modernism as something of a motivational strategy. In claiming that the artists had all "visited the factory while it was in operation and were shown where their work would hang before they started their work," Turmac tied abstract art to the factory environment, implying that it was the machinery of industrial civilization itself that inspired these works of modern art.[6]

The initial skepticism of workers and artists alike toward the collection only served to emphasize the foresight of company management. "All this nonsense" was the initial reaction of workers, according to Orlow. "Why spend money on paintings instead of putting it in our pockets?"[7] By his account, the artists were equally unconvinced. "They came with objections: there's so much noise, there are no walls, there's so much dust. . . . For them it was sacrilegious, paintings in a factory," Orlow later remembered. "Take it or leave it," he claims to have told them.[8] Such anecdotes not only sought to emphasize the originality of Orlow's vision but also provided an opportunity to insist that Turmac factories were, in fact, ideal spaces for the display of art. The modern filters and air conditioning that ensured the high quality of the company's products, and the pleasant conditions for its workforce, were the same technologies that they could claim also protected the art collection. As another company publication described of the Zevenaar facility, "Production is so modernized that there is no fear that the large paintings hanging from the ceilings of the factory halls will be damaged by dust and varying temperatures."[9]

Turmac's factory had opened in the midst of postwar reconstruction, concentrating production in the small town of Zevenaar near the German border, where—as a report on worker strikes in the tobacco industry had noted—wages were "significantly lower than in Amsterdam."[10] With new and increasingly automated machinery making increasingly popular American-style filter cigarettes, sales and production increased, and the cost and labor required for each cigarette fell.[11] But with automation and more rigorous divisions of labor came other perks. The company came to pride itself on its positive relations with its mainly female workforce. Along with redecorating lunchrooms and commissioning new uniforms from a leading fashion designer, installing paintings in the factory was part of a wide range of initiatives designed to improve workplace conditions.[12] As the company's head of human relations boasted, the factory experienced little staff turnover, and it was existing staff that recommended the majority of new Turmac job applicants. These facts were held up as proof of the company's success in cultivating positive workforce morale.[13]

Turmac's new art collection was unveiled on July 4, 1960. Prince Bernhard of the Netherlands visited the factory for the occasion. Accompanying Orlow on this royal tour was Paul Rijkens, an officer of Turmac's board of directors and the former president of Unilever, whose interest in the project was ensured by his own significant collection of modern art.[14] As Turmac's staff newsletter records of the prince's visit: "Not

only the art drew his attention. The Prince let himself be thoroughly informed about the manufacture of cigarettes, and he was full of admiration for the speed with which the girls worked. . . . He asked Mr Orlow numerous questions about production methods, the capacity of machines and the like."[15] The prince's visit was efficient too, lasting just twenty minutes, but it was a relationship that the company was sure to formalize. The prince provided further support for the initiative in a 1962 catalogue essay, writing that "the presence of paintings . . . stimulated the latent desire for better understanding of art" and enabled workers "to appreciate the factory atmosphere more."[16] In 1964, such positive relations must have helped secure a more commercial seal of approval in the form of a Royal Warrant, allowing Turmac to apply the prince's coat of arms to its packaging. Further official support for Turmac's initiative was provided at an evening launch event after the prince had left Zevenaar, where a speech by Hendrik Reinink, director-general of the arts and foreign cultural relations in the Ministry of Education, Arts and Sciences, and a key figure in transatlantic cultural relations, called on other companies to follow Turmac's example.[17] As governments around the world grappled with the health realities of cigarette smoking—increasingly understood to represent anything but the "joy of life"—Turmac's cultural activities secured praise for its business in the highest quarters of Dutch officialdom.

By December 1960, Turmac management had begun to try to quantify the benefits of their initiative by commissioning the company's research department to measure the opinions of workers on their art collection. Now held in the collection of the regional museum in Zevenaar, the resulting report assessed the tastes of Turmac staff with the same statistical rigor that the researchers would also have used in surveying the preferences of cigarette consumers. The researchers surveyed a total of 267 employees, issuing white forms to workers on the factory floor and yellow forms to those working in administrative offices.[18] Of surveyed personnel, 86 percent approved of the collection, and 78 percent said that they would be disappointed if the paintings were removed. Such positive ratings were higher still among male and older workers.[19] Turmac held up the results as testimony to the success of the initiative. Anita van Zeist from the packaging department was interviewed to provide further testimony. "We think it's great fun," she told a journalist. "The paintings are a nice break in the factory, and we get to see more than just cigarettes, tobacco and machines."[20]

A closer look at the results of the eighteen-page report suggests that the company was at least as interested in the effect of the paintings on the taste level of its employees as its impact on working conditions. The collected data revealed that 33 percent of workers claimed to have been previously interested in "modern (abstract) paintings," though only 26 percent of employees had ever been to an art exhibition. Some 32 percent of workers reported that they had changed their opinion about modern art since the painting's installation. At the same time, and in contrast to the abstraction of most artworks in the collection, 80 percent admitted that they would rather see the

factory decorated with "realistic representations."[21] Such equivocal responses to the artworks were confirmed by a visiting critic a few years later. "From my own conversations with members of the staff and people at the machines," wrote British critic Charles Spencer in a mildly snooty article for *The Studio*, "it was clear that the more straightforward or colourful paintings were the more popular."[22]

Turmac's statistical evaluation of employee taste should be understood within a broader, burgeoning field of sociological research into the leisure interests of the working class. In France, a team of sociologists from the University of Neuchâtel extended their 1966 study into working-class cultural habits by installing art in local factories. A questionnaire of forty-six questions was completed by a sample of one hundred workers in each factory and was analyzed "by means of punched cards and computers."[23] In the Cortaillod Cable Factory "the choice of non-figurative art" not only reflected its natural fit "in the world of machines" but was prompted by the example of Turmac, with "the encouraging results of the Dutch experiment" in stimulating the "latent desire" for modern art.[24] The latter report also quotes the then-recent research of Pierre Bourdieu and Alain Darbel into French museum visitation, which reported low attendance among agricultural and industrial workers.[25] Bourdieu would go on to use such findings to theorize taste itself as the "legitimation of social difference," but the commercial application of such research came to more prescriptive conclusions.[26] "The language of aesthetics is something that can be taught and learned," their article concluded. "The most important thing is for enterprises to press on patiently, without expecting immediate spectacular results, with work in those branches of culture which fit in best with their type of labour organization and their type of building. . . . *Elites* are to be found in all strata of the population."[27]

As automation required factory workers to acquire different technical skills, a receptiveness to modern art helped, I think, identify those workers most suited to handle new manufacturing technologies. Turmac's own research report described a stark discrepancy between the preferences of workers on the factory floor and those of higher-paid employees in the administrative offices. Among production hall workers, the most favored painting was by French painter Henri Thomas (fig. 64). Like many of the thirteen artists commissioned by the company, his work is little known today. This genre-crossing studio scene is chock full of pictorial anecdote that rewards prolonged exploration: a nude model stands beside an artist at their easel who paints a man on a horse by the sea. The work's layered planar ground and muscular profiles register the distortions of cubism, but the effect is softened by the artist's expressive brushwork, diffused with the lush, painterly color so characteristic of the "Peintres de la Réalité Poétique" movement with which Thomas was associated. By contrast, administrative staff overwhelmingly preferred an abstract work: the geometrical but richly worked tonalism of Swiss-born painter Max Gunther (fig. 65). Like Thomas, Gunther enjoyed modest success in the late 1950s and early 1960s, and David Rockefeller was among those to acquire his suave, shimmering canvases.[28] In his work for

FIGURE 64
Henri Thomas, *Joie de vivre*, 1960.
Oil on canvas, 65 × 52 in. Private
collection.

Turmac, the tiny silhouette of two figures near the center of the picture ensures that his abstraction is yoked to the more familiar sensations of an urban streetscape. Thomas and Gunther's works might be distinguished by their varying degrees of abstraction, but both assemble luminous compositions of planar color animated by intricate details that reward patient looking.

When it came to which work they liked least, both administrative and factory workers agreed: their bête noire was the bold, slashing abstraction of Peter Bischof (fig. 66). Unlike the paintings that the workers preferred, Bischof's mainly black abstraction declares its speed of manufacture, and its swooping motions simulate the rotary machines on the factory floor that enclosed tobacco in tubes of paper, and cigarettes in wrappers of foil. Even the color in the smeared underpainting of this canvas does not contradict the sense that it was made in less than a dozen strokes of a broad brush. Bischof's canvas was repeatedly featured in early publicity photographs. In its elevation above the pictures that their workers preferred, Turmac's preference not only for abstract art but for abstraction able to be perceived in an instant emerges as a

FIGURE 65
Max Günther, *My Enjoyment,* 1960. Oil on canvas, 47 $\frac{1}{5}$ × 71 in. Private collection. Courtesy of the Estate
of Max Günther.

key aspect of the company's preferred visual mode. The authors of the report went
to considerable effort to break down survey statistics by age, gender, and other
demographic factors, but it seems that these analyses were not about satisfying prefer-
ences but were part of a systematic effort to measure and improve the taste of their
workforce.

Turmac's ideology of trickle-down taste making became more explicitly didactic
through a range of other initiatives. Turmac hired Pierre Janssen, Dutch art critic and
television personality, to give a series of talks on modern art that would help explain
the artworks selected for the company's collection.[29] In boasting that its workers
attended such events "after a day's work in the factory," the company also raised the
possibility that art might even encourage staff to stay at work longer. Such motives
were no less relevant when the company would later plan office spaces whose design
would motivate their administrative personnel. Commissioning modernist architect
Hein Salomonson to design the company's new Amsterdam headquarters, Turmac's
brief was for "a building for the people whose daily work will require more than the
mandatory and economically necessary nine to five," ensuring that their staff would
not become "hurried, clock-watching wage earners."[30] Promoting the collection fur-
ther afield, Turmac would collaborate with the European division of the Connecticut-

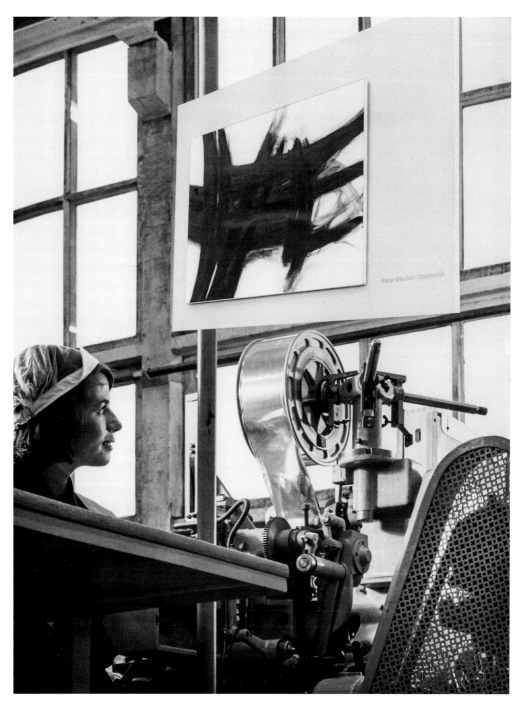

FIGURE 66

Worker at Turmac Tobacco Company, 1966. Photo: © Paul Huf / Maria Austria Instituut. Featuring Peter Bischof,
*Raumproblem mit dem kleinen Kreis* (*Lebensfreude*), 1960. Courtesy Peter Bischof.

based Famous Artists School to conduct a student art competition on the theme of *Arbeidsvreugde* or "job satisfaction."[31] When, later in the decade, they implemented a program for employees to purchase their own artworks in the form of editioned prints, company researchers were pleased to learn that "on visiting workers' homes, company social workers discovered that they were decorating them more tastefully."[32] With the right guidance and oversight, even factory workers could climb the ladder of good taste.

By the time the staff survey was conducted, at least one of the original thirteen paintings had already been removed, a decision that provides specific evidence of Turmac's efforts to direct staff taste toward the abstract. The purged painting was the work of Belgian painter Christiane Willemsen, extraordinary not only for her gender—the only woman in Paul Huf's group portrait of the artists—but also for the neoclassical style of its fresco-like representation of six figures in a pastoral setting, a throwback to a time before machines. Turmac seems to have removed Willemsen's work from display before its probable popularity could be confirmed. Unlike the figurative artworks that many workers seemed to prefer, abstraction promised to provide interest and stimulus to workers long after the more explicit content of a figurative painting would be exhausted. As Orlow explained of his pseudotherapeutic goals in a 1965 interview: "In the beginning the factory [workers] found naturalistic paintings the best, but after a while it appeared that they had had enough. This is understandable: factory work consists in part of automatic actions, there is much time for dreaming. The part of the mind that is squeezed is stimulated by abstract painting. . . . It has all sorts of wonderful effects— it is good for the whole atmosphere."[33] Realism was easy to understand, but like the machines in the factory itself, it was ultimately unfulfilling. "However complicated the operation of a machine may look," Orlow detailed elsewhere, "it soon becomes monotonous routine to a factory worker."[34] And the same was true of art: "Even employees with no particular feeling for non-figurative work would soon be bored forever looking at a quiet still life," he claimed.[35] Abstraction provided what work could not, compensating for its repetitive demands with metaphorical space and time for the imagination: less an opiate for the working class than a stimulant for the cigarette break. "The integration of works of art into industrial life should stimulate men to overcome the atrophying of their sensibility, aid them to discover their inner life, and help them to behave and react more harmoniously with their fellow men and environment, and not as cogs in a complicated machine," Orlow would later explain.[36] Orlow's succinct summary for *Newsweek* paints a more depressing image of factory life. "In situations where workers stare at a picture for eight hours a day," he explained, "it's got to be abstract."[37]

Responding to well-established critiques concerning the alienating psychological effects of the factory, Turmac imagined abstract art to ameliorate the boredom of the modern worker.[38] And yet when Turmac replaced Willemsen's pastoral scene, the company settled on a work that could hardly have been less expressive: a giant neo-

plasticist abstraction in the manner of Mondrian by Josef Ongenae. Where Turmac's first thirteen paintings tended toward gestural rather than geometrical abstraction, the purchase of works such as those by Ongenae marked a shift toward more works with more graphic and hard-edge forms, a shift that seems to have been prompted by the company's experience of displaying art in the factory context and the ocular regime it demanded. As one critic observed of the works in situ, the "setting and the position of hanging made it impossible to include small-scale work or paintings dependent on detailed visibility."[39] Like the production models of the factory itself, Turmac preferred artworks that demanded an engagement defined by speed.

In the case of the red-on-pink geometrical abstraction by Peter Coviello, critic Charles Spencer thought his work "too reticent for so public a setting."[40] Perhaps aware of such criticism, Coviello wrote to his patron to suggest that he produce a new work better suited for its context. As is "necessary in the environment of the factory," he told Orlow of the painting he had in mind, "the colour and image will be more emphatic."[41] Whether by artistic means, or more simply by the criteria of selection, Turmac's artworks were regulated by the requirements of their factory context. The engineering of the factory building sought to limit the number of internal supports, allowing the space to be adaptable to changing machinery and layouts. By installing the paintings in the air, Turmac further ensured that the workflows on the production floor below were not disrupted. Eventually, the company would fuse its concerns for both optical and spatial efficiency by altering the orientation of the suspended panels to be diagonal to the gridded structure of the building (fig. 67), not displaying the paintings according to the linear flows of the factory floor but angling them to ensure that an increased array of pictures was visible from any point within the workspace.

When Willemsen's figurative scene was replaced by the Ongenae abstraction, it is significant that the company chose the work of another Belgian artist. In fact, each of the thirteen artists in the initial selection represented a different European country. As one Dutch newspaper explained at the time of the collection's launch, the painters were all "from the countries of the EEC and the European Free Trade Area."[42] The nationality of the artists in the collection precisely replicated the membership of Europe's trade agreements at the time of their purchase: the "inner six" of the European Economic Community, established in 1957, and the "outer seven" of the European Free Trade Association, established in January 1960.[43] No longer split up into small, protected markets, these new alliances were among the first steps toward European economic integration. The new trade bloc they formed represented Turmac's newly expanded marketplace, a multinational commercial arena that allowed the company access to even the state-run tobacco monopolies in France and Italy. This collection was, then, inextricably linked to the trade liberalization of postwar Europe, its composition complying with corporate efforts to triumph over the restrictions of statehood.

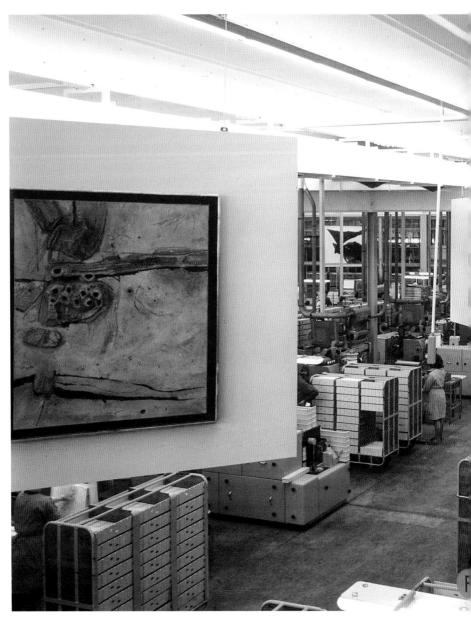

FIGURE 67

View of Turmac Tobacco Company, 1967. Photo: © Loomis Dean / The LIFE Picture Collection / Getty Images.

While Turmac's visual manifestation of European unity certainly supported its own business interests, the makeup of its collection was not wholly self-determined. The 1959–60 annual report of the Foundation for European Culture (Fondation européenne de la culture) describes the central role that this institution played in the formation of the collection. "In July 1960, the Fondation Européenne De La Culture sponsored an exhibition of art for an industrial organisation in the Netherlands," the report records. "The exhibits of art were contributed by artists selected by the Foundation from 13 different countries of Europe . . . purchased and shown in the factory." The project was conceived as a trial with wider applications. "It was hoped that if this scheme proved successful, it might lead to other exhibitions or collections of a similar nature, and thus bring the visual arts to the industrial worker in his factory surroundings."[44]

Though the foundation's involvement would be increasingly omitted from later accounts of the collection, Turmac's announcement press release indicates the involvement of German curator Eduard Trier in an advisory capacity. Trier had contributed as a curator to *Documenta II* the previous year, and while Turmac describes him—alongside graphic designer Wim Crouwel—as providing "direction and guidance" for the hanging of the collection, his billing as an "advisor to the Fondation Européenne" suggests that he was probably involved in the choice of the Turmac works.[45] One of the first selected artists, the Italian abstract painter Achille Perilli, was also included in Trier's *Documenta* selection.[46] Turmac may have sought to maximize the effectiveness of its paintings, but this was a corporate collection assembled by proxy, outsourced from the outset to external experts like an advertising campaign or printing job.

Established in 1954, the Foundation for European Culture's stated aim was to use the arts to support the rebuilding of postwar Europe. Its first president was Robert Schuman, former French prime minister and one of the principal architects of the European Economic Community.[47] In July 1960—the same month in which the Turmac initiative was launched—the Foundation relocated from Geneva to Amsterdam. When Bernhard and Rijkens had visited Turmac for the unveiling of the collection, they were the Foundation's incumbent president and treasurer respectively.[48] Along with David Rockefeller, both were also leading members of the Bilderberg Group, whose private conferences played an important behind-the-scenes role in strategizing European integration.[49] Hendrik Reinink, who had spoken at the evening launch of the Turmac collection, was also a friend of Rijkens and a board member of the Foundation but sat ex officio as the representative of the Council of Europe, whose formation of its own Cultural Fund in 1959 represented a state-backed equivalent to the Foundation's goals to promote intra-European relations.[50]

The Foundation for European Culture served to connect business and art world leaders around a common internationalist agenda. Their 1960 conference, for example, had included speeches by American cultural leaders such as James Johnson Sweeney and August Heckscher. Kenneth Clark delivered an address on artists Marc

Chagall and Oscar Kokoschka, who were attending to receive the Erasmus Prize, which was presented at the event. Unlike the leaders of the Council of Europe's fund, however, those of the Foundation for European Culture were primarily drawn from the corporate world. This who's who of Europe's industrialists included executives from companies like AEG, Bayer, Daimler Benz, Deutsche Bank, Esso, Philips, Mobil, Shell, Unilever, and others. When Prince Bernhard told this group that "European unity is the prime condition for the preservation of our free and independent territories," it thus wasn't just the threat of communism that motivated such beliefs. As Bernhard explained elsewhere: "One thing we need for a free exchange of goods is complete interchangeability of money, a common currency. I'm flat out for that. . . . And this implies a certain political unity. Here comes our greatest difficulty. For the governments of free nations are elected by the people, and if they do something the people don't like they are thrown out. It is difficult to reeducate people who have been brought up on nationalism to the idea of relinquishing part of their sovereignty to a supranational body."[51] Conspicuous visual displays of transcultural unity—such as that demonstrated by the composition of the Turmac collection—were thus a means to reeducate Europeans to support economic integration and the multinational consumer brands it would help proliferate.[52] Through the Foundation, corporations could help circumvent the problems of popular opinion expressed through the democratic process, using an organization that was declaredly free from political influences or government control to lobby for their interests via the sphere of culture. It was in line with such imperatives that it made sense for the innocuously named Foundation for European Culture to support a corporate collection. The art in Turmac's factory served not only as a case study for the integration of art into the lives of European workers to demonstrate corporate benevolence but as a visible expression of the free movement of art across the very boundaries of national sovereignty that many corporations wished to dissolve.

Though the role of art exhibitions in the cultural Cold War is widely understood, corporate involvement in this history has remained less comprehensively explored. As American state agencies faltered in their commitment to modern art as a sign of free expression, it was a mantle that business could profitably take on, using its resources to protect—as Alfred Barr and Nelson Rockefeller had memorably written to *Life* magazine publisher Henry Luce—the values of "artistic free enterprise."[53] As the example of the *Art USA Now* exhibit sent by household goods manufacturer S. C. Johnson and Sons to Japan and then across Europe in the early 1960s helps suggest, the export of American art was as commercial as it was political: its diversity of styles replicating the options of its sponsor's vast brand portfolio, its movement across national borders advancing the benefits of free trade for other kinds of modern products.[54] Large-scale companies like these sought to develop consumer brands that would transcend national barriers, able to move from market to market with minimal variation, and modernism offered a compelling parallel. Even when it had a distinctly American

accent, postwar abstraction could be understood as a global movement, one that could transcend historical borders. Language or nationality posed no barrier to its expressive effects and visual impact. Turmac's activities were similarly underpinned by the antiprotectionist and deregulatory agendas that were so crucial for the success of multinational business.

## IMAGING A GLOBAL BRAND

Turmac had begun manufacturing Peter Stuyvesant cigarettes in 1956, but this was a brand that they licensed, rather than owned.[55] "In this day and age there is no more room for local brands," Orlow explained to one magazine, a commercial principle echoing the mainly homogenous international abstraction materialized by the company's art collection.[56] In about 1960, Turmac stopped making cigarettes under its own name, instead licensing the Peter Stuyvesant name alongside other international brands such as Rothmans, Winfield, Rembrandt, Pall Mall, and St Moritz. In publicity for its art collection, Turmac's factory was occasionally dubbed the "Peter Stuyvesant factory," but that was never the name on the door, and the factory always manufactured multiple brands. It was a business decision that required the company's art collection to eschew the material fact of its corporate ownership and instead assume its identity in the illusory, fictive image of a consumer brand—and a brand, at that, ultimately owned by someone else.

Peter Stuyvesant was expressly conceived to engage an international market. Launched in 1954, it was the creation of South African tobacco magnate Anton Rupert. Turmac licensed the brand through its membership in the International Group of Cigarette factories, an affiliation of twenty six independent cigarette manufacturers around the world. Chaired by Rupert, the group was formed to capitalize on the advantages of bulk tobacco purchasing and to consolidate marketing and research activities for the increasingly global postwar consumer landscape. Orlow's business ties to Rupert might even have informed the decision to use art to promote the Peter Stuyvesant brand.[57] In 1956, Rupert's Rembrandt Tobacco Company had purchased and exhibited, predictably, a collection of nineteen Rembrandt etchings. Rupert's company had also run a competition for young South African artists to produce works on the theme "The Joy of Living." Providing a specific prototype for the theme of Turmac's collection, the same positioning would also align with an early tagline for the Peter Stuyvesant brand itself, *Geniet zoveel meer!* or "Enjoy so much more!"[58]

For both Orlow and Rupert, the habits of art connoisseurship closely corresponded to the business of consumer marketing. As was the case at Philip Morris, the Peter Stuyvesant pack resulted from close aesthetic attention. Recalling the "precise, concentrated experiencing of colour, form and design" that characterized Rupert's viewing of pack designs, one staffer noted that Rupert would "turn it around slowly, scrutinise it from all sides, take it to the window to examine it in a better light. The precise design, lettering, the exact shades of colors were of utmost importance."[59] A report

from the German licensees of the Stuyvesant brand further suggests the attentive looking upon that the sphere of cigarette packaging cultivated:

> You were wise not to use just the surname Stuyvesant but also the first name; it gives the product a far more personal character. White packages are highly problematic, since they can create an impression of coldness if not accompanied by warm colours. That is exactly what you have done here. The gold on the packet, which sometimes looks heavy, is used very subtly. You neatly circumvented the danger of black by using a paler shade that looks more like olive green. The asymmetrical red stripe running halfway round the packet creates a sense of quality and unique distinctiveness that I have never seen in any other packaging. Its asymmetry imparts a dynamic vitality to the packet and a self-assured image, suggesting that this is an established brand and its manufacturer is definitely a company of stature.[60]

That such practices of close looking and description bear some similarity to the practices of connoisseurship should not be a surprise—the same is true of many forms of commercial design—but it is significant that the company could also bring these discursive similarities into practical contact. In 1959, Turmac sued a competing cigarette manufacturer for copying key characteristics of the Peter Stuyvesant brand. Rupert had been scrupulous in registering trademarks internationally, avoiding the problems that plagued multinational companies as they pursued global markets—but local licensees still needed to be on the lookout for infringements. Turmac's case sought to demonstrate the visual similarities between the Peter Stuyvesant package and that of a local imitation launched by British American Tobacco under the name of Van Rensselaer.[61] The company's courtroom strategy centered on the testimony of art historian N.R.A. Vroom—a formalist art historian specializing in Dutch and Flemish still life painting. Vroom used his skills to demonstrate how the competitor's pack design represented an infringement on the "coloring, graphic effects and overall composition" of the Peter Stuyvesant pack.[62]

The Peter Stuyvesant brand was made from more, however, than just its visual signifiers. Its self-consciously internationalist identity drew legitimacy from the name of the seventeenth-century Dutch trader and colonist in what became New York, an evocation of old and new world exchange that fabricated a historical lineage for the jet-set imagery of its advertising campaigns. As Rupert's biographer explains, the brand sought to project "a youthful and dynamic image for a new, young international product at home in the whole world."[63] For the markets of postwar Europe, such values had added resonance. "As an escape from unpleasant wartime memories and the unpleasant past," Rupert explained of his American-style filter product, "Peter Stuyvesant conveyed to young and old the idea of easily achievable affluence and hope beyond their borders."[64] The capacity for Turmac's artworks to foster a satisfied workforce

therefore echoed the promise of the inexpensive luxury it manufactured to deliver social advancement. So too did the cultural aspirations supposedly inculcated by the company's art collection support the consumerist ideology upon which Turmac's continued growth relied. As Rupert would later tell *Time* magazine of such social investments, "Nobody can trade with paupers."[65]

Peter Stuyvesant adopted a global slogan that would memorably embody this promise of rising affluence through global consumerism: "The international passport to smoking pleasure!" The positioning corresponds with the international ambitions of the Peter Stuyvesant Collection itself. To expand its originally European scope, Turmac had turned to another organization, the Dutch Art Foundation (Nederlandse Kunststichting). Directed by Herman Swart, this group had considerable experience leading art-for-business schemes in the Netherlands. It had worked, for example, with paint manufacturer Sikkens to administer a prize for the "synthesis of space and color" awarded to design luminaries such as Gerrit Rietveld, Le Corbusier, and Johannes Itten.[66] The Dutch Art Foundation had also organized exhibits in recreation rooms and canteens for businesses like Philips. By the end of the 1950s, it claimed to have organized some three hundred such projects.[67] The Peter Stuyvesant Collection was part of this broader field of corporate cultural patronage, practices that were as important for progressive companies in the postwar reconstruction of the Netherlands as they were to the image of corporate liberals in the United States.[68]

By the launch of the *Peter Stuyvesant Collection* exhibition at Amsterdam's Stedelijk Museum in 1962, the selection of artworks seems to have become Swart's responsibility—according to one source, with the "assistance" of Stedelijk director Willem Sandberg and American-based British curator and critic Lawrence Alloway.[69] It is not clear just how much assistance the latter two curators provided, but the collection did increasingly feature the work of higher-profile artists. Exhibitions of the collection began to exclude the works of the less well-known painters like Henri Thomas and Max Günther as painters with more prominent art world standing were acquired. Sandberg's influence could certainly be detected in the addition of works by the former CoBrA-affiliated painters that his museum had frequently supported, including Lucebert, Jef Diederen, and Jan Meijer.[70] But it was the new "international" artists that flagged the expanded ambitions of the collection: Inger Sitter (Norway), Shirley Jaffe (USA), Marcelle Ferron (Canada), Christo Coetzee (South Africa), Michael Browne (New Zealand), Bruno Müller (Switzerland), Brett Whiteley (Australia), Peter Royan (Germany), and Bernard Saby (France). The international diversity was, at least in part, an illusion: all were based in Paris or London, and most worked in the dominant *art informel* or *tachisme* styles. For all its internationalism, the Peter Stuyvesant Collection was steadfast in its presentation of a postwar avant-garde that remained—against mounting evidence of its relocation across the Atlantic—headquartered in Europe.

The exhibition catalogue from the *Peter Stuyvesant Collection* exhibition at Amsterdam's Stedelijk Museum (fig. 68), opened in January 1962, is a rich record for the

peter
stuyvesant
collectie

amsterdam
stedelijk
museum

FIGURE 68

*Peter Stuyvesant Collectie,* Stedelijk Museum, Amsterdam, 1962. Cover. Designed by Wim Crouwel.

productive union of modernism and mass production that its patrons wished to promote. Dutch modernist designer and typographer Wim Crouwel designed the publication's cover—its striking red-on-red design suggesting of the work of Josef Albers, whose artworks had been seen at the Stedelijk the previous year, and whose impact on both sixties commercial design and avant-garde practice made his style an especially apt reference point. Here, the modernist square hovering at the top of the design served as a stand-in for the position of the paintings in both the factory and its museum showing. Along with plates illustrating works from the collection, the breadth and caliber of support for the initiative were powerfully demonstrated by the choice of the three writers for the catalogue: art critic Herbert Read, economist Jan Pen, and poet Bert Schierbeek.

Read's suitability for the project was no doubt suggested by his career-long interest in the union of art and industry.[71] Read dutifully praised the Turmac experiment for improving the "satisfactions" offered to the worker in the factory. Modern art was a new kind of faith for a secular world, which turned Turmac's factory into Zevenaar's temple: an "oasis of beauty and visual delight" in which, like "the cathedrals of the middle ages," the "visual arts were assembled and coordinated in a great symphony of colour and form."[72] (According to another source, Orlow had tried to use "psychological" colors in the factory before his foray into abstract art, but it "did not produce the desired results.")[73] But Read was also careful to stipulate that art in the workplace needed to engage the "symbolic or spiritual" sensibilities of the worker and could not be merely "decorative or therapeutic." The union of art and industry, he wrote—in an aside whose Marxist implications were presumably overlooked by his patron—could not be more than "a transition towards a more permanent solution to the problem of alienation."[74]

Read understood then that the collection could serve more programmatic ends, even if he gave Turmac the benefit of the doubt. "I do not suppose that increased efficiency was the motive of the experiment," he wrote. "Perhaps the industrial psychologist can give some rational explanation."[75] The catalogue's following essay by Pen, professor in political economy and theory in public finance at the University of Groningen, pursued Read's suggestion that the Turmac initiative might intersect with the field of industrial psychology. Pen was a Keynesian economist whose areas of expertise included labor relations and income distribution. In his interpretation of the initiative, Pen cited the influence of industrial management theorist Elton Mayo, whose studies earlier in the century had measured how improved factory conditions could boost morale and, in turn, productivity.[76] Underscoring the connections between the collection and the broader strategies of modern personnel management, Pen also compared the initiative to the phenomenon of *Music While You Work*, a British radio program for factory workers that sought to maximize worker efficiency and boost morale.[77] But Pen was careful to differentiate the lofty cultural ambitions of the Peter Stuyvesant Collection from the low tastes promoted by Muzak and its equivalents. "Telemann and Corelli are not usually played," he noted of such motivational soundtracks.[78]

The central focus of Pen's short essay was to contextualize the presence of art in the factory within the shifting economic status of the factory worker. In the factories of the nineteenth century, he explained, "the industrial product was ugly because it was for a market with little buying power."[79] But in the twentieth century, the "improved quality" of commodities now available to the working class had helped "reduce the stratification of society"—or, to use the even more Marxist translation in the company's own English-language adaptation of the text, "reduce class-consciousness."[80] As Pen explained, no longer should mass-produced goods "seem to be inferior to the more expensive product of the artisans."[81] As the manufacturer of mass-produced commodities, and one for whom an image of quality and taste was crucial, Pen's account provided theoretical legitimization for the role of consumer products—no less than art—in elevating the standards of the worker.

The themes of Read's cultural and Pen's socioeconomic perspectives on the collection found further avant-garde legitimacy in the final text of the Stedelijk catalogue: a poem by Dutch experimental poet Bert Schierbeek. Printed on a translucent glassine flysheet protecting the first color plate of the publication—its words hover over the pure forms of Ongerae's De Stijl-style canvas—his experimental syntax upheld the claims of the prose it followed. "Once stood cathedrals / in the lives of men," begins the poem, before going on to describe the offices and factories that saw workers "estranged from each other." Schierbeek's poem concludes by evoking the presence of art in the workplace by which "dream and work are reunited / in the form which the artist gives."[82] Like the collection itself, Schierbeek's poem complied with the discursive requirements of its patron by providing modernist credibility to the idea that abstract art might reenchant the working class.

The design of the Stedelijk Museum exhibition made Turmac's patronage unavoidable. In Wim Crouwel's innovative installation, paintings were hung above eye level, while large-scale Paul Huf photographic panels depicting the factory and its workers were displayed on the floor (fig. 69), an arrangement that sought to echo the experience of viewing the collection in the Zevenaar plant. Many of the printed images used multiple exposure or other treatments to evoke the motion and technology of the factory.[83] One extraordinary aspect of the Stedelijk exhibition not evident in such images was its *musique concrète* soundscape.[84] Produced by French experimental composers Pierre Schaeffer and Philippe Carson, its source recordings were made in the Turmac factory after hours, when the sounds of each machine could be isolated.[85] The resulting composition begins with a steady mechanical rhythm but develops into an increasingly high-tech electronic cacophony. Though its stated aim was to "simulate the working conditions" of the factory, the extant recording is sparse and otherworldly; like the paintings themselves, it substitutes for the repetitions of mechanization something altogether more unpredictable.[86] The almost ten-minute track was played continuously in the exhibition, providing what must have served as an incessant reminder of the collection's industrial origins.

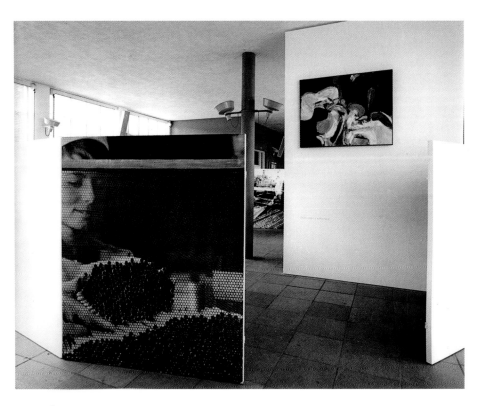

FIGURE 69

Installation of *Peter Stuyvesant Collectie*, Stedelijk Museum, Amsterdam, 1962. Collection Liemers Museum, Zevenaar. Photo: © Paul Huf / Maria Austria Instituut.

As Turmac sought to emphasize the positive impact of the collection on its workers, the company had to justify the fact that the paintings—especially those perceived as the collection highlights—would in fact spend much of their life traveling the world in touring exhibitions. Part of the explanation was that the collection had grown large enough to allow for substitutions. "In the beginning, the factory personnel reacted very strongly to the absence of the collection when the paintings went on tour, experiencing a sense of loss and a vast emptiness within the plant," recounted Crouwel. "However, the collection has grown quickly during the years, and now is large enough that part of it can be away at times."[87] Nevertheless, the importance of emphasizing work satisfaction is well suggested by one company anecdote, which claimed—in what is surely an unmatched example in which industrial strife became the subject for positive corporate public relations—that Turmac's workers once "threatened a shutdown strike because a group of their favorite paintings was removed."[88]

This latter dramatization—even if the subject of some exaggeration—seems to date from the second public exhibition of the collection. In September 1962, eighteen paintings from the collection were provided as the Netherlands' contribution to the

Berlin Industries Fair, a trade event bringing together state and private trade stands from across western Europe and beyond.[89] American companies had sent more than thirty stands showcasing American technology and business. Along with key political leaders in Germany, visitors to the display of paintings from the Turmac factory included collector and philanthropist John D. Rockefeller III and Franklin D. Roosevelt Jr., President Kennedy's undersecretary of commerce. In the shadow of the new Berlin Wall, the Peter Stuyvesant Collection used modern art to articulate the cultural promises of Western freedom in the shop window of the West, demonstrating the possibilities of corporate art patronage to key players of 1960s business.

The global reach of Turmac's art collection and its uses was further ensured by international press coverage. An article in *Time* magazine published for the collection's 1966 showing at the Musée des Arts Décoratifs in Paris described the success of the Turmac initiative, but notably omitted the Peter Stuyvesant brand name unknown to most American readers. *Time* reported that the art collection had been so popular in the company's Zevenaar factory that it had been extended to "two newer Turmac factories at Harderwijk in The Netherlands and near Zurich, Switzerland."[90] British business journal *International Management* quantified the return on investment for a 1967 article: Orlow's "$210,000 (£75,000) collection numbers about 300 works . . . not all masterpieces but they have given color and excitement to an otherwise humdrum—largely automatic—mass production factory." Turmac's art was "accessible to anyone on the payroll," and, the business journal reported, "Staff turnover is very low."[91]

In late 1963, the Peter Stuyvesant Collection was packed into custom crates—branded with a sleek graphic that looks like a disembodied eye enveloped by an abstracted frame—and loaded onto the Dutch ship *Nijkerk* to make its way to Australia, its first destination outside Europe (fig. 70).[92] Archival records concerning this tour provide a vivid insight into its carefully managed publicity program. Negotiations between Rothmans of Pall Mall (Australia) and the host museums were often tense, and archival documents help reconstruct the imperatives for the tour. When the Australian gallery directors collectively decided that Huf's photographic panels of factory workers were "not suitable" for exhibition, Turmac threatened to cancel the tour. "The parent company in Holland regards the collection as a unity," wrote Rothman's Sydney-based publicist George Hawkes, "and is not prepared to send the pictures without the appropriate background."[93] The Australian gallery directors quickly capitulated, and the photographs were incorporated into their displays.[94]

To promote the tour, press agent Hawkes dubbed himself the collection's "Organising Director" for interviews and arranged for prominent industrialists and government representatives to attend each exhibition opening. At the Art Gallery of New South Wales, the collection was launched by industrialist Sir James Kirby, founding chairman of the Manufacturing Industries Advisory Council, while in Newcastle, speeches were delivered by a manager from the Bradford Cotton Mills, one of the region's major factory employers, and union leader Laurie Short, national secretary of the Federated Iron

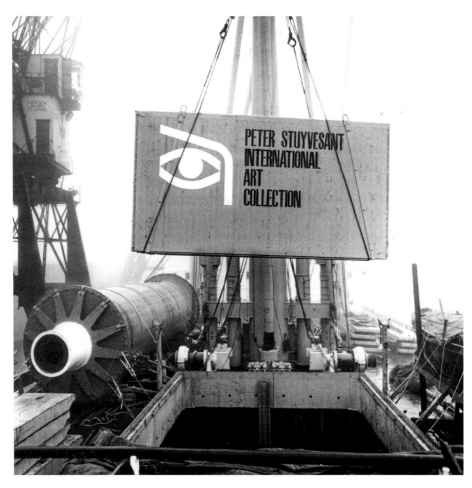

FIGURE 70
Shipping the Peter Stuyvesant International Art Collection, 1963. Collection Liemers Museum, Zevenaar. Photo: © Dolf Kruger / Nederlands Fotomuseum.

Workers Association. In Canberra, the Australian capital, the exhibition brought together both sides of politics, with Arthur Calwell, opposition leader and former union boss, and William McMahon, minister for labor in the conservative Menzies government, both in attendance. McMahon admitted he preferred impressionism to abstraction but still praised the company for "bringing their collection of factory paintings to the attention of the Australian worker."[95]

Peter Stuyvesant's social reputation was undoubtedly boosted by such endorsements, but it was the realization of the brand as the "international passport to smoking pleasure" that Hawkes ensured was the most persistent framework for the reception of the exhibition. Premiering as part of the Adelaide Festival program, the Art Gallery of South Australia used the exhibition to demonstrate the increasingly tran-

snational character of the avant-garde. Abstract painting, the gallery explained in its newsletter, was not just "the international trend in the visual arts today," but a trend that confirmed that it was "inevitable" that "national bias should disappear."[96] In this formulation, the persistence of national style was not evidence of cultural sovereignty but a symptom of artistic underdevelopment, a failure to produce the consistent products demanded by a global market. Commentators like Geoffrey Dutton reinforced such perspectives, happily announcing that "influences now come by jet" (never mind that they had actually arrived by a rather slower boat) and that, as a result, "The regional is abjured."[97] The same values were projected onto evaluations of Australian art: as the *Sydney Morning Herald* reviewer specified, the exhibition provided audiences the opportunity of "assessing by international standards the particular value of local painting."[98] Noting that a picture by the CoBrA group painter Lucebert looked just like works that Sydney painter John Olsen had made six years earlier, the effort of critic Daniel Thomas to defend the local scene only reinforced the desirability of global aesthetic consistency.[99] Motivated by the internationalist ideals of its advertising strategy, the reception of the Peter Stuyvesant Collection served to reinforce the "provincialist bind" by which local artistic variations were to be repudiated in the interests of international standardization.[100]

Just as the transnational composition but resolutely European character of the Peter Stuyvesant Collection was driven by commercial concerns, so too was its touring schedule. Not all licensees wanted to make use of the Turmac collection. The Austrian affiliate was too focused on building its own trademarked brands to promote any others—even ones that the company itself manufactured. "The Austria Tabakwerk AB are in principle opposed to any publicity activities in their own country," where it was not "their own brands concerned," records a 1968 letter.[101] In Britain, Rothmans of Pall Mall also declined the European collection. Whitechapel Art Gallery director Bryan Robertson, who judged the works in the Dutch collection as "not of a very high standard," proposed that the British license holder instead develop their own collection of British art rather than using a "second hand" collection.[102] By the end of the decade, this second "Peter Stuyvesant Collection"—managed separately, and affiliated through to Turmac only because they both existed under Rupert's global umbrella—was such a success that a London critic writing in *Art International* could claim that "a whole chapter of contemporary painting is bound up with the name Peter Stuyvesant."[103]

By the mid-1960s, it is also notable that Peter Stuyvesant advertising would, superficially at least, adopt a painterly style that distinguished its image from the color photography favored for most other cigarette advertising. Take a magazine advertisement for the French market in 1964 (fig. 71). Here, a painting of stylized jet planes on the tarmac shows the modern style by which the headline's promise of "Paris in the morning, New York at noon" is possible. But the picture furthers that message in other ways too. The brand's "international passport to smoking pleasure" tagline appears on

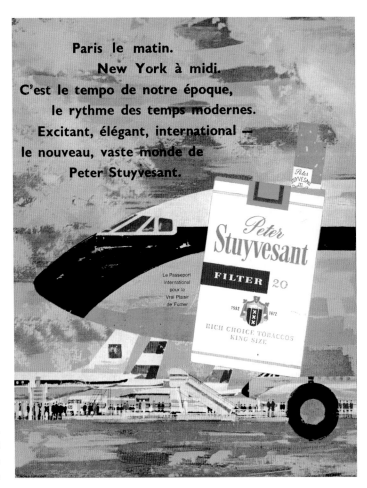

the nose of the aircraft beside the image of the cigarette pack, its crest, copperplate script, and other accoutrements of officialdom serving as a visual substitute for this document. Angled so that it interrupts the dominant horizontal streaks of the illustration, the tilted pack both blocks and replaces the doorway of the jet, confirming the brand's role as the necessary gateway for international travel. All of this is further reinforced by the smears of the palette knife from which the scene is built, deploying the surface effects of modern painting in aid of the brand's promise of chic, globe-trotting modernity.

Turmac mainly avoided the challenges that pop had presented Philip Morris, but its art collection would eventually reincorporate some of its own commercial imagery in other ways. As the company toured Karel Appel's *Torse de femme* (1964) across Australia, it also acquired a small collage (fig. 72) that served as its branded replacement, even souvenir—an artwork that Appel had clearly made with his patron in mind. This typically crazed figure seems to consume and is consumed by Peter Stuyvesant, hold-

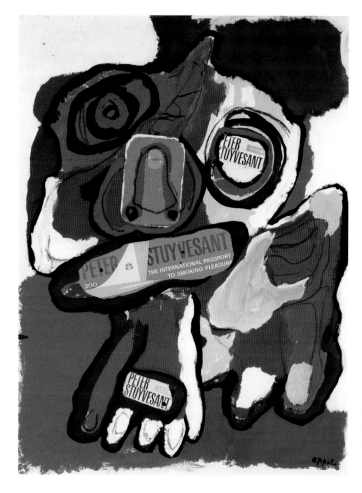

FIGURE 72

Karel Appel, *Dutch Peter Stuyvesant*, 1965. Gouache, colored crayons, and collage on paper, 29¾ × 22 in. Private Collection. © 2020 Karel Appel Foundation / Artists Rights Society (ARS), New York / c/o Pictoright Amsterdam.

ing the brand's name in its hand, mouth, and gaze. The largest collaged element, cut from the side of a cigarette carton, turns the brand name and slogan into the figure's broad, toothy mouth. Used in this way, the swooping, crested tail of the jet stands in for the two-tone filter cigarette itself, a substitution that not only extends the metaphorical link between international jet travel and the pleasures of smoking but further redoubles the giantism of Appel's contorted figure, imagining this gleeful ogre to be puffing on nothing less king-sized than a Boeing 707.

By the time the Peter Stuyvesant Collection toured Canada in 1968, the critics mainly reiterated what were, by then, well-worn tropes. "Undoubtedly some Canadian industrialists will be looking long and hard at the Stuyvesant show as it travels across the country," speculated one newspaper reviewer.[104] Others elaborated on the internationalism of the collection. "The striking thing about the collection is its universality," wrote one critic. "The painters are from all over the world but the language they use is astonishingly related."[105] But eventually the a dissonant voice would be raised in

the chorus of publicist-fed plaudits: "It is limiting to understand the arts as a 'refuge' from daily cares," wrote reviewer Gail Dexter, calling for a more critical alternative:

> The arts shouldn't pacify or reconcile men to a boring and repetitive existence. If anything, it should make them feel restless because it should widen the gap between the realities of the human condition and the imaginative possibilities of the liberated individual. Historically, art has been subversive to the social order because it has revealed the potentialities of freedom—in viewing a work of art, we participate in the unique freedom of the artist to create as he wills. But how can art possibly be a liberating force in the lives of these factory works when it is exhibited in an alien environment, when it is chosen for them by bosses and gallery directors.... Artists, no less than workers, should be concerned at the prospect.[106]

Her attack was thus directed not just at Turmac—and she was one of only a few to distinguish between the exhibition's brand name and the company responsible for it—but also at any artist who would participate in such an endeavor, necessarily under the thrall of the capitalist structures that she thought that art should subvert. "If it's true, as Orlow says, that the Turmac project is intended to educate the workers," she wrote, "then surely the next logical step is to let the workers themselves choose the art that decorates the factory walls."[107] As avant-gardes of the late sixties moved toward an expanded and frequently more socially engaged field of aesthetic practice, Turmac's top-down approach appeared intolerably authoritarian. "Perhaps that's why we must speak so often of the alienation of the artist from his society: his society has become the culturally active 2 percent," Dexter wrote. By 1968, she was not alone in calling for an art unshackled from the interests of multinational corporations.

# MARKETING MATERIALS

**IN 1964, HERBERT READ WOULD ESTIMATE** that some four-fifths of all new sculpture was made from metal, a trend that he understood to correspond with a "civilisation that is largely dependent on metallurgy for its machinery of production and distribution."[1] This is of course true, but postwar metal sculpture was made, not just in the image of modern industry, but also sometimes with the direct support of the companies whose materials it used. Widely publicized by these industrial patrons, these sculptural projects are only the tip of an iceberg of unrealized collaborations—canceled commissions and rejected proposals all shaped by the unfulfilled promise of industrial backing. Artists who participated in this field, I argue, absorbed the material values of the companies that sought their collaboration and were often forced to grapple with the transforming labor requirements of heavy industry in the face of globalization. In this chapter, I recontextualize the rising prominence of steel sculpture against the commercial requirements of three steel companies, highlighting the promotional and ideological entanglements of major works enabled by this support.

My account complicates the dominant framework by which the preference for metal in postwar sculpture has often been understood. Formalist readings have traditionally understood the embrace of welded metal to demonstrate the efforts of modernist sculptors to liberate their art from the figurative baggage of the past. Unlike carved or modeled sculpture, whose surface effects remained inextricably tied to illusionistic, painterly properties, the "raw, discolored surfaces of steel" could produce the purest

possible reflection on those qualities unique to metal sculpture.[2] This materiality allowed modernist sculpture, as Rosalind Krauss explains, to "depict its own autonomy" through the "representation of its own materials or the process of construction."[3]

It is true that postwar sculpture frequently seems absorbed in its own material properties, but this should also be understood to point toward the requirements of some of its most prominent patrons. Uninterrupted by figuration, material became content, and abstract sculpture could focus on those expressive qualities most important for industry: strength, scale and newness. Otherwise undistinguished industrial commodities gained a glamorous and contemporary vehicle to display their properties. Especially when one's products differed little from those of competitors, art and design helped imbue generic materials with a valuable sense of uniqueness and quality. This is not to suggest that such sculptures were without iconographic or symbolic content but rather to insist that it was their material properties that were of primary interest to industrial patrons.

There was also, it should be said, a broader field of sculptural practice that used new materials to engage with industrial marketing of this sort. The installations of Eva Hesse and Tony DeLap at the Owens-Corning-Fiberglas Center, or the sculptural trophies commissioned by the Pennsylvanian abrasives manufacturer Carborundum Company from Bernard Rosenthal, James Rosati, and others would be prime examples from this field.[4] An interest in industrial materials and forms did not, however, guarantee the suitability of sculpture for such contexts. Setting aside the symbolic relations between minimalism and industrial capitalism, artists associated with this movement were largely disconnected from the kind of direct, market-oriented engagements detailed here.[5] The evident unsuitability of minimalist sculpture for corporate promotion not only reflects its once less central position among mainstream 1960s sculptural practice but also suggests the redundancy of its aesthetic engagements with modular repetition and mass production for those businesses that regarded such tactics as primary structures of their own.[6]

In this section of the book, I set aside the industrial resonances of minimalism to focus instead on the direct industrial engagements between modern sculptors and three large-scale steel corporations: Italsider, U.S. Steel, and Kaiser Steel. By way of contrast, I also briefly consider projects conducted at Bethlehem Steel and under the auspices of the industry lobby group the American Iron and Steel Institute. My first and last sections examine well-known works by David Smith and Richard Serra, reinterpreting these sculptures against the complex industrial situations within which they were made. Other sculptures I consider have somewhat fallen from art historical prominence, such as the works of Beverly Pepper, José de Rivera, and Robert Murray, while others still—such as Pablo Picasso's monumental sculpture for Chicago, treated in this section's central chapter—might initially seem marginal to the history of 1960s sculpture. Through the prism of patronage, the rigid boundaries of a sculpture sorted by the borders of nation or artistic movement are revealed, I hope, to share rather more than their conventional histories might reveal.

Across this perhaps unreasonably diverse range of artists, my goal is to recover the engagement of sculptors in a constellation of industrial promotion, political lobbying, and labor relations. Tied to the push for corporate social responsibility and the need of corporations to compensate for the effects of automation and the deskilling of the workplace, these abstract sculptures served clear goals in shaping corporate image: smoothing over worker dissatisfaction, showcasing new products, and projecting an image of innovation and modernity. Artists working with the steel industry had to juggle their relations with both rank-and-file factory workers and the image makers of industrial public relations. As these sculptures engaged with the changing nature of work, they were also inevitably forced to address the globalized market for industrial materials that was transforming its labor requirements in the United States and across the world.

# 6

## MODERNIZING ITALSIDER

**I**N LATE 1963, ITALIAN STEEL manufacturer Italsider published a lavish promotional photobook titled *I colori del ferro*. With multilingual texts and almost one hundred pages of photographs, the book is a kind of global chronicle of steel production: from microscopic images of newly mined ore in Argentina and close-ups of smelting and cooling, to sleek piles of manufactured steel ready for use. Eventually, steel becomes scrap: a cliff of crushed Buicks and Studebakers photographed by American designer George Nelson that completes the productive cycle to return these products to a kind of raw material (fig. 73). Such imported waste was essential to feed the furnaces of the Italian industrial giant, based in a country short on local ore. Scrapped cars were melted into new steel for local use, but also for export within the European Coal and Steel Community and even back again to the United States.[1] Bringing together photographs from across Italy and around the world, the artfully cropped images in *I colori del ferro* might be aestheticized, but their content also repeatedly points toward the interconnected global systems of the postwar steel business.

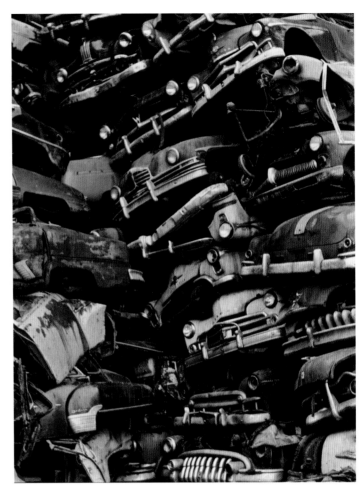

To write the introduction for the book, Italsider commissioned the young critic and philosopher Umberto Eco. "Anyone turning the pages of this book without first having examined the title and read the explanations under each of the reproductions," he wrote, "might well be led to believe that he was looking at a catalogue for an exhibition."[2] Eco's little-known essay continues in this vein. Scrawled jottings on tin are compared to the work of Cy Twombly; mildew and rust to Jean Dubuffet's *art brut*. In a section on the importance of material in modern art, he describes how contemporary sculpture has come to be "centred on the material itself."[3] Writing for Italy's largest steel producer, Eco graciously suggests not only that the material it produced was worthy of artistic consideration but that it was, in fact, already "stronger than art, more courageous and inventive, richer in possibilities."[4]

Eco's hyperbole was not just a matter of elevating the image of steel. Through modern art, Italsider was working to consolidate its own modernization. Formed in 1961 by

a merger of the Ilva and Cornigliano companies, and overseen by the public-backed consortium of industrial corporations in the Institute for Industrial Reconstruction (IRI), Italsider was an important player in Italy's so-called economic miracle, the postwar industrialization bolstered by Marshall Plan assistance from the United States.[5] The new company had rapidly restructured existing operations: old and inefficient facilities were closed, and production was concentrated in larger, specialized plants. Skilled steelworkers were replaced with cheaper labor—often poor rural workers relocated from the South. Unnecessary personnel were dismissed. The upheaval made employee relations a pressing concern for the company. "The main problem, after the merger," one account describes, "was to give the corporation a strong and recognizable character, to create a primarily inner-directed image to build up cohesion and loyalty among staff inherited from its constituents."[6]

Italsider hired artist and designer Eugenio Carmi to coordinate a unified graphic image for the company.[7] Carmi's pervasive aesthetic program followed the avant-garde style pioneered by Italian corporations like Olivetti and also sought, as Carlo Vinti has described, to "import the institutional communication philosophies that came from the United States."[8] According to the Swiss design journal *Graphis*, Carmi's boldly colored abstractions were designed to provide a unified image not only for the customers of Italsider but also for its workers. "There is no doubt," it explained, "that the introduction of so much color and lightness into a traditionally grey field helped not only to rationalize the organisation but to impart a stimulus that is felt by every employee. It led away from a frightening multiplicity and grey formlessness to a lively and cheerful visual order and unity."[9]

Just as Italsider's visual identity followed the strategies favored by American corporations, so too did the management of the company itself. Managing director Gian Lupo Osti and almost one hundred of his staff had, in advance of the merger, been sent to Armco Steel in Ohio to be trained in American industrial practices.[10] International management consultancy Booz, Allen & Hamilton was brought on to help restructure the company into the multidivisional hierarchy increasingly favored by multinational enterprise.[11] Carmi's infinitely variable abstract designs had, in fact, set out to accommodate the "intricate network of connections" of the new company's departments and divisions.[12] The company introduced a "job evaluation" scheme based on American examples in 1961, assessing each role against twelve criteria and replacing previously standardized wages with a hierarchy of twenty-four different pay grades. Incentives based on productivity were introduced and salaries became tied to responsibility and performance. Many workers earned more through such initiatives, but it came at a price: jobs were less varied and union involvement in labor relations was reduced.[13]

Alongside this new aesthetic regime, cultural programs were drawn into the new conglomerate's efforts to combat low morale. As Roberto Tolaini has described, the company "tried to motivate the workforce using 'human relations' . . . providing various kinds of educational, cultural, health, welfare and even spiritual services."[14] Not

only did such activities seek to compensate for an increasingly automated workplace, they also absorbed the traditional social role of the union. Italsider programs included art classes, film clubs, photography competitions, subsidized books and—like the Turmac Tobacco Company—even limited-edition prints, the latter promising that art "would not be limited to a privileged elite."[15] Many activities occurred inside the factories, including a theatrical production by Vittorio Gassman that toured company plants in late 1962.[16] Italsider's attempt to elevate the "cultural background of its employees" aligned with the need to cultivate the "more qualified workforce" of technicians and supervisors required to run a modern steel factory.[17]

Art was thus more than an image builder for Italsider: it was central to the company's labor relations strategy. Eco might have thought that the images of *I colori del ferro* "succeeded in humanizing industrial realities," but it is no coincidence that there is not a worker in sight. In 1962, Italsider had embarked on its most ambitious art scheme of all: hosting ten sculptors from around the world to work in its factories. The resulting sculptures were exhibited in the Umbrian hill town of Spoleto as part of Giovanni Carandente's *Sculture nella città* exhibition.[18] The event occupies an established position in the history of postwar sculpture, but the extent to which its works by Alexander Calder, Beverly Pepper, Lynn Chadwick, and others supported Italsider's sweeping industrial relations program has not been properly recognized. As well as surveying some of its major works, this section will consider how the sculptures that David Smith produced at Italsider—his landmark *Voltri* series—not only engage with the changing nature of steel work but signal Smith's shifting attitudes toward industrial patronage.

Italsider's involvement in the project had been suggested to its curator by Italian sculptor Nino Franchina, who had worked at the Cornigliano plant to produce a sculpture from scrap steel in 1959.[19] Though Carandente's original approach to Carmi was apparently more limited in its initial scope, Italsider decided that the project should—like Franchina's earlier sculpture, and many of its other factory-based cultural activities—enable the direct collaboration of workers with artists in plants throughout Italy.[20] With their formative role in the concept, Carmi and Franchina were among the ten artists to produce work in Italsider factories. Once Carandente began to recruit others for the project, the opportunity to access Italsider's industrial resources became central to his pitch. Carandente offered artists the chance to "work in any of their factories . . . with their workers at your disposition, and materials at your command."[21] As Beverly Pepper later recalled: "We had everything one dreams about—including any help one wanted. You could tack-weld something together, someone else would finish the welding. I told you that I cut a railroad car apart. Well, I wanted to cut it apart. But—phhhht! They cut it apart. While they were cutting, I had ten other workers welding and shearing. The whole thing was unbelievable."[22] This was sculpture with industrial materials, using industrial labor, made on an industrial scale. The international roster of artists confirmed the equivalent realities of postwar industry. "Factories," explained Pepper, "have no nationality."[23]

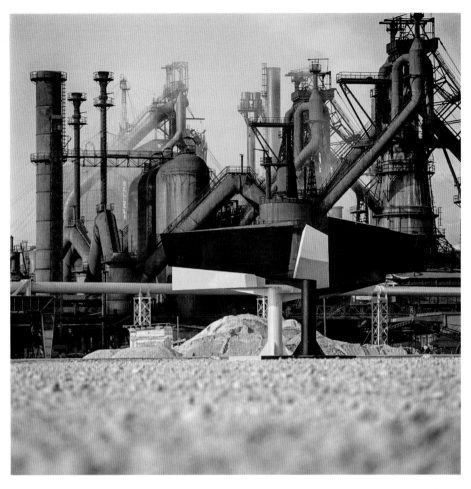

FIGURE 74

Lynn Chadwick, *Two Winged Figures*, 1962. Photo: Ugo Mulas © Ugo Mulas Heirs. All rights reserved. © Estate of Lynn Chadwick / Bridgeman Copyright.

The resulting sculptures represented an often-extreme departure from their makers' previous work. The sculpture of Pietro Consagra, for example, appeared to maintain the improvised immediacy of his other handmade reliefs but involved meticulously detailed drawings to scale up its design.[24] The account of one Italsider worker describes the potential for artistic and industrial modes of production to come into conflict: "They would then ask us to cut and weld without any logic, and they wanted us to work without any measurements and rulers, disregarding all technical guidelines. They would get unnerved if any of us, trying to produce something that was state of the art in our expertise, would smooth the imperfections and polish the edges."[25] In some cases, the logic of industrial production seems to have won out. Among the first works to be sent from Italsider's Cornigliano factory to Spoleto was Chadwick's *Two Winged Figures* (1962) (fig. 74). Its

cantilevered forms are stripped of the bodily referents that define Chadwick's smaller bronzes of the period. As one commentator wrote, they "lost their aggressive attitude inside the structure of what looks like a huge road sign."[26] Photographed beneath the work for a *Fortune* article titled "A Steel Company in the World of Culture," Chadwick and his wife are dwarfed by the giant yellow and black form, its hazard-signal palette perfectly in tune with the cranes and pipes of the surrounding plant. Pepper later claimed of Chadwick's sculpture that he "never repeated it because he had no kinship with it. . . . He was so unaccustomed to the technique that he felt uncomfortable with it. He seemed not to understand what he had done—as though it had nothing to do with him."[27]

Pepper's attention to what she regarded as Chadwick's estrangement from industrial techniques serves as a contrast to her own efforts in this arena. In a repeated anecdote, Pepper revealed that she lied about her ability to weld in order to secure a spot in the Italsider project. "I immediately went out and hired myself out, paid an iron monger to hire me," she has recalled of her effort to learn these skills in the months before the residency.[28] Because this local tradesperson specialized in decorative ironwork, Pepper has suggested that the florid loops of her sculptures echoed the context of her self-made apprenticeship, "since that's the kind of gate the gatemonger was making."[29] As Pepper created a space for herself in what Krauss rightly characterizes as the "international men's club of welders and forgers," and the industrial collaborations by which its gendered separation was reinforced, it is appropriate that Pepper would turn to a gate maker as she sought to gain admission to the field.[30] And yet, as a photograph of Pepper welding one large sculpture helps suggest, this would diminish the expansive ambition of the works she made at Italsider (fig. 75): taut, attenuated ribbons of stainless steel that seem to carve through space as much as they draw in it. Propelled through the air like the sparks of her arc welder, Pepper's forms transformed the domesticated thresholds from which her techniques derived into an explosive vortex with all the high-intensity energy of the Piombino blast furnace.

Alexander Calder's sculpture for the project was, by contrast, somewhat hampered by its arm's-length industrial fabrication. As the most high-profile participant in the initiative, Calder was the only artist not to be present for the construction of his work. Final calculations concerning scale were left to Italsider engineers working from only the vaguest instructions concerning the clearance of the work's central arch. They had been sent Calder's maquette but remade it themselves as a new working model. "When I heard that Italsider was multiplying it by 27," Calder wrote in a letter to Carandente, confirming his remove from the decision, "I was very excited."[31] The result was, as *Time* magazine reported, the "largest piece of modern metal sculpture in the world," and installed outside Spoleto's *ferrovia,* it stood as an unmistakable statement of the triumph of steel in modern society.[32]

The form of *Teodelapio* (fig. 76) betrays, however, Calder's limited oversight of its enlargement. While Calder had asked for the work to be "bolted, not riveted," the Savona shipbuilders instead joined its thick plates (a little thicker than the 3/8-inch

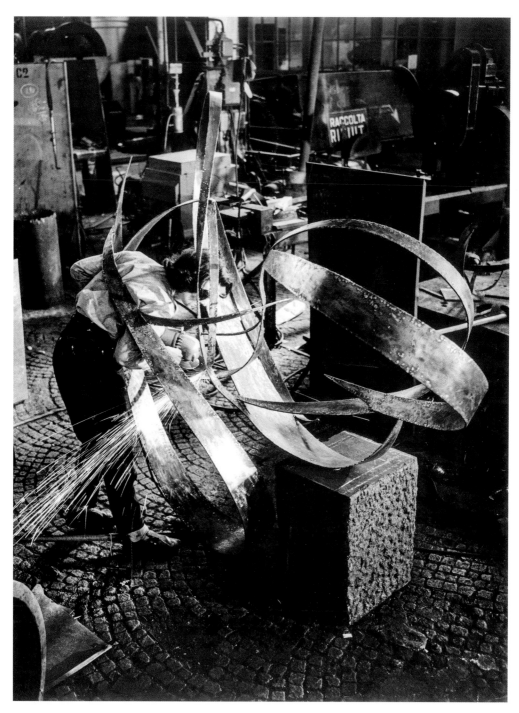

FIGURE 75

Beverly Pepper creating a steel sculpture at Piombino, 1962. Courtesy of Beverly Pepper Studio, Italy. Historical Archive of the City of Piombino, Ivan Tognarini, Photographic Archive of Acciaierie di Piombino, Binder 40, Photo No. 14512. Photo: Studio Lando Civilini, Courtesy of the owner of JSW Steel Italy Piombino S.p.A.

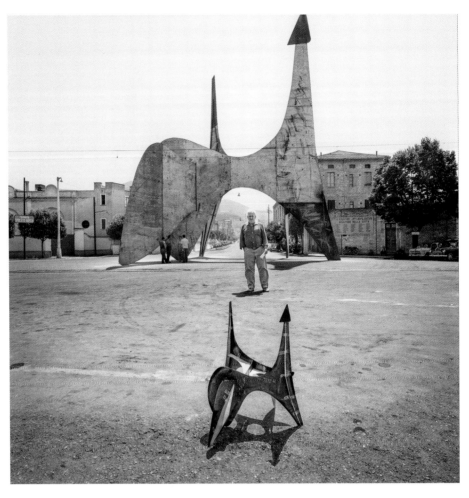

steel plate Calder had specified) with long, flush, and no doubt labor-intensive butt welds, depriving the sculpture of the peppering of fasteners that had punctuated his smaller stabiles since the 1930s. Once the sculpture was assembled in Spoleto, Calder had to rush across the Atlantic to help reinforce its unstable structure. His braces were hurriedly designed with cardboard strips taped to his maquette and installed *in situ* by Italsider workers.[33] These structural elements remain tellingly haphazard: their straight edges seem to ignore the work's curved silhouettes, and their joints appear uncharacteristically slapdash. It is no mistake that much of this is hidden in photographs taken of the work from the vantage point of the station. Their final form is a far cry from the confident skeletal ribs of a stabile such as Calder's *Trois Disques* (1967), a later mining industry commission that would eventually exceed the record scale set by

Italsider's production.[34] *Teodelapio* might have launched Calder's late-career monumental practice, but its form remains inextricably tied to the shipyard techniques according to which it was fabricated.

In short, it is not just the use of steel that marks the involvement of Italsider in these sculptures. Their form, finish, and scale repeatedly tie them to the industrial techniques involved in their production. Through the photographs of Ugo Mulas, these sculptures would quickly become some of the artists' most widely reproduced works.[35] In this form, they functioned as a major stimulus to the rise of monumental steel sculpture around the world. More indirectly, Mulas's vivid images of factory production probably added impetus to the outsourced production modes that would come to define minimalist sculptural practice from the mid-1960s onward. But the significance of these works is not just art historical: blue-collar involvement in the production of these sculptures aligned with the broader strategic goals of their patron. Just as Italsider hoped that the "clean-cut individualism" of its modern design would result in "increased unity and identification amongst its own staff," so did its integration of modern art into the factory experience tie together overlapping personnel and public relations goals.[36] In giving "new expression and interest to the ordinary working material and techniques of the factory employees," these sculptures provided visible validation of the very skills that the company's modernization efforts were placing under threat.[37]

The accounts of other artists do hint at the labor problems against which the project unfolded. Describing her efforts to quickly acquire metalworking skills, Pepper recalls, in one interview, that the steelworkers with whom she collaborated charged her with trying to *rubare il mestiere*—steal their profession. Pepper reclaims the slur with pride, explaining that she "has a great ability to watch someone do something and duplicate it."[38] But it is tempting to imagine the phrase delivered less generously by a steelworker at Italsider's Piombino plant—threatened by a welding woman, for sure, but perhaps also aware that her knotty sculptures of welded steel strip were indeed entangled in the changing realities of industrial work and the politics of such labor transformations. Pepper would also suggest that the reason she was sent to Piombino was that it was imagined that its workforce of "communist men would take better to a woman working in a factory."[39]

It was the work of David Smith that would, however, most directly confront the politics of this context. Smith had intended to make his work while at Italsider in stainless steel, but when he reached the Cornigliano factory near Genoa, he learned that the company "had not yet put into operation its new stainless mill in the South."[40] Smith seems to have planned to continue works in the mode of his *Cubi* series, having directed organizers to see these works as illustrated in the Italian art magazine *Metro* and sending the gravity-defying stainless steel modules of his *Cubi IX* for the Spoleto exhibition in advance.[41] Faced with the factories of Italsider, however, these were flashy geometries that Smith would put aside. Finding the enormous complex of factories noisy and crowded, Smith asked if there was anywhere else to work. Despite the

reservations of Italsider, it was agreed that he could shift to a complex of recently closed-down factories at Voltri. Dating to the mid-nineteenth century, but taken over by Ilva in the 1940s, the small complex of factories, nestled in a narrow valley without space for further expansion, produced small products such as springs, screws, bolts, spikes, and grinding balls. Such low-volume lines added little to Italsider's expansionist strategy, and the complex was soon abandoned. When Smith arrived in May 1962, Voltri—the factories that had been the heart of this small town since the late nineteenth century—had been shut only a few months.

In his account of his time at Voltri, Smith paid considerable attention to the changing technology and labor requirements of his patron. As Smith recognized, the Ilva complex had been "consumed by the automation of Italsider at Cornigliano." The emphasis of Smith's account, and I think also of the sculptures he produced there, is the changing nature of steelwork in the wake of automation: the shift from forging and other manual skills, first to varying levels of mechanization, and then to the high-speed continuous casting facilities installed in Italsider's newer factories. Of the Voltri complex, Smith wrote that its "factories were from the handmade days, the 10–11–12 hour days when working was living. In the new automated plant, the hours are shorter, the man is a machine part."[42] Smith saw the materials he found at Voltri as traces of this change: "The beauties of the forge shop, parts dropped partly forged, cooled now, but stopped in progress—as if the human factor had dissolved and the great dust settled—the found tombs of the twentieth century, from giants to tweezers headed to the open hearth to feed the world's speediest rolls."[43] The phrase describing the scrap metal transformed from "giants to tweezers" is sometimes dropped from this widely quoted passage, but it is important. Alongside the obsolete American cars and appliances sent across the Atlantic to Italy that were depicted in *I colori del ferro,* Italsider was now voraciously consuming its own equipment, transforming the once-productive machinery of the old Ilva factories into nothing more than scrap to feed the roaring Cornigliano furnaces. Smith knew that the salvage crew wanted only the heaviest material but still felt that he "had to hurry" to secure for his artworks the most interesting items or as he put it, the "material with history."[44] The welded steel objects that Smith found would become, sometimes in unaltered form, the basis for his sculptures at Voltri.

The history with which Smith was concerned was that of making steel: his own history of working in American factories, as well as the until-recently productive past of Voltri. Sculptures such as *Voltri XIX* (1962) (fig. 77) represent Smith's most straightforward expression of this history, suggesting as it does the manual work of a blacksmith's bench. Tools droop off the side of the L-shaped tableau, a Dali-like remembrance of times past, the forms of the small-scale forge rendered in its cast-off materials. As Sarah Hamill has described, Smith's incorporation of the remnants of steel production was thus "an act of tribute, a preservation of the trade's social histories and legacies."[45] In a pointed reference to the changing industrial context specific to his locale, the text "Ilva—Pio" can be read in raised lettering on a short fragment of

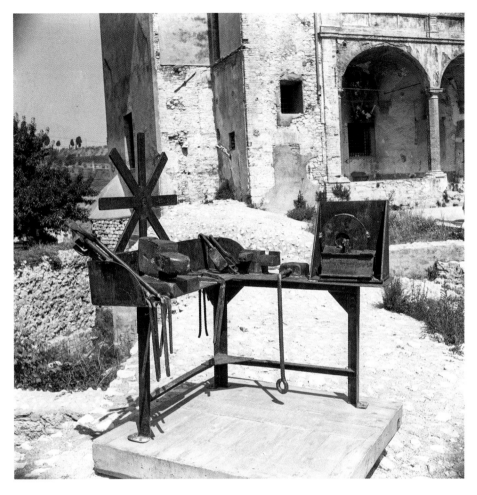

an I-beam in *Voltri XIX*. From safety signs in the workshop to stenciled markings on trains and trolleys, it was the name of the now-defunct Ilva that was omnipresent at Voltri. Disguised only by its inverted placement, the text refers to Ilva's Piombino plant, naming the company made obsolete by its merger into Italsider on the surface of Smith's sculpture.[46]

As this fragment attests, not all of Smith's materials originated in Voltri. In fact, much of the material for his work was scrap brought from the new and more automated facility eight kilometers south. "In the big operating factory at Cornigliano any plate end or found piece I wrote my name on and 'Voltri' was delivered," he recorded, acts of recovery that reversed the flow of scrap being devoured from the shuttered Voltri factory.[47] In one photograph of the artist welding *Voltri XVI*, the word "Save" can

be seen scratched into the arc form that bisects the leg of his modified workbench. In particular, Smith was looking for what he called "clouds." As he explained, "When a billet rolls out to a sheet no two ends are exactly the same, as in the edges of clouds."[48] Sheared off the edges of the rolled steel, many of the Voltri sculptures use these irregular curved forms. Throughout the Voltri series, Smith's "clouds" are signs for the unconstrained power of steel and its stubborn resistance to the geometry of the machine age. Remnants from the giant production lines at Cornigliano, these scraps preserve the messy, volatile realities of rolling steel.

It is not only the two especially dramatic "clouds" in his cart-like *Voltri VI* (1962) (fig. 78) that make this work evoke the rhythms of steel production. With its contradictory undercarriage of a stand and wheels and the push-me-pull-you of the opposing directions of the "clouds" it includes, the variable movement of this work indeed suggests the motion of rolling steel, the "ballet of white-to-red-to black sheet in a fast-rolling mill running back and forth billowing steam with the quenches" that Smith so evocatively described.[49] The formal focus of *Voltri VI* is on that which is missing: the bold zip of space in the center of the sculpture that makes the absent rectangle of rolled plate steel its central subject, the standardized form from which the remaining eccentric edges were pruned. But the work is also balanced on a more manual form of motion, the horizontal element repurposed from a long tong used for transporting forms too big for hand forging to the drop hammer. As Smith described, the cart-like form of *Voltri VI* is for "carrying and being a part of," an evocation of the bodily engagement of the steelworker that reiterates his interest in the experience of manual labor.[50]

Art historian Rosalind Krauss has provided rich accounts of the formal effects of Smith's sculpture but insists that his incorporated industrial fragments "register only as the constituents of pictorial representation."[51] Krauss chooses *Voltri VIII* (1962) (fig. 79) to emphasize how dramatically his work can change shape from different viewing positions. This is true, but it also passes over the technical explanation of the work's main curlicue form offered by Smith himself.[52] "When [a] sheet [of steel] runs back and forth under the rolls [of a steel mill] before it shoots thru quench and to the next rolling reduction, a rarity can happen," he explains, "it can stub like a toe, instead of rolling, fold up like a great stick of gum."[53] Smith's interest in making a sculpture that centered upon this florid shape was closely tied to his imagining of such a material mishap, and the workers whose skills it put to the test. As much as *Voltri VIII* might point to the cubist roots of Smith's sculpture, it also documents the sheer unpredictability of molten steel, preserving an industrial incident that would have temporarily stopped the "world's speediest rolls" at Cornigliano.

For all their abstraction, the connection of Smith's sculptures—both their form and their materials—to the techniques of steel production would have been legible to Italsider workers. In the factory at Voltri (fig. 80), Smith was especially anxious to ensure the "confidence of the workmen" that Italsider had allocated to serve as his assistants.[54] "After welding, moving, sweeping," Smith wrote of his tense first day in the

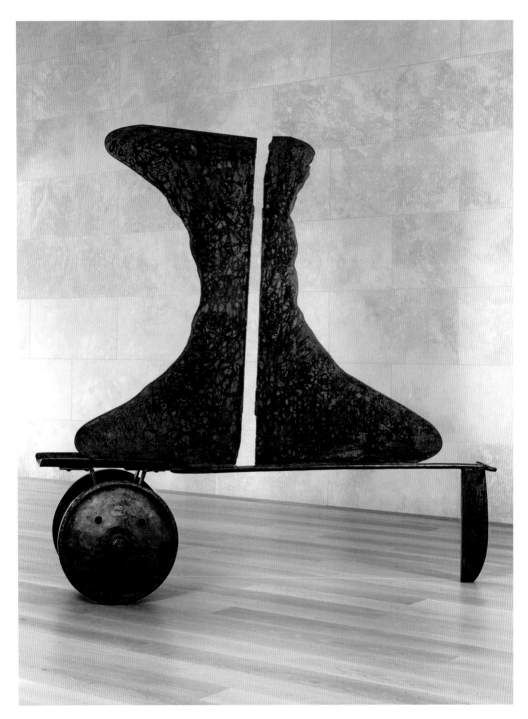

FIGURE 78

David Smith, *Voltri VI*, 1962. Steel, 98⅞ × 102¼ × 24 in. Raymond and Patsy Nasher Collection, Nasher Sculpture Center, Dallas. Photographer: Tom Jenkins. © 2020 The Estate of David Smith / Licensed by VAGA at Artists Rights Society (ARS), NY.

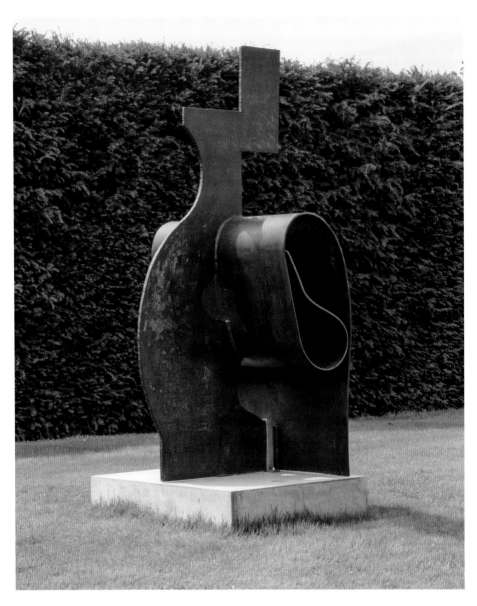

factory, "my collar was O.K."[55] It is clear that these men were important to Smith. He went to some effort to record their names: electrician Cova, welders Vassallo and Ferrando, and, finally, Ruello—Smith's interpreter and (in case Smith's allegiances weren't clear) "white-collar liaison" back to Italsider management.[56] These and other names are captioned on a photograph of a group with whom he is shown sharing

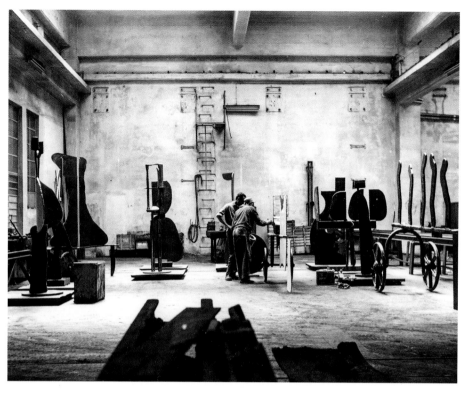

FIGURE 80

Steelworkers in Voltri factory, 1962. Photo: David Smith © 2020 The Estate of David Smith / Licensed by VAGA at Artists Rights Society (ARS), NY.

lunch.[57] It is to these men that the Voltri sculptures are addressed, the "small community within sight of the factory," the factory at which they could no longer work. Smith is specific on dedication in a letter to British critic David Sylvester: "All my large works were called Voltri in honor of the Village (on the coast 15km north of Genoa) of Voltri where the factories were located."[58]

In media coverage of the Italsider project as a whole, the interaction between workers and artists was—for all its initial unfamiliarity—upheld as a picture of harmony. "The workers, at the beginning, were very skeptical [of the artists]. They made us laugh," the steelworker Pasqualino Noli told Italian magazine *L'Europeo*, "because it was so blatant that they didn't know where to start from." Noli's general descriptions of the participating artists' scavenging might well describe Smith's raids on the Cornigliano complex: "They were roaming the warehouses and the courtyards like restless souls. They rummaged through the sawdust. They would pick random sheets and retraced barrels, rusted scraps corroded by acids, odd nuts and bolts, pitiful leftovers.... We thought they were crazy."[59] But as the article goes on to claim, Italsider's workers were eventually converted. "One day, we understood," explained Noli,

"Not just me. Everyone. We understood that there was a specific plan."[60] When *Time* magazine reported the event, it concluded its coverage by quoting another worker transformed by his exposure to modern sculpture. "I think I'll make some sculptures myself," he declared.[61] Such perspectives were repeated in much of the international press coverage. "Part of David Smith's productivity certainly had to do with his beautiful relationship with the workers who, as we all learn, are apt to treat abstract art with diffidence or ridicule," Robert Motherwell told his readers in *Vogue,* flattering their presumably more advanced tastes.[62] As much as such comments might be seen to confirm the resonance of Smith's tribute to steel production, they also conformed with Italsider's discursive requirements—demonstrating the company's success in its elevating the taste of its workers, and using their eventual acceptance of modernism as a surrogate for the consent the company required for its "American model" modernization plan.[63]

Smith's relation to his temporary workforce was also not without contradiction. In an interview with Sylvester two years earlier, Smith had declared that he couldn't "use studio assistants any more than Mondrian could have." His emphasis on the individual creation of the artist was, he claimed, "defensive in a certain way because it's contradictory to this age. We are among the few people left who are making the object from start to finish."[64] As Italsider shifted its own production to piecework and production lines, the labor made available to Smith saw this defense mechanism set aside. His output of twenty-seven sculptures in thirty days was not mass-produced, but it certainly flaunted his own productive capacity, as much as it also echoed the efficiency program of his patron.[65] "I'll do my best to make you and Italsider pleased," Smith had written to Menotti on his own distinctly corporate Terminal Iron Works letterhead.[66] "To see whether I fulfilled their confidence," the artist later wrote to Sylvester, "you must decide by the work."[67]

But could Smith fulfill the confidence of both Italsider and its workers? He certainly understood that the closure of Voltri was part of a broader field of social change. His view on the Italsider context was clearly filtered through his own long-held working-class identity and allied radical commitments; as Alex Potts has summarized, Smith's politics were characterized by an "overt anti-capitalism with a definite Marxist edge" and "emphatic, if very personal, loyalty to what he saw as the basic values of the labor movement."[68] To underscore the political ramifications of Italsider's workforce, Smith noted that the workers were "about equally divided politically between communism and socialism . . . [and] had political ease in association, with no obvious problems in relationship to work."[69] Smith's observations were apposite. As one journalist described in 1961, "The fundamental reason for the growth of the Italian steel industry, as for the Italian economy as a whole, is a political reason. It is simply that nobody can afford to let it fail. Italy has the lowest standard of living, and the strongest Communist Party, in Europe. If it is to be kept on the straight and narrow path, she must boom."[70] For Italian industry, especially operating under the sway of national and

transnational state support, ensuring worker satisfaction was not simply a matter of morale and productivity; it was political.

But for all of Smith's leftist views, the Voltri sculptures were, like those of his peers, unavoidably entangled in the goals of their patron, and it does not seem at all right simply to regard them as any straightforward kind of sculptural resistance to the trauma of postindustrialization. Art historian Anne Wagner has explored how Smith's sculpture serves, more generally, to figure "art's fraught relation to capitalist management of workers and work."[71] His modernism may have been committed to progress at the hands of industry, but it was also deeply ambivalent to its human ramifications. "Smith knew that obsolescence was inevitable," Wagner writes, "but he thought of welded sculpture as both a quintessential product of its moment and a means to preserve and display not a product or commodity but the skilled labor that brought it to be."[72] Wagner's account chimes with the Voltri sculptures. Made against the tumult of industrial change, and composed of its abandoned parts, they do indeed seem to pay tribute to the steelworker. For Wagner, their ambition is ultimately recuperative, a vision of modern sculpture as "a site, maybe even a theater, in which the havoc wrought by industrialization under capitalism could be repaired."[73]

There is no more famous theater for Smith's sculpture than Spoleto's Teatro Romano, the ancient amphitheater where many of the Voltri sculptures were installed for the *Sculpture in the City* exhibition (fig. 81). But here Smith's effort to pay tribute to the industrial past amid its present decline was, I think, set off balance. Decontextualized from the industrial sphere so crucial to their meaning, they were absorbed into the symbolic register of antiquity. Steel carts became chariots, the bodily traces of the steelworker pointed instead to classical statuary.[74] Through the union of ancient and modern, Smith's sculptures were received, not as records of industrial rupture, but instead as evidence of the continuity between old and new. To roughly the same end,

Italsider had made much of the centenary of the Italian Risorgimento in 1961, a historical lineage that positioned postwar industrial expansion as Italy's next Renaissance. The company's magazine had used this context to "reproduce art that glorifies Italy's ancient role in commerce," traditions that spanned "Machiavelli and multichuck lathes, Michelangelo and suspension bridges, Virgil and mechanical ploughs with multiple shares, and Plautus and millions of tons of oxygenated steel."[75] Works of art provided comforting continuities in a time of profound social and technological upheaval. "Even if this country is industrializing, it is not giving up its artistic traditions," the company explained. "Industry is promoting and creating new cultural and artistic events." Trucked to the Umbrian hills, on the IRI-built highway that was quite literally bypassing the town of Voltri as it crossed the valley in a new reinforced concrete flyover, Smith's tribute to the steelworker was no spanner in Italsider's works. Instead, it was a vehicle for the repercussions of industrial automation to be rerouted into the seemingly benign domain of history.

Carandente, who conceived of the setting for Smith's works and was equally keen to emphasize their classical sympathies, also subtly positioned the sculptures as a harmonious resolution for the trauma of modernization. "Italsider's Voltri ironworks did not close for the last time until . . . it had echoed to the blows of its last smith's hammer," he wrote.[76] Smith is Voltri's final smith, and Italsider's workers are invisible. The artist is envisaged, instead, "alone in the Ligurian scrapyard."[77] The same image is presented in the film that Italsider commissioned to document the project, with its sonorous voice-over declaring that Smith's sculptures seemed to be "dark, magical objects from a civilization lost to ancient floods . . . like the chariots of heroes, ghosts and gods, who returned to look at us for an hour from the infinity of time."[78] For Carandente too, workbenches such as *Voltri XIX* "brought tongs and clamps back to life and then flattened them onto the benches, finally inert for all eternity."[79] By Carandente's account, Smith's sculptural intervention functions as a poetic coda for Voltri's closure, a final flicker of production that confirms its consignment to history and ignores the very current trauma of postindustrialization for Italsider's workers in the early 1960s.[80]

Before Smith left Voltri, Italsider agreed to send a crate of leftover steel to his studio at Bolton Landing in upstate New York, an intervention that again reversed the flow of scrap heading the other direction across the Atlantic. This material would become the basis for his Voltri-Bolton sculptures.[81] Smith knew whom to thank for such assistance: he gave artworks to Italsider's designer Eugenio Carmi and its public relations director Carlo Fedeli, the latter dedicated "for much help in everything."[82] Smith also specified that *Voltri II*, which he donated to the city of Spoleto, was a "gift from the artist and Italsider."[83] Given his own engagement with the redundant workforce at Voltri, the way Smith rationalizes the support of his industrial patron is revealing: "I had absolute cooperation of Italsider—for my needs—I had absolute cooperation with the ministry of transport in getting my tons (27 pieces) to Spoleto on short notice—one would have that they like me and my work by their cooperation. . . . In my

own country I've never had such cooperation or appreciation—maybe it takes a socialist turn of the government to do such a generous thing."[84] This quote is from the previously unidentified version of Smith's letter held in the papers of David Sylvester. By the fourth and final page of this letter, Smith had persuaded himself that the Italian government had done what the American government could not: "Such a thing is not possible here—there is no affinity of the government or industry for my work (other artists as well)[.] The Italian government had to know about it with [the] approval Italsider gave it."[85]

A reordered and expanded version of this original letter, held in Smith's archives and dated to 1963, repeats most of this material with only minor variations.[86] But for the published version of this letter that appears in the *Voltron* book—based on the typescript but rewritten by the artist to appear like the handwritten original (complete with crossed out mistakes)—Smith makes several telling changes. He still notes that "one would have thot [*sic*] that my work was known there," but then adds, apparently pondering the limits of his international reputation, that "Venice was the only show I've had in Italy." [87] It is an addition that serves to emphasize Smith's sense that the generous treatment he experienced was prompted not by his artistic fame but by his patron's faith in him. Most significantly, after his determination that the Italian state must have approved of his visit, he adds a further sentence: "I've never known for certain but somewhere I've heard that Italsider is 51% government—one way or another they gave me the privilege."[88] For an artist whose self-identity was forged amid the state patronage of the New Deal, the idea of that 1 percent majority mattered.[89] But Italsider was indistinguishable from the American steel corporations upon which it was substantially modeled, and as the manager of one 1963 trade delegation observed, there were "no clear cut lines between private and public enterprise in Italy."[90] Smith's account avoids the realities of the company's modernization project—whose human impacts he had witnessed firsthand, and which he appears so directly to address in his works. Revising and reinforcing his account to resolve his own ambivalence, Smith rationalizes Italsider's support within his own socialist ideals.

As was the case during his Italsider residency, Smith's belief that his art should or could be "divorced from commercial persuasion" had evidenced its ambiguities for some time.[91] In 1957, Smith was approached to produce a sculpture for the Reynolds Aluminum Company.[92] Smith turned it down, but given that he asked to be considered again for the next year, it was apparently not the commercial nature of the project that was the problem. A month earlier, in fact, Smith had accepted an invitation to deliver the first Alcoa Foundation Lecture, and he may well have understood that another aluminum industry commitment would represent—at least in the eyes of such patrons—a problematic conflict. At around the same time, Smith was also among the modern artists considered by Inland Steel to decorate its new Chicago headquarters.[93] In this case, the competitive repercussions of industrial patronage were not lost on Smith. "As far as U.S. Steel's conservatism goes," he wrote in a 1957 letter referencing

the potential commission, "they cannot very well let a small firm like Inland Steel out taste them."[94]

By the mid-1960s, even the most staid quarters of American industry had developed a taste for abstraction and the possibilities of sculptural objects absorbed by their own material properties. In 1964, the American Iron and Steel Institute (AISI) invited Smith to take part in a $25,000 competitive commission. As the press release announced, Smith, along with José de Rivera, Seymour Lipton, and Theodore Roszak, was asked to design a "sculpture marking the second century of steel in America.[95] Celebrating one hundred years since "the first commercial heat of Bessemer steel flowed from a small convertor in Michigan," proposals were to be judged by a panel including Inland Steel's Leigh Block and Chase Manhattan's David Rockefeller, the latter still on the lookout for possibilities for his own forecourt sculpture.[96] In Smith's archives, his handwritten note on the AISI reminder letter appears to confirm his intention to participate. "Finish Dec 7," he scrawled in large letters on the correspondence, adding "also Photos."[97]

If Smith did submit a proposal for "the symbol of Century II of Steel," his *Construction December II* (1964) (fig. 82) seems a strong candidate.[98] Although the AISI guidelines called for a small model, such a scaled-down execution would not have suited Smith's direct working methods. The latter sculpture does, however, correspond to the seven-foot maximum that the competition stipulated for the final work. The instructions also specified that "any shape or form of steel may be used," and in this work he assembles a veritable trade catalogue of its stock varieties: structural beams, flats, and rods in a wide range of sizes and profiles. Following his own handwritten note, Smith did take the photographs he had intended of the work, his low perspective silhouetting its dynamic form against the sky. These were images important enough for him to have them printed in a larger-than usual format.[99] With its dramatic upward thrusts, Smith's gravity-defying cantilevers achieve the image of strength and optimism to which he would have understood this industry commission to aspire. The unapologetic abstraction of *Construction December II*, stripped of the tools of the manual past, gestured not only toward the future of the steel industry but also toward a new taste for the avant-garde among America's most powerful patrons.

Even if Smith did submit this work to the judges on time, he didn't win the commission. But his apparent interest in producing a sculpture that was intended to tour "steel centers throughout the country" before being finally installed at the Smithsonian Institution remains telling.[100] In January 1965, Smith also seems to have confirmed his interest in reprising the Spoleto experience at the International Sculpture Symposium at California State College Long Beach, this time planned as a collaboration with the resources of Southern Californian industry.[101] In February, US president Lyndon B. Johnson invited Smith to join the new National Council on the Arts. Before his death in May, Smith attended the group's first meeting at the White House, the sole visual artist among a bevy of executives, arts bureaucrats, and cultural

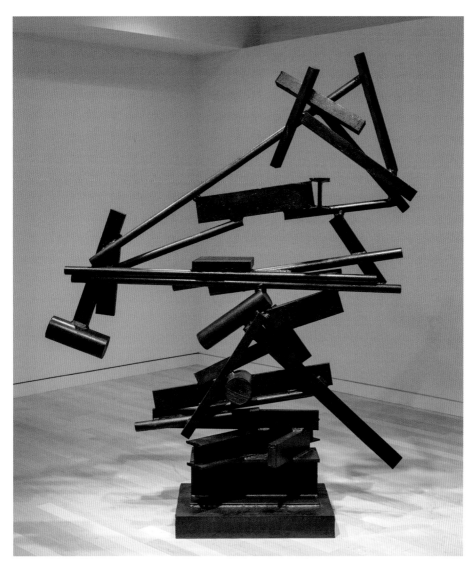

celebrities.[102] If Smith had once, in the words of Potts, "felt increasingly at odds with cultural and political life as it was shaping up in post-war America," such an outlook seems entirely less evident in these final, if incomplete, endeavors.[103] As diverse private and public interests jockeyed to administer American culture in the mid-1960s, and before Vietnam or Watergate eroded the collective faith in the expertise of its managers, Smith seemed ready to put aside old animosities and explore new possibilities of patronage in "the Great Society."

# 7

# THE RUSTING FACE OF U.S. STEEL

**A** GROUP OF STEEL INDUSTRY HEAVYWEIGHTS and arts patrons assembled in the courtyard of the Museum of Modern Art in November 1965 (fig. 83) to listen to a speech by William Paley, the museum's board president and the founder of broadcaster CBS. "Long before the phrase the 'Great Society' became a slogan," he told the audience, "Alfred North Whitehead wrote, 'A great society is a society in which the men of business think greatly of their functions.'" By the mid-1960s, art had emerged as one such function: an important sphere for enlightened businessmen to demonstrate their social commitments as evidence of their contribution to the "Great Society" promised by the progressive policies of President Johnson, a sweeping program of reform across poverty, education, health, urban development, and civil rights. "By this standard," Paley declared to an undoubtedly receptive audience, "the men in the steel industry are charter members of the great society."[1]

The occasion for such optimism was the unveiling of the sculpture chosen by the American Iron and Steel Institute (AISI) to

FIGURE 83

Unveiling of José de Rivera sculpture in courtyard of the Museum of Modern Art, 1965. Photo: George Cserna. Image courtesy of American Iron and Steel Photograph Collection, Hagley Museum and Library, Wilmington, Delaware. George Cserna photographs and papers, 1937–1978, Avery Architectural & Fine Arts Library © The Trustees of Columbia University in the City of New York.

mark the industry's centenary in the United States: a sleek abstraction in stainless steel by José de Rivera (fig. 84). The artist was missing from the launch, and for the AISI press release, prepared by public relations agency Hill and Knowlton, he insisted that "what I make represents nothing but itself."[2] His formal explanation also centered on the materiality of his sculpture but again insisted upon his own artistic agency: "Stainless steel gives me the complete control that I want," he explained.[3] Of course, steel's spin doctors at Hill and Knowlton went somewhat further. "While intended to convey the image of ever-changing opportunities for the American people and for steel's future in the century ahead," they explained of his gleaming sculpture, "it also dramatizes the fluidity and adaptability of stainless steel for countless new uses today."[4] The title of his sculpture was changed from *Construction 73* to *Steel Century Two,* and it was installed on a plinth cast using ingots from over 150 plants across the United States, Canada, and Latin America, samples drawn at midnight to mark the inauguration of steel's second century.[5]

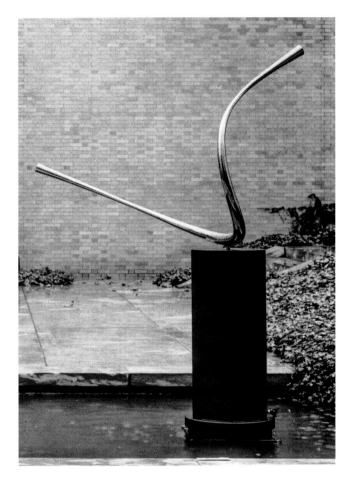

As Paley accepted the sculpture as a gift to the MoMA collection, he signaled to the electricians to start its motor, setting off the eight-and-a-half-foot-high sculpture's glistening vision of unstoppable progress. The sculpture's hidden motor made this future seem inevitable, even perpetual, a rejoinder of sorts to the scrappy mechanics of Jean Tinguely's *Homage to New York* (1960), the kinetic sculpture that had performed its own spluttering self-destruction in the same location six years earlier.[6] L. B. Worthington, the chairman of the AISI and president of U.S. Steel, declared the sculpture a "rallying point" for the second century of steel production in America. "In its very shape and fluid form—seeking, soaring and evolving," he proclaimed, "the sculpture is a reminder to this steel industry and to the public of the challenges ahead and the avenues of progress yet to be explored."[7] Even if de Rivera himself was absent, the form of his kinetic artwork materialized the optimistic spin that its patron required.

The reality faced by the American steel industry was somewhat less bright. Immediately after World War II, the United States produced 57 percent of the world's steel.

By 1960, this had dropped to 26 percent.[8] In 1959, the rallying cry that had most concerned the industry came from striking workers, who ground the sector to a halt in what became the longest strike in American history. This stoppage allowed overseas steel producers to gain a valuable foothold in the domestic market.[9] The American steel industry suffered in the new global market for steel, focused on shareholder profits rather than technological investment as countries with lower labor costs, often strengthened by state support, took advantage of the new and more efficient plants built during postwar reconstruction.[10]

It is no mistake that the launch of de Rivera's sculpture was framed as providing evidence of the steel industry's contribution to Johnson's "Great Society." The AISI was soon to relocate to Washington, where it urgently needed to rebuild government support. In 1962, just days after President Kennedy had negotiated an anti-inflationary pact between big steel and the labor unions, U.S. Steel chief Roger Blough ignored the negotiations and announced price increases. Other manufacturers quickly followed suit. Kennedy was incensed: "My father always told me that all businessmen were sons of bitches but I never believed it until now," he was infamously reported to have exclaimed.[11] As the steel industry sought new protectionist measures to shield its business from foreign competition, the installation of José de Rivera's sculpture at MoMA was part of a multimillion-dollar lobbying campaign by which steel sought to improve its reputation in the corridors of American power.[12]

But it wasn't just steel's tarnished image with the nation's most powerful elites that was the problem: among consumers too it was lagging behind its competitors, seen as a material of the past, of railroads, not jet planes. The need for "a new image" for steel was a priority for the industry throughout the early to midsixties.[13] "In the past, we've spent too much time telling the public we make nuts and bolts," a steel industry spokesman admitted to the *Wall Street Journal*.[14] The center of the industry's consumer campaign was the Steelmark, a new industry-wide logo seeking to symbolize "the modernity, lightness and stylishness" of American steel.[15] Originally designed by leading corporate design firm Lippincott and Margulies for U.S. Steel, the AISI took over ownership of the logo in 1960 and directed its use across millions of consumer products made from the steel produced by its eighty-seven members.

Following the tactics pioneered by aluminum, the AISI also sought to influence the designers and architects who chose the materials for consumer products.[16] In 1964, the group launched the "Design in Steel" awards, targeting architects, designers, and engineers not only to "demonstrate great versatility of modern steels" but also to "demonstrate that steel is progressive and dynamic—an industry that's moving forward."[17] Artists had been repeatedly drawn into such promotions, including José de Rivera himself. In October 1960, his works were exhibited at the American Iron and Steel Institute's stand at the National Automobile Show in Detroit, where carmakers and their suppliers sought to drive sales of the restyled models of the following year.[18] A de Rivera sculpture was also featured on the cover of the Institute's 1962 publication

FIGURE 85
José de Rivera sculpture with
model Charlene Lee, U.S. Steel
exhibit, Chicago, 1961. Photogra-
pher unknown. © Estate of José de
Rivera, Courtesy Gray, Chicago/
New York.

*Study in Steel*, the centerpiece of a campaign showcasing the use of steel by Pittsburgh-based industrial designer Peter Muller-Munk and encouraging other designers also to favor the material.[19]

For sculptors working with steel, the aggressive public relations tactics of the industry offered a significant patronage opportunity. De Rivera's work was exhibited as part of U.S. Steel's own "new program to make steel the top design material" (fig. 85).[20] Artists such as Len Lye and Richard Lippold would also work directly with U.S. Steel, lending their work for promotional exhibits and providing testimonials for trade literature, opportunities that they and their dealers appear to have actively courted.[21] The American steel industry might have been, in the words of one journalist, the "epit-ome of corporate conservatism," but it came to be enchanted by the dazzling metallic abstractions of sixties sculpture.[22] With its often-gleaming starburst forms and swoop-ing, shimmering motion, these artworks gave visual form to a fantastic future of steel.

The most prominent public expression of such values was another sculpture of sorts: U.S. Steel's *Unisphere* (fig. 86), designed by Peter Muller-Munk Associates. This

enormous steel globe was the centerpiece of the 1964–65 New York World's Fair. Its space-age design reflected as much on the apparently future-focused U.S. Steel as it did on the spectacle of progress that was the symbol of the fair as a whole; as the fair's historian has described, it was not just built by U.S. Steel but also "officially sponsored by the company, a public monument to its status as an icon of American muscle and know-how."[23] The *Unisphere* was at the center of a global flood of publicity that one journalist estimated "will receive 1,000,000,000 impressions in every conceivable type of advertising medium," making it "one of the greatest promotional undertakings in the nation's history."[24] The turnaround in perceptions that such activities produced was rapid. By late 1964, the *New York Times* would report that "mighty steel, which only a few years ago appeared to have lost to newer metals and materials in the battle for supremacy, has come back strong."[25] Similar gains were noted in Washington: as a *Business Week* article entitled "How Steel Is Winning Luster in Washington" reported, a "fresh spirit of cooperation exists between steel and government."[26]

Such tactics took a more surprising—and, at first pass, somewhat inexplicable—turn later in the decade, when the industry began to replace such aesthetic uses of stainless steel for a "new" material whose name would become better known in the art world than in the steel industry. That material was Cor-Ten, an industrial alloy designed to develop an outer layer of corrosion when exposed to the elements. Given that rust was the preeminent visual signifier of steel's inferiority, it was a most unlikely candidate for promotional use. For U.S. Steel, the replacement of rusty steel might have constituted some 40 percent of its sales, but its consumer visibility made it a serious public relations problem.[27] Since the late 1950s, consumers had watched in horror as their appliances and automobiles were infected by an onslaught of corrosion, eating away at the gleaming Duco and chromium plate that had so seduced them in the showroom. By 1960, it was reported that the national epidemic of corrosion had cost the United States an estimated $8 billion in the previous year.[28] The distress was fanned by the revelation in Packard's *The Waste Makers* (1960) that cars were indeed "designed to *rust* instead of last."[29] Durable goods were proving to be anything but.

Cor-Ten is not a metallurgical term: it is a patented alloy licensed and marketed by U.S. Steel. The brand-name neologism combines the material's corrosion resistance and high-tensile qualities, respectively the *cor* and *ten* in its name. Launched in 1933 for industrial uses, the alloy was one of countless material trademarks owned by the company.[30] Such specialist products had acquired new value for U.S. Steel by the 1960s, their apparent technical "innovation" serving as a useful riposte to those who thought that "U.S. Steel was an ailing giant leading a sickening industry."[31] When the company launched a range of new profiles and thicknesses of Cor-Ten in 1961, it sought more than just new sales.[32] The representation of the material as a new development, even if it was actually some thirty years old, served U.S. Steel's broader needs to communicate innovation and progress.

Up to this point, the aesthetic value of Cor-Ten had remained untapped. It was promoted instead as providing "outstanding cost and weight savings to the construction industries."[33] The initial revaluation of the aesthetic of Cor-Ten was the result of the initiative of architectural firm Eero Saarinen and Associates and its architects Kevin Roche and John Dinkeloo. When they approached U.S. Steel for samples of the material for the John Deere and Company Administrative Center, in Moline, Illinois, U.S. Steel had been initially "reluctant" to supply the materials for a building that was guaranteed to rust. "The hardest part of our job," Dinkeloo later told the American Institute of Steel Construction, "was selling the owner and the steel industry on liking corrosion, since we were dealing with people who have been fighting corrosion at great expense for many years."[34] But once the building was completed in 1964, the architect's use of the material was widely acclaimed. Capitalizing on the success, U.S. Steel began to promote Cor-Ten aggressively for architectural uses, publishing a color chart that illustrated the gradual formation of the oxidized coating so as to encourage architects to use the material.[35]

As a result, a flurry of Cor-Ten buildings in America and abroad appeared in the late 1960s. Roche and Dinkeloo used Cor-Ten in several buildings after Saarinen's death, including the Ford Foundation (1963–67), the Cummins Engine Factory (1964–65), and the New Haven Coliseum (1968–72). When U.S. Steel announced that it was building its own new headquarters in Pittsburgh, company president Leslie B. Worthington told the press that it would use it "as a construction marketing tool to dramatize to architects, engineers and others the advancements in design and steel technology."[36] Although the building would be constructed from the "full range of grades and types of steel," it was the use of Cor-Ten that took pride of place: "'This is in keeping with the growing trend toward the use of exposed steel in high-rise buildings,' he explained. 'These columns, as well as the exterior wall, will be made of U.S. Steel's COR-TEN, one of the fastest growing constructional steels, which weathers to a deep russet color and never requires painting.'"[37] No longer the blight of an industry, it was rust that gave Cor-Ten its beauty. Miraculously, Cor-Ten turned the scourge of the industry (and the target of countless aluminum trade promotions boasting of its own anticorrosion properties) into a product benefit, allowing rust to be repositioned as a sign of steel's durability, a kind of timeless patina. The spin was a counterintuitive—perhaps even desperate—move for a company for whom rust had been such a public relations headache. But for U.S. Steel, the benefits of Cor-Ten's new public uses were not just aesthetic. The use of Cor-Ten as a decorative finish required more steel than when the material was limited to structural uses, hidden beneath aluminum, glass, or concrete facings. Moreover, it could be sold at a higher profit margin than standard construction-grade carbon steel; Cor-Ten cost more up front but promised its customers to save on subsequent painting costs.

Among the high-profile buildings to use Cor-Ten was Chicago's new Civic Center, a thirty-one-story Miesian skyscraper completed in 1965 housing city offices and the county court. Leading a team of local architects working on the project, Jacques Brownson had visited Saarinen's building to confirm his choice of the material.[38] U.S. Steel won the $13 million contract to supply the Cor-Ten, beating a competing-brand weathering steel launched by Bethlehem Steel under the name of Mayari-R, one of several roughly equivalent alloys available before Cor-Ten emerged as the generic nomenclature for the alloy.[39] Brownson remembers that U.S. Steel executives took advantage of the use of Cor-Ten in the project, actively "touting" its use and the company's involvement in the project throughout the building's construction.[40]

Once the Civic Center was completed, U.S. Steel could turn its attention to an even more powerful aesthetic application, the sculpture planned for the building's fore-court. William Hartmann, from the architecture firm Skidmore, Owings & Merrill, assisted by the artist Roland Penrose, had persuaded Pablo Picasso to design a sculpture for the site.[41] The resulting work was unveiled in 1967 and, like the building it fronts, was made from Cor-Ten steel. Despite the prominence of the work, and its landmark status in the history of monumental sculpture, scholars have not explained

how and why Picasso's work stands as the first prominent use of Cor-Ten in public sculpture.

Hartmann and his colleagues had their first meeting at Picasso's villa in Mougins in May 1963, taking with them a scale model of the site that dramatized the color of the Civic Center's design, with the new building in the model painted the rusty hue of Cor-Ten while all other surrounding buildings were rendered in white, as a photograph of the meeting by Lee Miller records (fig. 87). Initial discussions had danced around "all sorts of possibilities" for the material of the work.[42] Sandblasted concrete, bronze, and painted iron were all mooted in initial meetings, and Picasso even showed some "samples of new plastic materials" he had been given—"very flashy, with inset colours," recorded Penrose.[43] Ultimately, though, Picasso avoided committing to a particular

material, telling the architects: "The idea of a sculpture in iron seems good to me, but that's just what I think today. Tomorrow I may think differently. We'll have to see."[44]

Picasso was not someone to be dictated to, and perhaps knowing that disagreements over materials had caused the artist to abandon his last public commission in Marseilles, Hartmann was smart enough not to try.[45] In July, he sent Picasso samples of the various materials used on the site.[46] When it seemed as though Picasso might suggest a work in concrete, Hartmann apparently stated his preference for a work in bronze. Early renderings of the site had indeed shown that the architects had considered a Henry Moore-style bronze for the forecourt.[47] However, Hartmann's later recollections are unequivocal as to what material he desired. "It was obvious that it ought to be in steel, and it ought to be like the building itself," Hartmann told an interviewer: ". . . This was an integrated project—one of the few times a sculpture had been done that way, I think, where it is one project. [It] isn't something separated by fifty years, and you have another material that's popular fifty years after the building's built."[48] The Civic Center and its monumental sculpture were to be a total work of art, bound together by the material they would help popularize. The choice may have been aesthetic, but it was probably also practical, given the significant cost savings of steel over bronze. Hartmann sought Picasso's approval with material samples and engineering drawings on his next visit to the artist's studio. And as Hartmann later recalled, "Picasso didn't object to anything."[49]

As with the works of Chadwick and Calder at Italsider, the final form of Picasso's work complied with the requirements of large-scale industrial fabrication. Picasso's roughly axonometric sketches for the work sometimes render its facial silhouette with careful shading that suggests a three-dimensional turned form that would have produced the same curved contour from all angles, something like an upturned wine glass, or the wooden spindle used in some of his early cubist sculptures. Such a bulbous contrast to the other flat planes is a typical Picasso tactic but would not have been possible to fabricate in sheet steel alone. His final maquette flattens this form into its final double profile, but even the capacity for the form to disappear from its side view was weakened by the addition of a rear support joining this U-shaped element to the monument's wedge base.

I would suggest that it was the requirements of monumental fabrication that saw the work stripped of the complexities of the artist's other approaches to this subject.[50] The Chicago Picasso's doggedly frontal realization turns its back on the visual ambiguities that characterized his other sculptural faces. Made not from a single plane of bent metal but from a patchwork of welded plates joined to create the illusion that the work was made from an impossibly large and seamless sheet, the American Bridge Company meticulously imitated the ever-so slightly wobbly outlines of Picasso's maquette. But scaled up according to the giant grid of its engineers, these variations are barely perceivable and lose any real connection to the embodied motion of Picasso's hand.

How might we understand Picasso's limited involvement in the final realization of the sculpture that bears his name? In *Patterns of Intention* (1985), Michael Baxandall seeks to extend the idea of intention from "a reconstituted historical state of mind" to encompass the wider range of social factors that might shape a work of art, circumstances and behaviors that are "implicit in institutions to which the actor unreflectively acquiesces."[51] In one chapter, Baxandall compares Picasso's intentions in his *Portrait of Daniel-Henry Kahnweiler* (1910) to those of Benjamin Barker, the nineteenth-century designer of Edinburgh's Forth Bridge whose wide range of contextual determinants provides the focus for his previous chapter. While the processes of "design and execution" were separate for Barker's cantilevered steel creation, Baxandall explains, Picasso "had no Forth Bridge Company."[52] But the unavoidably collaborative requirements of monumental sculpture complicate modernism's claims to individual authorship so that it was precisely a Bridge Company on which the creation of the Chicago Picasso relied. The very fact that the work came to include its artist's name in its title confirms, paradoxically, the collaborative process that led to its creation. According to Baxandall's expanded definition of artistic intention, the contributions of architects, steelworkers, patrons, and publicists to the making of this sculpture should rightly be understood as meaningful constituents of its "intended" form.

Another contributor to the realization of the Chicago Picasso was Mayor Richard J. Daley, who had long been an ally of U.S. Steel's public relations efforts. In 1958, Daley had collaborated with Blough and ad agency BBDO on a series of U.S. Steel–sponsored exhibits and lectures, declaring "an official steel architecture week" for the city.[53] Though Daley supported the initiative, he was apparently unwilling to risk public criticism by contributing to the costs of the Picasso sculpture from city coffers. The sole quote for the fabrication of the sculpture was sought from the American Bridge Company, a division of U.S. Steel.[54] The project was brought to the attention of the company's Pittsburgh executives, who quickly recognized its communications potential. U.S. Steel's vice president Edward Logelin was invited to sit on the committee for the project, and the staff of their public relations department "donated the services of their office."[55] The contribution was of modest in-kind value, but it offered immense publicity possibilities. As one journalist later described, it "guaranteed Cor-Ten (a trademarked product) a colossal visual plug which must have resulted in at least a three-day fiesta at United States Steel Corp. headquarters in Pittsburgh."[56]

U.S Steel's public relations staff engineered no less than three press events before the sculpture was even installed. In September 1966, the Art Institute of Chicago hosted journalists to announce the commission and display Picasso's three-and-a-half-foot-high maquette (fig. 88).[57] The second event occurred in December and ensured a focus on the contribution of U.S. Steel. Inviting the press to the American Bridge Company factory in Gary, Indiana, where the *Unisphere* had been constructed two years earlier, the event showcased the company's scale models of Picasso's sculpture.[58] In one photograph from the event (fig. 89), two versions are shielded from their

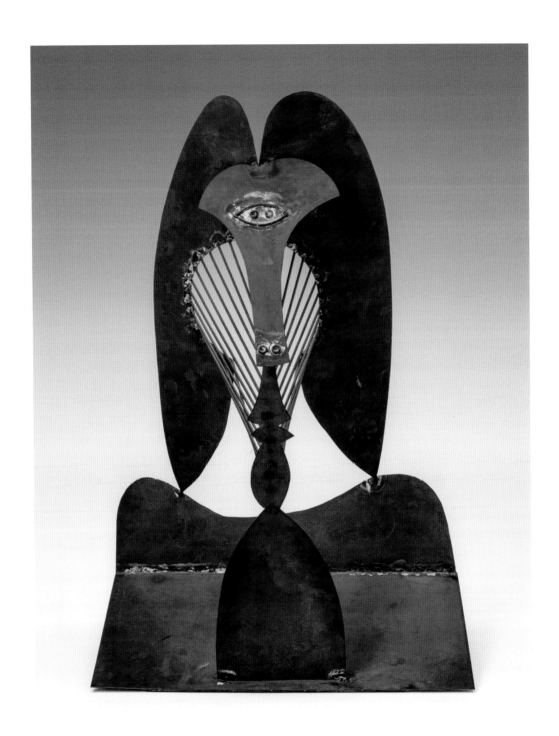

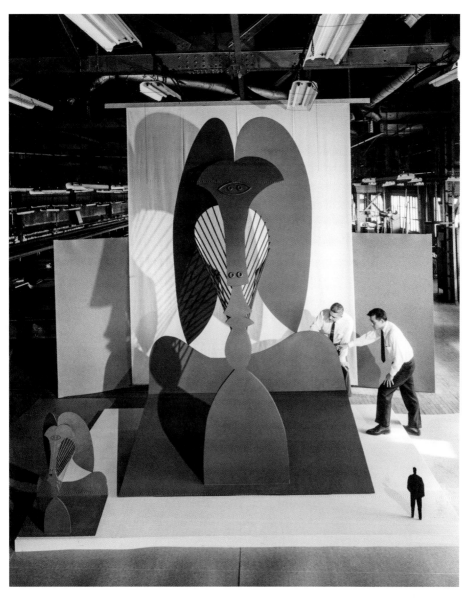

Scale models of Chicago Picasso sculpture in warehouse, 1966. Photo: © Hedrich-Blessing HB-29086-F2, Chicago History Museum, Hedrich-Blessing Collection.

industrial context by a white plinth and backdrop. Workers proudly inspect the enlargement, while a small silhouetted figure stages the eventual scale of the monumental object. The industrial context of the display inevitably informed the reception of the work. "Steel is the muscle and sinew of this factory city," reported art critic Harold Haydon. "What more fitting material for both civic design and civic art."[59]

Picasso's refusal to "explain" the sculpture allowed the choice of material to dominate how the work was interpreted. "Today's steel towers call for steel sculpture," wrote Haydon, describing the work as "a modern steel goddess, representing power and imagination."[60] Such representations must have delighted the corporation, which was increasingly faced by less positive associations for their material. As with the *Unisphere*, the work was routinely rendered in statistics, with articles describing its weight and size with lavish technical detail. One article noted that U.S. Steel used a computer for the more "abstruse calculations" required to realize the work and that the degrees of curvature required trigonometric logarithms to ensure exactitude.[61] Sounding more like a civil engineering project than a sculpture, such technical descriptions became a dominant thread in the work's media representations, reinforcing the central role of U.S. Steel's technical experts in its realization.

Lacking access to the artist, the press was given Anatol Rychalski, an engineer employed by U.S. Steel. He was billed as an "accomplished sculptor" and "follower of Picasso's works" who "also does professional-quality oil paintings of retiring company executives."[62] With U.S. Steel publicist Thomas Ward, Rychalski was advertised to community groups for a "free color slide presentation and lecture on the Picasso sculpture," which, in a remarkably barefaced claim of the work's corporate genesis, "trace[s] its history from its beginning in a Gary mill thru its dedication in the Civic Center."[63] Reporters lavished their prose on the aesthetic distinction and extraordinary colors of Cor-Ten. No less than the technical feat of the work's fifty-foot scale, its Cor-Ten surface served to demonstrate the innovation of U.S. Steel. As one newspaper reported, probably following a press release: "Cor-Ten steel, a new high strength alloy which can be used for any structural purpose, was used in the construction. Upon exposure to the elements, its surface begins to oxidize and harden, forming a molecular bond which in turn prevents further oxidation. It feels like stone, initially turning a bright rust color, but later turning dark. 'For centuries builders have been fighting rust,' said Rychalski, 'but the steel used in the Picasso giant will last indefinitely.'"[64] According to such spin, U.S. Steel had tamed nothing less than rust itself—transforming the toxic scourge of its material into a demonstration not only of strength and durability but of the aesthetic valuation of its product in modern art's highest quarters. In May 1966, a final event was held on the site of the sculpture to mark the "ground broken" for the work, at which Hartmann on "a fork-lift truck . . . raised the first block of granite from the plaza's pavement."[65] As with the earlier public relations events, the involvement of U.S. Steel as both the work's fabricator and the source for its material was consistently featured. Prerusted before it was installed, the work was finally unveiled to a crowd of some fifty thousand on August 15, 1967, declared "Picasso Day" by Mayor Daley and the committee (fig. 90). The resulting event was pure spectacle: the -fifty-foot-high work was theatrically unveiled from beneath a giant veil of blue fabric. Classical music and dedicatory poems were performed. Along with speeches by officials and religious leaders, a telegram of congratulations was read from President Johnson.

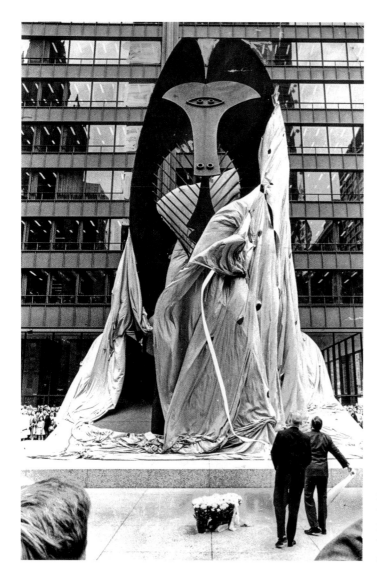

FIGURE 90
Unveiling of Chicago Picasso at
Richard J. Daley Center, 1967.
Unknown photographer. Author's
collection.

Photographs of the Chicago Picasso distributed by the press office of U.S. Steel ensured the continued presence of the corporation in coverage of the work. In one spread in *Life* magazine, for instance, the sculpture was recolored to intensify its rusty hue, while construction photographs on the following page emphasize the technical achievement inscribed in the headline that claimed this Picasso masterpiece to be "built to stand against the wind."[66] With such an emphasis on the technical qualities and requirements of the sculpture, it is little wonder that art critic John Canaday's equivocal review of the work described it as, first and foremost, "a satisfyingly firm piece of engineering that harmonizes with the new Civic Center."[67] Another critic wrote that "producing the Picasso sculpture in the same steel as that of the building

behind it somehow brought out in the piece all of its brute side . . . yet ironically the sculpture converts even the plate steel into airy and human material."[68] It is hard to know what Picasso would have made of such reviews, but U.S. Steel's publicists could only have regarded such coverage as a success.

The Chicago Picasso also provided an immediate vehicle for Roger Blough to counter the innovations of foreign steel manufacturers. While admitting that foreign steel companies were investing heavily in "process improvement," Blough explained in a 1967 speech that American steel had been pioneering the research and development of new products at "an average of one a week." His first example of such innovation was Cor-Ten, ignoring the fact that this invention was decades old. It was "known as the steel that paints itself," he explained, "because after a period of weathering, it develops a tight oxide coating of a deep russet color which does not chip or peel and which inhibits further oxidation." As evidence of its modernity and originality, Blough's audience of Indiana manufacturers was told that it had been used "even for the Picasso sculpture that we erected this year at Chicago's Civic Center."[69]

With the Chicago Picasso as a kind of billboard for the material innovation and technical capacity of the corporation, U.S. Steel's use of the project extended beyond its drive to secure positive press coverage. The company had commissioned a documentary crew to follow the construction of the sculpture and sponsored the screening of the film on national television. The film turned the sculpture into the locus for the heroic masculine labor of modern construction. Almost an hour long, more than half of the program depicted the construction of the work, including shots of the U.S. Steel logo on plans, hard hats, and cranes, and yet more effusive descriptions of the "magnificent" Cor-Ten and exhaustive technical details about the "162-tons of fine art" with a "total surface area of 6700 square feet."[70]

The Chicago Picasso was also used in several U.S. Steel print advertisements. A 1968 advertisement juxtaposed the Chicago Picasso with prefabricated housing and drainage pipes as evidence of the diverse uses of U.S. Steel products.[71] A 1970 campaign continued to focus on the sculpture (fig. 91). "What is U.S. Steel doing about art and architecture?" it asked, posing a question that one doubts had ever been asked before. The copy answered:

> USS COR-TEN Steel is one of the things we're doing. Add the imagination of architects and this steel becomes a handsome enduring building. . . . Add the genius of Picasso and this handsome material becomes a sculpture. . . . USS COR-TEN is a high strength steel developed and pioneered by United States Steel. It's as natural-looking as wood and as permanent as stone. Artists use it. Architects use it. The secret of its beauty, as well as its durability, is the rich, russet brown coating it forms to protect itself from corrosion. It doesn't need painting. And with age, it only grows more handsome. Because there's a need for the pleasing as well as the practical, we produce steel that is both.[72]

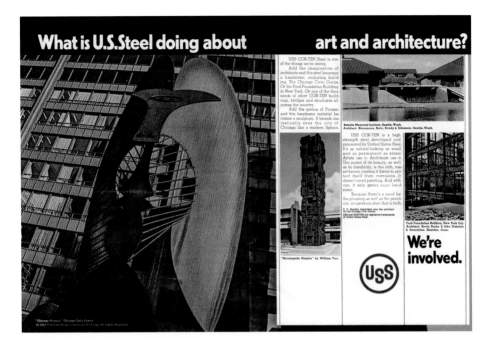

The corporate alignment with art was not simply about asserting the aesthetic value of a product, nor even about reinforcing its "handsome" masculinity in contrast to the superficial seductions of lightweight aluminum or plastics. As another advertisement in the series featuring the Chicago Picasso described, "Housing, transportation, highway safety, research, art and architecture and medicine are just a few of the areas in which the people at U.S. Steel are contributing to a better life."[73] Continuing the theme of community engagement, the slogan of these advertisements was "We're Involved." The application of U.S. Steel's products to art, no less than to more practical concerns, provided a persuasive statement of the civic engagements of the business. This was less a matter of consumer attitudes than of the social credibility of the industry in Washington. By the end of the decade, the steel industry and its lobbyists had so successfully repaired its government relations that it had restricted competition by securing limitations on foreign steel imports.[74]

The involvement of U.S. Steel in the project provided powerful evidence of the company's commitment to civic life. U.S. Steel invested some $7 million in such activities in the mid-1960s. As Blough would later put it, Americans "look to big business to discharge fully its obligations as a corporate citizen of the community." "Beyond the heavy burden of taxation that it bears," he said, never missing a chance to push corporate priorities, "they expect it to contribute both time and money to civic improvements,

charity drives, hospitals, schools and recreation facilities."[75] Such beliefs might be underpinned by enlightened self-interest, but they represented a significant ideological shift from the conflicts earlier in the decade with President Kennedy. When asked what he was doing about racial tensions at U.S. Steel's plants in 1963, Blough had asserted that "for a corporation to achieve a particular end in the social area seems to me to be quite beyond what a corporation should do."[76] But within a few years, in the interests of effective lobbying, civic involvement had become essential to effective corporate public relations, and the spheres of health, education, and culture provided vehicles that were difficult for even the industry's most vehement critics to rebuke.

The image of civic harmony that the unveiling of the Chicago Picasso provided was equally valuable for Mayor Daley. As governments turned to architects and planners to rebuild and revitalize American cities amid the fraught urban politics of the late 1960s, artists were drawn into such efforts to attract people back into downtown areas. In the case of the Chicago Picasso, artists and critics were not blind to the power interests served by its presence. In an "Open Letter to Picasso," *Art in America* produced photomontages of blown-up versions of his sculptures themed to the image of other American cities, designed "to save you and your prospective sponsors a bit of time and effort."[77] Claes Oldenburg's parodies of the Chicago Picasso—a soft version whose steel structure appears to have collapsed and a later drawing of the sculpture as executive cufflinks—lampoon modernism's status as "serious and permanent," and the forms of authority that such myths could serve.[78] As the public spaces of downtown America became more likely to be shown occupied by protesting crowds, the good news stories guaranteed by monumental public sculpture provided a visual (and physical) presence of significant political utility.

The sculpture itself was the subject of considerable political debate. One rumor held that "Picasso, a self-styled Communist, designed the sculpture as a joke on Chicago, a center of capitalism in the capitalistic United States."[79] Chicago's lone Republican alderman John J. Hoellen demanded that the "five stories of boiler-plate" be returned to wherever it came from (which, as Canaday wryly pointed out, was nowhere less *internationale* than Gary, Indiana).[80] But opposition from the notoriously reactionary Hoellen, whose recent public activities had included his opposition to civil rights marches and lobbying for the censorship of school textbooks, only reinforced the valuable impression that the Daley government was one that could tolerate dissent.[81] It was an image of unity that would be seriously dented by Daley's infamous "shoot to kill" order against demonstrators at the Democratic Convention in August 1968.[82] In the wake of the Chicago protests, Alexander Calder had his dealer write to Inland Steel's Leigh Block to advise that he would abide by an artists' boycott.[83] Block's response was furious. "You can tell him that we would not consider his work now because of his attitude and he can forget the whole matter."[84] Another signatory of this protest, Barnett Newman, chose Cor-Ten steel for his sculptural response to the violence in his *Lace Curtain for Mayor Daley* (1968), its barbed wire field marked with splashes of red paint.

But the use of Cor-Ten in even such critical contexts helped confirm its status as a prestige sculptural material. The growing prominence of Cor-Ten saw U.S. Steel license the brand name to other steel companies, including Inland Steel, which took advantage of the local publicity opportunities availed by the unveiling of the Chicago Picasso. In 1967, for instance, three hundred pounds of Cor-Ten was donated to the art school at the University of Illinois's main campus in Champaign-Urbana.[85] Dutifully, a journalist for the *Chicago Tribune* rhapsodized that the "special steel" would "revolutionize metal sculpture."[86] Such efforts also secured valuable third-party praise for the material. "Cor-Ten's champion is a young sculpture [*sic*] Jerald Jackard, Assistant Professor of Art," who told the journal *Progressive Architecture* that Cor-Ten had the "strength of steel and the permanence of bronze," proclaiming that it was "the first time in history that man has had this natural color in sculpture."[87]

In 1968, Inland Steel gave even more Cor-Ten to the art school at Southern Illinois University, which was told that the stock would be replaced as it was used by students. "All they asked of us in return," Professor Thomas Walsh told the local newspaper blithely, was "photographs of the students' work which can be used in their company magazine."[88] The dissemination of such stories, which linked big steel with art and education, while still managing to weave in sales-oriented product messages, supported corporate efforts to demonstrate commitment to community goals. It is not by accident that these donations occurred in regions heavily involved, not in the arts, but in the steel industry, and thus embroiled in all of the economic and social troubles facing the sector.

The art world establishment was hardly immune to these tactics. A particularly enthusiastic promoter of Cor-Ten was Lippincott Inc., the firm that was fast becoming America's leading fabricator of monumental sculpture. Here too, U.S. Steel seems to have seen a promotional opportunity. As a 1967 article notes in passing, "U.S. Steel supplied Lippincott with its new Cor-Ten steel . . . at a generous saving."[89] In fact, Don Lippincott, who founded the company in 1966, was the son of J. Gordon Lippincott, a partner of the leading corporate identity consultancy who had designed the Steelmark identity for U.S. Steel. A recent account confirms the relevance of the relationship: "Gordon's connections paid off for his son's new company when one of Lippincott and Marguiles's clients, U.S. Steel, generously shipped some its new weathering steel-plate product, trademarked as Cor-Ten, to Don."[90] By 1970, major works by Louise Nevelson, Robert Indiana, Claes Oldenburg, and others, all fabricated by Lippincott, were installed in cities across the country.

If it was perceptions rather than direct sales that caused U.S. Steel to promote Cor-Ten for use in sculpture, the market that resulted was—at least for a specialist product—not to be ignored. Works by David Smith, John Chamberlain, and others had already embraced corroded surfaces, and other artists had tried to speed up the process artificially.[91] But very few artists had used Cor-Ten before the Chicago Picasso.[92] Of more than 160 sculptures in Maurice Tuchman's *American Sculpture of the Sixties*

survey exhibition, opened in April 1967, none list Cor-Ten among their materials. By the *Sculpture in the Environment* exhibition later in the same year, several works showcased Cor-Ten in high-profile public locations on the streets of Manhattan.[93] By the end of the decade, art critic Hilton Kramer would write that Cor-Ten was "now widely used" for large-scale sculpture.[94] Within five years, more than three hundred works of Cor-Ten sculpture were installed in public locations across America.[95]

The burgeoning popularity of Cor-Ten, no doubt, also followed more general shifts in taste, from the "finish fetish" that swept midsixties practice on the West Coast, to the earthier palette and expressive textures that characterized much late sixties and early seventies postminimalist sculpture. The rugged industrial aesthetic of Cor-Ten certainly suited the masculinist self-fashioning of many of the abstract sculptors who used it. Perhaps it also helped fuel such shifts. As much as it showcased the "never requires painting" spin of U.S. Steel, Cor-Ten, in a sense, did paint itself, following the truth-to-materials dictum and avoiding the low regard in which coated sculpture had long been held.[96] For some sculptors, indeed, Cor-Ten appeared so natural as to have no color at all.[97] Perhaps Clement Greenberg was also unwittingly subject to the corporate imperatives behind such tastes when he infamously ordered several of David Smith's painted sculptures to be stripped of the artist's painted finishes and allowed to rust. As Krauss explained in her exposé of the affair, Greenberg's choice not only complied with the long-held bias against colored sculpture but also represented "a concession to some idea of contemporary taste—a taste for the monochrome of unadorned metal."[98]

In the case of Cor-Ten, it took only a few years for U.S. Steel to catapult its branded alloy from trade catalogues into the glossier pages of art magazines and so into the consciousness of America's cultural elite. "A new and very strong alloy," hailed Lucy Lippard in *Art International* in 1968.[99] In *Art News,* Thomas Hess waxed poetic about U.S. Steel's invented innovation, writing that the "Cor-ten sheet steel has a velvet rust surface, the tawny color of a lion or of a classic Parian marble which has been exposed to the rain and ferrous oil of the Cyclades."[100] With the assistance of artists—from art school students to Picasso himself—Cor-Ten was transformed from one of the company's least appealing industrial materials, characterized by the rust that so plagued the industry, into the height of avant-garde taste. Basking in the reflected glow of its russet hues, the beleaguered U.S. Steel secured, however superficially, the illusion of progress that it so desperately required.

# 8

## COLLAPSE AT KAISER STEEL

**F**OR POP ARTISTS, INDUSTRIALISM is an object of mockery," lamented *Fortune* magazine in 1966. To make the point, it contrasted the "strength and splendor of the machine age" epitomized by the sleek abstractions of Constantin Brancusi to assemblages of junked automotive parts being made by the likes of Richard Stankiewicz, John Chamberlain, and Jason Seley. "But there are still sculptors who carry on in the higher tradition," the magazine declared, and some were "so taken by the industrial age around them that they work in factories, elicit the help of skilled labor, and even apply some advanced techniques of metallurgy in producing their works of art."[1] The work *Fortune* illustrated to exemplify this "higher tradition" was Robert Murray's *Duet* (1965) (fig. 92). Held together by the force of gravity, its bent and counterbalanced units of one-inch bent steel plate fuse the reduced units of minimalism with the compositional tensions of abstract constructions in the manner of David Smith, divergent sculptural tendencies united by their shared faith in the constructive power of industry.

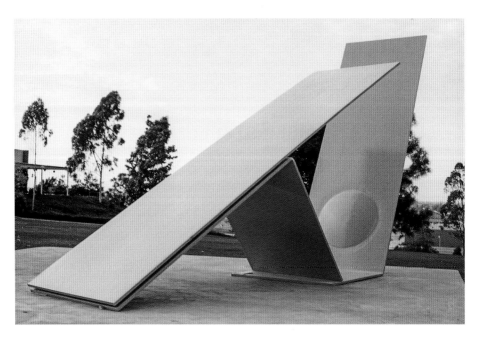

Robert Murray, *Duet (Homage to David Smith)*, 1965. Painted steel, 120 × 48 × 216 in. Photo: Baylis Glascock.
© Robert Murray.

The formal unions of *Duet* also echoed the "wedding of art and industry" that the work was meant to consummate.[2] "Plates of steel are taken for granted," Murray explained to one reporter. "I want to discover what I can make of them with my hands and with the extension of my hands through industry."[3] The context for Murray's embrace of industrial production was the International Sculpture Symposium at California State College at Long Beach. Organized by Kenneth Glenn, the program promised to reprise the success of the Italsider experiment by marshaling the resources of Southern Californian industry. In so doing, the college also sought to assemble a low-cost collection of monumental sculpture for its new and "somewhat utilitarian" campus.[4] Along with high-profile local curators like Maurice Tuchman and Walter Hopps, the symposium forged its links with the Italsider experiment by securing Giovanni Carandente as the international member of the symposium's selection committee.[5]

Drawn from some fifty artists who had registered their interest, Murray was one of ten artists chosen for the symposium, posing with Joop Beljon, Eduardo Paolozzi, Gabriel Kohn, Kengiro Azuma, and Kosso Eloul for a publicity shot beneath the event's slick logotype, its sinuous bends preempting the folded form of Murray's sculpture (fig. 93).[6] The organizers, however, proved more adept at securing publicity than any tangible support from companies. Worse still, a strike in the local heavy machinery industry made it all but impossible to access the "unlimited materials" they had recklessly promised participating sculptors.[7] Even before he arrived, Murray heard rumors

FIGURE 93

Participants in International Sculpture Symposium, 1965. Photographer unknown. International
Sculpture Symposium Collection, Box 1, Special Collections and University Archives, California State
University Long Beach.

that materials were actually in short supply, and the spare form of his work might even
be understood to have anticipated such limitations. "I withdrew my original idea sev-
eral weeks before the symposium began and proposed instead a less complicated
work," he told critic Barbara Rose in 1966.[8]

Fabricated in the San Pedro shipyards of Bethlehem Steel, Murray's sculpture used
techniques developed for the construction of ship hulls, objects that were, as he put it,
"already very abstract shapes to begin with."[9] Murray's engagement with the forms of
shipyard production helped the artist earn the esteem of the workers at Bethlehem
Steel, led by structural fabricating foreman Fergus McKay, who supervised the fabrica-
tion of the seven-thousand-pound sculpture.[10] But just as Smith had faced the signs of
industrial decline at Voltri, "only a skeleton of the bustling wartime production"
remained at San Pedro by 1965, its workforce now reduced to repairing rather than
building ships.[11] It is no coincidence that Murray's eager rapport with Bethlehem
Steel's workers recalls the Italsider example.[12] "Smith's enthusiastic account of
his experiences interested me in what looked like a similar situation in Long Beach,"

Murray explained. As the sculpture's plaque specifies, Murray would dedicate *Duet* in homage to the late David Smith.

The good relations that Murray apparently enjoyed with Bethlehem's workforce were in sharp contrast to his attitudes toward the symposium's organizers. In a letter to Clement Greenberg sent in late June, Murray complained that his progress had been "held up by poor organization."[13] A month later, the situation was worse. "I have been used as a pawn in fund raising drives," he complained in a letter to university administrators. "I have been subjected to cheap publicity stunts."[14] Other artists went further. Eduardo Paolozzi fled Long Beach after less than a week, protesting the "cell block" dormitory in which he was expected to live.[15] Giò Pomodoro resigned soon after, telling organizers that he felt treated "like a dog."[16] In what seems to be a reference to such dissatisfactions, Gabriel Kohn dryly titled his disjointed construction of laminated timber *Long Beach Contract,* reducing the very identity of his sculpture to the fulfillment of a signed agreement he couldn't get out of. Murray too waited until *Duet* was complete before he proclaimed his sculpture to be a statement of his disillusionment. "I declare it symbolic of my position with those who have left," he wrote in an indignant letter to the college. "I wish my presence here to be remembered. I wish my withdrawal from this symposium to be recorded. I dedicate this piece of sculpture to all men of dignity and good faith."[17]

Today, Murray's retrospective act of dissent remains as invisible as the welds that hold *Duet* together. Other disputes between artists and industry were undoubtedly subsumed within the "higher tradition" of industrial sculpture lauded by *Fortune* magazine. But not all sculptures made within the frameworks of industrial patronage contain the problems of their production so smoothly. Richard Serra's *Skullcracker* series (1969), made while he was artist in residence at Kaiser Steel, in Fontana, California, and named after the industrial yard in which they were made—decisively resist such a constructive reading. Where Murray elegantly balances the weight and scale made of his materials, Serra pushes such properties to their breaking point, flaunting failure and disintegration, and indeed the gruesome hazards that the *Skullcracker* title suggests. The propped and balanced steel plates that Serra would make his trademark are, according to the artist, "a direct result of the principles learned at Kaiser."[18] Given Serra's subsequent opposition to the kind of public sculpture that he saw as merely "corporate baubles," it is important to reconstruct the neglected commercial context that shaped these formative works.[19] Using archival accounts of the Kaiser residency, I suggest that these sculptures register both the requirements of their patron and the conflicts that racked their production. The seemingly imminent collapse of Serra's constructions materializes the bad faith between art and industry that characterized their increasingly fraught relationship by the end of the sixties.

Serra's residency was part of the decade's most prominent and ambitious effort to institutionalize industrial patronage: the Art and Technology Program of the Los Angeles County Museum of Art (LACMA). Conceived by Tuchman in 1966, the project

sought to fulfill the ambitions of the Long Beach symposium on whose committee he had served. Like its troubled predecessor, the scheme sought to match artists with the facilities, resources, and expertise of industrial corporations in Southern California. Tuchman's efforts to put art to work in a corporate setting were assisted by the involvement of Marilyn Chandler, the well-connected wife of *Los Angeles Times* publisher Otis Chandler. From a list of some 250 prospects, they persuaded 37 companies to participate.[20] In the case of Kaiser, this was no doubt helped by the fact that Otis Chandler's father sat on Kaiser Industries' board of directors. The scheme also accorded with the company's reputation as a corporation with a conscience. The Oakland-based Kaiser Industries had pioneered the provision of health care services for its workforce and had long been renowned for its positive relations with unions and the government alike.[21]

Art was a key part of such community relations. As an industrial conglomerate with diverse global interests, Kaiser sought to position "the cultural development of these countries as a parallel to the economic contribution" of their business.[22] In Argentina, for instance, Kaiser's automotive division founded the Bienal Americana de Arte in its factory town of Córdoba and persuaded art world cognoscenti such as Herbert Read, Arnold Bode, Alfred Barr, and Lawrence Alloway, to serve as judges.[23] "The contribution we might make to better understanding between peoples of the free world [is] difficult to assess," records one internal document, and while "cultural exchange is not *the* solution to international tensions . . . at least there is no strontium 90 in a tube of Grumbacher pigment."[24] As Kaiser faced mounting criticisms over the ecological impacts of its mining businesses, modern art seemed blessedly immune from the problems faced by large-scale industry.

Kaiser's interests in the Los Angeles area were a central rationale for their participation in the Art and Technology scheme. As Edgar Kaiser's assistant and company art coordinator Hal Babbitt explained to a representative from the Business Committee for the Arts, Kaiser's cultural activities were focused in "areas where we have major investments or plant operations."[25] Babbitt detailed further specifics of such a rationale in a 1969 letter, written to an artist unsuccessfully requesting direct assistance from the company. His account sheds light on the company's interest in participating in Tuchman's scheme: "My past efforts for direct involvement of the corporation with individual artists have been turned down. I was successful in persuading two of the Kaiser companies to support Maurice Tuchman's Art and Technology program but they did so on the basis of our corporate business interests and investments in the Los Angeles area, and the fact that it was a Museum program, in other words some possible 'public relations' benefits."[26] Requiring Babbitt's "persuasion," Kaiser's corporate stake in Art and Technology seems cautious at best, less interested in the idea of having an artist in residence than in the public relations value of the scheme as a whole. But the prominence of the project among the Southern Californian business elite was not to be ignored: not only for the publicity possible only with the imprimatur of a

museum but also in the interests of corporate relations with the other executives engaged in the program.

The task of selecting an artist who would deliver on this publicity potential proved, however, somewhat more complicated than all involved might have expected. That one Kaiser executive had recently made an anonymous donation of George Rickey's *Two Red Lines II* (1966) to the Oakland Museum (an institution near its headquarters, to which it provided a variety of support) provides some indication of the kind of sleek, engineered image predictably favored by the company's leadership.[27] In 1963, Kaiser Industries had shown sculpture on the roof garden of their modernist Oakland headquarters, and here too, corporate tastes for abstraction were clear. When Robert Arneson provided a sloppily modeled sculpture of a toilet, replete with ceramic turds, for one such outdoor exhibition, it was promptly removed. "No fucking artist is going to attack American capitalism in this manner, and god damn, the thing is going to have to get out of the show," is how the artist recalls a Kaiser executive's response to his work.[28] For the Kaiser Steel residency, then, Tuchman was undoubtedly judicious to begin his search by courting abstract sculptors such as Max Bill and Anthony Caro. Both expressed some interest, and though neither pursued the idea, their works would have presumably complied with corporate tastes. Len Lye had already worked with other steel industry patrons, but his "impatience with apparent technical limitations did not inspire the Kaiser personnel" when he visited.[29] Jules Olitski wanted to use coatings that would "be impervious to weathering," and Kaiser was apparently "quite interested in his proposals."[30] As the catalogue reports, however, Olitski's fabrication needs ultimately proved to be "beyond the resources of Kaiser's Fontana plant."[31]

Across several proposals, Kaiser Steel's limited technical capacity emerges as a central problem in choosing an artist. LACMA's report goes so far as to claim that the "plant is mainly a steel rolling mill with only limited fabrication facilities."[32] But Kaiser had, in fact, established substantial fabricating facilities at Fontana in 1964 and was continuing to convert "more of its raw production into fabricated products," producing everything from boilers to aircraft landing mats.[33] The fabricating shop, however, had the most volatile workforce at the site, and in late 1968, over three hundred of the skilled workers in this division had gone on strike over wage levels.[34] By the time of the Art and Technology residency, the fabricators were back on the job, working on a high-profile $16 million contract to make the welded steel structures required for Atlantic Richfield Plaza in downtown Los Angeles.[35] In this context, Kaiser's efforts to avoid sculpture that would require fabrication appears due less to the constraints of its facilities than to an effort to minimize the operational interference of hosting an artist in residence.

Of all the artists considered, Mark di Suvero's requirements from his potential corporate patron were perhaps the most extreme, though not because of his well-known radical politics.[36] (He had already alarmed scientists at the International Chemical and Nuclear Corporation when he suggested—apparently in earnest—that they let him

solve "the problem of helium fusion.")[37] In June 1968, di Suvero toured the Fontana plant. "After visiting your giant complex," he wrote directly to Kaiser Steel, bypassing the museum curators who were coordinating the process, "I have been filled by the extraordinary possibilities which exist in modern steel sculpture."[38] He not only wanted to work in the fabricating division but also required rolling and casting facilities. He proposed that the company supply a crew of between four and eight men and nothing less than "an unlimited supply of steel." Further, he stipulated that he would require "the written approval of Edgar Kaiser" for his residency. In the words of LACMA curator Hal Glicksman, his demands were all "a bit immoderate," and Kaiser's managers would have probably agreed.[39]

Serra visited Fontana on the same day as di Suvero—a competitive situation that di Suvero attempted to resolve by including the less established Serra within his own proposal.[40] After "six weeks on my own projects," di Suvero suggested, he would "invite" two other guest artists: Serra and Peter Voulkos.[41] According to Glicksman, di Suvero "wouldn't do it under any other terms."[42] Glicksman records that Serra agreed to this collaborative proposal but also said privately "that he wouldn't mind being chosen over di Suvero."[43] By then, LACMA was anxious to find a match, and the less pushy Serra emerged as the front-runner. Kaiser Steel staff seem to have been less certain: "He was not the artist I would like to have had here," Ted Chinn, from the company's public relations department, later admitted.[44] But Tuchman urged Serra via telegram to move quickly. "Please send whatever proposals you can as soon as possible," he wrote to the artist after his visit.[45]

From the outset, Serra's proposal emphasized his commitment to the kind of corporate collaboration that Tuchman's scheme sought to encourage. In an especially eager paragraph of Serra's proposal, excluded from the version that appeared in the Art and Technology catalogue, he wrote enthusiastically of the "new ideas" that would result from his work at the company: "Collaboration with the industry is imperative, for once the idea of a work is established there are many side effects that cannot be imagined. The controlling of these effects often assumes the form of new ideas for new works. Perception of ideas leads to new ideas. In this instance collaboration is imperative for imagination cannot lead to perception until the work is completed."[46] As nebulous as they sound, Serra's claims for creative experimentation resonate as much with the commercial possibilities of research and development as they do with his interests in sculptural process. Just as site specificity would come to offer an appealingly bespoke art for corporate space, Serra's rhetoric flattered those interests unique to his patron. "The work will be related to both the physical properties of the site (Kaiser Steel) and the characteristics of the materials and processes concomitant to it," he explained.[47] With its businesslike layout of numbered and indented sections (fig. 94), the only illustration Serra provided was a "striated form" that he intended to construct, a modest, layered stack no less ordered than the document itself, the very image of rational uniformity and structure. Across his text, Serra emphasized the constructive power of

PROPOSAL FOR LOS ANGELES COUNTY MUSEUM

IN CONJUNCTION WITH KAISER STEEL

The work will be related to both the physical properties
of the site (Kaiser Steel) and the characteristics of
the materials and processes concomittant to it.  The
work falls into three basic categories:

    A. casting in location
    B. overlaying processes
    C. constructions.

A. Casting:  The molten metal for casting is to be brought
               directly from the furnaces by turret car to
               the yard.  Sand casting molds are to be used
               to control the pouring flow in location.

       1.  Slabs are to be embedded and supported
           in place in the molds.

       2.  Shapes are to be derived from direct
           pouring.

B. Overlaying Processes:  Specific diverse processes
                       are to be superimposed in
                       final states.  The juxtaposition
                       is to point to the specific
                       characteristics contained in
                       each step and method of
                       processing.  Work will assume
                       a holistic striated form.
                       Stacking will be the control.
                       Example: poured form overlaid
                            by in crops, hot
                            rolled slab,
                            galvanized sheet,
                            cold rolled,
                            discarded gangue, etc.

C. Constructions:  Work is to be erected in place.
                    Slabs, hot rolled (ploom), to be used.
                    Principle of work is to rely on
                    physical tension, balance, and
                    gravity.
                        Example: Stonehenge type
                             construction.

FIGURE 94

Richard Serra, "Proposal" for Los Angeles County Museum of Art in conjunction with Kaiser Steel, 1969. © 2020 Richard Serra / Artists Rights Society (ARS), New York.

steel, promising sculptures that would "rely on physical tension, balance, and gravity." His suggestion that his work might use "Stonehenge type construction" powerfully evoked the timeless strength that the steel industry desperately sought to project.[48] Serra's proposal suggests that he understood that his art could bolster the image of his patron and that he was ready to trade this service for the technical assistance required to realize his ideas in new materials at a vastly expanded scale.

Admittedly, other elements of Serra's proposal do indicate the more problematic aspects of a Stonehenge made from steel. It is hard to know what Kaiser staff would have made of his suggestion, for instance, that "specific diverse processes are to be superimposed in final states."[49] And despite Serra's own professed experience as a steelworker, his technical jargon fell short, mistakenly referring to the semifinished steel "bloom" he had seen at Fontana as "ploom." But such gaffes were easy to overlook. Unlike other artists, Serra did not need the support of the fabricating division, nor did he require technical expertise on chemical finishes or electronic components. Neither did his faith

in industry go as far as that of Donald Judd, whose suggestion to Tuchman that he make "rectangular shapes" at Kaiser "in absentia"—presumably from his Soho loft—would have surely been a difficult sell for a company paying $7,000 for the privilege of an artist in residence, however much they wished to minimize its operational impacts.[50]

In *Modern Art and Common Culture,* Thomas Crow connects Serra's work at Kaiser to the declining fortunes of his industrial patron. But when Crow speculates that "a plant working at full capacity would probably not have afforded him the room he was using," his characterization somewhat underestimates public relations ambitions of the residency.[51] Further, Kaiser's falling fortunes meant that the efficient management of its facilities and labor was forced to become even more vigilant. "Everyone in that plant is accounted for," Kaiser staffer Vic Fisher recalled of the fiscal scrutiny within which Serra's residency unfolded. "If Serra used any equipment or men then it was accounted for."[52] Kaiser's choice of Serra conformed to the requirements of industrial efficiency; far from a token gesture designed to utilize surplus capacity, it was expected to maximize public relations benefits with minimal impact on the bottom line.

A further impetus to Kaiser Steel's participation had been provided by the opportunity for work made at Fontana to be exhibited at Expo '70 in Osaka, Japan. In April 1969, the designers of the American pavilion approached Tuchman to discuss a potential collaboration. By May, LACMA had signed a contract with the United States Information Agency (USIA) to provide an exhibition for Osaka early the next year. The short lead time certainly added new impetus to finalize Kaiser's choice of artist when Serra was selected in June. It was a prospect that the company was informed of, and about which they were evidently excited. By September 1969, when Kaiser Steel's staff magazine *The Ingot* ran a piece on Serra's residency, it appeared under the headline "Artist's Steel Sculptures May Be Shown at Expo '70."[53] The article itself reported that Serra's work "may assume a place of honor for Kaiser Steel in the 1970 World Exposition in Osaka." This opportunity may well have appealed to Serra's own competitive impulses: he had not been among the thirteen sculptors tapped to participate in the International Sculpture Symposium planned for the Osaka Expo, whose work in the factories of Japan Iron and Steel Federation members also began in September 1969.[54]

Just as Italsider's collaboration with modern sculptors should be understood within Italy's economic miracle earlier in the decade, Japan had come to occupy a central position in the globalized steel industry of the late sixties, benefiting from widespread adoption of improved steel-making technology. As the Federation's chairman and Nippon Steel president Yoshihiro Inayama explained, the value of the Osaka initiative was not simply that business should "keep abreast of the times in operating any enterprise" but that artists could help "overcome national boundaries by exchanging information and deepening mutual understanding."[55] Like Italy, Japan was a country lacking the raw materials to make steel, so transnational exchange was crucial to its industry, and it is within such corporate interests in globalization that these cultural projects should be understood.

Japan was of major strategic importance to Kaiser too. Japanese imports provided the company's major competitor in the West Coast steel market. But even while complaining about the "dumping" of such low-cost imports, Kaiser was diverting to Japan its own raw materials, the sale of which could "produce a higher rate of profit than the company's Fontana mill."[56] In the late sixties, the company had signed major new contracts to supply Japanese steel producers with both coal and iron ore.[57] These were relations that made the possibility of a presence at the Osaka Expo especially opportune. When asked to buy a commercial stand, however, Kaiser Steel CEO Jack Ashby argued against the idea. "I think it is quite possible," he informed his colleagues in December 1969, "that we will be asked to participate in some other manner in Expo 70."[58] Serra was, I suspect, the possibility he had in mind, promising Kaiser a prominent—and low-cost—position for its product to take the spotlight at America's national pavilion, with all the neutral credibility and national clout that such a state-sponsored display of its raw material could provide.[59]

On July 21, 1969, less than a month after his site visit, Serra had arrived at Fontana to start work. Serra's constructions not only displayed "the process by which they were built" but also spanned the company's product range.[60] Serra recalls that he worked with "everything they processed" at Fontana. "I was able to make distinctions between a one-inch plate, a two-inch plate, and a three-inch plate, between a thirty-foot plate and a forty foot plate," Serra has described. "Those are distinctions that you can't imagine, the differences between thicknesses, weights and lengths."[61] In focusing on material properties and processes, Serra may have turned his back on the compositional rigor of formalist sculpture, but such thinking also represents the culmination of an industrial self-referentiality that had been significantly energized by industry itself. Moreover, once Serra's experiments were completed, the steel they used could return to usable stock. Douglas Crimp would later claim that Serra's rejection of the museum allows his work to resist the "complete capitulation to the system of commerce" that plagued modernist sculpture, but at Kaiser the temporary and site-specific nature of his constructions allowed quite the opposite: the most minimal disruption to the production and circulation of steel.

Serra's first construction was made in the foundry yard, where he stacked sixteen cast iron "stools," the heavy plugs used to seal the bases of ingot molds. As the artist recounts, "The first day, I built a cantilevered work from slabs stacked up forty feet which tilted twelve feet off axis."[62] Unlike the stable and neatly stacked pile he had drawn in his proposal, the construction he made arched precariously to one side (fig. 95). Each unit weighed six tons—as much as a small truck—exerting enough downward pressure on its dominant edge to appear to flaunt the rules of gravity. "It leaned as far as it could while remaining stable," Serra has explained. "It was at the boundary of its tendency to overturn."[63] Interestingly, this photograph appears to have been taken not by the artist or by the professional photographer hired by LACMA, but by a Kaiser Steel public relations staffer—a collaborative contribution to what has become

FIGURE 95
Richard Serra, *Stacked Steel Slabs
(Skullcracker Series)*, 1969.
Hot-rolled steel, 20 × 8 × 10 ft.,
temporary site-specific installation
made on the grounds of the Kaiser
Steel Company, Fontana,
California, as part of the Art and
Technology Program of the Los
Angeles County Museum of Art,
1969. © 2020 Richard Serra /
Artists Rights Society (ARS),
New York.

the most iconic image of the *Skullcracker* series, now subsumed under the singular
authorship of Serra himself.[64]

Accounts of the production of these works from a little-known 1971 interview with
Kaiser staff provides new insight into their perilous form, the criticisms of the Fontana
workers providing a historical alternative to the spatial and bodily experiences of Ser-
ra's art by which it has frequently been understood.[65] On his first visit to the plant,
Serra had seen piles of ingot molds stacked haphazardly in the yard. "Jesus, that's
beautiful," he reportedly exclaimed. "Because of that the whole attitude from then on
was one of ridicule," recalled Don Butler, one of the foremen designated to work with
the artist. Such attitudes might explain the fate of one particular construction. As
Serra records, "The yard crew knocked it over after the day shift ended; I put it back
up the next day. This time it remained up through the swing shift, but they knocked it

down on the night shift. I guess they were threatened by the precariousness of the construction."[66] The incident was significant enough to be brought to the attention of staff at the parent company's Oakland headquarters, whose staff "could never find out why" Serra's work was destroyed. "Either the night crew didn't understand what was being done," Kaiser's representative claimed, "or they were just malicious."[67]

Serra's interactions with the Kaiser workers were evidently plagued by such problems. The artist's own report on the residency records that "a hand language was learned" so that he could communicate with the operator of the elevated magnetic crane that lifted and released each hefty slab of steel.[68] While the account of Kaiser's foreman confirms the importance of these signals, their use by Serra was cited as further evidence of his outsider status: "He was giving directions for piling ingot mold on top of each other and using hand signals like you would measure a fish. There are standard crane signals but he didn't know them. Well, the crazy bastard had them piled up and thought they were balanced. He stood back and said, 'Beautiful, beautiful.' Just then, John, the crane operator, let the top ingot loose and the whole mess smashed apart. We got a laugh out of that."[69] Such antics not only represent the humble protest of Kaiser's workers against Serra's art but also suggest that the anarchic form of the collaboratively produced *Skullcracker* constructions may be understood to record these disputes in material form. Rank-and-file opposition was not universal: "I felt sorry for him because no one would have anything to do with him" explained Butler. "I used to say to people, don't laugh at him." Perhaps Serra was oblivious to his status as "the object of scorn and ridicule" at the Kaiser plant.[70] But if he did feel the sting of rejection, he was also careful to smooth over such stresses in his account of the project. "Collaboration existed between the operator and myself," he writes, with a certainty that, given evidence to the contrary, cannot help but read as overly insistent.[71] The Art and Technology catalogue further records that Serra "worked closely with the crew of assistants, often during the night shift, when the crane was available."[72] But according to Kaiser staffer Vic Fisher, Serra shifted his production to the evenings, not so much to gain access to the crane when it wasn't being used, but so that he could "show the night crew what he was doing . . . [so] they could appreciate things."[73] For Kaiser management, Serra's task was then rather like its own—to secure the cooperation of a workforce upon which plant productivity relied.

As art historian Christopher Bedford has shown, Serra's "much publicized identification with heavy industry and manual labour" was central to his masculine performance of blue-collar identity.[74] This industrial posture did little, however, to ingratiate the artist with the workers at Fontana. Fisher apparently tried to help improve Serra's communication style: "I would tell him: Richard, if you want something you have to tell us ahead of time so we can get it for you. You have to cooperate. This was hard for him. When Serra worked, he was so tense, he did not think about other people and what they must do so they can help him."[75] The perilous form of Serra's constructions embodied such difficulties. And as they grew in scale, they also became increasingly

shambolic—as a photograph of the artist by Malcolm Lubliner helps capture (fig. 96). Without entirely abandoning the zigzag balance and counterbalance tensions that characterized a welded sculpture like David Smith's *Construction December II*, Serra's perilous piles pushed this logic past the limits of control. The sense of impending collapse that would define Serra's *Skullcracker* series provides the sculptural materialization of his troubled residency and suggests the fracturing relations between artist and worker and, ultimately, between art and industry.

When Serra explained, in Kaiser's company magazine, that "equipment like cranes are merely extensions of my hand," it is not difficult to see how his McLuhanesque turn of phrase might have struck the Fontana workers as plain arrogance.[76] The idea that Serra's sculptures are enacted by his linguistic command retains some of this faintly depreciative attitude toward industrial work, positioning words rather than workers as the "generators" of his sculpture.[77] In the case of the *Skullcracker* constructions, Serra's patently supervisory role in the making of his sculptures was acutely recognized by Kaiser employees. Serra didn't do "any of the work," one worker complained. "The foreman did all the work."[78] Serra's leading interpreters have sought to emphasize the sympathies of his practice for the plight of the industrial worker, but in the case of Kaiser Steel it seems particularly difficult to recast the hostile reception of his art as evidence of its political force.[79]

In July 1969, Serra cut his time at Kaiser Steel short. He had completed much less than the intended three-month stint but agreed to return in December.[80] In line with Serra's original proposal to experiment with "casting in location," he was to "begin pouring iron in sand castings at the Foundry."[81] Serra had already worked with molten lead, flung from a crucible for his casting and splashing experiments. But as Kaiser's director of public affairs Vic Fisher recalls, the artist's access to molten steel was ultimately vetoed. "Too dangerous," Fisher recalls, "He didn't know anything about it."[82]

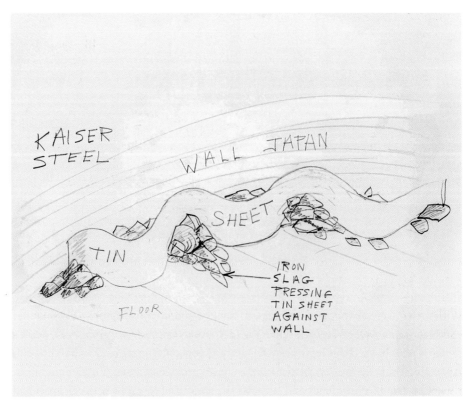

In the sketch: KAISER STEEL / WALL JAPAN / SHEET / TIN / FLOOR / IRON SLAG PRESSING TIN SHEET AGAINST WALL

FIGURE 97
Robert Smithson, *Kaiser Steel—Wall Japan,* 1969. Graphite on paper, 13¾ × 16¾ in. Private Collection. © 2020 Holt/Smithson Foundation / Licensed by VAGA at Artists Rights Society (ARS), New York.

Just as fabricated construction had been limited according to corporate requirements, the restraints on Serra's access to casting facilities proscribed the possibilities of his residency according to the interests of his risk-averse patron.

By the start of 1970, the tense relations between artist, worker, and corporation seem to have begun to wear on all concerned. When Serra returned to Kaiser in January, his work took a turn that was as timely as it was defiant. "He searched around the Kaiser plant for a new type of steel material and eventually located a vast yard of 'slag,'" records the catalogue, "an impure oxide residue from smelting which takes the form of giant boulder."[83] Serra propped new steel plates against these craggy leftovers, a sculptural juxtaposition of waste with new metal that was a departure for Serra, but one that would have been familiar to both artist and company from the earlier proposal of Robert Smithson. When Smithson had toured Fontana in April 1969, he had proposed to make a long trail of slag covered by a shimmering layer of tin sheet, the kind Kaiser made for the Californian canned food business. Smithson wanted this undulating trail of industrial residue to run, as he recorded in one sketch, for "as long

as possible," determining the form of his work according to the limits of the site and the materiality of his industrial medium.[84] In another sketch (fig. 97), Smithson appears to directly reference the pressure that Japan exerted on the Kaiser Steel business, proposing to install this terrain of industrial slag and tin against a curved barricade he marked as a "Japan Wall."

Unsurprisingly, Kaiser Steel had rejected Smithson's idea.[85] Trade barriers were better built by Washington lobbyists than by land artists. Given Smithson's persistent interest in "finding alternative funding through corporate support," its rejection should not be mistaken, however, as evidence of its latent environmentalism.[86] Later in 1970, Serra would help Smithson on the construction of *Spiral Jetty*—a work Smithson would use to promote the public relations potential of his work to the mining industry. On the one hand, as Erika Doss has explained, Smithson's earthworks can be understood to "mitigate environmental destruction by disguising it, after the fact, as art."[87] And yet the sheer visibility of his solution was also problematic in its own way; as Robert Hobbs has suggested, for "executives who felt compelled to cover the tracks of mining, Smithson's proposals looked like impediments."[88] The slag piles at Kaiser Steel comprised some twenty million tons of material accumulated since the 1940s, piled some forty feet high over almost five hundred acres along the San Bernardino Freeway. "It's amazing how many people pull off the freeway, and demand [to know] what we're going to do with our man made mountains," recorded one employee of the problem.[89] As Kaiser sought to defend the company from escalating "potshots from environmentalists" by contending, in a 1971 campaign, that "everyone" was contributing to air pollution, artistic interest in the company's slag piles threatened to draw even more unwelcome attention to the plant's most unavoidably visible environmental impact.[90]

In any case, Serra lasted only a few days at the site before he abandoned the residency once and for all. According to the catalogue, his "work was bogged down . . . due to the lack of proper assistance."[91] A more comprehensive explanation is preserved in an unedited manuscript held in the LACMA archives:

> In retrospect, Serra attributed this to Kaiser's system of incentive pay, by which a worker is placed on a high wage scale if he works on certain high-priority contracts. It was thus not particularly advantageous to be assigned to an art project, and Serra consequently had difficulty obtaining qualified crane operators to assist him. Instead he would be assigned a workman needing experience whom the supervisors wished to break into the skill. Serra found it impossible to erect sculptures requiring delicate feats of balance and ballast under such conditions. After much wasted time and numerous futile attempts to establish a workable situation, Serra left for new work before completing his expected period of collaboration.[92]

As we know, the failures of Kaiser's crane operators were—at least in part—a deliberate effort to interfere with Serra's artmaking. But in a misplaced gesture of solidarity,

Serra seems instead to have directed blame further up the Kaiser hierarchy: to the supervisors allocating inexperienced workers, to the managers whose productivity bonuses devalued his art, and ultimately to the company itself whose profit motives did not allow for the kind of "collaboration" Serra had hoped for.

Serra's reference to Kaiser's incentive pay scheme merits further investigation. In fact, the company had all but abolished the industry-standard use of incentive-based pay schemes—which remunerated workers according to their productivity, the fundamental orientation of a "piecework" model—in favor of an elaborate and widely publicized profit-sharing arrangement known as "the Fontana Plan."[93] Rather than incentivizing the output of each worker per hour, workers received a share of the plant's productivity improvement each month. Under the agreement, workers had also been guaranteed not to lose their jobs to automation or other efficiency gains. The scheme meant that the cheaper it became to make each ton of Kaiser Steel, the more workers got paid, but since the bonus was collectively distributed, workers were encouraged not only to maximize their own productivity but to monitor that of their colleagues too.[94] These payments were calculated monthly, usually representing a bonus of between fifty and sixty cents an hour that was then distributed across the workforce. As the *New York Times* reported at the scheme's launch, "Workers who once grumbled about 'speed up' pressure from supervisors now complain that these same bosses are not diligent enough in rooting out waste and trimming production costs."[95]

It is a subtle but significant difference. Serra's experiments might have had value as public relations exercises for the parent company Kaiser Industries, but under this system they were also dragging down plant productivity at the Kaiser Steel Company—and therefore workers' own pay packets. In early 1968, the unions had agreed with company management to continue the plan with increased bonuses, but what had once been celebrated as a landmark in progressive industrial relations appeared an increasingly tenuous accord. As historian Mike Davis describes of the situation at this time, "Kaiser's much vaunted labor peace was beginning to erode."[96] For Kaiser Steel's workers, Serra might easily have seemed a symptom of a company that had lost touch with its workforce, more concerned with positive publicity than the efficient production it had long emphasized as the means of survival. Kaiser's workers had good reason to be concerned about the productivity of the Fontana plant: the fact that the company had begun to export resources to its principal competitor while allowing its own technology to become obsolete would shatter the self-interested solidarity that had once characterized labor relations at Kaiser Steel. The seemingly wasteful work required for Serra's artwork stood as an unmistakable symbol of Kaiser's bad faith toward its workforce.

Indeed, when Kaiser personnel reflected on the project a few years later, they saw Serra's residency less as a symptom of decline than as an expression of late decadence. As one worker explained, "Things were different then. Times weren't so hard and we could afford to do it."[97] Asked if they would do the project again, another Kaiser Industries staffer replied: "Frankly, no. We are in a depression now. And steel costs so much

more."[98] By 1971, when these views were expressed, Kaiser Steel laid off 12 percent of its workforce, breaching the company's promise to find new jobs for any workers surplus to company requirements and representing the first round of rolling retrenchments by which the company would slowly shrink the Fontana plant into extinction.[99] "Most of the people who worked with him are no longer at Kaiser," foreman Don Butler told the interviewer in July 1971. "Everyone just wants to forget the whole damn mess."[100]

Serra too had revised his position toward the possibilities of collaboration between art and industry. In his 1969 interview for Kaiser's internal magazine, he had already acknowledged the fundamentally different values that he thought underpinned the problems he had faced at Fontana. "Science and art deal with the inexplicable. Technology concerns itself with man's tools," he explained. "The work I've been involved with is not preconceived." By the following year, Serra would recast this distinction in more resolutely negative terms: "Technology is a form of tool making. Technology is not art—not invention. It is a simultaneous hope and hoax. It does not concern itself with the undefined, the inexplicable: it deals with the affirmation of its own making. Technology is what we do to the Black Panthers and the Vietnamese under the guise of advancement in a materialistic theology."[101] Serra wrote this frequently quoted passage for LACMA's exhibition catalogue, a context where his connection between the category of "technology" and the materialism and militarism of late sixties America unavoidably read as a critique of both the program and his corporate patron.[102] For an artist who had, less than a year earlier, written that industrial collaboration was "imperative," it was a dramatic turnaround, and one that the artist must have understood would cause a stir. "*This text should be used in total,*" Serra told the museum, underlining his phrase for emphasis, "or NOT AT ALL. It should not be edited or used in part. OR SUMMARISED."[103] Nor was Serra's determination to distance himself from his own foray into industrial public relations short-lived: several years later, this was the statement that he would read to an interviewer as his way of demonstrating his sense of "political responsibility."[104]

As Serra shaped his identity in the art world, the "principles learned at Kaiser" were indeed formative.[105] Serra disavowed his former idealism for industrial collaboration, even though his art would continue to rely on the capacity of heavy industry. He might well have sought to distinguish the raw materiality of his sculpture from the visible newness of stainless steel, which he would claim he "always thought reflected cultural consumerism and a bourgeois notion of products," but as the artist would eventually do more than anyone to make the Cor-Ten brand name famous in the art world, his efforts to escape the imbrication of steel sculpture in the imperatives of big business were, at best, unfulfilled.[106] By the late sixties, such paradoxes were inescapable. "They say the art world is corrupt and yet they continually express their contempt for everything it stands for, even as they accept its blessings," was how Cindy Nemser described the mood in a 1969 essay, responding to an exhibition in which Serra was included, seeking to "shed light on the motives behind the artists' belligerent impulse to bite the

art establishment hand that feeds them."[107] "Caught between rage and dependency," she described of such tactics, "they strike out whenever possible, but they still know what side their bread is buttered on."[108] Serra has openly grappled with such contradictions, even if his conclusions are questionable. "The interesting thing about abstract art is that . . . the work remains free, it doesn't need to serve any ideological premise," he has explained. "When work ends up in museums or galleries, it can't escape from the morality implicit in those institutions, it's not independent of that larger capitalistic structure which needs close scrutiny. Well, every artist I know, to a degree—and it's to this degree that we are more of less guilty—has to deal with those inconsistencies in his or her life."[109] Elsewhere, Serra declares of his sculpture that "any use is a misuse," while admitting in the next breath that "every artist is always asked to betray himself, constantly."[110] Ultimately, Serra's own faith in the political agency and independence of his abstraction is at best, such sources suggest, ambivalent. In the wake of the destruction of *Tilted Arc*, Serra's oppositional politics would become as intractable as his declaredly autonomous forms were dogmatic, but I think we can trace these earlier, more equivocal anxieties about the commercial entanglements of his art to his experience at Kaiser Steel.[111] It was at Fontana that Serra was forced to come to terms with these conflicts. Serra's subsequent efforts to distance his art from the interests of industry were far from unique. At Expo '70, sculptor Jean Tinguely declared his work for the fair to be a "protest" against the "hyperbole and pomposity" of the event, while Isamu Wakabayashi would bury his work underground, criticizing his peers for "encouraging commercialism in collusion with large enterprise."[112] Such commitments were not enough, however, to prevent these artists from accepting the invitation to work with industry.

Was it right for art, implicated in the public relations activities that sought to rescue the reputation of multinational corporations, to defend (or at least distract from) those corporations' environmental negligence, their stake in the military-industrial complex, their manipulations of public opinion and government policy, and the labor impacts of their programmatic cost cutting and voracious global profit seeking? "A materialistic world . . . has transformed the artist into a court jester," Nemser observed, but artists "cannot accept being the entertainers and decorators of the rich."[113] "Pretend you are supplying high art, when you are only delivering the products of a viciously destructive environment," was what she prescribed to deal with such conflicts. "Deprive the dealers of consumer goods that can be sold as art, but supply the media with plenty of novelty news."[114] By the end of the sixties, many artists would turn their backs on the idealistic dreams of corporate collaboration. Yet the avant-garde was forever changed by the romance, remade by the very values that they would so stridently profess to reject.

# CONCLUSION

Conceptualizing Corporate Sponsorship

As much as one might despise the Madison Avenue mercenaries, they are sophisticated professionals. One can learn a lot from them.

**HANS HAACKE, "WHERE THE CONSCIOUSNESS INDUSTRY IS CONCENTRATED," 1985**

THIS BOOK WOULD NOT HAVE BEEN POSSIBLE, to follow the conventions of the sponsor credit, without the work of Hans Haacke. More than anyone else, it was Haacke that drew the art world's attention to the ideological imperatives of arts funding in the late twentieth century. In his *On Social Grease* (1975), the bluntly self-interested statements of David Rockefeller and other advocates for corporate arts patronage—the kind of sources also used in this book—are immortalized on a series of engraved metal plaques. Eventually, Haacke would also mimic his target's brand identities. For the oversized cigarette package in *Helmsboro Country* (1990) (fig. 98), for instance, he replaced the Surgeon General's fine-print warnings with quotes from Philip Morris executive George Weissman and reactionary culture wars agitator Senator Jesse Helms, whose reelection campaign the tobacco giant supported. The work's cigarettes are rolled reproductions of the Bill of Rights, much like the copies that Philip Morris circulated to mark the document's two-hundredth anniversary, a public relations campaign tied to their

FIGURE 98

Hans Haacke, *Helmsboro Country*, 1990. Deichtorhallen Hamburg, Germany. Photo: Wolfgang Neeb/Bridgeman Images © Hans Haacke / Artists Rights Society (ARS), New York / VG Bild-Kunst, Bonn.

sponsorship of the National Archives. In this work and many others, Haacke did more than anyone to reveal the politics of the corporate patronage model that, in the wake of the projects I have described, began to flourish in the United States in the 1970s and continues to dominate the cultural sector today.[1]

The strength of Haacke's research-based practice is such that it came to acquire a monopoly of sorts on the subject of corporate sponsorship, his "institutional critique" providing self-contained lessons for countless survey courses and conference papers that have tended, as a result, to connect the rise of corporate art patronage with American conservatism of the 1980s and the totalized "neoliberalism" with which it is associated. Haacke's art historical prominence has seen his practice wield an unsurpassed influence over the methods of artists, collectives, and critics seeking to challenge corporate power in late twentieth- and early twenty-first-century art worlds.[2] To claim that Haacke's art would not be possible without the corporation is not simply to observe his frequent mimicry of corporate modes of branding and publicity, or, to use the artist's own phrase, agree that he did "learn a lot" from Madison Avenue. Haacke's compelling corporate critique derives its force, I would like to suggest, from his own firsthand encounters with the field of business-art collaboration toward the end of the 1960s.[3]

In the space of less than three years, Haacke's work appeared in three Philip Morris exhibitions. The most famous of these was *When Attitudes Become Form* (1969), pre-

sented in Bern, Krefeld, and London and curated by influential curator Harald Szeemann. Philip Morris Europe's support of this landmark exhibition is hardly a secret. Haacke has repeatedly addressed the significance of this exhibition's sponsorship in his own writings. One popular art historical anthology even reproduces the self-aggrandizing publicity statement of its sponsor, passing over the catalogue essay to spotlight the company's involvement, as though this was the exhibition's noteworthy legacy.[4] In its own conceptual gesture of self-disclosure, Szeemann's original exhibition catalogue itself reproduced the curator's contacts list for the show, a page in which representatives from Philip Morris and their PR agency Ruder & Finn are listed above almost all the participating artists.[5]

Asked to account for his involvement in *When Attitudes Become Form* in 2010, Haacke explained that "in 1969 . . . since most of us smoked and smoking was not yet generally recognized as potentially lethal, we were not concerned about lending our work and name to the promotion of a peddler of unhealthy products."[6] Admitting that his art participated in Philip Morris's promotional goals, and even implying his awareness of these functions at the time, Haacke nevertheless seeks to constrain his involvement to that of a lender, carefully demarcating the making of his art from its subsequent misuse. It was a distancing strategy that curator Harald Szeemann had also employed in negotiating the sponsorship with Philip Morris. As his diary notes, the Bern Kunsthalle's committee worried about "selling out to an American company," but such concerns were "dispelled with reference to the fact that the director will retain sole responsibility for organizing the exhibition."[7]

It is altogether too neat to pretend, however, that either this exhibition or the art it contained can be quarantined from its marketing functions. The project originated in a July 1968 meeting at which Ruder & Finn's Nina Kaiden, who had led the *11 Pop Artists* project of a few years before, and Jean-Marie Theubet, the vice president of public relations for Philip Morris Europe, offered to fund Szeemann to produce an exhibition.[8] Cigarette manufacturers had been seeking new symbolic languages for their products since the mid-1960s. Indeed, one prominent market research firm had recommended that big tobacco "systematically search world literature, art, philosophy, psychology and related fields for new translations, verbal and non-verbal forms of describing the qualities of cigarettes, including tactile, visual and other means."[9] In this context, the exhibition pretitle *Live in Your Head* was as much a nod to the dematerialization of conceptual art as it was a sales proposition for cigarettes, a rallying cry for young radicals to align smoking with the experiential and experimental attitudes of the drop-out era. As art historian Caroline Jones has observed of the exhibition's self-consciously individualistic radicalism, *When Attitudes Become Form* captured Philip Morris's strategy to "affiliate its addictive exports with youthful innovation and drug-fueled experiment."[10]

Szeemann's show should also be understood to have exploited new artistic interests in natural materials and processes to tap into the values of an emergent hippie

market. At the same time, Philip Morris Europe was planning a new cigarette brand to target such permissive and antiauthoritarian consumers, a market segment described in the company's strategy as "young progressives . . . new leftists, [and] protest-smokers" such as "political pioneers," "student leaders," and "artists."[11] Even if such strategic goals remained unknown to artists and visitors alike, critics were sensitive to the paradox between the exhibition's declaredly antiestablishment values and its sponsorship. "If this exhibition stands for anything," wrote British critic Michael McCay of the exhibition's subsequent presentation at London's Institute of Contemporary Arts (ICA), "it stands for the rejection of all fine art concepts and all capitalist cultural values." But its sponsorship ensured, McCay added, that while "these young revolutionary artists turn their backsides on society" they "have their hip pockets stuffed with dollar bills."[12]

Haacke's art was also prominently featured in two less famous Philip Morris exhibitions whose promotional resonances were even clearer: *New Alchemy: Elements Systems Forces* (1969), presented in Canada, and *Air: A Philip Morris Exhibition* (1970–71), which toured Australia, Venezuela, and the Netherlands.[13] These shows included a range of Haacke works involving weather and environmental systems. For the exhibition catalogue of *Air,* curator James Harithas breathlessly explained the transcendental theme. "For modern man, air is a chemical density of elements, forces, breaths, and external events; for the artist, it is also an inner poetic experience," he wrote, casting the "organic and inorganic elements" of air as nothing less than the stuff of human enlightenment: "Air contains inner and outer sequences, time, infinite reflections, wind, crystals, micro-organisms, and inspiration, materialisations and transformations from one physical state to the next, and mythological beings, like Mexico's plumed serpents, springing from air inspired displacements in the mind, displacements which carry thoughts to higher levels of cognition and recognition."[14] This is more than just a pseudophilosophical effort to capture the immaterial sensations of recent artistic practice. Smoke is never mentioned, but the focus on airborne particles and elements also points to the cigarette industry's discourses concerning filtration. Manufacturers were continuing to claim that paper and cellulose filters minimized the health risks of cigarettes. Constituting less than 1 percent of the market in 1950, filtered cigarettes had come to almost entirely dominate the market by the end of the sixties.[15] High-filtration, "ultra hi-fi," "selective filtration," "micronite filters," and Philip Morris's own Multifilter "fresh-air system" sought to reassure customers of the safety of the smoke they inhaled while steering clear of any health claims that could not be substantiated.[16] While Szeemann rejected "Micro-emotive Art" as the title for his exhibition, its focus on subjective experience and natural phenomena was barely less aligned with the techno-mystical reimagining of the cigarette than *New Alchemy* or *Air,* and perhaps its less blatantly branded theme helped secure the more lasting avant-garde credibility of *When Attitudes Become Form.*[17]

The cigarette industry further realized that widespread concerns over air pollution could help obscure and confuse the health risks of smoking, linking smoke with more expansive and complex environmental challenges and providing an alternative discourse through which they could stress the value of individual action over government intervention. "The public's concern with the quality of air it is being forced to breathe," complained one 1970 submission to the Federal Trade Commission, "has become fair game for cigarette advertising."[18] Such messages were central to the reception of *Air*, as one review of the exhibition's Melbourne presentation suggests. "In the new pollution awareness there is much talk of foul air," explained newspaper critic John Larkin. "We have become preoccupied with destruction," but this exhibition provides "a way of transcending this attitude, of becoming poets and dreamers again." The works in the exhibition thus show visitors "how to involve ourselves in air as a basic element, part of the new movement away from the scientific approach."[19]

This effort to cultivate a skepticism of scientific expertise was tied to the exhibition's antiestablishment message. "Many artists and young people were trying to move forward with the basic elements of life," curator Harithas told one critic, citing the "back-to-the-land movement" and "young people's communes" as examples where Americans were "throwing away all the old sense of limitation, the old fears." And finally, environmentalism served as a cover to advocate for individual enterprise over government intervention. Larkin explains that he was "very skeptical of many politicians'" talk about pollution, suggesting that "the human mind working through it showed more promise than political promises."[20] When *Air* was shown at the Stedelijk Museum, at least one Dutch critic was suspicious of its recourse to environmentalism, worrying that its "artists treat the problem of air pollution very 'airily.'" In an "age of commitment," this critic concludes, something about the exhibition's theme "smells."[21]

In 1971, as the cancellation of Haacke's Guggenheim exhibition outraged the New York art world, his art was then simultaneously on display as part of an American corporation's vast effort to clean up its corporate image through art. These are the contradictions that animate a range of Haacke's practice from this period. Haacke's interests in scientific phenomena had also ensured engagement with the art and technology scene in the late 1960s. His membership form for Experiments in Art and Technology listed his interests as "engineering of acrylics and plastic film," along with "sculpture, chemistry, hydrodynamics, aerodynamics, devices responding to light, temperature, humidity and other environmental conditions."[22] In late 1967, Haacke was listed among a group of Experiments in Art and Technology members interested to meet with IBM representatives to discuss a possible collaboration.[23] For the Art and Technology program at LACMA, Haacke pitched several proposals, all of which failed to secure the collaboration of the companies to which they were addressed, including Ampex and General Electric.[24]

Experiments in Art and Technology also brokered Haacke's 1968 lecture at the annual general meeting of the Inter-society Color Council.[25] The talk was part of a

symposium covering "color in commerce and the arts," organized by packaging designer Karl Fink.[26] Attendees were informed of the event that an "'oddball' balance will be struck between a sound marketing forum and a presentation of the sights and sounds of the newest art media."[27] For the designers and manufacturers that were the event's chief constituency, Haacke played the role of the avant-garde futurist. His talk may have pointedly avoided the subject of color, but in describing how his work "engages the viewer in a multi-sensory way, not only involving his eye, but also his touch, hearing and sense of rhythm," his expansive imagining of aesthetic experiences was not difficult to translate into the business of consumer marketing.[28] These relations went in both directions. As art historian John Tyson has recognized, the survey techniques that Haacke would soon incorporate into his practice were "not so far removed from advertising," their form no less associated with the fields of consumer marketing and motivational research than their equivalents in sociology and politics.[29]

The paradox of a conceptual art posing ideological challenges to capitalism while attracting the support of corporate sponsors was difficult to miss in the late 1960s and early 1970s. In the Museum of Modern Art exhibition *Information* (1970), as Mary Anne Staniszewski has described, Haacke's controversial *MOMA Poll* (1970) was juxtaposed at the exhibition's entry with a branded "visual jukebox" supplied by business machine manufacturer Olivetti. The prominence of corporate sponsors in museum exhibitions in the early 1970s—one that had shifted from a direct interaction with artists to more likely an engagement with the curator—would soon make way for more subtle, and sometimes even covert, forms of acknowledgment that capitalized on the persuasive possibilities of avant-garde practice while dodging the challenges of working with artists. "MoMA's current practice of treating exhibition design as an aesthetic experience that is ideologically, politically, and economically neutral represent a new type of cultural apparatus that attracts corporate sponsorship," Staniszewski writes of the manifestation of these relations in museum display. "However indispensable corporations are now in the production of museum exhibitions, their presence has become, in a very important sense, less visible. . . . In effect, with the changes that took place in the 1960s and 1970s art apparatus, the corporation—and the power that it wields—went underground."[30] The tumultuous history of corporate art patronage in the 1960s helps explain the paradigms of sponsorship that would emerge in its wake.

In other contexts, Haacke demonstrated his understanding of the importance of recognizing corporate support. The invitation for a 1968 exhibition at the Howard Wise Gallery indicates his modest success in securing in-kind support and understanding the kind of acknowledgment it required: "Execution of refrigerated works has been assisted by Harry Appell and King Freeze Corp., New York. . . . Photo electric equipment is supplied courtesy of Standard Instruments Corp., a division of Automatic Timing and Controls." But more often than not, his interest in technology was thwarted by corporate indifference. When Haacke approached several news syndicates to participate in his work *News* (1969), all except UPI refused, and even this agency

charged him installation and rental fees for its prominently branded unit.[31] In the case of Jack Burnham's exhibition *Software* (1971), held at the Jewish Museum (for which public relations agency Ruder & Finn helped secure American Motors as a major sponsor), Haacke's visitor survey remained unrealized because of the malfunction of the computer lent by the Digital Equipment Corporation.[32]

These were the kinds of letdowns that further encouraged many artists to alter their views on the potential benefits of working with business. For example, not long before Guerrilla Art Action Group cofounder Jean Toche would dramatically protest Standard Oil's connections to MoMA through the Rockefellers and Xerox sponsorship at the Metropolitan Museum of Art, he had been actively seeking corporate support for his light art projects, writing to bulb manufacturer Sylvania requesting four hundred free light globes for an exhibition in return for a "one-page advertisement in the catalog."[33] When that request failed, he asked E.A.T. staff for contacts at General Electric and Philips.[34] For all of the rhetoric about the possibilities of corporate patronage, the repeated failure of companies to deliver on the needs of artists undoubtedly sharpened the critical turn of Haacke and others against the rhetoric of this field.

Some might regard the contradictions of such fluctuating allegiances as circumstantial. And they were far from consistent or permanent; nor were they unidirectional. But given that Haacke's reputation would eventually depend on his exposé of the role of museum sponsorship in corporate persuasion, his own proximity to the work of so-called Madison Avenue mercenaries seems, to me, to be significant. At the very least, these details provide a relevant context for the artist's shift from environmental and technological actions to corporate and institutional critique, whatever consistent methodologies might underpin these approaches. Further, when Haacke claims of his inclusion in Szeemann's 1969 exhibition that the "implication of corporate sponsorship on culture was not yet recognized as an issue," he artificially isolates exhibition sponsorship from the more substantive artistic engagements with corporate persuasion, neglecting the mounting critical cynicism toward corporate art in the late sixties and early seventies, including several of the exhibitions in which his work was featured.[35] These were emerging critiques that his own practice would build upon but did not originate.

By the mid-1960s, questions about the status of the art object as an economic instrument already played a central role in the practices of many artists. As a wide range of practitioners embedded the legalistic form of the contract, or the financial fluctuations of speculative investment, in the very substance of their works, the result was not simply to attack the values of managerial capitalism or high finance but to use these genres—as Sophie Cras has argued—"to critique art as a confined and self-regulated discipline."[36] As Cras and others have begun to demonstrate, a wide range of artists of the sixties mounted richly theoretical critical engagements with the economic frameworks of capitalism.[37] One of the most sustained engagements with corporate models in postwar art was Fluxus, whose self-appointed chairman George Maciunas systematically exploited the boundaries between the "corporate imagina-

tion" and avant-garde practice. As art historian Mari Dumett has shown, Macunias's own encounters with the corporate sphere undoubtedly informed his approach. He had worked for Skidmore, Owings & Merrill during its design of the Chase Manhattan headquarters and, as Dumett points out, might well have been "privy to the firm's role in promoting the corporatization of art."[38] To say that Macunias's attitude toward capitalism was merely ambivalent would not quite go far enough. "What at first appears contradictory—a radical incorporated art collective," Dumett explains, is "a coherent, if complicated, set of critical artistic practices devised specifically for the realities of life in the increasingly corporatized culture of the 1960s and 1970s."[39]

Or, to choose a lesser-known example, consider the mail art of Minneapolis-based artist Don Celender, a corporatized conceptualism that approaches the absurdity of Monty Python. Begun in 1969, Celender's project was documented in a publication titled *Political Art Movement, Religious Art Movement, Affluent Art Movement, Academic Art Movement, Corporate Art Movement, Cultural Art Movement, Mass Media Art Movement, Organizational Art Movement* (1972). Celender mailed farcical proposals in each of these categories to potential patrons, including some twenty-five chief executive officers of major corporations.[40] Campbell Soup Company chairman John Dorrance, for example, was asked to make a "facsimile" of Andy Warhol, add him to a batch of Chicken Noodle Soup packaged in human-shaped cartons, and ship these products to cannibals in Papua New Guinea.[41] In this case, and in many other cases of absurdly unrealizable ideas, Celender's corporate muses simply ignored his letters, their lack of response registered as blank pages in the resulting artist book.

But some companies did reply. Standard Oil Company of New Jersey had been asked to "change all current pipe lines to clear plastic and place them above ground on illuminated supports so that oil can be seen moving from refineries to points of distribution." As the artist explained, the result would be "continuous linear forms in flux or liquid illuminated sculpture in motion," sounding something like the kind of environmental systems that once so interested Haacke. Almost a year later, Standard Oil finally replied to the proposal. "Plastic pipe cannot, at the present time, meet the requirements of 'Oil Transportation code ASA B 31.4,'" wrote Standard Oil's apparently humorless (or exceedingly dry) manager. "Even if the use of plastic pipe were technically feasible, the cost would be prohibitive." Not all responses were so tolerant. A vice president from paper manufacturer Georgia-Pacific thought that Celender's request was contemptible. "In these times of social and economic need, your proposal can only be viewed as one without merit."[42] General Motors, by contrast, played along. "Your proposal for a new line of Pop Art automobiles in the shape of celebrities like Ralph Nader and Charles DeGaulle has aroused our interest. . . . If all goes smoothly we could probably have the first Nader car off the assembly line before General Foods fills the last manhole with cherry Jello, as you suggested to them."[43]

Rather than miming the modes of corporate public relations to achieve a kind of foot-in-the-door journalistic exposé, Celender inhabits the corporate imagination in

all its creativity and strangeness—engaging with its aesthetic and discursive modes in ways that, I think, more profoundly destabilize its authority. By so carefully elaborating upon the imaginative routines of public relations, a project like this rightly understands corporate image to be just as sophisticated and complex as the artworks that were drawn into its orbit. For what could be more conceptual than a brand? Or more carefully composed than a press release or a media stunt? Or more blandly abstract and yet densely symbolic than a modern logo? These were aesthetic acts that were influenced by art and artists, and that could shape the works that they made.

There are some signs that the norms of museum sponsorship that came to play such a central place in cultural funding since the 1970s are beginning to splinter. There have certainly been many attempts to instigate direct collaboration between artists and businesses over the past decades, but many contemporary artists remain unwilling to grapple with the complex ethical dilemmas of corporate patronage, systems they are quick to criticize but also usually content to delegate to museums. In 2014, for example, a group of artists withdrew from the Biennale of Sydney over the sponsorship of Transfield, a construction and infrastructure conglomerate involved in the operation of the Australian government's asylum seeker detention facilities. In response, the Biennale organizers dropped the company's sponsorship. "This changes everything and I would be proud to work with an organisation that stands up for human rights in the way the Biennale has done," responded one of the protesting artists of the result.[44] Their protest vindicated, it apparently mattered less that the Australian government itself remained the event's major funder.

Seen historically, the connections between state and private interests exemplified by the Biennale of Sydney are more complex still. Transfield was not just a sponsor of the Biennale; it basically created it. Founded in 1973 by company cofounder Franco Belgiorno-Nettis, and building on the success of the company's high-profile art prize throughout the 1960s, the Biennale was always already in the business of corporate image. This was not the first time that the event had provoked protests either. In 1976, Prime Minister Malcolm Fraser and Belgiorno-Nettis faced three hundred demonstrators at the opening of the event, protesting the government's uranium-mining policy and budget cuts to the national broadcaster, but also the unequal gender representation of the exhibition itself.[45] Then and now, such protests are neither ineffectual or misguided, but the idea that Transfield's withdrawal restored the event's prior purity fails to grapple with the complexities of a much longer history of intersecting state, corporate, and cultural interests.

In other instances, artists would do well to learn from Haacke's own careful research into the webs of art patronage and museum sponsorship. In early 2018, photographer Nan Goldin led a protest at the Metropolitan Museum of Art over the support it accepted from the Sackler family, majority owners of the company Purdue Pharma, which produced and marketed the widely abused pain medication OxyContin.[46] The protest occurred in the museum's Sackler Wing, where protesters hurled

prescription bottles into the reflecting pool and, with a nod to 1960s parlance, staged a "die-in" in the shadow of the museum's Temple of Dendur. Similar actions have since occurred at museums around the world. But the Sackler Wing was funded by Arthur Sackler in the 1970s, long before OxyContin was invented. "Passing judgment on Arthur's life's work through the lens of the opioid crisis some 30 years after his death is a gross injustice," read a response from the philanthropist's widow.[47] Goldin's rage against the makers of OxyContin is, of course, entirely justified, but failing to distinguish between the involvement of different members of the Sackler family undermines the credibility of its critique, settling for the moral certainty of a named villain rather than grappling with the more complex thicket of commercial, scientific, and regulatory interests behind the epidemic.[48] "Philanthropy has always been toxic," writes art historian David Joselit in the wake of the forced expulsion of board cochair and defense industry executive Warren Kanders from the Whitney Museum of American Art's board of trustees in 2019. "Expelling villainous benefactors who are museum trustees, as much as they deserve it, will leave toxic philanthropy intact unless a systematic analysis is sustained."[49] The necessary foundation for such analyses is more detailed historical accounts of modern patronage and its operating strategies.

Angry mobs on the steps of the museum might make good photo ops, but actions that stop here fail to take full advantage of the most powerful tool at the disposal of contemporary artists dissatisfied with entanglement of corporate interests in the museum: that is, artistic practice itself. Targeting Tate's connections to big oil through the sponsorship of BP, the gallery interventions of artist collective Liberate Tate achieve their force by engaging more creatively with operating strategies of their targets. For their performance *Toni and Bobbi* (2010), for instance, two artists smuggled bags of molasses into Tate Britain under capacious floral dresses and then staged a messy "oil spill" in the midst of the gallery's twentieth anniversary celebration of the BP sponsorship. By feigning surprise at the spill, attempting to contain the mess, and reassuring onlookers that the accident had affected only a very small part of the gallery, the pair mimicked the actions of the company that at the very same time was trying to clean up its own spill in the Gulf of Mexico.[50]

For their even more ambitious 2012 performance *The Gift,* Liberate Tate sought to donate a 16.5-foot blade from a wind turbine to the museum, its Brancusi-like form convincingly playing the part of a sleek modernist abstraction. The group deposited the 1300-kilogram "work" in Tate Modern's Turbine Hall, the former power station whose reliance on fossil fuels (first coal, and later oil) was maintained in more metaphorical terms through BP's institutional support. Completing the necessary paperwork for the museum to have to consider this gleaming white sculptural object as a gift to the collection under the terms of Britain's Museums and Galleries Act, the group left the museum with an unwieldy reminder of the possibilities of renewable energy sprawled across its most public gallery space. By fully inhabiting the image-conscious mindset of contemporary museum sponsorship, and the corporate image require-

ments they serve, such culture-jamming interventions provide, I think, more powerful engagements with the ethics of corporate patronage than protest banners and other conventional signs of dissent.

Still, the rise of museum sponsorship since the 1970s has allowed many contemporary artists to be insulated from the pressures of corporate patronage that they once might have faced head on. In the 1960s, as artists engaged directly with big business and its representatives, such illusions of autonomy were more difficult to maintain. As Alexander Alberro has rightly suggested of the period, the corporate world "imagined ambitious art not as an enemy to be undermined or a threat to consumer culture, but as a symbolic ally."[51] Further, I would suggest, many artists returned the favor, understanding big business as a generative force for their art, even at the same time as they could resist, even resent, its influence. Artists and businesses worked together to make forms of persuasion by which the consensus of the corporation's constituents—workers, consumers, and regulators—could be secured. In the United States and beyond, modern art provided big business with a powerful medium through which its image could be honed and its values materialized. Such practices represent a defining and central phenomenon of sixties art whose widespread impact and significance have remained too seldom acknowledged, marginalized by those who wish to preserve the fantasy of modernism disconnected from everyday life, and dodged by a social art history intent on reinforcing the avant-garde's contributions to the counterculture radicalism that has come to be regarded as the decade's defining legacy.

To strictly subscribe to either position disqualifies the practices of too many artists to provide a productive basis on which to understand the art of the sixties. And it fosters profound misconceptions about the politics of modern art, which, as Joselit has observed, "continue[s] to be guided by fantasies of revolution and subversion whose blatant impracticality renders them either cynically opportunistic or childishly naïve."[52] The diverse products of the postwar "culture boom" were produced not only to meet the demands of middle- and upper-class consumers but also to supply the persuasion industry with the material it needed to enrich the corporate image. Artists were far from idle bystanders in such activities. Whether they contributed to the realization of their patrons' commercial aims or sought to negate them, and no matter if their contributions were part of that always-unpredictable proportion of the "marketing mix" that actually achieved its goals, the artworks involved in these contexts were inextricably entangled in the vast machinery by which corporate capitalism sought to enhance its reputation and secure its global influence.

# ABBREVIATIONS

| | |
|---|---|
| AAA | Archives of American Art, Smithsonian Institution, Washington, DC |
| AAPG | American Art Museum / National Portrait Gallery Library, Smithsonian Institution, Washington, DC |
| AGSA | Art Gallery of South Australia Archives, Adelaide |
| AKAG | Albright-Knox Art Gallery Archives, Buffalo, NY |
| BANC | Bancroft Library, University of California, Berkeley |
| CSULB | University Archives and Special Collections, California State University, Long Beach |
| FAA | Fondazione Ansaldo Archives, Genoa |
| FLSC | Fales Library and Special Collection, New York University, New York |
| GRI | Getty Research Institute Special Collections, Los Angeles |
| HAT | History of Advertising Trust, Norwich |
| HML | Manuscript and Archives Department, Hagley Museum and Library, Wilmington, DE |
| LACMA | Los Angeles County Museum of Art Archives, Los Angeles |
| LMZ | Liemers Museum, Zevenaar |
| LOC | Library of Congress, Washington, DC |
| LTDL | Legacy Tobacco Documents Library, University of California San Francisco, http://legacy.library.ucsf.edu |
| MoMA | Museum of Modern Art Archives, New York |
| NMAH | Archives Center, National Museum of American History, Washington, DC |

| PMPDA | Philip Morris Public Document Archive, http://www.pmdocs.com |
| R&B | Ryerson and Burnham Art and Architecture Archive, Art Institute of Chicago |
| SAAM | Smithsonian American Art Museum, Washington, DC |
| SCRC | Special Collections Research Center, University of Chicago, Chicago |
| SIA | Smithsonian Institution Archives, Smithsonian Institution, Washington, DC |
| TGA | Tate Gallery Archive, London |
| UBAG | University of Buffalo Art Gallery, Buffalo, NY |
| WAG | Whitechapel Art Gallery Archive, London |
| WHS | Wisconsin Historical Society, Madison |

# NOTES

**INTRODUCTION**

The epigraph is from "Business Takes to Collecting Art; Shows It with 'Beaming Vitality,'" *Chicago Daily Tribune*, May 21, 1961, B10. "Thru" is an example of the "simplified" spelling once widely used by American newspapers.

1. See, for example, "Latest Fad among the Brass: Find the Corporate Image," *Business Week*, October 3, 1959, 44–72, and Aaron Spector, "Basic Dimensions of the Corporate Image," *Journal of Marketing* 25, no. 6 (October 1961): 47–51.

2. Lee Hastings Bristol, *Developing the Corporate Image: A Management Guide to Public Relations* (New York: Scribner, 1960), xiii.

3. Pierre Martineau, *Motivation in Advertising* (New York: McGraw Hill, 1957), vii.

4. Martineau, *Motivation in Advertising*, 147.

5. John W. Riley, *The Corporation and Its Publics: Essays on the Corporate Image* (New York: John Wiley and Sons, 1963), ix.

6. I borrow this useful collective term for the interconnected but also distinct fields of advertising and public relations from John Pearson and Graham Turner, *The Persuasion Industry* (London: Eyre and Spottiswoode, 1966).

7. See, for example, Reinhold Martin, *The Organizational Complex: Architecture, Media and Corporate Space* (Cambridge, MA: MIT Press, 2003), Lynn Spigel, *TV by Design: Modern Art and the Rise of Network Television*

(Chicago: University of Chicago Press, 2009), Alice T. Friedman, *American Glamour and the Evolution of Modern Architecture* (New Haven, CT: Yale University Press, 2010), and John Harwood, *The Interface: IBM and the Transformation of Corporate Design, 1945–1976* (Minneapolis: University of Minnesota Press, 2011).

8. Monica E. Jovanovich and Melissa Renn, "Introduction: Beyond the Commercial: Corporate Patronage Reconsidered," in *Corporate Patronage of Art and Architecture in the United States, Late 19th Century to the Present*, ed. Monica E. Jovanovich and Melissa Renn (New York: Bloomsbury, 2019), 1.

9. For the former, see Thomas Frank, *The Conquest of Cool: Business Culture, Counterculture and the Rise of Hip Consumerism* (Chicago: University of Chicago Press, 1997), David Brooks, *Bobos in Paradise: The New Upper Class and How They Got There* (New York: Simon and Schuster, 2000), Fred Turner, *From Cyberculture to Counterculture: Stewart Brand, the Whole Earth Network and the Rise of Digital Utopianism* (Chicago: University of Chicago Press, 2006), and Joshua Clark Davis, *From Head Shops to Whole Foods: The Rise and Fall of Activist Entrepreneurs* (New York: Columbia University Press, 2020). For the latter, see, for example, Matthew Wisnioski, *Engineers for Change: Competing Visions of Technology in 1960s America* (Cambridge, MA: MIT Press, 2012) and Fred Turner, *The Democratic Surround: Multimedia and Liberalism from World War II to the Psychedelic Sixties* (Chicago: University of Chicago Press, 2013). Art historical accounts of these contacts include Pamela M. Lee, *Think Tank Aesthetics: Midcentury Modernism, the Cold War and the Neoliberal Present* (Cambridge, MA: MIT Press, 2020), and John Blakinger, *Gyorgy Kepes: Undreaming the Bauhaus* (Cambridge, MA: MIT Press, 2019).

10. See, for instance, Mari Dumett, *Corporate Imaginations: Fluxus Strategies for Living* (Berkeley: University of California Press, 2017), and Sophie Cras, *The Artist as Economist: Art and Capitalism in the 1960s* (New Haven, CT: Yale University Press, 2019). I return to the important contribution of these books in my conclusion.

11. The classic account of the development of such systems and structures is Alfred Chandler, *The Visible Hand: The Managerial Revolution in American Business* (Cambridge, MA: Harvard University Press, 1977). For a useful survey of the economic factors that defines the period, see Stephen A. Marglin and Juliet Schor, *The Golden Age of Capitalism: Reinterpreting the Postwar Experience* (Oxford: Clarendon, 1990). Growing scholarly attention to the social and cultural influence of the corporation includes Kenneth Lipartito and David B. Sicilia, *Constructing Corporate America: History, Politics, Culture* (Oxford: Oxford University Press, 2004), and Marina Welker, Damani J. Partridge, and Rebecca Hardin, eds., "Corporate Lives: New Perspectives on the Social Life of the Corporate Form," Supplement, *Current Anthropology* 52 (April 2011).

12. See, for example, Elspeth H. Brown, *The Corporate Eye: Photography and the Rationalization of American Commercial Culture, 1884–1929* (Baltimore: Johns Hopkins University Press, 2005), and Terry Smith, *Making the Modern: Industry, Art and Design in America* (Chicago: University of Chicago Press, 1993).

13. T.J. Jackson Lears, *Fables of Abundance: A Cultural History of Advertising in America* (New York: Basic Books, 1994), 270. The "hybrid" status of the nineteenth-century "artistic" posters is well described in Ruth Iskin, *The Poster: Art, Advertising, Design and Collecting, 1860s to 1900s* (Hanover, NH: Dartmouth University Press, 2014).

14. Michele H. Bogart, *Artists, Advertising, and the Borders of Art* (Chicago: University of Chicago Press, 1995), 7.

15. Bogart, *Artists, Advertising*, 284.

16. Bogart, *Artists, Advertising*, 291. Similarly, in revealing how fine art supported the corporate liberalism of *Fortune* magazine in the 1930s, Michael Augspurger concludes that this "did not survive the post-war moment," which saw a "withering of *Fortune*'s vision of a harmonious and

mutually beneficial relationship between business and art." Michael Augspurger, *An Economy of Abundant Beauty: Fortune Magazine and Depression America* (Ithaca, NY: Cornell University Press, 2004), 13.

17. For a period recognition of this expansion, see, for example, the republished essay on art and business by Russell Lynes that notes that "since this article appeared in *Art in America* in the Spring issue of 1956, more and more corporations have befriended the arts." Russell Lynes, "Whose Business Is Art?," in *Confessions of a Dilettante* (New York: Harper and Row, 1966), 25.

18. Steuart Britt, *The Spenders: Where and Why Your Money Goes* (New York: McGraw-Hill, 1960), 140.

19. On Stern and Penn's contributions to the "For Those Who Think Young" campaign, see "Think Young," *Pepsi-Cola World*, March 1961, 17–19.

20. László Moholy-Nagy, *Vision in Motion* (Chicago: P. Theobald, 1947), 77.

21. On Pepper's *Contrappunto,* see Aaron Ziolkowski, "Art on the Ground Floor: From the Lobby to the Plaza, the Art and Architecture of Cold War Corporate Modernism" (PhD diss., Pennsylvania State University, 2020), 247–51.

22. Under her maiden name Beverly Gussin, her work for J.D. Tarcher & Co. included award-winning print advertisements for Coty Cosmetics in the late 1940s that used the swift, decisive drawings of Carl "Eric" Erikson to cultivate a chic, European air.

23. "Public Relations: Gallery 500," *Pepsi-Cola World,* November 1962, 17.

24. Stuart Preston, "Dark Horses: Young French Painters, Groups Elsewhere," *New York Times,* June 16, 1963, 100. On Pepsi-Cola's partnership with Source Perrier, see *Foreign Commerce Weekly,* March 5, 1962, 378.

25. Lygia Clark was featured in *Brazil: New Images* in March-April 1963, including her "critter" *Sundial* (1960), now in the MoMA collection. See Bernard J. Buranelli, "Brazilian Art Show Called Worth Seeing," *The Record* (Hackensack, NJ), March 27, 1963, 80. Marta Minujin was included in *Buenos Aires 64* in September-October 1964. On the reception of this touring exhibition, see Andrea Giunta, *Avant-Garde, Internationalism and Politics: Argentinian Art in the Sixties* (Durham, NC: Duke University Press), 210–11.

26. Cleveland Armory, "First of the Month," *Saturday Review,* August 7, 1965, 6.

27. "Public Relations," *Pepsi-Cola World,* May 1959, 12.

28. Designed by Chermayeff and Geismar for Pepsi-Cola, the exhibition was toured by the Smithsonian Institution throughout the 1960s. "U.S. Flag Story on Exhibit," *Star-Gazette* (Elmira, NY), August 13, 1968, 3.

29. Brian O'Doherty, "Art: An Exhibition of Firearms Opens," *New York Times,* June 9, 1962, 22. For an installation image showing the bullet-hole ridden exhibition graphic, see "Gallery 500," *Pepsi-Cola World,* November 1962, 17.

30. The 1960s does, however, receive broad coverage in Judith A. Barter, "The New Medici: The Rise of Corporate Collecting and the Uses of Contemporary Art, 1925–1970" (PhD diss., University of Massachusetts, 1991). Other texts describe aspects of the phenomenon as context for their own subjects. See, for example, the useful summaries in Alexander Alberro, *Conceptual Art and the Politics of Publicity* (Cambridge, MA: MIT Press, 2003), 12–16, and James Meyer, *Minimalism: Art and Polemics in the Sixties* (New Haven, CT: Yale University Press, 2001), 28–29.

31. Chin-Tao Wu, *Privatising Culture: Corporate Art Intervention since the 1980s* (London: Verso, 2002); Mark Rectanus, *Culture Incorporated: Museums, Artists and Corporate Sponsorships* (Minneapolis: University of Minnesota Press, 2002). Frankfurt School models also underpin the accounts of Herbert Schiller, *Culture Inc.: The Corporate Takeover of Public Expression* (Oxford: Oxford University Press, 1989), and Timothy Luke, *Shows of Force: Power, Politics, and Ideology and Art Exhibitions* (Durham, NC: Duke University Press, 1992).

32. Much of the scholarship on corporate patronage has come from outside the field of art history. My approach also rejects the sociological empiricism of Rosanne Martorella, *Corporate Art* (New Brunswick, NJ: Rutgers University Press, 1990), and the policy analysis of Marjorie Garber, *Patronizing the Arts* (Princeton, NJ: Princeton University Press, 2008), which claims college sports as a model for the university's potential as an ideal arts patron.

33. Erika Doss, *Benton, Pollock, and the Politics of Modernism* (Chicago: University of Chicago Press, 1991), 239.

34. Patricia Johnson, *Real Fantasies: Edward Steichen's Advertising Photography* (Berkeley: University of California Press, 1997), 3. Other texts that have influenced my thinking here include Thomas Crow, *Modern Art in the Common Culture* (New Haven, CT: Yale University Press, 1996), and Nancy Troy, *Couture Culture: A Study in Modern Art and Fashion* (Cambridge, MA: MIT Press, 2003).

35. Francis Haskell, *Patrons and Painters: A Study in the Relations between Italian Art and Society in the Age of the Baroque* (New York: Harper and Row, 1971), xviii.

36. Haskell, *Patrons and Painters*, 3–23; Francis Haskell, *Past and Present in Taste: Selected Essays* (New Haven, CT: Yale University Press, 1987), 58.

37. Michael Baxandall, *Painting and Experience in Fifteenth Century Italy: A Primer in the Social History of Pictorial Style* (Oxford: Oxford University Press, 1988), 1, and Michael Baxandall, *The Limewood Sculptors of Renaissance Germany* (New Haven, CT: Yale University Press, 1980).

38. Among scholars of American art, Baxandall remains a key model for recent studies of late nineteenth-century patronage. See, for example, John Ott, *Manufacturing the Modern Patron in Victorian California: Cultural Philanthropy, Industrial Capital and Social Authority* (Farnham: Ashgate, 2014), and Melody Barnett Deusner, *Aesthetic Painting in Britain and America: Collectors, Art Worlds, Networks* (London: Paul Mellon Centre for Studies in British Art, 2020).

39. David Nye, *Image Worlds: Corporate Identities at General Electric, 1890–1930* (Cambridge, MA: MIT Press, 1985), 4.

40. Oscar Schisgall, "American Business Sponsors Art," *Today's Living*, April 24, 1960, 26.

41. On the central position of consumer capitalism and trade to this activity, see Laura Belmonte, *Selling the American Way: U.S. Propagandists and the Cold War* (Philadelphia: University of Pennsylvania Press, 2010), 116–35. For an excellent account of how "public-private partnerships" were essential to this field, see Greg Barnhisel, *Cold War Modernists: Art, Literature, and American Cultural Diplomacy* (New York: Columbia University Press, 2015), 55–92.

42. Galbraith's talk was subsequently expanded into an essay, and it is from this source that I quote. John Kenneth Galbraith, "Economics and Art," in *The Liberal Hour* (Boston: Houghton Mifflin, 1960), 52.

43. Galbraith, "Economics and Art," 69.

44. On the key players and claims of the so-called creative revolution, see Robert Jackall and Janice M. Hirota, *Image Makers: Advertising, Public Relations and the Ethos of Advocacy* (Chicago: University of Chicago Press, 2000), 67–89.

45. John Kenneth Galbraith, *The Affluent Society* (London: Hamish Hamilton, 1958), 194.

46. Schisgall, "American Business Sponsors Art," 26.

47. On the former, see, for instance, Victoria Grieve, *The Federal Art Project and the Creation of Middlebrow Culture* (Chicago: University of Illinois Press, 2009); on the latter, see Gary O. Larson, *The Reluctant Patron: The United States Government and the Arts, 1943–1965* (Philadelphia: University of Pennsylvania Press, 1983).

48. Bogart, *Artists, Advertising*, 11; Doss, *Benton, Pollock*, 5.

49. Such strategies are extensively described in Caroline Jones, *Machine in the Studio: Constructing the Postwar American Artist* (Chicago: University of Chicago Press, 1996).

50. Presciently, Boorstin further noted that "moral indignation" about the "untruthfulness" of advertising merely obscured the more profound "reshaping of our very concept of truth" it involved. Daniel Boorstin, *The Image: A Guide to Pseudo-events in America* (New York: Harper and Row, 1961), 195, 205. On Boorstin's unique attention to the circulation and dissemination of the image in modern mass media, see Vanessa Schwartz, *Jet Age Aesthetic: The Glamour of Media in Motion* (New Haven, CT: Yale University Press, 2020), 106–10.

51. On earlier efforts to regulate advertising, see Inger L. Stole, *Advertising on Trial: Corporate Activism and Corporate Public Relations in the 1930s* (Urbana: University of Illinois Press, 2006).

52. Historians have noted the significance of Packard's work for the rise of consumer protections in the 1960s. See, for example, Lizabeth Cohen, *A Consumers' Republic: The Politics of Mass Consumption in Postwar America* (New York: Alfred A. Knopf, 2003), 347. Packard's influence on artists has also been well recovered. See Joshua Shannon, *The Disappearance of Objects: New York Art and the Rise of the Postmodern City* (New Haven, CT: Yale University Press, 2009), 60–80, Michael Lobel, *James Rosenquist: Pop Art, Politics and History in the 1960s* (Berkeley: University of California Press, 2009), 61–64, 128–29, and John Curley, *A Conspiracy of Images: Andy Warhol, Gerhard Richter and the Art of the Cold War* (New Haven, CT: Yale University Press, 2013), 62–65.

53. Vance Packard, *The Status Seekers* (London: Longmans, 1960), and Vance Packard, *The Waste Makers* (London: Longmans, Green, 1961).

54. See, for example, the defense of Packard's work in Herbert Marcuse, *One Dimensional Man: Studies in the Ideology of Advanced Industrial Society* (Boston: Beacon Press, 1964), xvii, or his repeated citation in Ernest Mandel, *Marxist Economic Theory* (New York: Monthly Review, 1969). By the 1970s, Packard's critique of advertising would come to seem insufficient to more systemic critiques of consumer capitalism. See, for example, Stuart Ewen, *Captains of Consciousness: Advertising and the Social Roots of the Consumer Culture* (New York: McGraw-Hill, 1976), 187–220.

55. For a useful survey of such criticisms, see Charles Perrow, *The Radical Attack on Business* (New York: Harcourt Brace Jovanovich, 1972).

56. Students for a Democratic Society, *The Port Huron Statement* (Chicago: C.H. Kerr, 1990), 23.

57. Terry H. Anderson, "The New American Revolution: The Movement and Business," in *The Sixties: From Memory to History*, ed. Dennis Farber (Chapel Hill: University of North Carolina Press, 1994), 176.

58. Quoted in Elizabeth A. Fones-Wold, *Selling Free Enterprise: The Business Assault on Labor and Liberalism 1945–60* (Urbana: University of Illinois Press, 1994), 286. See also Roland Marchand, *Creating the Corporate Soul: The Rise of Public Relations and Corporate Imagery in American Big Business* (Berkeley: University of California Press, 2001).

59. Riley, *Corporation and Its Publics*, 20.

60. Lipartito and Sicilia, *Constructing Corporate America*, 346. After World War II, many companies focused on community and public relations efforts designed to weaken big labor and promote free enterprise. See Fones-Wold, *Selling Free Enterprise*, and William L. Bird, *"Better Living": Advertising, Media and the New Vocabulary of Business Leadership, 1935–1955* (Evanston, IL: Northwestern University Press, 1999).

61. Edward C. Bursk, "Thinking Ahead," *Harvard Business Review*, May–June 1960, 26.

62. Richard Eells, *The Corporation and the Arts* (New York: Macmillan, 1967), 11.

63. On the litany of criticisms that General Electric had to deal with, see Jerry Demuth, "GE: Profile of a Corporation," *Dissent*, July–August 1967, 502–12.

64. This is the claim that appears on the dust jacket of Eells, *Corporation and the Arts*.

65. I borrow this characterization from Hansfried Kellner and Frank W. Heuberger, *Hidden Technocrats: The New Class and New Capitalism* (New Brunswick, NJ: Transaction, 1992).

66. See Donna M. Binkiewicz, *Federalizing the Muse: United States Arts Policy and the National Endowment for the Arts, 1965–1980* (Chapel Hill: University of North Carolina Press, 2004).

67. Although BCA has not yet been the subject of a critical history, it published several volumes promoting its activities in this period, including Arnold Gingrich, *Business and the Arts: An Answer to Tomorrow* (New York: Paul S. Eriksson, 1969) and Gideon Chagy, ed., *The State of the Arts and Corporate Support* (New York: Paul S. Eriksson, 1971).

68. Milton Friedman, *Capitalism and Freedom* (Chicago: University of Chicago Press, 1962), 133.

69. Milton Friedman, "The Social Responsibility of Business Is to Increase Its Profits," *New York Times*, September 13, 1970, 32.

70. M. Friedman, "Social Responsibility of Business," 122. Citing Friedman, Lewis Powell's August 1971 "Attack on American Free Enterprise System" memorandum for the United States Chamber of Commerce specifically mentions "the arts" among the threats to American business. See "Powell Memorandum: Attack on American Free Enterprise System," Powell Papers, Powell Archives, Scholarly Commons, https://scholarlycommons.law.wlu.edu/powellmemo/.

71. On these practices, see Julia Bryan-Wilson, *Art Workers: Radical Practice in the Vietnam Era* (Berkeley: University of California Press, 2009).

72. On the politics of the Coke bottle in 1960s art, see John J. Curley, *Global Art and the Cold War* (London: Lawrence King, 2018), 129–33. For an example of this discourse at work, see the Latin American responses to Esso-sponsored exhibits in Latin America detailed in Niko Vicario, *Hemispheric Integration: Materiality, Mobility, and the Making of Latin American Art* (Oakland: University of California Press, 2020), 210–13.

73. Wolf Von Eckardt, "There's No Variety in Modern Art," *Washington Post*, April 12, 1964, G5.

74. Rosalind Krauss, "Post-modernism within and beyond the Frame," in *Art of the Western World*, ed. Denise Hooker (London: Boxtree, 1989), 424–26. These are persistent models: the same sentences also appeared in the *Art since 1900* textbook fifteen years later.

75. Alex Potts, *The Sculptural Imagination: Figurative, Modernist, Minimalist* (New Haven, CT: Yale University Press, 2000), 255.

76. Potts is writing here about minimalism (*Sculptural Imagination*, 255). In a more recent text, Potts explores the shifting politics of 1960s avant-gardes but concludes by defining his interest to be "the complex interplay between political commitment and artistic commitment that loomed large for the more radically minded artists working in the long postwar period, and that came to a head with the explosion of counter-cultural activity in the 1960s." Alex Potts, *Experiments in Modern Realism: World Making, Politics and the Everyday in Postwar European and American Art* (New Haven, CT: Yale Unversity Press, 2013), 21.

77. Jeremi Suri, "The Rise and Fall of an International Counterculture," *American Historical Review* 114, no. 1 (February 2009): 48. See also Tor Egil Førland, "Cutting the Sixties Down to Size: Conceptualizing, Historicizing, Explaining," *Journal for the Study of Radicalism* 9, no. 2 (Fall 2015): 125–48, and Alexander Sedlmaier and Stephan Malinowski, "1968—A Catalyst of Consumer Society," *Cultural and Social History* 8, no. 2 (2011): 255–74. Boltanski and Chiapello have further suggested that the "paradoxical impact" of late 1960s critiques of capitalism was that its "artistic critique" hastened the "flexible" labor transformations of so-called neoliberalism. Luc Boltanski and Ève Chiapello, *The New Spirit of Capitalism* (London: Verso, 2005), 199.

78. Philip Ursprung, *Allan Kaprow, Robert Smithson and the Limits to Art* (Berkeley: University of California Press, 2013), 191–92.

79. I am indebted to other accounts of this episode, including Marga Bijvoet, *Art as Inquiry* (New York: Peter Lang, 1997), 41–44, Lynne Cooke, "Through a Glass Darkly . . .," in *Robert Whitman: Playback* (New York: Dia Art Foundation, 2003), 74–86, Anne Collins Goodyear, "Expo '70 as Watershed: The Politics of Art and Technology," in *Cold War Modern*, ed. David Crowley and

Jane Pavitt (London: V&A, 2008), 198–201, and Fred Turner, "The Corporation and the Counterculture: Revisiting the Pepsi Pavilion and the Politics of Cold War Multimedia," *Velvet Light Trap* 73 (Spring 2014): 66–78.

80. "Exhibits: Involving the Viewer," *Wilson Library Bulletin,* March 1966, 727–29.

81. Alan Pottasch, Telex from Tokyo to New York, April 10, 1969, Box 44, Folder 11, Experiments in Art and Technology records, GRI.

82. Douglas Davis, "Uncle Sam Takes Pop Man to Lunch: Money, That's What Happening," *National Observer,* May 2, 1966, 1.

83. Billy Klüver, "The Artist in Industry," December 16, 1968, Box 138, Folder 24, Experiments in Art and Technology records, GRI. In September, Klüver had presented the same lecture at an Artist Placement Group event in London, an initiative that also sought to encourage collaborations between art and industry.

84. Klüver, "Artist in Industry," unpaginated. Klüver had in fact unsuccessfully invited Galbraith to join the board of E.A.T. See Box 41, Folder 3, Experiments in Art and Technology records, GRI.

85. Billy Klüver, "Artist in Industry," unpaginated.

86. "Pepsico International Makes $25,000 Grant to E.A.T.," *Soft Drink Review,* ca. 1968, Experiments in Art and Technology records, GRI.

87. For the best account of this iconic campaign, see Frank, *Conquest of Cool,* 169–71.

88. "There's a beat . . .," unidentified advertisement, ca. 1969, Box 151, Experiments in Art and Technology records, GRI.

89. Billy Kluver, "The Pavillion," in *New Media Reader*, ed. Noah Wardrip-Fruin and Nick Monfort (Cambridge, MA: MIT Press, 2003), 223. Early critical responses to the project also toed the line: "We are children embarking on a journey of discovery," wrote Gene Youngblood of the reflective dome in "The Open Empire," *Studio International,* April 1970, 178.

90. Harold Rosenberg, "The Artist as Perceiver of Social Realities: The Post-art Artist," in *The Arts and the Human Environment* (Madison: University of Wisconsin Extension Division, 1971), 503. Rosenberg's work for the Advertising Council has not yet been studied in detail but was not unknown to his contemporaries. See Neil Jumonville, *Critical Crossings: The New York Intellectuals in Postwar America* (Berkeley: University of California Press, 1990), 140–43.

91. Calvin Tompkins, "Talk of the Town: Automation House," *New Yorker,* March 14, 1970, 32; Alex Gross, "Who Is Being Eaten?," *East Village Other,* March 3, 1970, 14.

92. "Scenes," *Village Voice,* June 18, 1970, 20.

93. Quoted in Billy Klüver, Julie Martin, and Barbara Rose, *Pavilion* (New York: E.P. Dutton, 1972), 102.

94. Barbara Rose, "Art Fiction at the Fair," undated manuscript, 21, Barbara Rose Papers, GRI. In similar terms, Jackson Lears records the response of Pepsi executives to the avant-garde style of commercials by Ed Vorkapich: "We're not making art films! We're making commercials!" Lears, *Fables of Abundance,* 342–43.

95. "The reputation of E.A.T. was irreparably hurt by its rupture with the Pepsi-Cola Company," writes Jack Burnham in "Art and Technology, the Panacea That Failed," in *The Myths of Information: Technology and Post-industrial Culture,* ed. Kathleen Woodward (Madison, WI: Coda Press, 1980), 205.

96. "New Pepsico Headquarters Dedicated in Westchester," *New York Times,* October 3, 1970, 28. At the dedication of the new headquarters, the executive director of the National Urban League sought to reassure the audience that the company's move was not motivated "by the desire to escape some of the major social responsibilities of our time, leaving them behind in the city." Whitney Young quoted in "A New Motivation," *Pepsi-Cola World,* November-December 1970, 9. On the flight of American corporations from the city to the suburbs, see Louise A. Mozingo, *Pastoral Capitalism: A History of Suburban Corporate Landscapes* (Cambridge, MA: MIT Press, 2011).

**PART 1. REPACKAGING POP**

1. Exceptions include Cécile Whiting, *A Taste for Pop: Pop Art, Gender and Consumer Culture* (Cambridge: Cambridge University Press, 1997), and Anthony Grudin, *Warhol's Working Class: Pop Art and Egalitarianism* (Chicago: University of Chicago Press, 2017).

2. Christin J. Mamiya, *Pop Art and Consumer Culture: American Super Market* (Austin: University of Texas, Austin, 1992), 49.

3. Donald Kuspit, "Pop Art: A Reactionary Realism," in *Pop Art: The Critical Dialogue*, ed. Carol Anne Mahsun (Ann Arbor: UMI Research Press, 1997), 205.

4. On this point in the field of "corporate image" architecture, see Alice T. Friedman, *American Glamour and the Evolution of Modern Architecture* (New Haven, CT: Yale University Press, 2010), 3, 109–47, and "The Cultured Corporation: Art, Architecture and the Postwar Office Building," in *Architectures of Display: Department Stores and Modern Retail,* ed. Anca Lasc, Patricia Lara-Betancourt, and Margaret Maille Petty (Abingdon, Oxon: Routledge, 2018), 233–48.

**CHAPTER 1. TRADEMARKING CAMPBELL'S SOUP**

1. Martin Mylas, "Big Case Over lower case," *New York Herald Tribune*, October 20, 1963, 1–2, 6.

2. Mylas, "Big Case," 2.

3. Rainer Crone, "Form and Ideology: Warhol's Techniques from Blotted Line to Film," in *The Work of Andy Warhol*, ed. Gary Garrels (Seattle, WA: Bay Press, 1989), 73.

4. In one early version, Warhol makes a start on the medallion but seems to abandon the effort after just a few strokes. See George Frei and Neil Printz, *The Andy Warhol Catalogue Raisonné*, vol. 1: *Paintings and Sculpture, 1961–1963* (London: Phaidon Press, 2002), cat. no. 048.

5. Cécile Whiting, *A Taste for Pop: Pop Art, Gender and Consumer Culture* (Cambridge: Cambridge University Press, 1997), 45.

6. The paintings of cans exhibited at the Ferus Gallery in Los Angeles in 1962 were 20 x 16 inches each, and the first 1964 version was 36 x 24 inches.

7. On Warhol's "embrace" of off-register images, see Gerard Malanga, *Archiving Warhol: An Illustrated History* (New York: Creation Books, 2002), 34–37, 141, 144.

8. George Frei and Neil Printz, *The Andy Warhol Catalogue Raisonné*, vol. 2: *Paintings and Sculptures, 1964–1965* (London: Phaidon Press, 2003), cat. no. 1849.

9. While the commission is detailed in the 2002 catalogue raisonné, it is absent from almost all the copious literature on the Campbell's works. David Bourdon, *Warhol* (New York: Harry N. Abrams, 1989), 213, Anthony Grudin, *Warhol's Working Class: Pop Art and Egalitarianism* (Chicago: University of Chicago Press, 2017), 99, and Blake Gopnik, *Warhol* (New York: HarperCollins, 2020), 419, include passing mentions of the commission.

10. On the former point, see Benjamin Buchloh, *Neo-Avantgarde and Culture Industry: Essays on European and American Art from 1955 to 1975* (Cambridge, MA: MIT Press, 2000), 506.

11. Irving Blum quoted in Dick Polman, "But Is It Art?," *Philadelphia Inquirer*, November 2, 1985, D01. Blum says he never received a response to his suggestion. This account contradicts Blum's frequent claim that his goal was to keep the works together. See, for instance, "Oral History Interview with Irving Blum," by Paul Cummings, May 31, 1977, AAA.

12. Commissioned for Skidmore, Owings & Merrill's H.J. Heinz Research Center (1958), the work is now in the collection of the Carnegie Museum of Art, Pittsburgh, PA.

13. David Bourdon, "Warhol Interviews Bourdon," 1962–63, unpublished manuscript from the Andy Warhol Archives, Pittsburgh, PA, in Kenneth Goldsmith, *I'll Be Your Mirror: The Selected Andy Warhol Interviews, 1962–1987* (New York: Carroll and Graf, 2004), 12.

14. John Giorno, "Andy Warhol Interviewed by a Poet," 1963, unpublished manuscript from the Andy Warhol Archives, Pittsburgh, PA, in Goldsmith, *I'll Be Your Mirror*, 23. Drew Heinz

was the third wife of Henry John Heinz III, whose father was the CEO of the H.J. Heinz Company.

15. See James Stevenson, "If the Modern Museum Doesn't Snap It Up, Sam, the Bufferin People Certainly Will," *New Yorker,* December 22, 1962, 29. Having been found guilty by the FTC for making exaggerated claims for its headache pill Bufferin, Bristol Myers would have had good reason to turn from hard sell advertising to more creative tactics. See "4 Drug Concerns Accused on Ads: Makers of Aspirin, Anacin and Bufferin Are Cited," *New York Times,* March 20, 1961, 25.

16. Andy Warhol quoted in Bourdon, *Warhol,* 90.

17. E. Marshall Nuckols Jr., Vice President—Administrative Services, Campbell Soup Company, to William G. Linich, August 25, 1964, Collection Billy Apple.

18. Nuckols to Linich, August 25, 1964.

19. William C. Parker to Mr I.C. Karp, October 6, 1964, Leo Castelli Gallery Records, Box 22, Folder 32, AAA.

20. In a special issue of the trade journal *Printers' Ink* dedicated to the Campbell Soup Company, it was noted that "the intensity with which the company strives for quality in product laps over into an obsession with accuracy in marketing." "People, Tomatoes and Advertising: The Story of Campbell's Soup," *Printers' Ink,* February 18, 1955, 34.

21. Anthony Grudin, "'A Sign of Good Taste': Andy Warhol and the Rise of Brand Image Advertising," *Oxford Art Journal* 33, no. 2 (2010): 211–32.

22. Ann Ferebee, "Memorable Packages," *Industrial Design,* July 1960, 31. The clipping is quoted, but unidentified, in Frei and Printz, *Andy Warhol Catalogue Raisonné,* vol. 1, cat. nos. 043–050.

23. Ferebee, "Memorable Packages," 31. The article includes several packages Warhol would subsequently use in his work, including Listerine, Coca-Cola, and Chanel. In a later adaptation of this text, Ferebee would allude to Warhol's use of the Campbell Soup can design. See Ann Ferebee, *A History of Design from the Victorian Era to the Present* (New York: Van Nostrand Reinhold, 1970).

24. Martyn Howe, *International Business: Principles and Problems* (New York: Free Press of Glencoe, 1964), 93. See also G.E. Thomas, "The Importance of Color," in *The Power of Packaging* (New York: American Management Association, 1961), 65.

25. Daniel Sidorick, *Condensed Capitalism: Campbell Soup and the Pursuit of Cheap Production in the Twentieth Century* (Ithaca, NY: Cornell University Press, 2017), 153.

26. Sidorick, *Condensed Capitalism,* 154.

27. Campbell Soup Company, *Annual Report,* 1962, 6.

28. Campbell Soup Company, *Annual Report,* 1965, 5.

29. Campbell Soup Company, *Annual Report,* 1965, 148–49.

30. William C. Parker to Mr. I.C. Karp, October 6, 1964, Box 22, Folder 32, Leo Castelli Gallery Records, AAA.

31. "Campbell's Soups on Canvas," 18, unidentified clipping from Time Capsule 11, 1964, Andy Warhol Museum, Pittsburgh, PA.

32. "U.S. Action Urged in Trademark Bid," *New York Times,* February 14, 1966, F43. Aries fled the United States to escape a $21 million damages claim from drug companies for "industrial espionage."

33. In December 1965, Aries's role as the founding president of L'Institut International d'Expertise Scientifique (ISART) was announced in *La Chronique des Arts: Supplement à la Gazette des Beaux-Arts,* December 1965, 20. Its sole publication was Robert S. Aries, *Les faux dans la peinture et l'expertise scientifique* (Monte-Carlo, Monaco: Prochim S.A., 1965).

34. See, for instance, George Churchill memo to Ian Bruce et al., ca. November 1964, Campbells Soup Company, J. Walter Thompson Collection, 1/32/2/2/4, HAT.

35. "Op and Pop on the Walls," *New York Herald Tribune,* January 12, 1966, 15. On Warhol's own wallpaper projects from the same year, see Charles E. Stuckey, "Warhol in Context," in Garrels, *Work of Andy Warhol,* 17–18.

36. Rosalind Constable, "Styles Too Are Pushed Further Out by Pop," *Life,* February 26, 1966, 64. Made by major garment maker Rugg Togs Inc., the range was designed by Jeannemarie Volk. Bernadine Morris, "Dress Designers Turn to the Fashion Underworld," *New York Times,* October 26, 1965, 40.

37. For the most sustained treatment of this pivot, see Thomas Crow, "The Absconded Subject of Pop," *Res* 55–56 (Spring-Autumn 2009): 5–20, and its revised version that serves as the conclusion of Thomas Crow, *The Long March of Pop: Art, Music and Design, 1930–1995* (New Haven, CT: Yale University Press, 2014).

38. "Pillows, Place Mats Join Ranks of Media under Pop-Arts Plan," *Advertising Age,* May 13, 1968, 38.

39. "Labels Popular as Objets d'Art, Pop Arts Finds," *Advertising Age,* January 29, 1968 24. For an example of this product, see "Pop-Art Pillows from Kleenex," advertisement, *Seventeen,* August 1968, 28.

40. "Agency Takes 'Pop Art' Push into Marketplace," *Advertising Age,* March 29, 1965, 38. For a detailed account of Lichtenstein's imitation in advertising, see Whiting, *Taste for Pop,* 137–45.

41. "Show of Pop Art Objects Closes before Opening," *New York Times,* July 3, 1964, 45. Rosenquist remembers that artists had been invited to the show by Joan Crawford and that "her idea of pop art was the Pepsi paraphernalia: bottle caps, plastic spoons and glasses with the Pepsi logo, trays, signs, and so on." James Rosenquist, *Painting below Zero* (New York: Alfred A. Knopf, 2009), 114.

42. Gail Sheehy, "Pop Portraits and Pulp Profundities," *New York Herald Tribune,* March 20, 1965, 16.

43. Gopnik, *Warhol,* 400.

44. On the Mondrian dress, see Nancy Troy, *The Afterlife of Piet Mondrian* (Chicago: University of Chicago Press, 2013), 229–35.

45. The dress has indeed been mistaken in at least one book as the work of Warhol himself. See Adam Geczy and Vicki Karaminas, *Fashion and Art* (London: Bloomsbury, 2012), 8.

46. The product was manufactured by the Mars Manufacturing Company (unrelated to the confectionary brand), run by Audrey and Robert Bayer. See, for example, "It's a Happening!," advertisement, *New York Times,* November 8, 1966, 19, and "Notions," *New Yorker,* March 4, 1967, 34. The Bayers' papers are held at the University of North Carolina, Asheville, and their collection of paper clothing by the Asheville Art Museum.

47. William M. Freeman, "New Wares Shown by Premium Men," *New York Times,* September 27, 1966, 86.

48. "The Painting on the Dress Said 'Fragile,'" *New York Times,* November 11, 1966, 49. For another account of the event, see Ultra Violet, *Famous for Fifteen Minutes: My Years with Andy Warhol* (San Diego: Harcourt Brace Jovanovich, 1988), 106–7.

49. On Warhol's paper bag prints, see Constance W. Glenn, *The Great American Pop Art Store: Multiples of the Sixties* (Long Beach: University Art Museum, California State University, 1997); and Wendy Weitman, *Pop Impressions Europe/USA: Prints and Multiples from the Museum of Modern Art* (New York: Museum of Modern Art, 1999), 56.

50. Poster Originals had been founded by former investment banker Leo Farland in 1965. See Rita Reif, "Art Posters Drawing in Profits," *New York Times,* May 24, 1976, 55. For an example of the bag's promotion, see Barbara Plumb, "For the Home $25 and Under," *New York Times,* December 11, 1966, 355.

51. W. L. White Jr., Assistant Counsel, Campbell Soup Company, "Letter to Post [*sic*] Originals Ltd," January 17, 1967, Box 22, Folder 32, Leo Castelli Gallery Records, AAA.

52. Jerald Ordover, Attorney at Law, to W.L. White Jr., January 20, 1967, Box 22, Folder 32, Leo Castelli Gallery Records, AAA. Ordover later represented Richard Serra and Hans Haacke in matters concerning their art.

53. Warhol had also represented the product with its label torn, an act of destruction that Curley has argued tapped into the brand's nuclear-era reputation as the "comfort food of apocalypse." John Curley, *A Conspiracy of Images: Andy Warhol, Gerhard Richter and the Art of the Cold War* (New Haven, CT: Yale University Press, 2013), 130.

54. On the dispute with Caulfield, see Martha Buskirk, *The Contingent Object of Contemporary Art* (Cambridge, MA: MIT Press, 2003), 84–86. As Michael Lobel has pointed out, such cases have tended to inaccurately cast Warhol as a "rapacious, undiscriminating image thief." See Michael Lobel, "In Transition: Warhol's Flowers," *Andy Warhol Flowers* (New York: Eykyn Maclean, 2012), unpaginated.

55. For more on this work, see Thomas Morgan Evans, *3D Warhol: Andy Warhol and Sculpture* (London: I.B. Tauris, 2017), 126–27, 140.

56. John D. Goodloe to Andy Warhol, May 18, 1967, Andy Warhol Museum Archives, Pittsburgh, PA.

57. "Coca-Cola Raps Warhol," *Philadelphia Inquirer,* May 27, 1967, 26.

58. Cited in Bill Cunningham, "That New York City Collection," *Chicago Tribune,* December 4, 1967, D4.

59. Judy Klemesrud, "Trees for Christmas, Celebrity Style: Wants Pretty Tree," *New York Times,* November 29, 1967, 50.

60. Michele H. Bogart, *Artists, Advertising, and the Borders of Art* (Chicago: University of Chicago Press, 1995), 300.

61. Clive Barnes, "Making It in Brooklyn," *New York Times,* June 2, 1968, D26.

62. Peg Bracken, "Author Has Good Mention Going," *Montgomery Advertiser,* October 26, 1965, 7.

63. William C. Parker, email to author, May 6, 2014. Such insistence remains firm: "It is unfortunate that you chose to focus your inquiry on the relationship between Campbell Soup Company and Mr Warhol, because no such relationship ever existed. . . . Write about Warhol if you must—but his choice of subject matter was not influenced in any way by the Campbell Soup Company." Parker says that the commission he arranged was "the only exception" to this "policy." In 1985, when Warhol was again commissioned by Campbell's to promote the company's struggling dry soup line, a company representative claimed that the company had been "mortified" by his works and "didn't want to acknowledge his existence." Lisa Gubernick, "The Good Housekeeping Seal for Hip," *Forbes,* April 28, 1986, 61. See also Bourdon, *Warhol,* 396.

64. William C. Parker to Christopher Cerf, August 4, 1967, Random House Records, quoted in Lucy Mulroney, *Andy Warhol, Publisher* (Chicago: University of Chicago Press, 2018), 66.

65. Ivan Karp quoted in Marianne Hancock, "Soup's On," *Arts Magazine* 39 (May/June 1965): 18.

66. Karp quoted in Hancock, "Soup's On." Willits sold the painting at Sotheby's in 1974. In 1994, Campbell's Soup Company purchased another work from the same series, which remains in their collection. See Frei and Printz, *Andy Warhol Catalogue Raisonné,* vol. 2, cat. no. 1844.

67. Andy Warhol and Pat Hackett, *Popism: The Warhol '60s* (New York: Harcourt Brace Jovanovich, 1980), 129.

68. Andy Warhol, *The Philosophy of Andy Warhol: From A to B and Back Again* (New York: Harcourt Brace Jovanovich, 1975), 197.

69. Malanga, *Archiving Warhol,* 11, and Bourdon, *Warhol,* 110. See also Patrick C. Smith, *Warhol: Conversations about the Artist* (Ann Arbor: UMI Research Press, 1988), 168.

70. A flurry of these projects occurred in 1968. On his collaboration with Art Kane for Champion Papers, see Thomas Crow, "Warhol among the Art Directors," in *Andy Warhol Enterprises*, ed.

Sarah Urist Green and Allison Unruh (Indianapolis: Indianapolis Museum of Art, 2010), 99–113. On his 1968 advertisement for Schraft's Ice Cream, see David Joselit, *Feedback: Television against Democracy* (Cambridge, MA: MIT Press, 2007), 13–14, and Lynn Spigel, *TV by Design: Modern Art and the Rise of Network Television* (Chicago: University of Chicago Press, 2009), 260–61. Warhol's work for RCA/J. Walter Thompson, and the legal suit that followed, have not yet received in-depth treatment. See "This Little Piggy Came to Madison Avenue," *Printers' Ink*, February 27, 1967, 13–14.

## CHAPTER 2. CONTAINER CORPORATION'S ART DIRECTION

1. The only detailed information about these works is to be found in George Frei and Neil Printz, *The Andy Warhol Catalogue Raisonné*, vol. 2: *Paintings and Sculptures, 1964–1965* (London: Phaidon Press, 2003), 450–51.

2. Walter P. Paepcke, "The 'Great Ideas' Campaign," *Advertising Review*, Autumn 1954, 25.

3. Paepcke's use of art has been well recounted in Jackson Lears, "Uneasy Courtship: Modern Art and Advertising," *American Quarterly* 39, no. 1 (Spring 1987): 133–54, and Neil Harris, *Cultural Excursions: Marketing Appetites and Cultural Tastes in Modern America* (Chicago: University of Chicago Press, 1990), 349–78.

4. For more on Paepcke's activities, see James Sloan Allen, *The Romance of Commerce and Culture* (Chicago: University of Chicago Press, 1983).

5. Arthur A. Cohen, *Herbert Bayer: The Complete Work* (Cambridge, MA: MIT Press, 1984), 336.

6. Walter Paepcke quoted in Ralph Eckerstrom, "Design and Management," in *Communications: The Art of Understanding and Being Understood*, ed. Robert O. Bach (New York: Communication Art Books, 1963), 37.

7. On N.W. Ayer & Son and its influential art director Charles Coiner, see Michele H. Bogart, *Artists, Advertising, and the Borders of Art* (Chicago: University of Chicago Press, 1995), 157–70.

8. Fred Farrar, "Ad Series Successful—but It Boomerangs," *Chicago Daily Tribune*, February 14, 1963, F7.

9. Quoted in David Finn, "Stop Worrying about Your Image," *Harper's Magazine*, 1962, 80.

10. Finn, "Stop Worrying."

11. Pierre Martineau, "Sharper Focus for the Corporate Image," *Harvard Business Review*, November/December 1958, 55, 57.

12. Rosser Reeves, *Reality in Advertising* (New York: Knopf, 1961), 118. A more literary critique of the same advertisement, tackling the greatness of its quote and the relevance of its artwork, also concludes that it is "inefficient as well as pretentious." See John Atlee Kouwenhoven, *The Beer Can by the Highway: Essays on What's American about America* (Garden City, NY: Doubleday, 1961), 205–11.

13. David Ogilvy, *Confessions of an Advertising Man* (New York: Atheneum, 1963), 118. According to N.W. Ayer's in-house history, Ogilvy would later come to regard the Great Ideas of Western Man series as "the best campaign of corporate advertising that has ever appeared in print." N.W. Ayer, *Ayer: 125 Years of Building Brands* (New York: N.W. Ayer, 1990), 67.

14. Container Corporation of America, *The First Fifty Years, 1926–1976* (Chicago: Container Corporation of America, 1976), 80.

15. The catalogue of Warhol's oeuvre reproduces the uncorrected proof of this advertisement rather than the final published version. See George Frei and Neil Printz, *The Andy Warhol Catalogue Raisonné*, vol. 1: *Paintings and Sculpture, 1961–1963* (London: Phaidon Press, 2002), 451.

16. The advertisement appeared in *Business Week* and *Modern Packaging* in 1964. Proofs of the advertisement are held in the N.W. Ayer Advertising Agency Records, NMAH.

17. Container Corporation of America, *Annual Report* (Chicago: Container Corporation of America, 1962), 2.

18. The brand of the ham is visible in the preliminary collage for the work. See Frei and Printz, *Andy Warhol Catalogue Raisonné*, 1:451.

19. Though my conclusions differ according to the context of Warhol's production, this analysis was prompted by the attention to effaced and illegible brands in Michael Lobel, *Image Duplicator: Roy Lichtenstein and the Emergence of Pop Art* (New Haven, CT: Yale University Press, 2002), 42–55, and Joshua Shannon, *The Disappearance of Objects: New York Art and the Rise of the Postmodern City* (New Haven, CT: Yale University Press, 2009), 82–83.

20. For an earlier instance of this tactic, see John Curley, *A Conspiracy of Images: Andy Warhol, Gerhard Richter and the Art of the Cold War* (New Haven, CT: Yale University Press, 2013), 168.

21. There are many other examples of Warhol's use of this strategy. As Curley has described of Warhol's early pop paintings, his use of "awkward erasures and cover-ups" use "the tropes of commercial art against themselves." Curley, *Conspiracy of Images*, 72–73. This chimes with Warhol's *13 Most Wanted Men* (1964) mural for the World's Fair, obscured by a layer of silver paint that only made the intervention of his patron more startlingly visible. Richard Meyer, *Outlaw Representation: Censorship and Homosexuality in Twentieth-Century American Art* (Oxford: Oxford University Press, 2002), 144.

22. Again, a similar contradiction is evident in the varying titles of Warhol's portrait of Watson Powell in shades of beige, titled *The American Man* (1964)—but also referred to by Warhol as "Mr. Nobody"—commissioned for the new headquarters of the American Republic Insurance Company. Caroline Jones, *Machine in the Studio: Constructing the Postwar American Artist* (Chicago: University of Chicago Press, 1996), 203.

23. Several of the brands Warhol selected were among Container Corporation's clients. See, for instance, the Brillo boxes in the photograph accompanying "Walter Paepcke's Profit Package," *Forbes*, October 1958, 11.

24. As Golec notes, a similar effect was produced when Canadian customs officers would not waive import duties for the "sculptures." Michael J. Golec, *The Brillo Box Archive: Aesthetics, Design and Art* (Hanover, NH: University Press of New England, 2008), 5.

25. Grace Glueck, "'No!' Says Yes Art," *New York Times*, October 24, 1965, X34. In one of several further references to Warhol's work, the exhibition gave buyers S&H Green Stamps with the purchase of their works—the same trading stamp used in Warhol's silkscreen *S&H Green Stamps* (1962).

26. "Pop Art Palls: Now Yes Art's 'In,' No?," *Advertising Age*, November 29, 1965, 4.

27. See "Meeting Held at Brillo," April 7, 1965, and "Report of a Meeting held at 40 Berkeley Square," August 4, 1965, 50/1/20/1/5, J. Walter Thompson Collection, HAT.

28. See, for instance, Bogart, *Artists, Advertising*, 167, 266.

29. Container Corporation of America, *First Fifty Years*, 7.

30. *Annual of Advertising and Editorial Art and Design* (New York: Art Directors Club of New York, 1963), unpaginated.

31. Nicholas Samstag, *How Business Is Bamboozled by the Ad-Boys* (New York: James H. Heineman, 1966), 81.

32. N. W. Ayer & Son to A. D. Gruskin, Midtown Galleries, July 5, 1950, Reel 5329, Midtown Galleries Records, AAA.

33. "Fine Arts for an Institutional Series," *American Artist*, September 1966, 41.

34. John Massey, ed., *Great Ideas Container Corporation of America* (Chicago: Container Corporation of America, 1976), xiv.

35.  Edward Warwick, interview conducted by Martina Novelli, Interviews regarding the Container Corporation of America, 1984–1985, AAA. A proof of the proposed advertisement is held in the archives of the Josef and Anni Albers Foundation.

36.  "Ad Art Suffers under Collaborative System in U.S., Designer Bayer Says," *Advertising Age,* January 16, 1961, 32.

37.  Herbert Bayer in Massey, *Great Ideas,* xi.

38.  Bayer in Massey, *Great Ideas*, xi.

39.  In 1966, Bayer became the design consultant for the Atlantic Richfield Company. On Bayer's corporate work, see Gwen Finkel Chanzit, *Herbert Bayer and Modernist Design in America* (Ann Arbor, MI: UMI Research Press, 1987), 85, 183–204.

40.  Richard Sessions, Container Corporation of America, to Edith Halpert, March 14, 1962, Box 15, Downtown Gallery Records, AAA.

41.  Curated by MoMA curator Peter Selz, and coordinated by Nina Kaiden from Ruder & Finn, their works are reproduced in *Art across America* (Dayton, OH: Mead Corporation, 1965), unpaginated. The full list of jurors is included in *Mead Annual Painting of the Year* (Dayton, OH: Mead Corporation, 1962), unpaginated.

42.  Arthur L. Harris to C.R. Schiable, Mead Corporation, May 25, 1961, Box 51, American Federation of Arts Records, AAA.

43.  See "To Show Your Creative Work," *Art Education* 16, no. 3 (1963): 23.

44.  Clifford R. Schiable, Director of Advertising, Mead Corporation, to Miss Anne Kobin, American Federation of Arts, May 19, 1961, Box 51, American Federation of Arts Records, AAA. For Christmas 1962, the company distributed forty thousand "Painting of the Year" reproductions. See Jack Wilson, "Painting of the Year Exhibition Opens at Local Library," *Kingsport Times News,* December 16, 1962, 21.

45.  Edward Warwick to Leo Castelli, October 12, 1964, and Leo Castelli to Edward Warwick, October 17, 1964, Box 18, Folder 2, Leo Castelli Gallery Papers, AAA.

46.  In 1967, the company boasted that "the art works [that] cost about $200,000 in commissions, now are valued at $1-million." See "Container Seeks a Bigger Package," *Business Week*, October 21, 1967, 190.

47.  It toured almost continually until CCA donated the collection to the Smithsonian. See "Great Ideas Touring Exhibition Schedule," undated, Container Corporation of America, Curatorial Files, SAAM.

48.  Edward Warwick to Leo Castelli, May 12, 1965, Box 18, Folder 2, Leo Castelli Gallery Papers, AAA.

49.  Walter Reinsel to Constance Trimble, January 20, 1961, Box 9, Folder 11, Leo Castelli Gallery Records, AAA. This work has not been traced.

50.  Warwick, interview by Novelli.

51.  Other artists already recognized the politics frequently inscribed in Container Corporation's chosen quotes. Bernarda Shahn had, in 1950, refused to illustrate a Thucydides passage because she thought it "the very essence of the credo behind authoritarian government." Howard Greenfeld, *Ben Shahn: An Artist's Life* (New York: Random House, 1998), 249.

52.  All quotations from David Sylvester, ed., *René Magritte: Catalogue Raisonné,* vol. 4 (Houston, TX: Menil Foundation, 1994), 205–6. Magritte accepted a second commission from the company in 1962.

53.  "The Great Ideas," *Time,* April 24, 1950, 26.

54.  Ruder & Finn was contracted by the Great Books publisher Encyclopaedia Britannica in 1957 to undertake this campaign. See Box 39, Mortimer Adler Papers, SCRC.

55. The Great Books promised to "guide you to the decisions and actions which have eternally resulted in the greatest success and contentment." "Great Books of the Western World," advertisement, *Life*, September 26, 1960, 5.

56. Mortimer Adler, *Philosopher at Large: An Intellectual Autobiography* (New York: Collier Books, 1977), 264. Adler's compilation conformed with corporate obsessions about the "efficient use of time." See Tim Lacy, *The Dream of a Democratic Culture: Mortimer J. Adler and the Great Books Idea* (New York: Palgrave Macmillan, 2013), 44.

57. Benjamin Buchloh, *Neo-Avantgarde and Culture Industry: Essays on European and American Art from 1955 to 1975* (Cambridge, MA: MIT Press, 2000), 467. The notion that the New Bauhaus represented an American commercialization of its utopian prewar namesake is further contradicted by the ways that the Bauhaus had itself "anticipated many instruments of modern public relations and corporate relations." See Patrick Rossler, *The Bauhaus and Public Relations: Communications in a Permanent State of Crisis* (New York: Routledge, 2014), 1.

58. Walter P. Paepcke, "'Great Ideas' Recall Our Heritage, Help Build Container," *Industrial Marketing*, January 1955, 86.

59. The quote by progressive social justice lawyer Louis Brandeis (1856–1941) actually begins, "The margin between . . ." See Solomon Goldman, ed., *The Words of Justice Brandeis* (New York: H. Schuman, 1953), 62.

60. Gerald Berk, *Louis D. Brandeis and the Making of Regulated Competition, 1900–1932* (Cambridge: Cambridge University Press, 2009), 121.

61. Warwick, interview by Novelli. A similar point was made by Herbert Bayer: "We tried to select the artist to fit the message we wanted to convey." "Ad Art Suffers," 32.

62. James Rosenquist, "Interpretation," Curatorial Files, SAAM.

63. Henry J. Seldis, "The 'Pop Art' Trend: This, Too, Will Pass," *Los Angeles Times*, August 4, 1963, D3.

64. Rosenquist quoted in Joyce Haber, "The Paper Society—or, Beating Us to a Pulp," *Los Angeles Times*, November 20, 1966, M9. On Rosenquist's paper suit, see Michael Lobel, *James Rosenquist: Pop Art, Politics and History in the 1960s* (Berkeley: University of California Press, 2009), 1–4.

65. According to critic Brian O'Doherty, for instance, minimalist artists had determined to "mimic" the operation of such cycles of obsolescence as a "way of coping with these forces." Brian O'Doherty, "Minus Plato," in Geoffrey Battcock, *Minimal Art: A Critical Anthology* (Berkeley: University of California Press, 1995), 251–55.

66. June Owen, "Food Store Starts Riots in a Psyche," *New York Times*, November 9, 1957, 34.

67. Theodore Roszak, "The Summa Popologica of Marshall McLuhan," *New Politics* 5, no. 4 (Fall 1966): 28–29.

68. "What Nature Abhors," *The Nation*, December 5, 1966, 596–97; "The Package Is the Product," advertisement, *Packaging Innovator*, 1966, N.W. Ayer Advertising Agency Records, NMAH.

69. Marshall McLuhan, *Understanding Media: The Extensions of Man* (London: Routledge and Kegan Paul, 1964), 243. He later would go even further in such projections, claiming that if "the businessman had perceptions trained to read the language of the arts . . . he would be able to foresee not ten but fifty years ahead in all fields of education, government and merchandising." Marshall McLuhan, *Understanding Me: Lectures and Interviews* (Cambridge, MA: MIT Press, 2003), 49.

70. Philip Marchand, *Marshall McLuhan: The Medium and the Messenger* (New York: Ticknor and Fields, 1989), 195.

71. Philip A. Hart, "Truth in Packaging," *The Nation*, June 29, 1963, 543. Hart's terms draw liberally on the terms of Packard, who had claimed that designers were "hypnotizing" consumers. Vance Packard, *The Hidden Persuaders* (Harmondsworth: Penguin, 1960), 90.

72. Packaging and Labeling Practices, Hearings before the Subcommittee on Antitrust and Monopoly, Committee on the Judiciary, United States Senate, 87th Congress, First Session, October 25, 1961, 183.

73. Walter Carlson, "Advertising: Product Discovery by Shopper," *New York Times*, January 18, 1966, 74.

74. Although Tom Wolfe once parodied Container Corporation's high-minded image as the "Transcendental Can Company," Container Corporation did not make metal cans. See Tom Wolfe, "Advertising's Secret Messages," *New York Magazine*, July 17, 1972, 23.

75. Warwick to Castelli, May 12, 1965.

76. "Super Operating Corporation, et al. and International Brotherhood of Teamsters, Chauffeurs, Warehousemen and Helpers, Taxi Drivers and Terminal Employees, Local Union 826," *Decisions and Orders of the National Labor Relations Board*, vol. 133, September-October 1961, 240–47.

77. Scull's early career as an illustrator, his booming taxi business, and his effort to get dinner with Marshall McLuhan are detailed in Tom Wolfe, "Enjoy! Move up with Robert and Ethel Scull," *New York Herald Tribune Magazine*, October 23, 1966, 16–21. See also "Man Who Is Happening Now," *New Yorker*, November 25, 1966, 64–120.

78. Rosenquist's portrait of Scull was illustrated in a follow-up story by Tom Wolfe, "Upward with the Arts—The Success Story of Robert and Ethel Scull," *New York Herald Tribune Magazine*, October 30, 1966, 21–25. As Crow points out, the Sculls were "more than consumers" of pop, providing behind-the-scenes funding for Green Gallery, Rosenquist's representative. Thomas Crow, *The Rise of the Sixties: American and European Art in the Era of Dissent* (New York: Harry N. Abrams, 1996), 91.

79. See James Rosenquist, *Painting below Zero* (New York: Alfred A. Knopf, 2009), 140–44, and Lobel, *James Rosenquist*, 97–121.

80. Edward Warwick to Leo Castelli, June 2, 1965, Box 18, Folder 2, Leo Castelli Gallery Papers, AAA.

81. Warwick to Castelli, June 2, 1965.

82. "Fine Arts for an Institutional Series," 41.

83. Edward Warwick to A.D. Gruskin, November 5, 1951, Reel 5329, Midtown Galleries Records, AAA.

84. For an example of such a request, see Rosenquist, *Painting below Zero*, 54.

85. Dr Alvin Eurich to William Benton, August 16, 1965, Box 27, Mortimer Adler Papers, SCRC.

86. See the photograph of the seminar in *Pop Art: The John and Kimiko Powers Collection* (New York: Gagosian Gallery, 2001), 21. The other artists in residence were Friedel Dzubas, Allan D'Arcangelo, and Larry Poons. See Jan Van Der Marck, "Reminiscing on the Gulf of Mexico: A Conversation with James Rosenquist," *American Art* 20, no. 3 (Fall 2006): 94. Ben Yoshioka was the CCA staffer in attendance.

87. Edward Warwick to Mr. H.R. Fischer, Marlborough Fine Art Ltd., March 19, 1964, Larry Rivers Papers, FLSC.

88. Walter Reinsel to Tibor de Nagy, September 22, 1961, Box 33, Artist Files, Larry Rivers, Tibor de Nagy Gallery Archives Papers, AAA.

89. On Container Corporation's systematic segregation policies, see Timothy Minchin, *The Color of Work: The Struggle for Civil Rights in the Southern Paper Industry, 1945–1980* (Chapel Hill: University of North Carolina Press, 2001), 164–65.

90. Warwick, interview by Novelli; and John Massey, interview by Martina Novelli, Interviews regarding the Container Corporation of America, 1984–1985, AAA.

91. For an earlier example of this tactic, recall how the American Tobacco Company "reduced the reform sentiment of [Thomas Hart] Benton's modern art to substantiate their authority." See

Erika Doss, *Benton, Pollock, and the Politics of Modernism: From Regionalism to Abstract Expressionism* (Chicago: University of Chicago Press, 1991), 4–5.

92. According to Novelli, the mat board of the picture covered the offending panel when the work entered the Smithsonian American Art Museum collection in 1984. The artist was not able to object: he died before the advertisement appeared. See Warwick, interview by Novelli.

93. Michael Harrigan to Sandra Levinson, January 21, 2003, Curatorial Files, SAAM.

## CHAPTER 3. THE BOLD NEW TASTE OF PHILIP MORRIS

1. William Wilson, "Los Angeles: James Rosenquist," *Artforum*, December 1964, 12.

2. "The Fine Art of Flavor" was used for "corporate image" advertisements throughout the mid- to late 1960s. See letter to Jerry Wojtanowski, Leo Burnett Company, March 5, 1969, document no. 2049387239, PMPDA.

3. Louis Cheskin, *Business without Gambling: How Successful Marketers Use Scientific Methods* (Chicago: Quadrangle Books, 1963), 39.

4. *Pop and Op: An Exhibition of 65 Graphic Works Sponsored by Philip Morris and Circulated by the American Federation of Arts* (New York: Philip Morris, 1965), unpaginated.

5. Karin Moser, "New York's Nina Kaiden Brings Pop to Canada," *Ottawa Journal*, December 28, 1966, 35. Weissman credited Kaiden with the success of their arts projects. "Before things didn't grow by plan. But five years ago Nina [Kaiden] Wright brought sense and order into our lives." John Forbes, "Business Flexes Plastic Art," *New York Times*, November 23, 1969, F14.

6. Nina Kaiden Wright, conversation with the author, October 14, 2011.

7. These include *A Lot to Like* (1961), whose title uses the tagline that launched Marlboro, and *The Light That Won't Fail* (1962), among whose sources is imagery from a 1951 Philip Morris advertisement.

8. Tim Murphy, "110 Minutes with James Rosenquist," *New York Magazine*, November 29, 2009, 20.

9. Nina Kaiden to James Rosenquist, June 7, 1965, Box 15, Folder 5, Leo Castelli Gallery Papers, AAA.

10. "Tobacco: Symptoms of Slump," *Time*, February 14, 1964, 85.

11. Joseph Hixton, "Aftermath of Report: 13 Billion Fewer Cigarettes in 3 Months," *Boston Globe*, June 14, 1964, 41.

12. The Cigarette Advertising Code was a joint venture between the "Big Six": American Tobacco, Brown & Williamson, Liggett & Myers, Lorillard, Philip Morris, and Reynolds Tobacco Company.

13. "Ruder & Finn Appointed Philip Morris PR Counsel," *The Call*, February 1964, 1. Ruder & Finn itself imitated Container Corporation's "Great Ideas" series with their self-promoting Conference Room posters, featuring works by Giacometti, Moore, and others. See David Finn, *The Way Forward: My First Fifty Years at Ruder Finn* (New York: Millwood, 1998), 70–72, 88–89.

14. Kaiden joined Ruder & Finn in 1959, having previously worked for the American Federation of Arts. For details of her early career, including an early promotional exhibition of Latin American modernism for engineering and chemical company Brown & Root, see Peter B. Greenough, "Business Turned to Art Collecting: Woman Expert Runs Andover Exhibit for Ohio Firm—Calls Shows Subtle Sales Pitch," *Boston Globe*, May 14, 1962, 25.

15. Ruder & Finn, "Philip Morris Incorporates Twenty City Summary Report on Dr. William L. Dunn Jr. Taste Testing Tour," December 1964, document no. 1003288546/8567, PMPDA. This and other industry documents used in this section are available as part of the six million documents the tobacco industry released under the terms of the Master Settlement Agreement of 1998.

16. Robert H. Miles, *Coffin Nails and Corporate Strategies* (Englewood Cliffs, NJ: Prentice-Hall, 1982), 67.

17.　On the American Artists Group, see Murdock Pemberton, *Object: Every American an Art Patron* (New York: American Artists Group, 1945). Finn would maintain these interests as collector and photographer. See Finn, *Way Forward*.

18.　On the former, see Allen Center, *Public Relations Ideas in Action: 500 Tested Public Relations Programs and Techniques* (New York: McGraw Hill, 1957), 291–95; on the latter, see "It's Acrilan: Gas and Air Derivative Makes Fabric," *Washington Post*, August 29, 1952, 35.

19.　George N. Gordon and Irving A. Falk, *The War of Ideas: America's International Identity Crisis* (New York: Hastings House, 1973), 124.

20.　"Billboards—Five Artists and an Industry," *Art in America*, March-April 1967, 54.

21.　Each of the artists received a $500 check from Ruder & Finn for their design, and the winner Stephen Antonakos received a further $1,500 from the Institute of Outdoor Advertising. See Nina Kaiden to Stephen Antonakos, December 6, 1965, Box 42, Folder 17, Howard W. and Jean Lipman Papers, AAA.

22.　Joseph Kaselow, "Attack Plan to 'Legislate Beauty,'" *New York Herald Tribune*, June 2, 1965, 36. On such ideological conflicts over the public regulation of beauty, see John W. Houck, ed., *Outdoor Advertising: History and Regulation* (Notre Dame, IN: University of Notre Dame Press, 1969).

23.　Kaselow, "Attack Plan," 36. The Outdoor Advertising industry later worked with PR firm Ruder & Finn to commission artworks for billboard reproduction. See "Billboards," *Art in America*, March-April 1967, 46–51.

24.　On Ruder & Finn's work for the Comic Book Association of America, see David Hadju, *The Ten-Cent Plaque: The Great Comic-Book Scare and How It Changed America* (New York: Farrar, Straus and Giroux, 2008), 287.

25.　"Philip Maw-Riss Calling to Pop and Op Exhibition," *Oklahoma Advertiser*, July 27, 1967, 6.

26.　David Finn, "The Businessman and His Critics," *Saturday Review*, September 12, 1964, 63.

27.　"New York Coliseum," Box 14, Folder 6, Paul B. Zucker Papers, WHS.

28.　Richard Weiner, to George Weissman, September 26, 1966. David Finn, co-president of "Art International" and co-owner of Philip Morris's PR agency, forwarded the letter to MacAgy on the same day. David Finn to Douglas MacAgy, September 26, 1966. Douglas MacAgy Papers, AAA.

29.　Weiner to Weissman, September 26, 1966.

30.　Ruder & Finn, Summary of Public Relations Study on Health and Smoking for Philip Morris, Inc., ca. April 1968, document no. 1003288546/8567, PMPDA. Ruder & Finn's art program for Mead Corporation sought, similarly, to "bring out community leaders—college heads, political leaders, bank presidents—that don't turn out for a commercial event." "Art for the Corporation's Sake," *Business Week*, October 12, 1968, 83.

31.　George Weissman, memorandum to Joseph F. Cullman, September 29, 1966, document no. 2012580170, PMPDA.

32.　Walter Carlson, "Advertising: Grey Stays on Winning Streak," *New York Times*, March 29, 1966, 64.

33.　Douglas MacAgy, memorandum to "Milt" [Milton Fox, arts editor, Harry N. Abrams Publishing], March 29, 1966, Douglas MacAgy Papers, AAA.

34.　Paul B. Zucker to Dr. Rudolf Farner, May 18, 1964, Box 22, Folder 4, Paul B. Zucker Papers, WHS. Finn denies that these activities were "a ploy to divert public attention from the health controversy. . . . I know that was not the case . . . There was never any mention of the health issue when plans for arts programs were developed." Finn, *Way Forward*, 41. The firm was later fired by health clients for its association with Philip Morris (146–47).

35.　Marilyn Bender, "An Upturn in Business Giving?," *New York Times*, May 16, 1971, 15.

36.　"The Marketing Merlins of Philip Morris," *Dun's Review*, April 1968, 33.

37.　"Pop and Op," *Aiken Standard and Review*, February 18, 1966, 4.

38. Nicolas Calas and Elena Calas, *Icons and Images of the Sixties* (New York: E. P. Dutton, 1971), 17.

39. George Weissman, foreword to *Pop and Op,* unpaginated.

40. "Pop and Op," 4.

41. "Tobacco Man Hits Cigarette Cancer Talk," *Washington Post,* March 31, 1954, 6.

42. Forbes, "Business Flexes Plastic Art," F14. Weissman's reference here is probably to the art program of Rembrandt Tobacco Company, further discussed in chapter 5.

43. Grace Glueck, "67 Coliseum Show of Art Postponed," *New York Times,* December 31, 1966, S16.

44. Harold Heffernan, "Artist Captures 'Essence' of Television in Oils," *Pensacola News,* June 4, 1965, 9. Based in Westport, Connecticut, the Famous Artists Schools was a widely advertised correspondence school for amateur artists.

45. "Dashing Duke Handy Tackles Job of Bolstering Philip Morris Brand Sales," *Printers' Ink,* March 21, 1958, 5.

46. Wendy Weitman, *Pop Impressions Europe/USA: Prints and Multiples from the Museum of Modern Art* (New York: Museum of Modern Art, 1999), 13.

47. The inclusion of Gerald Laing—whose work is less obviously pop inflected than that of the others in the portfolio—was apparently at the insistence of dealer Richard Feigen, who also represented Allen Jones. Rosa Esman, email to author, June 26, 2012.

48. Rosa Esman, Original Editions, to Leo Castelli, September 27, 1965, Box 15, Folder 5, Leo Castelli Gallery Papers, AAA.

49. Existing accounts include the catalogue of a student-led exhibition at the Clough-Hanson Gallery. See David McCarthy, ed., *10 Pop Artists on Paper* (Memphis, TN: Rhodes College, 2000). Another account of *11 Pop Artists* provides a useful examination of its international tour. See Danielle Fox, "Art," in *Culture Works: The Political Economy of Culture,* ed. Richard Maxwell (Minneapolis: University of Minnesota Press, 2001), 31–40.

50. Victoria Donohoe, "Four Exhibits," *Philadelphia Inquirer,* March 20, 1966, 124.

51. Tom Harney, "All the New That's Fit in Prints," *Washington Daily News,* July 22, 1966, 37.

52. Dine's images are taken from features including "The Small Dress . . . Now It's Black Wool," *Vogue,* July 1964, 62–70, and "The Strapped Slipper," *Vogue,* July 1964, 60–61.

53. Early exhibitions of *Tobacco Rose* list this work's title as *Durham Rose*—after the North Carolina tobacco city where many of Philip Morris's competitors were based—and it seems possible that the company may have influenced its retitling to *Tobacco Rose.* See *11 Pop Artists: The New Image* (Munich: Galerie Friedrich + Dahlem, 1966), unpaginated.

54. Cigarette Advertising Code, 1964, 4, document no. 83681095/1102, LTDL.

55. Clive Barnes, "No Hot Habits," *New York Times,* April 11, 1965, X21.

56. Henry J. Seldis, "The 'Pop Art' Trend: This, Too, Will Pass," *Los Angeles Times,* August 4, 1963, D3.

57. This distance from his commercial sources is registered in the best writings on Ramos's work, including Liz Claridge, "Mel Ramos: Sex Appeal and the Product," *London Magazine,* June-July 1975, 83–86, and Honey Truewoman (Judith VanBaron), "Realism in Drag," *Arts Magazine,* February 1974, 44–45.

58. Rosa Esman to Mel Ramos, November 20, 1965, Mel Ramos Papers, AAA.

59. Esman, email to author, June 26, 2012. A gouache of the same image held in a private collection correctly depicting the Colgate brand corresponds with this account, and close examination of examples of the print indeed reveals the remnants of a subtly different shade of red on the edges of the reprinted area, which was corrected on each of the total edition of 250 prints. On Ruder & Finn's work for the Colgate brand, see Box 5, Folder 8, Paul F. Zucker Papers, WHS.

60. Rosa Esman to Mel Ramos, February 21, 1966, Mel Ramos Papers, AAA.

61. This left just one Ramos print—the unbranded and less revealing print from the first portfolio, titled *Chic* (1965).

62. Thomas Crow, *Modern Art in the Common Culture* (New Haven, CT: Yale University Press, 1998), 61.

63. Federal Cigarette Labeling and Advertising Act, Pub. L. No. 89-92, 79 Stat. 282 (1965).

64. John Wilcock, "The Teen Scene," *Village Voice*, December 31, 1964, 2.

65. Nina Kaiden to Leo Castelli, November 18, 1965, Box 15, Folder 5, Leo Castelli Gallery Papers, AAA.

66. Kaiden to Castelli, November 18, 1965.

67. Leo Castelli to Nina Kaiden, Ruder & Finn, December 7, 1965, Box 15, Folder 5. Leo Castelli Gallery Papers, AAA.

68. "Pop, Op Art Show Cuts Jackie, Nudes," *Oakland Tribune*, February 8, 1966, 10.

69. "Pop, Op Art Show," 10.

70. Wesselmann's long-running series of smoking nudes commenced soon after *11 Pop Artists*. The artist later claimed "he had been a light smoker until the morning the first *New York Times* headline of a link between smoking and lung cancer. He immediately threw away his cigarettes and never again smoked one." *Tom Wesselmann* (Milan: Edizioni Charta, 2003), 21.

71. Ruder & Finn, "Unique Pop Graphic Exhibition Premiere at (Museum or Gallery)," ca., January 1966, Box 98, National Museum of American Art, Office of Program Support, SIA.

72. Joan Fraser, "Wham! Pow! Sock! Pop Art Meets Business," *The Gazette* (Montreal), November 30. 1966, 25.

73. "Roy Lichtenstein to Arrive This Week for Opening of Pop Art Show: Will Meet with Local Artists," *Daily Journal*, March 3, 1966, 11.

74. Trying to compete against the more established Gillette and Wilkinson brands, Ever-Ready Personna was disappointed by the exhibition's poor reception. "Is this because the critics feel unhappy with the 'smack of commercialism' that goes with a commercial organisation's sponsorship?" asked the brand's disgruntled marketing director. See C. Graeme Roe, "Letters to the Editor: Art and Industry," *The Guardian*, November 19, 1966, 8. On the brand's other marketing tactics, see C. Graeme Roe, *Profitable Marketing for the Smaller Company* (London: Director's Bookshelf, 1969), 98. The prints were subsequently donated to the Arts Council collection. See "Briefly," *Art and Artists*, March 1968, 4.

75. *Pop and Op*, unpaginated. Kozloff's original essay was used in the international touring exhibition of *11 Pop Artists*. For his earlier criticism of pop, see Max Kozloff, "Pop Culture, Metaphysical Disgust and the New Vulgarians," *Art International*, March 1962, 34–36. For his later criticisms of corporate art, see Max Kozloff, "The Multimillion Dollar Art Boondoggle," in *Cultivated Impasses: Essays on the Waning of the Avant-Garde, 1964–1975* (New York: Marsilio, 2000), 284–98.

76. "Major Exhibition of 'Pop and Op,'" press release, January 24, 1966, 1, American Federation of Art records, Box 65, AAA.

77. Elmo Roper, "A Look at the Cigarette Industry and Philip Morris' Role In It," February 26, 1957, 21, document no. 2024922634, PMPDA.

78. Eric Westbrook, *Belvedere Op Art Exhibition* (Melbourne: Philip Morris Australia, 1968), unpaginated.

79. *Pop and Op*, unpaginated.

80. Myron Helfgott, Lippincott & Margulies, quoted in Gregory Dunne, "A Survey of Cigarette Packages," *Industrial Design*, February 1959, 33.

81. Raymond Loewy and William Snaith, "Report on the Development of New Cigarette Packaging Concepts for R.J. Reynolds Tobacco Company," November 1966, document no. 50312/791, LTDL.

82. Sandra Salmans, "Philip Morris and the Arts," *New York Times*, November 11, 1981, D1.

83. "To Make Them Buy—Try Science," *Business Week*, September 17, 1955, 43.

84. Dunne, "A Survey of Cigarette Packages," 42. On Arens's other work for Philip Morris, including his color plans for their offices, see Regina Lee Blaszczyk, *The Color Revolution* (Cambridge, MA: MIT Press, 2012), 232–37.

85. Joseph Cullman, *I'm a Lucky Guy* (New York: Philip Morris, 1998), 90.

86. Cheskin wrote about his work for Philip Morris in several books. See, for instance, Louis Cheskin, *Why People Buy: Motivation Research and Its Successful Applications* (New York: Limelight, 1959), 72–73. It is relevant that Cheskin's first book was a broadly formalist guide to art appreciation. See Louis Cheskin, *Living with Art* (Chicago: A. Kroch and Son, 1940), 44–45, 131–45.

87. For this image, see William M. Freeman, "News of the Advertising and Marketing Fields," *New York Times,* September 18, 1955, F10.

88. George Weissman, "Project Mayfair," June 14, 1955, document no. 2022239477/9482, PMPDA.

89. A little-known publication by Mildred Constantine and Egbert Jacobson is *Sign Language* (New York: Reinhold, 1961), whose melding of commercial and artistic concerns ranged from Container Corporation factory signs to György Kepes's shopfront neon mural for Radio Shack—more than a decade before similar tactics were presented in the more famous book by Robert Venturi, Denise Scott-Brown, and Steven Izenour, *Learning from Las Vegas* (Cambridge, MA: MIT Press, 1972).

90. Mildred Constantine, "The Package," *Bulletin of the Museum of Modern Art* 27, no. 1 (1959): 14.

91. Rivers made several paintings of cigarette packages that explore this intersection. This quotation comes from the typescript of "A Discussion of the Work of Larry Rivers," Box 19, Folder 32, Larry Rivers Papers, FLSC, but is cut from the edited version of this essay in *Art News* 60 (March 1961): 44–46.

92. On this project, see John J. Curley, "Hybrid Sculpture of the 1960s," *British Art Studies,* no. 3 (2016), doi: 10.17658/issn.2058-5462/issue-03/jcurley-1960s.

93. For a useful account of the Art Nouveau revival of the 1960s, see Elizabeth E. Guffey, *Retro: The Culture of Revival* (London: Reaktion Books, 2006), 57–64.

94. *Slide* was based on a steel wall sculpture exhibited at Richard Feigen Gallery in 1965, abstracting the shapes from his earlier images of parachuting skydivers and the smoke from drag racing cars. See David Knight, *Gerald Laing Catalogue Raisonné* (London: Lund Humphries, 2017), 93.

95. James Rosenquist and Cheryl Kaplan, "Interview with James Rosenquist," *DB Artmag* 14 (2003), unpaginated. For a more detailed account of this work, see Alex J. Taylor, "Optics: James Rosenquist and the Politics of Vision," in *James Rosenquist: Visualizing the Sixties* (London: Thaddeus Ropac Galerie, 2019), 12–41.

96. Rosenquist's 1966 show was scheduled at the last minute when Poons canceled his exhibition slot. James Rosenquist, *Painting below Zero* (New York: Alfred A. Knopf, 2009), 181–82.

97. Exhibition Committee Meeting, March 7, 1967, Box 1, Folder 2, Office of Exhibition and Design Records, National Collection of Fine Arts, SIA.

98. Philip Morris's photo opportunity was made possible by their donation of $500 of the total $23,000 raised for the exhibition.

99. John Latham, Special Assistant to the Director, NCFA, note to Meredith Johnson, July 21, 1966, Box 3, National Collection of Fine Arts, Office of the Director, SIA.

100. Dean Jensen, "Show Opens Up Frontier," *Milwaukee Sentinel,* December 4, 1975, 8. By contrast, the Smithsonian's eventual engagement with this subject for *The West as America* (1991) explicitly tackled the ideological nature of such mythology. See Alan Wallach, "The Battle over 'The West as America,'" in *Exhibiting Contradiction: Essays on the Art Museum in the United States* (Amherst: University of Massachusetts Press, 1998), 105–17.

101. Roy Moyer, memorandum to American Federation of Arts Exhibition Committee, May 1, 1967, Box 65, American Federation of Arts Records, AAA.

102. "First Showing of Campbell Museum Collection," press release, Philadelphia Museum of Art, Box 65, American Federation of Arts, AAA. See also Marvin D. Schwartz, "Antiques: Designs from the Campbell's Kitchen," *New York Times*, December 6, 1969, 34. The collection is now held at the Winterthur Museum.

103. Quoted in James S. Turner, *The Chemical Feast: The Ralph Nader Study Group Report on Food Protection and the Food and Drug Administration* (New York: Grossman, 1970), 83–84.

104. Museum of Contemporary Crafts, *Made with Paper* (New York: Container Corporation of America, 1967), unpaginated.

105. John Perreault, "Notes on Paper," *arts/canada*, April 1968, 13.

106. Maurice Tuchman, *Art and Technology: A Report on the Art and Technology Program of the Los Angeles Country Museum of Art, 1967–1971* (Los Angeles: Los Angeles County Museum of Art, 1971), 306–19. Interestingly, James Rosenquist also met with Container Corporation staff in Los Angeles when considering his own potential—though unrealized—participation in the Art and Technology scheme, to which I will return in chapter 8. See Tuchman, *Art and Technology*, 297.

107. John S. Morgan, *Improving Your Creativity on the Job* (New York: American Management Association, 1968), 30.

108. Rosenquist, *Painting below Zero*, 197.

109. Allan D'Arcangelo, [We are not trying to cause a split . . .], 1970, reproduced in *Allan D'Arcangelo Retrospettiva/Retrospective* (Milan: Silvana Editoriale, 2005), 128.

## PART 2. ABSTRACTION AT WORK

1. "The Corporate Splurge in Abstract Art," *Fortune*, April 1960, 139.

2. *Executive Report: Business and Art* (Englewood Cliffs, NJ: Prentice Hall, 1962), 22–23.

3. Alfred H. Barr, *What Is Modern Painting?* (New York: Museum of Modern Art, 1943), 44.

4. Meyer Schapiro, "The Liberating Quality of Avant-Garde Art," *Art News*, Summer 1957, 38–39.

5. Jules Langsner, "Sense and Sensibility in Modern Painting," *Arts and Architecture*, July 1958, 31. Setting aside the example of Container Corporation, which he regarded as an "isolated occasion," Schapiro also maintained that modern artists were "more like inventors and industrialists" than employees and as such represented "an exception in modern society." See Meyer Schapiro, "On the Relation of Patron and Artist: Comments for a Proposed Model for the Scientist," *American Journal of Sociology*, 70, no. 3 (November 1964): 368–69.

6. Clement Greenberg, "The Plight of Our Culture," in *The Collected Essays and Criticism*, vol. 3: *Affirmations and Refusals*, ed. John O'Brian (Chicago: University of Chicago Press, 1993), 150n11.

7. Greenberg, "Plight of Our Culture."

8. Clement Greenberg, "The Case for Abstract Art," in *The Collected Essays and Criticism*, vol. 4: *Modernism with a Vengeance*, ed. John O'Brian (Chicago: University of Chicago Press, 1993), 76.

9. Douglas McGregor, *The Human Side of Enterprise* (New York: McGraw-Hill, 1960).

10. Greenberg, "On Looking at Pictures," in *The Collected Essays and Criticism*, vol. 2: *Arrogant Purpose*, ed. John O'Brian (Chicago: University of Chicago Press, 1988), 34. Caroline Jones has argued that Greenberg's privileging of efficient vision was "taken from a more public realm . . . administrative approaches to the human sensorium that were intensifying in the United States between the 1930s and 1960s." Caroline A. Jones, *Eyesight Alone: Clement Greenberg's Modernism and the Bureaucratization of the Senses* (Chicago: University of Chicago Press, 2005), 7.

11. Susanne Leeb, "Abstraction as International Language," in *Art of Two Germanys: Cold War Cultures,* ed. Stephanie Barron and Sabine Eckmann (New York: Abrams; Los Angeles: Los Angeles County Museum of Art, 2009), 120.

12. Architectural historians have provided rich accounts of postwar corporate space that emphasize the instrumental goals of architecture and design, permeated by the ideals of systems theory

and cybernetics. See, for example, Reinhold Martin, *The Organizational Complex: Architecture, Media and Corporate Space* (Cambridge, MA: MIT Press, 2003), and John Harwood, *The Interface: IBM and the Transformation of Corporate Design, 1945–1976* (Minneapolis: University of Minnesota Press, 2011).

13. Chris Welles, "How It Feels to Live in Total Design," *Life*, April 29, 1966, 59. Welles's comments were prompted by the newly completed headquarters of CBS, in New York, and the American Republic Insurance Company, in Des Moines, Iowa. For a useful account of the role of one medium in "warming up" corporate architecture of this sort, see K. H. L. Wells, *Weaving Modernism: Postwar Tapestry between Paris and New York* (New Haven, CT: Yale University Press, 2019), 184–99.

14. Leo Schoenhofen quoted in Clyde Matthews, "The Corporate Medici," *Public Relations Quarterly* 11, no. 1 (Spring 1966): 27.

## CHAPTER 4. CHASE MANHATTAN'S EXECUTIVE VISION

1. Dorothy Miller, telefax to Sidney Janis, June 21, 1960, Box 13, Folder 28, Dorothy Miller Papers, AAA.

2. As Deusner has argued of aesthetic painting in the late nineteenth century, modern art "did more than testify to the possession of a certain kind of 'cultural capital' or connoisseurial discernment" by its patrons; it also provided a "reflected picture of the other people and paintings that constitute the patronage network to which they belong." Melody Barnett Deusner, *Aesthetic Painting in Britain and America: Collectors, Art Worlds, Networks* (London: Paul Mellon Centre for Studies in British Art, 2020), 28.

3. David Rockefeller quoted in "Masterpiece by Mark Rothko from the Collection of David Rockefeller to Be Sold," press release, Sotheby's, May 15, 2007, 2.

4. *A Family Exhibit, for the Benefit of the National Urban League* (New York: Knoedler Galleries, 1959), 5.

5. Souren Melikian, "A Rothko Sells for $72.84 Million at Record-Setting Sotheby's Sale," *New York Times*, May 16, 2007.

6. Dorothy Miller to Richard Dana, Chase Manhattan Bank, August 16, 1960, Box 13, Dorothy Miller Papers, AAA.

7. Miller to Dana, August 16, 1960.

8. For useful accounts of the project, see Achim Borchardt-Hume, ed., *Rothko* (London: Tate, 2008), 15–28, and James E. B. Breslin, *Mark Rothko: A Biography* (Chicago: University of Chicago Press, 1993), 371–410.

9. B. H. Friedman, "The Most Expensive Restaurant Ever Built," *Evergreen Review*, November-December 1959, 108.

10. On the art collection assembled for the Seagram Building, including the Rothko commission, see Phyllis Lambert, *Building Seagram* (New Haven, CT: Yale University Press, 2013), 150–93.

11. "The Corporate Splurge in Abstract Art," *Fortune*, April 1960, 140. Rockefeller saw *Brown and Blacks in Red* in early 1960 in the Whitney Museum's *Business Buys American Art* exhibition, where it was displayed alongside several of the bank's own early acquisitions. David Rockefeller to Alfred Barr, May 18, 1960, Alfred Barr Papers, AAA.

12. The museum's updated press release for the exhibition noted that the exhibition included thirty-four works. This figure was repeated in the *Buffalo Evening News* on August 30. Dated September 15, the bank's press release listed thirty-five works, adding Rothko's canvas at the end of the otherwise alphabetized list. See "For Immediate Release," undated, and "An Exhibition of Works of Art . . .," September 15, 1960, Gordon M. Smith Papers, AKAG.

13. Paul Goodman, *Utopian Essays and Practical Proposals* (New York: Vintage Books, 1964), 185.

14. *White Center* provided the background for a red plaid suit with a wide black belt by designer Geoffrey Beene in "New Importance of American Fashion," *Vogue,* March 1962, 90.

15. For a useful alternate perspective on these photographs, see Nancy Troy, *The Afterlife of Piet Mondrian* (Chicago: University of Chicago Press, 2013), 178–81.

16. "A Fine Arts Program for the Chase Manhattan Bank," Box 23, Folder 21, Betty Parsons Gallery Records and Personal Papers, AAA.

17. For an earlier example of this, see Seth Feman, "The Corporate Person as Art Collector: Andrew Mellon's Capital and the Origins of the National Gallery of Art," in *Corporate Patronage of Art and Architecture in the United States, Late 19th Century to the Present,* ed. Monica E. Jovanovich and Melissa Renn (New York: Bloomsbury, 2019), 99–116.

18. Barrett McGurn, "How the French View America," *Daily Times-News,* October 31, 1963, 50.

19. "Patronizing Arts Described as Privilege for Businessmen," *Buffalo Evening News,* September 29, 1960, Gordon M. Smith Papers, AKAG.

20. Katherine Kuh, "First Look at the Chase Manhattan Bank Collection," *Art in America,* Winter 1960, 69.

21. Ada Louise Huxtable, "Some New Skyscrapers and How They Grew," *New York Herald Tribune,* November 6, 1960, X12. The claim also appears in Ada Louise Huxtable, *Will They Ever Finish Bruckner Boulevard?* (New York: Macmillan, 1963), 66.

22. Helen Nelson, "Status Symbols in the Office," *Pageant,* March 1962, 55.

23. C. Wright Mills, *White Collar: The American Middle Classes* (New York: Oxford University Press, 1951), 73.

24. Sarah K. Rich, "Staring into Space: The Relaxing Effect of Rothko's Painting on Critics in the 1950s," in *Seeing Rothko,* ed. Glenn Phillips and Thomas Crow (Los Angeles: Getty Research Institute, 2005), 86.

25. The widespread comparison between Rothko's canvases and the sunset furthered such ideas—as in a cartoon of a couple who relax while staring at the artist's trademark stacked forms hovering in the sky. See James Stevenson, "Now, There's a Nice Contemporary Sunset," *New Yorker,* August 29, 1964, 21.

26. Quoted in Rich, "Staring into Space," 82. T.J. Clark illustrates *White Center* to claim that "the great Rothkos are those that everybody likes, from the early 1950s mainly: the ones that revel in the new formula's cheap effects." See T.J. Clark, *Farewell to an Idea: Episodes from a History of Modernism* (New Haven, CT: Yale University Press, 1999), 386–87.

27. As Sarah Burns has shown, such claims were well established for nineteenth-century painting. See "Painting as Rest Cure," in Sarah Burns, *Inventing the Modern Artist: Art and Culture in Guilded Age America* (New Haven, CT: Yale University Press, 1996), 135–56.

28. For this early installation of the space, see the two views in "1 Chase Manhattan Plaza," *Interior Design,* August 1961, 80. While the Rothko remained in the same location for decades, the smaller work on the facing wall differs in later photographs.

29. David Rockefeller in *The David and Peggy Rockefeller Collection,* vol. 2 (New York: privately published, 1988), 85.

30. Mary Coffey, "Corporate Patronage at the Crossroads: Situating Diego Rivera's 'Rockefeller Mural' Then and Now," in Jovanovich and Renn, *Corporate Patronage of Art,* 15.

31. See, for instance, his comments in Leah Dickerman, "Leftist Circuits," in *Diego Rivera: Murals for the Museum of Modern Art* (New York: Museum of Modern Art, 2011), 36–41.

32. Robert Linsley, "Utopia Will Not Be Televised: Rivera at Rockefeller Center," *Oxford Art Journal* 17, no. 2 (January 1994): 59–60.

33. At least one observer of the Chase Manhattan collection recalled the legacy of the Rivera debacle. Peter Lyon, "The Artful Banker," *Horizon: A Magazine of the Arts,* November 1960, 6.

34. Michel Butor, *Inventory* (New York: Simon and Schuster, 1968), 271. First published as Michel Butor, "Les Mosquées de New-York ou l'art de Mark Rothko," *Critique* 17 (October 1961): 843–60.

35. Hilton Kramer quoted in George McCue, "Art Critics on Art Criticism: Three Authorities Take Wide-Apart Positions," *St. Louis Post-Dispatch*, November 12, 1961, 5C.

36. Balcomb Greene, "A Thing of Beauty," *Art Journal* 25, no. 4 (Summer 1966): 368. Greene had himself increasingly abandoned abstraction for a representational expressionism. Chase Manhattan had rejected Greene's *Rock at Edge of Sea* in 1960. See "Art Committee Meeting," June 2, 1960, Dorothy Miller Papers, Box 13, Folder 28, Dorothy Miller Papers, AAA.

37. John Canaday, "Bank's Art Works Offer Bright and Happy Show," *New York Times*, September 15, 1971, 49.

38. Daniel Boorstin, *The Image: A Guide to Pseudo-events in America* (New York: Harper and Row, 1961), 193.

39. Boorstin, *Image*, 193–94.

40. Several purchases came directly from recent MoMA exhibitions. James Brooks's *R-1953* (1953) and Theodore Stamos's *Red Sea Terrace* (1959) had been shown in *The New American Painting* touring exhibition. Both Dmitri Hadzi sculptures had been included in the museum's *Recent Sculpture U.S.A.* exhibition.

41. Guy A. Weill to Dorothy Miller, March 9, 1960, Box 13, Dorothy Miller Papers, AAA. For another source that emphasizes the key position of this work, see "Colorful Banking," *New Yorker*, October 31, 1959, 35–36.

42. Weill to Miller, March 9, 1960.

43. "New Chase Branch Changes the Face of Banking," *New York Times*, October 14, 1959, 61.

44. Vartanig Vartan, "Abstract Art Adds Zip to Banking," *Christian Science Monitor*, November 17, 1959, 13.

45. "I took David Rockefeller, Gordon Bunshaft, and some other higher Chase official, higher than David then, to the studio." Only John McCray was more senior to Rockefeller on the bank's staff. Peter Morrin, *Chase Manhattan: The First Ten Years of Collecting, 1959–1969* (Atlanta, GA: High Museum of Art, 1982), 9.

46. Morrin, *Chase Manhattan*, 8. Miller later seemed to suggest that the work was completed before it was purchased by Chase Manhattan, but contractual records contradict this claim. See Marshall Lee, ed., *Art at Work: The Chase Manhattan Collection* (New York: E.P. Dutton, 1984), 28.

47. Yoshiaki Tono, "From a Gulliver's Point of View," *Art in America*, December 1960, 58.

48. Yoshiaki Tono, "Sam Francis, or after the Death Mask," *Mizue* 675 (July 1961): 19.

49. Sam Francis and Pontus Hulten, *Saturated Blue: Writings from the Notebooks* (Santa Monica, CA: Lapis Press, 1995), unpaginated.

50. "Art at 410 Park Avenue," undated typescript, late 1959, Box 7, Folder 29, Leo Castelli Gallery records, AAA.

51. Davis Allen, *Davis Allen: 40 Years of Interior Design at Skidmore, Owings & Merrill* (New York: Rizzoli, 1990), 34.

52. Francis and Hulten, *Saturated Blue*, unpaginated. See also Debra Burchett-Lere, *Sam Francis: Catalogue Raisonné of Canvas and Panel Paintings, 1946–1994* (Berkeley: University of California Press, 2011), 91, 189–90.

53. Lee, *Art at Work*, 58.

54. Lee, *Art at Work*, 58.

55. David Rockefeller, *Memoirs* (New York: Random House, 2002), 164.

56. "Chase's New Building Said to Hold World's Largest Underground Banking Operations," *Wall Street Journal*, March 3, 1961, 4, and "Chase Bank's Automated Check Center," *New York Herald Tribune*, March 18, 1961, 17.

57. See Chase Manhattan Bank, *Annual Report* (New York: Chase Manhattan Bank, 1961), 15, 22, and *Annual Report* (New York: Chase Manhattan Bank, 1962), 22. For later motion study efforts at the bank, see "Stop-Watching the Girls at Their Office Tasks," *Des Moines Tribune,* October 12, 1966, 43.

58. "Fine Arts Program." The same quotation was attributed to Rockefeller himself in "American Business Sponsors Art," 26.

59. Walter McQuade, "Architecture: Chase Manhattan Bank," *The Nation,* September 23, 1961, 187.

60. Quoted in Lee, *Art at Work,* 16.

61. Harriet F. Senie, "Studies in the Development of Urban Sculpture: 1950–1975" (PhD diss., New York University, 1981), 454.

62. Vance Packard, *Hidden Persuaders* (Harmondsworth: Penguin, 1960), 61.

63. "Big Bank Wins Friends," *Emporia Gazette,* April 24, 1963, 4.

64. "Ted Bates Builds a Friendly Client," *Printers' Ink*, February 22, 1963, 31. Compton Advertising also worked on the bank's account.

65. "Big Bank Wins Friends," 4.

66. "Fine Arts Program." On the structure of the bank's fifty-eight-person public relations team, see L.L.L. Golden, "Public Relations: No More Starched Collars," *Saturday Review,* February 11, 1967, 76.

67. Tom Geismar quoted in Sean Adams, Noreen Morioka, and Terry Stone, *Logo Design Workbook* (Gloucester, MA: Rockport, 2006), 118. For a period account that confirms this description, see Peter Wildbur, *Trademarks: A Handbook of International Designs* (London: Studio Vista, 1966), 53.

68. "Background Information on New Symbol," September 1960, Box 2, Folder 8, Francis Brennan Papers, LOC.

69. "Our New Symbol of Service," flyer, 1960, Box 13, Folder 28, Dorothy Miller Papers, AAA. According to another explanation, the logo depicted the cross section of the primitive water pipes laid by the bank's predecessor, the Manhattan Company, with a shape formed from nailed planks. The origins of this widely circulating version are unclear. See, for example, Sam Roberts, "When Government Plays Entrepreneur," *New York Times,* December 11, 1994, 1.

70. Rudolf Arnheim, *Visual Thinking* (Berkeley: University of California Press, 1969), 146. On the similarities of the design to later Frank Stella works, see Caroline Jones, *Machine in the Studio: Constructing the Postwar American Artist* (Chicago: University of Chicago Press, 1996), 162.

71. James Webb Young, "The Changing Advertising Symbol," *Saturday Review,* December 10, 1960, 49.

72. Dorothy Miller to Clare Fisher, November 8, 1967, Box 14, Folder 1, Dorothy Miller Papers, AAA.

73. In 1965 the committee evaluated 250 works of art in a three-hour, fifteen-minute meeting, and in 1967 it looked at 156 works in a two-hour, fifteen-minute meeting. See "The Chase Manhattan Bank Art Acquisition Committee Meeting," April 21, 1967, and "The Chase Manhattan Bank Art Acquisition Committee Meeting," March 26, 1955, Alfred Barr Papers, AAA.

74. "Wall Street Treasure," *Time,* June 30, 1961, 44.

75. Lee, *Art at Work,* 23.

76. David Rockefeller, "Businessmen Urged to Encourage Arts," *Buffalo Evening News,* date unknown, ca. September 1960, Gordon M. Smith Papers, AKAG.

77. Noel Frackman, "Visit to the New Chase Manhattan," *Scarsdale Inquirer,* January 31, 1963, 6.

78. The abstract paintings purchased were by Jack Youngerman (two works), Kenzo Okada (two works), José Guerrero (three works), Hedda Sterne (one work), and Enrico Donati (one work). Other works bought at Parsons during the bank's initial spree were by Chryssa and Walter Murch. See "Sales Invoices," Box 25, Folder 44, Betty Parsons Gallery Records and Personal Papers, AAA.

79. Miller denied such a feedback mechanism: "I don't really believe that corporate buying has had a significant impact on the artists themselves." Lee, *Art at Work,* 40.

80. Morrin, *Chase Manhattan,* 4.

81. The minutes of the first committee meeting records that Bunshaft also presented the architectural model of the new building to help show "where painting and sculpture should be used." David Rockefeller to Alfred Barr, September 29, 1958, Alfred Barr Papers, AAA.

82. An inventory from April 1961 breaks the collection down by these categories, listing thirty-two size A purchases (3 × 3 ft.), twenty-six size B (3 × 3 to 4× 5 ft.), twenty-eight size C (4 × 5 to 6 × 8 ft.), and three size D (6 × 8 ft. and over)—the largest category featuring works by Gottlieb, Guerrero, and Youngerman. "Major Artworks Purchased for the Chase Manhattan Art Building by the Art Committee," Box 13, Folder 29, Dorothy Miller Papers, AAA.

83. Nancy L. Ross, "High Art: Boss's Favorite Wine for Bank Decorators," *Washington Post,* April 19, 1969, C2.

84. John W. H. Baur and Lloyd Goodrich, *American Art of Our Century* (New York: Praeger, 1961), 220.

85. For the image that confirms this scene to be a sample room design, see "1 Chase Manhattan Plaza," 83.

86. For various installation contexts of this work, see "Portrait of a Building," *New York Times,* June 4, 1961, 15, and Morrin, *Chase Manhattan,* 11. In Lyon, "Artful Banker," 5, the picture served as the backdrop for a portrait of David Rockefeller.

87. Emily Genauer, "Here's How and Why Business Buys Art," *New York Herald Tribune,* March 20, 1960, D7.

88. For a survey of this activity, see Gino Cattani and Adrian Tschoegl, "An Evolutionary View of Internationalization: Chase Manhattan Bank, 1917 to 1996" (Center for Financial Institutions Working Papers, Wharton School, University of Pennsylvania, 2002).

89. "Nigerian Premier Is Feted by David Rockefeller," *New York Times,* July 8, 1959, 39.

90. Michael Crowder, "The Chase Manhattan Sculpture," *Nigeria Magazine* 70 (September 1961): 285.

91. "Money?," *Pittsburgh Courier,* September 22, 1962, 24.

92. In this meeting, the committee acquired Alan Davie's *Study for BP No. 2* (1965) but decided to lend works from the New York collection to the Paris branch. Art Committee Meeting, November 1, 1966, Dorothy Miller Papers, AAA.

93. Perry Rathbone, "Report on the Art Program of the Chase Manhattan Bank," February 1973, 3, Box 4, Folder 15, Perry Townsend Rathbone Papers, AAA.

94. Rathbone, "Report on the Art Program," 9.

95. On the Francis, see Glenn Sease, "People," *Pittsburgh Press,* March 21, 1965, 2. On the prints from the *London—New York—Hollywood: A New Look in Prints* exhibition, see William Lieberman, Memorandum to David Rockefeller, September 21, 1966, William S. Lieberman Papers, Series I, A.211.a, MoMA.

96. At the February 17, 1960, meeting, the committee considered—though it didn't buy—Ellsworth Kelly's *Wave Motif* (1959) and Richard Lytle's *Procession*—which, as Miller's inventory noted, was "offered by the artist through the exhibition '16 Americans.'" The bank also bought Jack Youngerman's *Black-Red* (1959) at this meeting, once again delivered directly from MoMA. "Works of Art to be Submitted to Art Committee for the Chase Manhattan Bank on February 17, 1960," Dorothy Miller Papers, AAA.

97. Geoffrey Hellman, "Talk of the Town: David Rockefeller," *New Yorker,* July 23, 1960, 15.

98. These works were purchased at a modest total cost of $2,775. "Art Purchases at Art Committee Meeting," March 26, 1965, Dorothy Miller Papers, Box 13, Folder 31, Dorothy Miller Papers, AAA.

99. Rockefeller purchased, for example, Jack Tworkov's *Strait* (1965) for his own collection after it was presented at the April 21, 1967, committee meeting. The work was sold by Rockefeller at Sotheby's New York on February 22, 1986, lot 14. At another committee meeting, works by Sidney Nolan and Carlos Scliar were listed as the property of David Rockefeller. See "Art Purchased at Committee Meeting," March 26, 1965, Box 13, Folder 32, Dorothy Miller Papers, AAA.

100. "Princes of American Commerce Are Today's Major Art Purchasers," *Hartford Courant*, October 17, 1965, 10B.

101. Eugenia Sheppard, "The Uptown Beatniks," *New York Herald Tribune*, March 28, 1960, 23.

102. Dorothy Miller to Mr H.J. Stresemann, Chase Manhattan Bank, March 6, 1963, Dorothy Miller Papers, AAA.

103. The bank did track the latter for insurance purposes and by 1967 thought it "gratifying to know that the collection is worth approximately one-third more than was paid for it." See Clare Fischer to Alfred Barr, April 28, 1967, Alfred Barr Papers, AAA.

104. Quoted in Lee, *Art at Work*, 25.

105. Ibid.

106. Dorothy Miller to Stefan Munsing, Cultural Affairs Officer, American Embassy, June 10, 1960, Box 13, Folder 28, Dorothy Miller Papers, AAA.

107. "1 Chase Manhattan Plaza," 82. On Bennett's reputation, see Cynthia Kellogg, "Best of the Old Lends Warmth to the New in Rooms Designed for Today," *New York Times*, August 10, 1960, 34. Rockefeller had initially approached Florence Knoll to design the interiors. See David Rockefeller to W. Cornell Dechert, Knoll Associates, October 29, 1958, Florence Knoll Bassett Papers, AAA.

108. "Wall Street Treasure," 44.

109. "Art at Chase Manhattan," *Vogue*, March 1, 1962, 180.

110. "1 Chase Manhattan Plaza," 82.

111. "New Building Art Ranges from Primitive to Abstract," *Chase Manhattan News*, May 1961, 5.

112. Rockefeller himself came to stand for the pressure to appreciate abstract art. When Richard Bissell grumbled, in 1962, of the need to tolerate abstract art "for fear of losing caste," he concluded his resistance by declaring that "Rockefeller doesn't scare me a bit, even if he does have a Braque and two Picassos in the men's room." Richard Bissell, *You Can Always Tell a Harvard Man* (New York: McGraw-Hill, 1962), 203.

113. "Wall Street Treasure," 44. According to a guide of the artworks displayed on the seventeenth floor, Jack Youngerman's work was installed in the office of Francis G. Ross, executive vice president. *Art at 1 Chase Manhattan Plaza, 17th Floor* (New York: Chase Manhattan, ca. 1960), 32.

114. "Art Abounds at Chase Bank," *Christian Science Monitor*, September 17, 1971, 6.

115. William H. Whyte, *The Organization Man* (New York: Simon and Schuster, 1956), 194.

116. The similarity of this scene to the widely circulating photographs of the Calcagno abstraction installed at 410 Park Avenue can hardly be coincidental. See, for instance, John Gordon, "Business Buys American Art," *Art in America*, Spring 1960, 88–89.

117. "Man at the Top," *Time*, September 7, 1962, 72.

118. "Art Committee Meeting," March 26, 1965, Box 13, Folder 32, Dorothy Miller Papers, AAA.

119. Quoted in Morrin, *Chase Manhattan*, 10.

120. Rockefeller, *Memoirs*, 167.

121. See, for instance, "David Rockefeller, Banker's Banker," *Business Week*, April 3, 1967, 74. As with Rothko's *White Center*, Rockefeller's solution was to buy the work personally. "I waited for a weekend when no one was around to hang it in its original location. . . . Nobody said a thing;

the bank bought it back from me, and it has remained in place ever since. . . . George and I never discussed the controversial artwork." Rockefeller, *Memoirs* 177. While Rockefeller dates this incident to the early 1960s, his recollection is contradicted by the Art Committee meeting minutes, which record this work being tested at One Chase Manhattan Plaza in 1965. See "Art Committee Meeting," March 26, 1965, Box 13, Folder 32, Dorothy Miller Papers, AAA.

122. Chase received approval from the city to extend this ruling to 27.3 percent. See Nicholas Kenji Machida, "The Syntax of Sites: Art and United States Urban Infrastructure, 1956–1980" (PhD diss. University of California, Los Angeles, 2017), 95.

123. Specifically, see "New Chase Bank Called Part of Wall Street Area Revitalization Plan," *Wall Street Journal,* May 18, 1961, 15. On the broader history of this move, see Jerold S. Kayden, *Privately Owned Public Space: The New York Experience* (New York: John Wiley, 2000), 1–12.

124. Paul Goldberger, *The City Observed, New York* (New York: Vintage, 1979), 23.

125. "Buildings for Business and Government on View at Museum," press release, February 27, 1957, Press Archives, MoMA. The exhibition was cosponsored by the philanthropic arm of Seagram Distilleries, whose building also featured prominently in the exhibition. Inland Steel, General Motors, and others companies provided in-kind support as well. *Buildings for Business and Government* (New York: Museum of Modern Art, 1957), 3.

126. Chase Manhattan, *Annual Report* (New York: Chase Manhattan Bank, 1955), 13.

127. For a useful account of the DLMA, see Sharon Zukin, *Loft Living: Culture and Capital in Urban Change* (Baltimore: John Hopkins University Press, 1982), 43–49.

128. Machida, "The Syntax of Sites: Art and United States Urban Infrastructure, 1956–1980," 59.

129. Martin Friedman, *Noguchi's Imaginary Landscapes: An Exhibition* (Minneapolis: Walker Art Center, 1978), 13.

130. Friedman, *Noguchi's Imaginary Landscapes*, 79. For a further reading of Noguchi's sunken garden and its relevance to the bank, see Bert Winther-Tamaki, *Art in the Encounter of Nations: Japanese and American Artists in the Early Post-war Years* (Honolulu: University of Hawai'i Press, 2001), 163–68.

131. See, for instance, "1 Chase Manhattan Plaza," 87.

132. Marjorie Meares to Gordon Smith, July 6, 1960, Gordon M. Smith Papers, AKAG. Barr later suggested an enlargement of Calder's standing mobile *Sandy's Butterfly* (1964) as a possible solution, but the artist instead provided two more grimly serrated and monochrome proposals: *The Long Plate* (ca. 1964) and *Archway in Two Sections* (1965). See "Chase: Don't Use AHB's Name!," handwritten note, undated, Box 14, Folder 4, Dorothy Miller Papers, AAA, and "Head Office Art Program Art Committee Meeting," January 19, 1966, Alfred Barr Papers, AAA.

133. Quoted in Ivan Chermayeff, Thomas Geismar, and Aaron Kenedi, *Identify: Basic Principles of Identity Design* (New York: Print, 2011), 34.

134. Bunshaft's suggestion was an enlargement of *Trois hommes qui marchent,* the very image of the "lonely crowd"—and much like the sculpture titled *City Square* in the architect's own collection. Reinhold Hohl, *Alberto Giacometti* (New York: H.N. Abrams, 1972), 160.

135. Arthur C. Danto, "Sculpting the Soul," *The Nation,* December 3, 2001, 34–35.

136. Without naming Chase Manhattan's role in Giacometti's earlier large-scale figures, Selz's catalogue essay discreetly notes that they were "conceived in connection with an outdoor project." Peter Selz, *Alberto Giacometti* (New York: Museum of Modern Art, 1965), 13.

137. James Lord, "In Memoriam Alberto Giacometti," *L'Oeil,* March 1966, 46. See also James Lord, *Giacometti: A Biography* (London: Faber and Faber, 1986), 499.

138. This source indicates that Giacometti imagined the work to be eight meters in height. Monroe Denton, "The Chase Manhattan Project," in *Alberto Giacometti and America*, ed. Tamara S. Evans (New York: City University of New York, 1984), 114.

139. Proposals by Zorach, Moore, and Noguchi are shown on the building model in Lee, *Art at Work*, 20. On Hadzi's proposals, see Alfred Barr to Dmitri Hadzi, January 21, 1959, Alfred Barr Papers, AAA; and Skidmore, Owings & Merrill, Minutes of the Art Committee, March 9, 1961, Dorothy Miller Papers, AAA. Contact sheets of his proposals from 1966 are held in Dmitri Hadzi Papers, AAA. Somaini's proposals, which do not appear in other accounts of the commission process, appear to have been rejected by Rockefeller directly. See Richard Dana to Dorothy Miller, April 16, 1963, Dorothy Miller Papers, AAA.

140. Jane Jacobs, *The Life and Death of American Cities* (London: Pimlico, 2000), 9. Jacobs explicitly attacks Rockefeller's DLMA (154–61).

141. Serge Chermayeff and Christopher Alexander, *Community and Privacy: Toward a New Architecture of Humanism* (Garden City, NY: Doubleday, 1963), 72.

142. An undated note in Miller's papers—attributed to Barr but with the note "not to use AHB's name!"—confirms this desire to avoid geometrical abstraction: "Moore and Calder both have quasi-organic forms to contrast with building," while "T[ony] Smith and most of the young sculptors are using straight-edge forms." "Chase: Don't Use AHB's Name!"

143. "Chase Manhattan Bank Art Committee Meeting," May 1, 1969, Dorothy Miller Papers, AAA.

144. Amanda Douberley, "The Corporate Model: Sculpture, Architecture and the American City, 1946–1975" (PhD diss., University of Texas Austin, 2015), 34.

145. David Rockefeller to Dorothy Miller, January 15, 1968, Box 14, Folder 4, Dorothy Miller Papers, AAA.

146. Chase's art committee had already selected a work by Dubuffet in this style for its collection, where it received the highest rating at that meeting. See "Art Committee Meeting—Major Works—1 Chase Manhattan Plaza," November 6, 1967, Box 14, Folder 3, Dorothy Miller Papers, AAA.

147. For an extended account of this commission, see Daniel Abadie, *Dubuffet as Architect* (Paris: Editions Hazan, 2011).

148. David L. Shirey, "Dubuffet Is Doing 40-Foot Sculpture for Chase Plaza," *New York Times*, November 24, 1970, 31. The approximately $250,000 cost of the sculpture was ultimately met by David Rockefeller himself—who also retained ownership of the work. Chase's profits fell some 10 percent from 1971 to 1972—almost $40 million—a financial context that saw many corporations cut their art programs. See H. Erich Heinemann, "Chase Replaces President after Competitive Decline," *New York Times*, October 13, 1972, 1.

149. "Dubuffet, French Artist, Chosen to Create Sculpture for Plaza," *Chase Manhattan News*, December 1970, 1.

150. See "Towering Chase Manhattan Building Will Let Light into Wall St. Canyon Area," *Architectural Forum* 104 (May 1956): 12. For more on this point, see Douberley, "Corporate Model," 82–83.

151. "Dubuffet, French Artist," 2.

152. *Jean Dubuffet: A Retrospective* (New York: Solomon R. Guggenheim Museum, 1973), 36. Recent scholarship has argued, by contrast, that Dubuffet's architectural engagements of the late 1960s seek to rethink "authoritarian and profit-driven urban planning." See Sophie Berrebi, *Dubuffet and the City: People, Place, and Urban Space* (Zurich: Hauser and Wirth, 2018), 188.

153. *Jean Dubuffet*, 36. Dubuffet linked banking with crime in the early 1960s: in paintings of the urban streetscape, he marks one establishment as "Banque Crapuleuse" (Villainous Bank), and another "Banque Tenebreuse" (Shady Bank). See Alex Potts, *Experiments in Modern Realism: World Making, Politics and the Everyday in Postwar European and American Art* (New Haven, CT: Yale Unversity Press, 2013), 142–44.

154. Harold Rosenberg, *Art on the Edge: Creators and Situations* (New York: Macmillan, 1975), 87.

155. Rosenberg, *Art on the Edge,* 91.

156. Randall Jarrell, *A Sad Heart at the Supermarket: Essays and Fables* (New York: Atheneum, 1962), 20.

157. Theodore Jones, "49 Arrested at Chase Building in Protest on South Africa Loans," *New York Times,* March 20, 1965, 11.

158. On the former, see "Napalm Valentine Is Sent at Amherst," *New York Times,* February 15, 1968, 2, and "Protest at Cornell," *New York Times,* March 11, 1969, 44. On the latter, see Joseph Carroll, "Attacks on US Banks in Paris," *The Guardian,* March 19, 1968, 16, and Robert Erlandson, "Brazil Regime, Students Set for Rockefeller," *Baltimore Sun,* June 15, 1969, 4.

159. Francis X. Clines, "Bombs Here Linked to 4 Earlier Blasts; Letter Attacks War," *New York Times,* November 12, 1969, 22.

160. "Letter to Times on Bombings Here," *New York Times,* November 12, 1969, 22.

161. Quoted in Terry Anderson, "The New American Revolution: The Movement and Business," in *The Sixties: From Memory to History,* ed. Dennis Farber (Chapel Hill: University of North Carolina Press, 1994), 187.

162. Donald Judd to Gerhardt Liebman, June 7, 1969. Box 1, Folder 2, Soho Artists' Association Records, AAA.

163. As this article noted, it was not simply out of respect for its board president that the museum avoided involvement: "The museum is preparing to undertake a complicated building program, for which a zoning variance is required." Grace Glueck, "Artists Assail Downtown Expressway," *New York Times,* June 20, 1969, 37.

164. Glueck, "Artists Assail Downtown Expressway," 37.

165. "Artists Attack Expressway," *Village Voice,* June 26, 1969, 51. Drexler's private consultancy had redesigned the Chase Manhattan Money Museum, a numismatic display in the Rockefeller Center. See Stuart Preston, "Money, Money, Money," *New York Times,* September 1, 1963, X15.

166. David Rockefeller to Alfred Barr, August 8, 1969, Alfred Barr Papers, AAA.

167. The sale raised $62,087.50 for the Studio Museum, some 50 percent of its annual operating budget. Some portion of this came from artists themselves, who donated all or a portion of sale prices to the museum. Thirty-three works were sold at the sale, totaling $35,045, while Chase Manhattan purchased the remaining thirty-one works, totaling $79,550. See Gideon Chagy, *The State of the Arts and Corporate Support* (New York: Paul S. Eriksson, 1971), 104–6.

168. "Patrons: A Businessman and Bank," *Wall Street Journal,* January 29, 1970, 18.

169. Faith Ringgold, *We Flew over the Bridge: The Memoirs of Faith Ringgold* (Durham, NC: Duke University Press, 2015), 174.

170. Douglas Robinson, "David Rockefeller Urges Minorities to Develop More Initiative," *New York Times,* January 17, 1968, 42.

171. Ringgold, *We Flew over the Bridge,* 174. *The American Spectrum* is included in the fundraising exhibition's checklist, which suggests that *Flag for the Moon: Die Nigger* was excluded from the sale itself—and, by extension, any risk of acquisition by the bank. See "Exhibition and Sale for the Studio Museum in Harlem, January 26–31, 1970," Martha Jackson Gallery Archives, UBAG.

172. For further exploration of this incident, see Patrick Hill, "The Castration of Memphis Cooly: Race, Gender and Nationalist Iconography in the Flag Art of Faith Ringgold," in *Dancing at the Louvre: Faith Ringgold's French Collection and Other Story Quilts* (Berkeley: University of California Press, 1998), 26–34.

173. Ross, "High Art," C1.

174. Henry-Russell Hitchcock, *SOM: Architecture of Skidmore, Owings & Merrill, 1950–1962* (New York: Monticelli Press, 1963), 13.

175. See, for example, Gene Davis to Dorothy Miller, July 11, 1966, Box 13, Folder 33, Dorothy Miller Papers, AAA.

## CHAPTER 5. A PASSPORT FOR PETER STUYVESANT

1. "David Rockefeller Urges Free Trade," *New York Times,* October 17, 1968, 77.

2. "David asked if I would return this to you with thanks. In the rush of leaving for Europe he had no comment that we were able to pick up." Richard H. Dana, note to Bates Lowry, October 9, 1968, MoMA, Collector Records, Folder 81. Rockefeller was a founding member of the Business Committee for the Arts, established in January 1968.

3. "Peter Stuyvesant Collectie, vernissage te Zevenaar," press release, Turmac, July 4, 1960, 3, Turmac Tobacco Company collection, LMZ.

4. "Peter Stuyvesant Collectie, vernissage te Zevenaar," 2.

5. "Peter Stuyvesant-Collectie, moderne schilderkunst in sigarettenfabriek," *De Tijd de Maasbode,* July 11, 1960, 116.

6. "Peter Stuyvesant Collectie, vernissage te Zevenaar," 2.

7. Kay Kritzweiser, "Canadians Included in Show at Stratford," *Globe and Mail,* June 11, 1968, 16.

8. Paul Hellmann, "Kunst zit Alex Orlow hoog, schilderijen bij machines," unidentified newspaper clipping, February 25, 1965, Peter Stuyvesant Collection archive, LMZ.

9. "Art—Advanced to the Surroundings of the Working Class," undated typescript, Peter Stuyvesant Collection archive, LMZ.

10. "Stakende British en Turmacarbeiders demonstreerden door de stad," *De Waarheid,* March 16, 1949, 8. Turmac was a contraction of the company's original name, the Turkish-Macedonian Tobacco Company, which produced the darker "Oriental-style" cigarettes popular in Europe before the war.

11. For a detailed history of the company, including its postwar automation program, see Ben Janssen, Theo Keultjes, Frans Wienk, and Gerrie Willemsen, *Onder de rook van Turmac te Zevenaar* (Zevenaar: Een uitgave van de Cultuurhistorische Vereniging Zevenaar, 2005).

12. Janssen et al., *Onder de rook,* 31. The company claimed to have pioneered the five-day working week in the Netherlands.

13. "Het moderne leven, Alexander Orlow kunst bij het werk," *Elsevier,* November 19, 1966, 75.

14. His collection was on public exhibition while the Turmac initiative was being planned. *Collectie Dr Paul Rijkens* (The Hague: Haags Geemeentemuseum, 1960).

15. "Peter Stuyvesant-Collectie officieel overgedragen," *Turmac Post,* July 1960, 1.

16. Prince Bernhard, "Ten geleide," in *Peter Stuyvesant Collectie* (Amsterdam: Stedelijk Museum, 1962), unpaginated.

17. "Peter Stuyvesant-Collectie officieel overgedragen," 1. On Reinink's broader position in the field of commercially oriented cultural diplomacy, see Giles Scott-Gilbert, *Networks of Empire: The US State Department's Foreign Leader Program in the Netherlands, France and Belgium, 1950–1970* (Brussels: Peter Lang, 2008), 207–18.

18. "Vragen over Peter Stuyvesant Collectie," December 15, 1960, Turmac Tobacco Company collection, LMZ.

19. Charles S. Spencer, "The Peter Stuyvesant Collection," *Studio,* January 1963, 19. In fact, the original report actually records that only 74 percent of those surveyed said that they would regret the paintings being removed.

20. "Peter Stuyvesant-Collectie officieel overgedragen," 2.

21. "Vragen over Peter Stuyvesant Collectie."

22. Spencer, "Peter Stuyvesant Collection," 19.

23. Jean Gabus, "The Museum Goes Out to the Factory," *Museum International* 22, no. 2 (January/December 1969): 116.

24. Gabus, "Museum Goes Out," 122.

25. Pierre Bourdieu and Alain Darbel cited in Gabus, "Museum Goes Out," 116.

26. Pierre Bourdieu, *Distinction: A Social Critique of the Judgment of Taste* (Cambridge, MA: Harvard University Press, 1984), 7.

27. Bourdieu and Darbel cited in Gabus, "Museum Goes Out," 124.

28. See *Cité décomposée*, 1958, Collection of Peggy and David Rockefeller, Nadeau's Auction Gallery, Windsor, CT, June 2, 2018, Lot 554.

29. Jacques Maerten, "Hebben wij reden een Peter Stuyvesant Collectie te bezitten," unidentified clipping, ca. 1965, Turmac Tobacco Company collection, LMZ.

30. "Het moderne leven," 74.

31. The competition attracted seven hundred entries for the European branch of the American commercial art school. "Famous Artists Schools organiseert Peter Stuyvesant schilder-en teken-wedstrijd," *Euro*, July 1964, 11.

32. Gail Dexter, "Is Art for Pretty or Is Art for Real?," *Toronto Daily Star*, June 15, 1968, 29.

33. Hellmann, "Kunst zit Alex Orlow hoog."

34. Quoted in "Art in the Factory," in *The BAT Artventure Collection Formerly Known as the Peter Stuyvesant Collection* (Amsterdam: Sotheby's, 2010), 11.

35. "Art in the Factory," *Windsor Star*, June 8, 1968, 41.

36. Wim Crouwel, "The Peter Stuyvesant Collection: The Art Gallery in the Factory Sponsored in Canada by Rothmans of Pall Mall Limited," *arts/canada*, 1968, 36. The article also misquotes the survey to prove this point, claiming that "a poll taken after the first six months showed that 95% of the male and 81% of the female employees preferred the abstract and non-figurative paintings." The same figures appear in H.L. Swart, "The Peter Stuyvesant Collection," *Museum International* 21, no. 1 (January/December 1968): 24.

37. "Industry: Art on the Line," *Newsweek*, April 12, 1971, 83.

38. For a European example of this discourse, available in Dutch by the late 1950s, see Erich Fromm, *The Sane Society* (London: Routledge and Kegan Paul, 1956).

39. Spencer, "Peter Stuyvesant Collection," 21.

40. Spencer, "Peter Stuyvesant Collection," 21.

41. Peter Coviello to Alexander Orlow, January 28, 1962, 3, Artist files, Peter Stuyvesant Collection archive, LMZ.

42. "Peter Stuyvesant-Collectie, moderne schilderkunst," 116.

43. The "inner six" of the Economic Community—formed by the Treaty of Rome in 1957—were Belgium, France, West Germany, Italy, Luxembourg, and Netherlands, joined by the "outer seven" in 1960—comprising Austria, Denmark, Norway, Portugal, Sweden, Switzerland and the United Kingdom. On the early history of European economic integration, see Neill Nugent, *The Government and Politics of the European Union* (Basingstoke: Palgrave Macmillan, 2010), 3–45.

44. Foundation for European Culture, *Annual Report, 1959–1960* (Amsterdam: Fondation européenne de la culture, 1960), 17. Because the report does not separate this project in its financial statements, the extent of their sponsorship is not clear. Turmac does not appear to have been a financial contributor, as it is not listed as a donor. See "Fondation européenne de la culture," *Character and Culture of Europe* 1, no. 1 (January 1960): 56–58.

45. "Peter Stuyvesant Collectie, vernissage te Zevenaar," 4.

46. See *Documenta II—Druckgrafik* (Kassel: M. DuMony Schauberg Koln, 1959), 76.

47. Anne-Marie Autissuer, *50 Years Sharing Cultures, 1954–2004* (Amsterdam: European Cultural Foundation, 2004), 4–8. The group would work closely with Prince Bernhard's own philanthropic foundation, Prins Bernhard Cultuurfonds.

48. For a useful summary of the involvement of these figures in the Foundation, see Alden Hatch, *H.R.H. Prince Bernhard of the Netherlands* (London: George G. Harrap, 1962), 232–38.

49. The Bilderberg Group is the subject of considerable conspiracy theories, but for a more scholarly account of its goals, see Hugh Wilford, "CIA Plot, Socialist Conspiracy, or New World Order? The Origins of the Bilderberg Group, 1952–55," *Diplomacy and Statecraft* 14, no. 3 (2003): 70–82.

50. The Fund and the Foundation had agreed to avoid competing for private funds. Foundation for European Culture, *Annual Report, 1959–1960*, 13–14. On Reinink's role in Dutch culture and its export, see Giles Scott-Smith, *Networks of Empire,* 208–14.

51. Hatch, *H.R.H. Prince Bernhard,* 225.

52. For an evocative account of this history, see Victoria de Grazia, *Irresistible Empire: America's Advance through 20th Century Europe* (Cambridge, MA: Harvard University Press, 2005), 336–75.

53. Quoted in Frances Stonor Saunders, *The Cultural Cold War: The CIA and the World of Arts and Letters* (New York: Norton, 2000), 267.

54. On this project, see Alex J. Taylor, "Transactions: Trade, Diplomacy and the Circulation of American Art," *American Art* 31, no. 2 (Summer 2017): 89–90.

55. Janssen et al., *Onder de rook,* 116.

56. Quoted in Hellman, "Kunst zit Alex Orlow hoog."

57. Rupert knew Prince Bernhard through the Bilderberg Group and other shared philanthropic interests. See Maja Spierenburg and Harry Wels, "Conservative Philanthropists, Royalty and Business Elites in Nature Conservation in Southern Africa," *Antipodes* 42, no. 3 (June 2010): 648.

58. Turmac recognized the connection between this slogan and the theme of the paintings. See "Peter Stuyvesant-Collectie officieel overgedragen," 1.

59. Quoted in Ebbe Dommisse, *Anton Rupert: A Biography* (Cape Town: Tafelberg, 2009), 340.

60. Dommisse, *Anton Rupert,* 105.

61. To compare the two package designs, see "Peter Stuyvesant—ze zijn zo lekker," *Het Vrije Volk: Democratisch-Socialistisch Dagblad,* December 22, 1958, 12, and "Van Rensselaer—de fantastisch goede filtersigaret," *Nieuwsblad van het Noorden,* January 20, 1959, 8.

62. "Aanhechting," *De Telegraaf,* January 9, 1959, 62. The imitation was named after Stephen Van Rensselaer, like Peter Stuyvesant, a Dutch colonist in the early history of New York City.

63. Dommisse, *Anton Rupert,* 108.

64. Quoted in Dommisse, *Anton Rupert,* 108.

65. Quoted in "South Africa: King-Sized Deal," *Time,* October 2, 1972, 95.

66. See "Sikkens-Prijzen," *Het Vrije Volk: Democratisch-Socialistisch Dagblad,* March 7, 1966, 2. Sikkens also sponsored the Stedelijk exhibition *Colour* (1959), and its managing director August M. Mees was the speaker at the opening of the *Peter Stuyvesant Collection* exhibition at the Stedelijk Museum in 1962.

67. See "Vijf jaar 'Kunststichting' en 'Kunst en Bedrijf,'" *De Waarheid,* October 31, 1956, 4. In the 1960s, Philips would engage with avant-garde light art practices in the 1960s, sponsoring *Kunst Licht Kunst* (1966) at the Van Abbemuseum in Eindhoven, and collaborating with kinetic light sculptor Nicolas Schöffer.

68. See Kees Schuyt and Ed Taverne, *Dutch Culture in a European Perspective: 1950 Prosperity and Welfare* (Basingstoke: Palgrave Macmillan, 2004), 377–404.

69. Spencer, "Peter Stuyvesant Collection," 19. Sandberg is misnamed "Carl Sandburg" in this article. The extent of Sandberg and Alloway's involvement is unclear.

70. Karel Appel and Corneille were later additions to the collection. Like the Peter Stuyvesant Collection, CoBrA was a self-consciously transnational brand, completing with typographic conventions, formed by an acronym of its founder's cities of Copenhagen, Brussels, and Amsterdam.

71. Herbert Read, *Art and Industry* (London: Faber and Faber, 1953), his study of industrial design in the machine age first published in 1936, drew heavily on Marx, as well as Morris and Ruskin.

72. *Peter Stuyvesant Collectie*, unpaginated.

73. Swart, "Peter Stuyvesant Collection," 23.

74. *Peter Stuyvesant Collectie*, unpaginated.

75. *Peter Stuyvesant Collectie*, unpaginated.

76. *Peter Stuyvesant Collectie*, unpaginated.

77. See Keith Jones, "Music in Factories: A Twentieth-Century Technique for Control of the Productive Self," *Social and Cultural Geography* 6, no. 5 (2005): 723–24; on the commercial equivalent in the United States, see Simon C. Jones and Thomas G. Schumacher, "Muzak: On Functional Music and Power," *Critical Studies in Mass Communication* 9, no. 2 (1992): 156–69.

78. *Peter Stuyvesant Collectie*, unpaginated.

79. *Peter Stuyvesant Collectie*, unpaginated.

80. "Peter Stuyvesant Collectie, Amsterdam Stedelijk Museum, Translation from the Dutch," typescript, AGSA.

81. *Peter Stuyvesant Collectie*, unpaginated.

82. *Peter Stuyvesant Collectie*, unpaginated.

83. The notably glamorous female workers in these images were professional models brought from Amsterdam by Huf for the purpose of the shoot. Frans Wienk, conversation with author, August 12, 2013.

84. The idea may well have been suggested by Edgard Varèse's work for Philips. See Marc Treib, *Space Calculated in Seconds: The Philips Pavilion, Le Corbusier, Edgard Varèse* (Princeton, NJ: Princeton University Press, 1996).

85. The track has been released on *Traces One* (2012), part of the Recollection GRM series from Editions Mego, drawn from the archives of the Groupe de Recherches Musicale.

86. Spencer, "Peter Stuyvesant Collection," 19.

87. Crouwel, "The Peter Stuyvesant Collection: The Art Gallery in the Factory Sponsored in Canada by Rothmans of Pall Mall Limited," 36.

88. "Industry: Art on the Line," 83.

89. "Peter Stuyvesant Collectie In Berlijn," *Euro*, October 1962, unpaginated.

90. "Abstracts for Industry," *Time*, October 21, 1966, 126.

91. "Abstract Art in the Factory," *International Management*, February 1967, 57.

92. Alexander Orlow to Ben Heyart, December 28, 1963, Peter Stuyvesant Collection archive, LMZ.

93. Robert Campbell to W. G. Stone, Advertising Director, Rothmans of Pall Mall (Australia), September 25, 1963; Robert Campbell, "To all State Gallery Directors, Peter Stuyvesant Collection," October 21, 1963, AGSA.

94. Robert Campbell to State Gallery Directors, November 15, 1963, AGSA.

95. "With Just a Wisp of Concrete," *Canberra Times*, September 17, 1964, 9.

96. "The Peter Stuyvesant Collection," *Bulletin of the National Gallery of South Australia* 25, no. 4 (1964): unpaginated.

97. Geoffrey Dutton, "A Brilliant Adelaide Festival," *The Bulletin*, March 21, 1964, 40.

98. "Some Positive Gains and One Serious Loss," *Sydney Morning Herald*, July 13, 1964, 58.

99. Daniel Thomas, "We've Never Had So Many So Good," *Telegraph* (Sydney), December 6, 1964, 62.

100. On the broader context of this issue in an Australian context, see Terry Smith, "The Provincialism Problem," *Artforum*, September 1974, 54–59.

101. H.F. Reemtsma and Ph.F. Reemtsma to Mr. Maerten, October 11, 1968, Peter Stuyvesant Collection archive, LMZ.

102. Alan Kimber, "Rothmans of Pall Mall Call Report," May 13, 1963, EXH/2/95/1, WAG. I am grateful to Hilary Floe for this reference.

103. Bernard Denvir, "London Letter," *Art International,* October 1969, 71. On Peter Stuyvesant's role in the "new generation" of sixties British art, see Simon Faulkner, "Art, Cigarettes and Visual Culture in the Sixties: The Peter Stuyvesant Foundation at the 'New Generation' Exhibitions, 1964–66," *Visual Culture in Britain* 1, no. 1 (2000).

104. Barry Lord, "Major Works 'Turn On' Stratford Gallery's Fake Factory," *Kitchener-Waterloo Record,* June 15, 1968, 9.

105. Kay Kritzweiser, "An Electronic Aria of Industry Serenading Stratford," *Globe and Mail,* June 15, 1968, 27.

106. Dexter, "Is Art for Pretty," 29.

107. Dexter, "Is Art for Pretty," 29.

## PART 3. MARKETING MATERIALS

1. Herbert Read, *A Concise History of Modern Sculpture* (London: Thames and Hudson, 1964), 239.

2. Clement Greenberg, "David Smith's New Sculpture," in *Collected Essays and Criticism,* vol. 4, *Modernism with a Vengeance,* ed. John O'Brian (Chicago: University of Chicago Press, 1993), 191.

3. Krauss uses this description to differentiate postmodern "sculpture in the expanded field" from earlier modernist modes. Rosalind Krauss, "Sculpture in the Expanded Field," *October* 8 (Spring 1979): 34.

4. See, respectively, Lawrence Alloway, *Trio: Tony Delap, Frank Gallo, Eva Hesse* (New York: Owens-Corning Fiberglas Corporation, 1970), and *The Carborundum Sculpture Awards, 1961–1970* (Niagara Falls, NY: Carborundum Company, 1971).

5. See, for example, Joshua Shannon, *The Disappearance of Objects: New York Art and the Rise of the Postmodern City* (New Haven, CT: Yale University Press, 2009), 149–86, and Susanneh Bieber, "'The Bulk of the Best Visible Things': Judd's Review of *Twentieth Century Engineering* at the Museum of Modern Art," *Panorama* 6, no. 1 (Spring 2020), doi: 10.24926/24716839.9742.

6. On minimalism's collectors, see Anna Chave, "Revaluing Minimalism: Patronage, Aura and Place," *Art Bulletin* 90, no. 3 (September 2008): 466–86. Chave's account still manages to validate the neglect of patronage in modernist art history: "Patronage studies are scarce in the literature on contemporary art for a reason: patrons have rarely exercised a decisive sway over the course of that art, broadly viewed," she writes. "But the leading patrons of the Minimalist movement may be counted as exceptions" (466).

## CHAPTER 6. MODERNIZING ITALSIDER

1. According to one source, some 60 percent of Italian steel was made from imported scrap. See Geoffrey Parker, *An Economic Geography of the Common Market* (New York: Praeger, 1969), 65–66.

2. Umberto Eco in Eugenio Carmi, ed., *I colori del ferro* (Genoa: Italsider, 1963), XI.

3. Carmi, *Colori del ferro,* XII.

4. Carmi, *Colori del ferro,* XI.

5. Italy received $3.5 billion in Marshall Plan aid, and much was invested in the "iron triangle" between Genoa, Milan, and Turin. See "Italy's Booming North: Land of Autocratic, Energetic Business Giants," *Time,* January 12, 1962, 72–75.

6. F.H.K. Henrion and Alan Parkin, *Design Coordination and Corporate Image* (London: Studio Vista, 1967), 148.

7.  For the company magazine *Rivista Italsider*, Carmi secured contributions from artists including Gino Sererini, Arnoldo Pomodoro, Louise Nevelson, Victor Vasarely, Jesús Rafael Soto, Nicolas Schöffer, and Pierre Soulages. The magazine followed the example of *Civiltà delle Macchine*, the corporate magazine of another IRI division, which had illustrated modern art since the early 1950s.

8.  Carmi was particularly influenced by the sweeping corporate identity programs of Mobil, Shell, and Esso, who all had Genoa offices. Carlo Vinti, *Gli anni dello stile industriale, 1948–1965* (Venice: Marsilio, 2007), 124. On the earlier innovations of Olivetti, see Sibylle Kicherer, *Olivetti: A Study of the Corporate Management of Design* (New York: Rizzoli, 1990).

9.  Willy Rotzler, "Italsider: The Graphic Profile of a Group of Italian Steelworks," *Graphis* 18 (May/June 1962): 289–90. On Carmi's intersecting commercial and fine art practices, see Umberto Eco, "Eugenio Carmi: The Value of the Temporary," *Art International,* May 1969, 21–26.

10. Ten managers, thirty-eight technical employees, and forty-six junior staff were sent and subsequently placed in important positions in the company. See Vinti, *Anni dello stile industriale,* 104.

11. Franco Amatori, "Italy: The Tormented Rise of Organizational Capabilities between Government and Families," in *Big Business and the Wealth of Nations,* ed. Alfred Chandler, Franco Amatori, and Takashi Hikino (Cambridge: Cambridge University Press, 1997), 259–60.

12. Willy Rotzler, "Italsider: The Graphic Profile of a Group of Italian Steelworks," *Graphis* 18 (May-June 1962): 289.

13. Italsider struck a deal with the union that worker complaints would be handled internally. See "Un fatto nuovo nel sindacalismo italiano," *Rivista Italsider,* 11, no. 1 (1962): 1. The system was abolished after worker protests in 1970.

14. Roberto Tolaini, "Ilva-Italsider organizzazione e lavoro," Storia e cultura dell'industria website, Turin, February 2008, www.storiaindustria.it/repository/fonti_documenti/biblioteca/testi /Testo_Ilva-Italsider_Organizzazione_lavoro.pdf.

15. "Opere grafiche per il personale dell'Italsider," *Rivista Italsider* 3, no. 6 (1964): 14. An example of these prints is Piero Dorazio's *Blera* (1963), published in an edition of two hundred. Italsider employed around twenty thousand workers. See *The Work of Piero Dorazio* (Cleveland, OH: Cleveland Museum of Art, 1965), unpaginated.

16. The latter project featured plays by Shakespeare, Pirandello, and Brecht and resulted in the publication by Vittorio Gassman and Luciano Lucignani entitled *Cinque modi per conoscere il teatro* (Rome: Edindustria Editoriale, 1962).

17. "Due Assemblee Italsider," *Rivista Italsider* 3, no. 2 (1964): 2. See also "A Steel Company in the World of Culture," *Fortune,* October 1963, 140.

18. Presented as part of Gian Carlo Menotti's fifth annual Festival dei Due Mondi (Festival of the Two Worlds), the exhibition featured 102 works by fifty-three artists. For a broader account of the exhibit, see Marin Sullivan, "Material Dispersion: Sculpture, Photography, and International Interventions in Italy, 1962–72" (PhD diss., University of Michigan, 2012), 21–72.

19. Giovanni Carandente, *Sculture nella città—Spoleto, 1962* (Spoleto: NE Editrice, 2007), 143.

20. Vinti, *Anni dello stile industriale,* 156.

21. Giovanni Carandente to Alexander Calder, undated (ca. March 1962), Giovanni Carandente Letters, AAA.

22. Beverly Pepper quoted in Barbaralee Diamonstein, *Inside New York's Art World* (New York: Rizzoli International, 1979), 296–97.

23. Diamonstein, *Inside New York's Art World,* 294.

24. In a film commissioned by Italsider, Consagra is seen comparing his original to these detailed drawings. See *Acciaio a Spoleto* (1962), dir. Aglauco Casadio, Corona Productions, FAA.

25. Giorgio Pecorini, "Videro le muse negli altiforni," *L'Europeo*, September 30, 1962, 29.

26. [Umbro Apollonio], "Sculture nella città," quoted in Carandente, *Sculture nella città*, 188.

27. Quoted in Diamonstein, *Inside New York's Art World*, 296–97. Pepper and Chadwick had later visited Smith at his studio at Bolton Landing. Lynn Chadwick, "Interview with Lynn Chadwick," by Cathy Courtney, Parts 16–17, Artists' Lives Oral History, British Library.

28. Chadwick, interview, 295.

29. Quoted in Kay Larson, "Hot Pepper," *New York Magazine*, June 8, 1987, 46.

30. Rosalind A. Krauss, *Beverly Pepper: Sculpture in Place* (Buffalo, NY: Albright-Knox Art Gallery, 1986), 42.

31. Alexander Calder to Giovanni Carandente, Giovanni Carandente Letters, reproduced in Giovanni Carandente, *Teodelapio: Alexander Calder* (Milan: Edizioni Charta, 1996), 21.

32. "Art: A Town Full of Sculpture," *Time*, August 24, 1962, 50.

33. These cardboard pieces are still held, along with the Calder maquette, at the Galleria Civica d'Arte Moderna di Spoleto / Archivio Carandente.

34. For an account of the industrial patronage of this work for Expo '67, first known as *Man*, see Alex J. Taylor, "Alexander Calder's Industrial Revolution," in *Alexander Calder: Radical Inventor*, ed. Anne Grace and Elizabeth Hutton Turner (Montreal: Montreal Museum of Fine Arts, 2018), 181–85.

35. Mulas took over 2,500 photographs of the event. See Sullivan, "Material Dispersion," 61–62.

36. Rotzler, "Italsider," 290.

37. Henrion and Parkin, *Design Coordination*, 152.

38. Quoted in Larson, "Hot Pepper," 46.

39. Quoted in Marion Garmel, "Space Age Sculpture," *Indianapolis News*, April 8, 1978, 4.

40. David Smith, "Report on Voltri," in *David Smith*, ed. Garnett McCoy (New York: Praeger, 1973), 161–62. Smith's reference to an Italsider factory in the South must refer to the giant Taranto facility, not completed until 1965.

41. See Gillo Dorfles, "Attualità di David Smith/David Smith: A Lesson in Modernity," *Metro* 4/5 (May 1962): 18.

42. Smith, "Report on Voltri," 156–59.

43. Smith, "Report on Voltri," 159.

44. Smith, "Report on Voltri," 159.

45. Sarah Hamill, *David Smith: Works, Writings, Interviews* (Barcelona: Polgrafa, 2011), 35.

46. In a further instance of Smith's use of his sculptures as a surface to be read, *Voltri VI* originally had text scrawled by the artist into its corroded surface. See Rosalind Krauss, *The Sculpture of David Smith: A Catalogue Raisonné* (New York: Garland, 1977), 102.

47. Smith, "Report on Voltri," 159.

48. Smith, "Report on Voltri," 162.

49. Smith, "Report on Voltri," 161.

50. Smith, "Report on Voltri," 162.

51. Krauss is speaking here of his earlier *Agricola* sculptures, but the point presumably extends to the *Voltri* works, as she maintains that "at the end of his life, Smith's use of the found object had not changed. . . . He continued to stress its functional arbitrariness." Rosalind Krauss, *Terminal Iron Works: The Sculpture of David Smith* (Cambridge, MA: MIT Press, 1971), 162.

52. Smith, "Report on Voltri," 162.

53. Smith, "Report on Voltri," 162.

54. David Smith to David Sylvester, December 11, 1962, reproduced in David Smith, Giovanni Carandente, and Ugo Mulas, *Voltron* (Philadelphia: Institute of Contemporary Art, University of Pennsylvania, 1964), 15.

55. Smith, "Report from Voltri," 160.

56. Smith, "Report from Voltri," 159–60.

57. Smith's annotated photograph notes that foreman Variera Cortesia (*sic?*)—whose seniority is suggested by the inclusion of his surname—was from the "other factory," presumably referring to the Cornigliano plant. This image also includes a welder named Agostino and Bruzzone, a "Tow Motor."

58. Smith to Sylvester, December 11, 1962, in Smith, Carandente, and Mulas, *Voltron*, 14. This sentence varies slightly across the different extant versions of the letter, as will be examined in the conclusion of this chapter.

59. Pecorini, "Videro le muse negli altiforni," 29.

60. Pecorini, "Videro le muse negli altiforni," 29.

61. "Art: A Town Full of Sculpture," 50.

62. Robert Motherwell, "David Smith: A Major American Sculptor," *Vogue*, February 1, 1965, 190.

63. For a detailed account of the extent of American influence over Italsider's strategy, see Ruggero Ranieri, "Remodelling the Italian Steel Industry: Americanization, Modernization, and Mass Production," in *Americanization and Its Limits: Reworking US Technology and Management in Post-war Europe and Japan*, ed. Jonathan Zeitlin and Gary Herrigel (Oxford: Oxford University Press, 2000), 236–68.

64. David Sylvester, *Interviews with American Artists* (London: Pimlico, 2002), 11.

65. Smith had done this before: contributing to a 1963 project to produce limited-edition ceramics, he "painted plate after plate," working "on weekends after the pottery shut down." See Cleve Gray, "Ceramics by Twelve Artists," *Art in America*, December 1964, 27.

66. David Smith to Gian Carlo Menotti, May 17, 1962, Papers of Giovanni Carandente, AAA. The naming of Smith's studio as the Terminal Iron Works after a closed foundry on the Brooklyn Navy Pier was not simply nostalgic, since it functioned as "his professional identity to attain discounts and credits from suppliers." Hamill, *David Smith*, 10.

67. Smith, Carandente, and Mulas, *Voltron*, 13.

68. Alex Potts, *The Sculptural Imagination: Figurative, Modernist, Minimalist* (New Haven, CT: Yale University Press, 2000), 160. On the labor contexts of Smith's politics, see also Paula Wisotzki, "Artist and Worker: The Labour of David Smith," *Oxford Art Journal* 28, no. 3 (October 2005): 347–70.

69. Smith, "Report on Voltri," 160. Smith's estimation seems to be representative: in 1963, 48.9 percent of the population of the town of Voltri had voted for the Italian Communist Party in the national election. See Mattei Dogan and Orazio Maria Petracca, eds., *Partiti politici e strutture sociali in Italia* (Milan: Edizioni di Communità, 1968), 566.

70. Godfrey Hodgson, "Steel Spurs Hopes of Poor in Southern Italy," *Los Angeles Times*, December 4, 1961, D10.

71. Anne M. Wagner, "Heavy Metal," in *David Smith: Cubes and Anarchy*, ed. Carol Eliel (Los Angeles: Los Angeles County Museum of Art, 2011), 65.

72. Wagner, "Heavy Metal," 81.

73. Wagner, "Heavy Metal," 82.

74. "Voltri sculptures cannot be said to have any theme beyond his sensitivity to the Antique aura of Italy." Quoted in Carmen Giminez and Rosalind Krauss, *David Smith: A Centennial* (New York: Guggenheim Museum, 2006), 706. Krauss criticized the "made-in-Italy" display of the Voltri series in a faux amphitheater at the National Gallery of Art, in Washington, D.C. See Rosalind Krauss, "Changing the Work of David Smith," *Art Journal* 43, no. 1 (1983): 89.

75. George H. Favre, "Italy Exports 'Suave Sell,'" *Christian Science Monitor*, November 22, 1961, 16.

76. Quoted in Smith, Carandente, and Mulas, *Voltron*, 6.

77. Smith, Carandente, and Mulas, *Voltron*, 7.
78. *Acciaio a Spoleto* (1962).
79. Smith, Carandente, and Mulas, *Voltron*, 9.
80. Reading Carandente's essay for *Voltron*, Smith complained that its "florid descriptions" were "just too much, too fancy. It's not that fiery or dramatic." David Smith to WM [W.F. McCormick?], July 1, 1964, 1, David Smith Papers, AAA.
81. For a reading of one such work that takes this context into account, see Maggie Cao, Sophie Cras, and Alex J. Taylor, "Art and Economics beyond the Market," *American Art* 33, no. 3 (Fall 2019): 20–21.
82. The work remains in Fedeli's collection. Conversation with the author, March 12, 2013.
83. See Carandente, *Sculture nella città Spoleto 1962*, 166. Pepper also selected a sculpture to be "presented to her 'comrades' at the plant," a work that ended up in Italsider's corporate collection. *Beverly Pepper a Forte Belvedere: Trent'anni di scultura* (Milan: Electa, 1998), 51.
84. David Smith to David Sylvester, undated, David Sylvester Papers, 200816/2/1/934, TGA.
85. Smith to Sylvester, undated; parentheses in original.
86. David Smith to David Sylvester, marked "Dup 2 [1963]," David Smith Papers, AAA.
87. David Smith in Smith, Carandente, and Mulas, *Voltron,* 12. Thot is probably Smith's application of American Simplified Spelling.
88. Many scholars follow Smith's lead, describing his visit as "on the invitation of the Italian government." See Potts, *Sculptural Imagination,* 162. Potts also names the Spoleto project as the "one major exception" to Smith's refusal of corporate patronage.
89. Smith had participated, for example, in the Federal Art Project in 1937. See Sylvester, *Interviews with American Artists,* 3–4.
90. Roy Gootenberg, "Italy, Too, Has Alphabet Agencies; IRI and ENI Own, Operate Multitude of Firms," in *Industry and Opportunity in Italy: Report on the United States Industrial Automation Mission to Italy* (Washington, DC: US Department of Commerce, 1963), 5.
91. McCoy, *David Smith,* 78.
92. Smith suggested de Rivera for the commission, who was indeed offered and accepted the opportunity. Harris K. Prior to David Smith, December 18, 1957, David Smith Papers, AAA. This annual commission involved artists including Harry Bertoia, Alexander Liberman, and Theodore Roszak, resulting in touring exhibitions including *Visions of Man in Ten Aluminum Sculptures* (Richmond, VA: Reynolds Metal Company, 1966).
93. Smith's involvement in the Inland Steel project is unclear. See John Wetenhall, "The Ascendency of Modern Public Sculpture in America" (PhD diss., Stanford University, 1987), 172, 209.
94. David Smith to Paul Randolph[?], December 29, 1957, David Smith Papers, AAA.
95. John Roche to David Smith, November 17, 1964, David Smith Papers, AAA. According to an earlier letter, Calder was also on the list of "invited" artists. See Leigh Block to René d'Harnoncourt, August 12, 1964, Series VI, Folder 36, René d'Harnoncourt Papers, MoMA. The exclusion of Calder's name from the final press release suggests that the participation of the other artists, including Smith, had been confirmed.
96. Other judges came from major museums: William Seitz (MoMA), John Baur (Whitney Museum of American Art), and Andrew Ritchie (Yale University Art Gallery).
97. As is clear from the letter, entries were due December 1, although the judging panel was not meeting until December 7. It is possible that Smith's entry was not received by the AISI in time to be considered.
98. The Roman numeral in the work's title may refer to the AISI's commission for "Century II of Steel." This is further supported by the absence of any known work titled "Construction December I."

99. Most of Smith's photographs were printed at 10 × 8. For *Construction December II,* Smith's produced several more substantial 17 × 11 prints. I am grateful to Susan Cooke for this observation.

100. John Roche, American Iron and Steel Institute, to David Smith, August 24, 1964, David Smith Papers, AAA.

101. "These Sculptors Have Replied Affirmatively . . .," undated mimeograph, International Sculpture Symposium records, CSULB.

102. Marjorie Hunters, "Johnson Chooses Council for Arts," *New York Times,* February 24, 1965, 53.

103. Potts, *Sculptural Imagination,* 160.

## CHAPTER 7. THE RUSTING FACE OF U.S. STEEL

1. "Remarks by Mr Paley, The Museum of Modern Art, New York," November 10, 1965, Series VI, Folder 36, René d'Harnoncourt Papers, MoMA.

2. American Iron and Steel Institute, "José de Rivera, Sculptor of Steel Century Two Symbol[,] Has Worked with Stainless Steel since 1939," press release, January 8, 1965, José de Rivera Papers, AAA. On the work of Hill and Knowlton for the AISI, see Marvin N. Olasky, *Corporate Public Relations: A New Historical Perspective* (Hillsdale, NJ: Lawrence Erlbaum Associates, 1987), 104–6.

3. American Iron and Steel Institute, "José de Rivera."

4. American Iron and Steel Institute, "José de Rivera."

5. The creation of the plinth was as publicized as the sculpture itself. One source suggested the ceremony was originally intended to provide the "ingot which the sculptor will fashion." "Steel Ingot to Mark Milestone," *Christian Science Monitor,* September 14, 1964, 15.

6. See, for instance, Pamela Lee, *Chronophobia: On Time in the Art of the 1960s* (Cambridge, MA: MIT Press, 2006), 133–40.

7. "Mr L.B. Worthington's Steel Sculpture," November 10, 1965, Series VI, Folder 36, René d'Harnoncourt Papers, MoMA.

8. William T. Hogan, *Economic History of the Iron and Steel Industry in the United States,* vol. 5 (Lexington, KY: Lexington Books, 1971), 113.

9. Jack Metzgar, *Striking Steel: Solidarity Remembered* (Philadelphia: Temple University Press, 2000), 13–83.

10. The latter factor in the decline of the US steel industry was, ironically, funded by the United States' Marshall Plan policies. See Judith Stein, *Running Steel, Running America: Race, Economic Policy and the Decline of Liberalism* (Chapel Hill: University of North Carolina Press, 1998), 205.

11. Wallace Carroll, "Steel: A 72-Hour Drama with an All-Star Cast," *New York Times,* April 23, 1962, 25. For a slightly different account of the episode, see L.L.L. Golden, *Only by Public Consent: American Corporations Search for Favorable Opinion* (New York: Hawthorn Books, 1968), 11.

12. The industry's goals included levies on imported steel and relief from government antipollution measures. See "Steel Moves to Repair the Damage," *Business Week,* September 27, 1962, 32–33.

13. Peter Bart, "Advertising: Merger of 2 Agencies," *New York Times,* September 27, 1962, 65.

14. David R. Jones, "Steel Men Plan to Push to Brighten an Image Dimmed by Price Flop," *Wall Street Journal,* August 13, 1962, 1.

15. "Producers Agree on Symbol to Appear on Products," *New York Times,* January 14, 1960, 52.

16. See, for instance, de Rivera's contribution to *Aluminum in Modern Architecture* (Richmond, VA: Reynolds Metals Company), 5.

17. "Steelmarketing," August 1964, 1, American Iron and Steel Institute Papers, Box 82, HML.

18. Richard E. Paret, American Iron and Steel Institute, to José de Rivera, August 25, 1960, José de Rivera Papers, AAA.

19. *Study in Steel* (Pittsburgh, PA: United States Steel Corporation, 1962), cover.

20. It was probably this de Rivera work that U.S. Steel later contributed to a Boston exhibit of corporate collections. See *Corporations Collect: Art in the Business Environment* (Boston: Institute of Contemporary Art, 1965).

21. On Lye's use in U.S. Steel publicity, see Howard Wise to Julian Street Jr., March 24, 1962, Howard Wise Gallery Records, AAA. On Lippold's collaboration with advertising agency BBDO and U.S. Steel, see C. James Price to Richard Lippold, June 16, 1965, Richard Lippold Artist File, AAPG.

22. "American Steel—the Dinosaur Moves," *The Economist*, August 3, 1968, 63.

23. Lawrence R. Samuel, *The End of the Innocence: The 1964–1965 New York's World's Fair* (Syracuse, NY: Syracuse University Press, 2007), 18.

24. Myron Kandel, "Advertising: World's Fair Promotion Cost Is Estimated," *New York Times*, July 25, 1962, 50. A mandatory credit line for all illustrations of the monument reading "Presented by U.S Steel" was strictly enforced. See John M. Lee, "Business at Fair Seeking Prestige," *New York Times*, April 18, 1964, 16.

25. Sal Nuccio, "Advertising: Mighty Steel on the Offensive," *New York Times*, November 1, 1964, F15.

26. "How Steel Is Winning Lustre in Washington," *Business Week*, November 26, 1966, 146.

27. "New Ways to Fight Corrosion," *Steel*, August 27, 1957, 68.

28. David Talbott, "Rust Damage Far Exceeds That Done by Fire," *Coshocton Tribune*, March 27, 1960, 23.

29. Vance Packard, *The Waste Makers* (London: Longmans, Green, 1961), 63.

30. D.T. Llewellyn and Roger C. Hudd, *Steels: Metallurgy and Applications* (Oxford: Butterworth-Heinemann, 2000), 158.

31. Kenneth Warren, *Big Steel: The First Century of the United States Steel Corporation, 1901–2001* (Pittsburgh, PA: University of Pittsburgh Press, 2001), 241.

32. "Patented Steel Improvement Is Announced," *New Castle News*, December 19, 1961, 9.

33. "Patented Steel Improvement Is Announced," 9. See also Douglas Alan Fisher, *The Epic of Steel* (New York: Harper and Row, 1963), 163–64.

34. John Dinkeloo, "The Steel Will Weather Naturally," *Architectural Record*, August 1962, 148–50.

35. Eeva-Liisa Pelkonen and Donald Albrecht, eds., *Eero Saarinen: Shaping the Future* (New Haven, CT: Yale University Press, 2006), 73. There seems to have been initial confusion over exactly what color Cor-Ten would become. In 1964, one publication reported that it "eventually turns olive green/grey." See "World News," *Architectural Design*, July 1964, 315.

36. "U.S. Steel to Erect a Huge New Building at Pittsburgh," *Morning Herald*, March 2, 1967, 16. Aluminum had already successfully used this strategy since the 1950s. See Thomas W. Ennis, "Company Edifices 'Sell' Products," *New York Times*, August 7, 1960, 6.

37. "U.S. Steel to Erect," 16.

38. Jacques Calman Brownson, oral history interview by Betty J. Blum, December 4-9, Chicago Architects Oral History Project, R&B, 183. The project's supervising architect was C.F. Murphy Associates, with Skidmore, Owings & Merrill and Loebl, Schlossmann, Bennett & Dart as associates.

39. Brownson, oral history interview, 185.

40. Brownson, oral history interview, 188.

41. Penrose was involved at Alfred Barr's suggestion. See Patricia Ann Stratton, "Chicago Picasso" (master's thesis, Northwestern University, 1982), 47.

42. Elizabeth Cowling, *Visiting Picasso: Notebooks and Letters of Roland Penrose* (London: Thames and Hudson, 2008), 253.

43. Cowling, *Visiting Picasso*, 253–54.

44. Cowling, *Visiting Picasso*, 254.

45. Cowling, *Visiting Picasso*, 290n76.

46. Stratton, "Chicago Picasso," 53.

47. Stratton, "Chicago Picasso," 18. Perhaps by way of rivaling Chase Manhattan's own concurrent plans, explored in chapter 2, the work of Giacometti was also mooted at this stage. See "Sculpture by Picasso or Giacometti May Adorn Civic Center Plaza," *Chicago Sun-Times*, August 12, 1964, 41.

48. Brownson, oral history interview, 185.

49. William Hartmann quoted in Stratton, "Chicago Picasso," 118.

50. In his later drawing *Head of a Woman* (June 3, 1962), Picasso further abandons the symmetry of the composition to explore side profile views. See Stephanie D'Alessandro, ed., *Chicago and Picasso: 100 Works, 100 Years* (Chicago: Art Institute of Chicago, 2013), 95.

51. Michael Baxandall, *Patterns of Intention: On the Historical Interpretation of Pictures* (New Haven, CT: Yale University Press, 1985), 42.

52. Baxandall, *Patterns of Intention*, 46.

53. "U.S. Steel and BBDO Join Forces to Promote Good Architecture and Steel," *Printers' Ink*, January 24, 1958, 66–67.

54. American Bridge Company quoted $300,000 to fabricate the sculpture, which Hartmann raised from private donors: the Chauncey and Marion Deering McCormick Foundation, the Field Foundation of Illinois, and the Woods Charitable Trust.

55. Stratton, "Chicago Picasso," 122.

56. Paul Gapp, "'Old Rustyside': A Monumental Success Story," *Chicago Tribune*, February 2, 1975, E12.

57. Sanka Knox, "Chicago to Get a 5-Story Picasso," *New York Times*, September 15, 1966, 52.

58. Harold Haydon, "Picasso Sculpture Slowly Takes Form," *Washington Post*, December 23, 1966, C8.

59. Harold Haydon, "12 1/2 Foot Model Puts Our Picasso at Second Stage," *Chicago Sun-Times*, December 22, 1966, 4.

60. Haydon, "Picasso Sculpture," C8.

61. Edward Barry, "Build 12 1/2 Ft. Model of Chicago's Picasso," *Chicago Tribune*, December 22, 1966, 19.

62. Van Sauter, "Picasso's Bird Taking Shape," *Corpus Christi Times*, April 17, 1967, 8B.

63. "Notes and Exhibits," *Chicago Tribune*, March 24, 1968, E2.

64. Richard Busse, "Describes Giant's Creation," *Chicago Tribune*, August 20, 1967, A3.

65. Edward Barry, "Break Ground for Big Statue in Civic Center," *Chicago Tribune*, May 26, 1967, C21.

66. "Chicago's Picasso," *Life*, August 24, 1967, 85–86.

67. John Canaday, "Picasso in the Wilderness," *New York Times*, August 27, 1967, D23.

68. Joshua Kind, "The Dragon's Necessity," *Inland Architect*, December 1967, 8.

69. Roger Blough, "Progress Is Not Our Most Imported Product," speech delivered to the Indiana Manufacturers Association, Indianapolis, November 16, 1967, unpaginated, American Iron and Steel Collection, HML.

70. *The Chicago Picasso* (ca. 1968), dir. Mallory Slate, National Education Television Network, 50 mins. The film concludes with the credit line "This program was made possible in part by a contribution from U.S. Steel."

71. "United States Steel International," advertisement, *The Economist*, March 9, 1968, 81.

72. "What Is U.S. Steel Doing about Art and Architecture?," advertisement, *Chronicle-Telegram*, June 16, 1970, 5.

73. "What Is U.S. Steel Doing to Contribute to a Better Life?," advertisement, *Chicago Daily Defender*, January 2, 1971, 13.

74. See Stein, *Running Steel*, 205.

75. Quoted in David Finn, *The Corporate Oligarch* (New York: Simon and Schuster, 1970), 235.

76. Andrew Hacker, "Do Corporations Have a Social Duty," *New York Times Magazine*, November 17, 1963, 21.

77. "Open Letter to Picasso," *Art in America*, September-October 1968, 122–24.

78. Max Kozloff quoted in Jo Applin, *Eccentric Objects: Rethinking Sculpture in 1960s America* (New Haven, CT: Yale University Press, 2012), 54. On these works, see Barbara Haskell, *Claes Oldenburg: Object into Monument* (Pasadena, CA: Pasadena Art Museum, 1971), 85–86.

79. Edward Schreiber, "Picasso Work Rubs Reilly in Wrong Place," *Chicago Tribune*, June 15, 1967, C16.

80. Canaday, "Picasso in the Wilderness," D23.

81. On the effort to restrict James Baldwin's novel *Another Country* (1962), see "Hoellen Hits Failure to Act in Book Row," *Chicago Tribune*, January 2, 1965, S3; on his call for police to stop civil rights marches, see "Daley's Aim: Resolve Rights Issues," *Chicago Tribune*, August 10, 1966, 5.

82. For more on this context, see Patricia Kelly, *1968: Art and Politics in Chicago* (Chicago: De Paul University Art Museum, 2008), 12–25.

83. Klaus Perls to Leigh Block, September 10, 1968, Perls Gallery records, AAA. For more on the wide range of artists who participated in this boycott, see Dan Sullivan, "Artists Agree on Boycott of Chicago Showings," *New York Times*, September 5, 1968, 41.

84. Leigh Block to Klaus Perls, September 13, 1968, Perls Gallery records, AAA.

85. Joan Pinkerton, "Explore New Art Technique: Rust Proof Steel Sculpturing," *Chicago Tribune*, April 27, 1967, F4.

86. Pinkerton, "Explore New Art Technique," F4.

87. "'Blue Cinnamon' Used in Sculpture," *Progressive Architecture*, September 1969, 42.

88. The article also notes donations of material from Dow Chemical and Alcoa. "Companies Aid SIU Sculptors," *Southern Illinoisian*, September 1, 1968, 14.

89. "Master of the Monumentalists," *Time*, October 13, 1967, 44.

90. Jonathan Lippincott, *Large Scale: Fabricating Sculpture in the 1960s and 1970s* (New York: Princeton Architectural Press, 2010), 14.

91. Alexander Liberman had experimented with acids to accelerate corrosion, while Newman apparently tried orange juice. Jeanne Siegel, "Around Barnett Newman," *Art News*, October 1971, 62.

92. Pepper's *Cor-Ten Viewpoint* (1965) and Newman's *Here I* (1965) and *Here II* (1965) are among the very few earlier examples. Dating ambiguities increase the confusion; Cor-Ten was used for Naum Gabo's Cor-Ten enlarged reconstruction of *Head No. 2* (1914), fabricated in approximately 1966.

93. These included by Newman's *Broken Obelisk* (1963–67) and Tony Rosenthal's *Alamo* (1967), both fabricated by Lippincott.

94. Hilton Kramer, "An Unlikely Gamble," *New York Times*, December 21, 1969, D33.

95. The "Save Outdoor Sculpture" database at the Smithsonian lists Cor-Ten as the material for about 350 works dated before 1975 across America.

96. As Lippard put it in 1967, "A sculpture painted gray is more 'colored' than a gray stone sculpture." Lucy Lippard, "As Painting Is to Sculpture," in *American Sculpture of the Sixties*, ed. Maurice Tuchman (Los Angeles: Los Angeles County Museum of Art, 1967), 34.

97. See, for example, Ursula Meyer in Elayne Varian, "Schemata 7," reproduced in Geoffrey Battcock, *Minimal Art: A Critical Anthology* (Berkeley: University of California Press, 1995), 372.

98. Rosalind Krauss, "Changing the Work of David Smith," *Art in America*, September/October 1974, 32.

99. Lucy Lippard, "New York Letter," *Art International*, January 1968, 42.

100. Thomas Hess, "Editorial: New Man in Town," *Art News*, November 1967, 27.

**CHAPTER 8. COLLAPSE AT KAISER STEEL**

1.  "Sculptors in the Factory," *Fortune*, April 1966, 142. For a related mass media account on Chamberlain and Stankiewicz, see "Art Crashed through the Junk Pile," *Life*, November 24, 1961, 63–66.

2.  Jerome Hall, "'The Most Exciting Thing to Happen to Sculpture in a Long Time,'" *National Observer*, August 2, 1965, 6.

3.  Elise Emery, "Sculptor Molds Steel to 'Talk,'" *Independent Press-Telegram*, July 1, 1965, B3.

4.  Gordon Hazlitt, "The Sculptures They Left Behind," *Westways*, March 1967, 8. The college became California State University, Long Beach in 1972.

5.  Other advisers included James Elliott, Don Brewer, and Thomas Leavitt. See "International Sculpture Symposium," report, February 22, 1965, 3, International Sculpture Symposium records, CSULB.

6.  Besides Murray, those recorded as sending photographs "to be considered in the final selection" include Ettore Colla, Francesco Somaini, David Weinrib, Carlo Lorenzetti, Peter Agostini, David Smith, David Hare, Charles Ginniver, and Tony Smith. "International Sculpture Symposium," 4.

7.  Carl McIntosh, "Another View of the Symposium," August 21, 1965, 5, International Sculpture Symposium records, CSULB.

8.  Barbara Rose and Robert Murray, "Bad Day at Long Beach (Calif.)," *arts/canada*, July 1966, 7.

9.  Rose and Murray, "Bad Day," 9.

10. Louis G. Redstone, *Art in Architecture* (New York: McGraw-Hill, 1968), 143.

11. Lee Bastajian, "Shipbuilding Slides Much since WWII," *Los Angeles Times*, July 25, 1965, C81.

12. On Murray's relations with the Bethlehem workers, see Julia Bryan-Wilson, *Art Workers: Radical Practice in the Vietnam War Era* (Berkeley: University of California Press, 2009), 101–2.

13. Robert Murray, postcard to Jenny and Clement Greenberg, June 27, 1965, Box 5, Folder 69, Clement Greenberg Papers, AAA.

14. Robert Murray to Carl MacIntosh, July 23, 1965, International Sculpture Symposium records, CSULB.

15. Elise Emery, "Sculptor, Irked at Pad in Dorm, Takes Rain Pass," *Independent Press-Telegram*, July 3, 1965, A11. Paolozzi's place at the symposium was subsequently filled by Claire Falkenstein.

16. R. T. Maloney, "Mr Giò Pomodoro, Participant in CSCLB International Sculpture Symposium," memorandum, July 20, 1965, 2, International Sculpture Symposium records, CSULB.

17. Robert Murray to Carl McIntosh, July 25, 1965, 1, International Sculpture Symposium records, CSULB.

18. Richard Serra, *Writings, Interviews* (Chicago: University of Chicago Press, 1994), 28.

19. Serra, *Writings, Interviews*, 126.

20. Kaiser was, in fact, further convinced to become one of ten special "Patron Sponsors," contributing $7,000 to help support the program's administration. Maurice Tuchman, *Art and Technology: A Report on the Art and Technology Program of the Los Angeles Country Museum of Art, 1967–1971* (Los Angeles: Los Angeles County Museum of Art, 1971), 10–12.

21. Hal Babbitt to Peter M. Mensey, April 5, 1968, Carton 413, Folder 1, Edgar Kaiser Papers, BANC.

22. Hal Babbitt, interoffice memorandum to Edgar Kaiser, 1962, 5, Carton 359, Folder 3d, Edgar Kaiser Papers, BANC.

23. On the corporate sponsorship of this and other Latin American events, see Claire F. Fox, *Making Art Panamerican: Cultural Policy and the Cold War* (Minneapolis: University of Minnesota Press, 2013), 183–85.

24. Interoffice memorandum to Edgar Kaiser, 1962, 4, Carton 359, Folder 3d, Edgar Kaiser Papers, BANC. Increased strontium 90 levels from nuclear fallout were the subject of widely reported scientific studies in the fifties and early sixties. See, for example, Rachel Carson, *Silent Spring* (New York: Houghton Mifflin, 2002), 6. Grumbacher was a brand of artist's paint.

25. Hal Babbitt to David MacDermott, January 9, 1969, Carton 420, Folder 2, Edgar Kaiser Papers, BANC.

26. Babbitt to MacDermott, January 9, 1969.

27. Jerome Keithley to Arnold Gingrich, February 29, 1968, Carton 421, Folder 1, Edgar Kaiser Papers, BANC. Rickey's *Two Red Lines II* had been recently exhibited at LACMA. See Maurice Tuchman, ed., *American Sculpture of the Sixties* (Los Angeles: Los Angeles County Museum of Art, 1967), 185.

28. Robert Arneson, oral history interview by Mady Jones, August 14–15, 1981, AAA.

29. Tuchman, *Art and Technology*, 21.

30. Tuchman, *Art and Technology*, 270.

31. Tuchman, *Art and Technology*, 270.

32. This description appears in the catalogue description of the unsuccessful proposal of British sculptor Philip King. See Tuchman, *Art and Technology*, 146.

33. John F. Lawrence, "Kaiser Steel Forges Stronger Ties with Overseas Markets," *Los Angeles Times*, September 4, 1969, D13.

34. "Strike Shuts Down 2 Kaiser Plant Units," *Los Angeles Times,* October 29, 1968, A2.

35. "Steel for Tower Cost Estimated $16 Million," *Los Angeles Times,* April 13, 1969, J7.

36. Di Suvero had, for instance, played a leading role in the collaborative protest installation *Peace Tower* (1966). See Francis Frascina, *Art, Politics and Dissent: Aspects of the Art Left in Sixties America* (Manchester: Manchester University Press, 1999), 57–107.

37. Glicksman explained that di Suvero intended to do this using "an artist's sensibility and . . . free association, I guess. This isn't exactly how he said he was going to do it but all he wanted was a chance." Hal Glicksman and Gail Scott, interview by Jane Livingstone, June 9, 1970, 2, Art and Technology records, LACMA.

38. Tuchman, *Art and Technology,* 85.

39. Glicksman and Scott, interview by Livingstone, June 9, 1970, 3.

40. According to LACMA records, Serra also visited the Jet Propulsion Laboratory. See Art and Technology 8th report, July 1, 1969, Modern Art Department Art and Technology records, LACMA.

41. It is possible that di Suvero knew that Voulkos had already worked with Kaiser Aluminum. See Hal Babbitt to Roger Bolomey, July 16, 1968, Carton 85, Folder 61, Edgar Kaiser Papers, BANC. Voulkos had considered participating in *Art and Technology* but was one of the few artists to decline over concerns about industry involvement in Vietnam. See Tuchman, *Art and Technology*, 329.

42. Glicksman and Scott, interview by Livingstone, June 9, 1970, 3. Di Suvero's crane-like forms later provided the Institute of Scrap Iron and Steel with a triumphant image of constructive power in Washington, D.C., when the lobby group commissioned his public sculpture *Isis* (1978) for the Hirshhorn Museum.

43. Glicksman and Scott, interview by Livingstone, June 9, 1970, 3.

44. Ted Chinn quoted in Louis Fox, "Kaiser since Serra," unpublished paper, July 27, 1971, unpaginated, Art and Technology records, LACMA. According to a handwritten note on the first page of this manuscript, the interviews in Fox's "final paper" were undertaken for an "Art since 1945" class. A painter by this name is listed in a local newspaper piece as having "done graduate work at Scripps College"—in San Bernardino, near Fontana—where a course of this title was indeed taught by printmaking lecturer James Fuller. See "UR Art Show Opens Tomorrow at Reception," *Redlands Daily Facts,* February 11, 1967, 18.

45. Maurice Tuchman, telegram to Richard Serra, Serra folder, June 17, 1969, Art and Technology records, LACMA.

46. Richard Serra, untitled statement, Serra folder, undated, Art and Technology records, LACMA.

47. Reproduced in Tuchman, *Art and Technology*, 298.

48. Tuchman, *Art and Technology*, 298.

49. Tuchman, *Art and Technology*, 298.

50. Tuchman, *Art and Technology*, 21. The final cost, split between Kaiser Industries and Kaiser Steel, was closer to $10,000. See Chinn quoted in L. Fox, "Kaiser since Serra," unpaginated.

51. Thomas Crow, *Modern Art in the Common Culture* (New Haven, CT: Yale University Press, 1996), 146.

52. Vic Fisher quoted in L. Fox, "Kaiser since Serra," unpaginated.

53. "Artist's Steel Sculptures May Be Shown at Expo '70," *The Ingot*, September 1969, 4.

54. The participating artists were George Rickey, Len Lye, George Baker, Philip King, Eduardo Paolozzi, Bernhard Luginbühl, Jean Tinguely, Karl Prantl, Heinrich Brummack, Kazuo Yuhara, Isamu Wakabayashi, and Yoshikuni Iida. Alexander Calder and Nicolas Schöffer had declined invitations to participate. Len Lye, who had also been considered for the Kaiser residency, had accepted the invitation to work in Osaka but withdrew at the last minute. See *International Sculptors Symposium, 1969–70* (Osaka: Tobbi Design, 1970), unpaginated.

55. *International Sculptors Symposium*, unpaginated.

56. Lawrence, "Kaiser Steel Forges Stronger Ties," D13.

57. John F. Lawrence, "Heads or Tails, Kaiser Steel Wins," *Los Angeles Times*, September 15, 1968, M1.

58. Jack L. Ashby, "Expo 70 Osaka, Japan," memorandum to E.R. Ordway, December 16, 1969, Carton 424, Folder 1, Edgar Kaiser Papers, BANC.

59. William Wilson, "L.A. 'Art, Technology' Prepares for Japan Expo," *Los Angeles Times*, August 28, 1969, E1. With the mooted Osaka stand costing between $15,000 and $25,000, plus display and staffing costs, Serra's art was also cheaper.

60. Tuchman, *Art and Technology*, 302.

61. Serra, *Writings, Interviews*, 128. This recalls Buchloh's observation that Warhol's soup cans were "determined by the apparently random and external factor of a product line and its variations." Benjamin Buchloh, *Neo-Avantgarde and Culture Industry: Essays on European and American Art from 1955 to 1975* (Cambridge, MA: MIT Press, 2000), 506.

62. Serra, *Writings, Interviews*, 128.

63. Serra, *Writings, Interviews*, 128.

64. In the LACMA catalogue, those images not taken by Malcolm Lubliner are simply credited as the work of the "Kaiser Steel Corporation [*sic*]." Tuchman, *Art and Technology*, 386. In the Fox interview, Ted Chinn takes credit for these images: "I took a lot of photographs but I gave them all to Serra." Quoted in L. Fox, "Kaiser since Serra," unpaginated. As Kee has described, conceptual art documentation often "ran counter to entrenched ideas of copyright." See Joan Kee, *Models of Integrity: Art and Law in Post-Sixties America* (Oakland: University of California Press, 2019), 7, 38.

65. L. Fox, "Kaiser since Serra," unpaginated. On the phenomenological narratives of Serra's art, see Rosalind Krauss, "A View of Modernism," *Perpetual Inventory* (Cambridge, MA: MIT Press, 2010), 127.

66. Serra, *Writings, Interviews*, 128.

67. Vic Fisher quoted in L. Fox, "Kaiser since Serra," unpaginated.

68. Serra, *Writings, Interviews*, 8.

69. Vic Fisher quoted in L. Fox, "Kaiser since Serra," unpaginated.

70. Don Butler quoted in L. Fox, "Kaiser since Serra," unpaginated.

71. Serra, *Writings, Interviews*, 8.

72. Tuchman, *Art and Technology*, 299.

73. Vic Fisher quoted in L. Fox, "Kaiser since Serra," unpaginated.
74. Christopher Bedford, "'Labour Fetishism' and Its Discontents in the Sculpture of Richard Serra and Robert Smithson," *Sculpture Journal* 13, no. 1 (2005): 75.
75. Vic Fisher quoted in L. Fox, "Kaiser since Serra," unpaginated.
76. "Artist's Steel Sculptures May Be Shown at Expo '70," 4. Serra's terms suggest the characterization of technology in the subtitle of Marshall McLuhan, *Understanding Media: The Extensions of Man* (London: Routledge and Kegan Paul, 1964).
77. For this structuralist reading, see Rosalind Krauss, *Passages in Modern Sculpture* (Cambridge, MA: MIT Press, 1981), 276.
78. Vic Fisher quoted in L. Fox, "Kaiser since Serra," unpaginated.
79. Crimp claimed, for example, that Serra "presents the steelworker with the very product of his alienated labor." Douglas Crimp, *On the Museum's Ruins* (Cambridge, MA: MIT Press, 1993), 173. Buchloh argues that Serra's early films render visible the "universal conditions of the invisible and alienated industrial laborer." Benjamin Buchloh, "Richard Serra's Early Work: Sculpture between Labor and Spectacle," in *Richard Serra Sculpture: Forty Years*, ed. Kynaston McShine and Lynne Cooke (New York: Museum of Modern Art, 2007), 56–57.
80. It is not clear how long Serra spent at Kaiser Steel in total, but in Jane Livingstone's catalogue essay his residency is described as only "a few weeks." In his own description of the project, he claims to have stayed "one month." See Tuchman, *Art and Technology,* 44, 304.
81. "Artist's Steel Sculptures," 4.
82. Vic Fisher quoted in L. Fox, "Kaiser since Serra," unpaginated.
83. Tuchman, *Art and Technology,* 304.
84. For an illustration of this sketch, titled *For Kaiser Steel* (1969), see Michael Fitzgerald, *A Life of Collecting: Victor and Sally Ganz* (New York: Christies, 1997), 215.
85. It has been argued that Smithson's unrealized Kaiser proposal "represented an important watershed" for his interest in industrial collaboration. See Robert Hobbs, *Robert Smithson: Sculpture* (Ithaca, NY: Cornell University Press, 1981), 145.
86. Hobbs, *Robert Smithson*, 22.
87. Erika Doss, *Spirit Poles and Flying Pigs: Public Art and Democracy in American Communities* (Washington, DC: Smithsonian Institution, 1995), 119.
88. Hobbs, *Robert Smithson,* 22. On the intersecting legal and economic frameworks of artistic land reclamation projects, see Kee, *Models of Integrity*, 8–9.
89. Charles Hillinger, "'Creeping' Slag Mountains to Vanish—but Will Take Awhile," *Los Angeles Times*, 1968, H1.
90. "Air Pollution: Everyone's Problem" was the title of Kaiser Industries' 1960 education film on the subject but was a slogan still in use in the early 1970s. Ron S. Heiznel, "Kaiser Official Says Steel Industry to Bounce Back," *Los Angeles Times,* April 7, 1971, D13.
91. Tuchman, *Art and Technology,* 304.
92. Glicksman and Scott, interview by Livingstone, June 9, 1970, 3.
93. "The Kaiser Plan," *New York Times*, January 23, 1963, 6.
94. On the latter point, see William Trombley, "Edgar Kaiser—Maverick in Motion," *Saturday Evening Post*, June 22, 1963, 21.
95. A.H. Raskin, "Approach to Automation: The Kaiser Plan," *New York Times*, November 3, 1963, SM11.
96. Mike Davis, *City of Quartz: Excavating the Future in Los Angeles* (London: Verso, 2006), 411.
97. Quoted in L. Fox, "Kaiser since Serra," unpaginated.
98. Vic Fisher quoted in L. Fox, "Kaiser since Serra," unpaginated.
99. "Southland: Kaiser Steel to Lay Off 282 in Two Plants," *Los Angeles Times,* January 13, 1971, 2.

100. Don Butler quoted in L. Fox, "Kaiser since Serra," unpaginated.

101. Tuchman, *Art and Technology,* 300.

102. For an influential account of this connection, see Anne Collins Goodyear, "From Technophilia to Technophobia: The Impact of the Vietnam War on the Reception of 'Art and Technology,'" *Leonardo* 41, no. 2 (April 2008): 169–73.

103. Richard Serra, "Skullcracker Stacking Series (name of yard)," unpaginated. Art and Technology records, LACMA.

104. Serra, *Writings, Interviews,* 19.

105. Serra, *Writings, Interviews,* 28.

106. Serra quoted in James Hall, "Lust for Rust," *The Guardian,* September 25, 1992, 32.

107. Cindy Nemser, "The Art of Frustration," *Art Education* 24, no. 2 (February 1971): 14. The exhibition to which Nemser responds was *Anti-illusion: Procedures/Materials* at the Whitney Museum.

108. Nemser, "Art of Frustration," 15.

109. Serra, *Writings, Interviews,* 41.

110. Serra, *Writings, Interviews,* 100.

111. On this controversy, see Harriet F. Senie, *The Tilted Arc Controversy: Dangerous Precedent?* (Minneapolis: University of Minnesota Press, 2002), and Clara Weyergraf-Serra and Martha Buskirk, *The Destruction of Tilted Arc: Documents* (Cambridge, MA: MIT Press, 1991).

112. *International Sculptors Symposium,* unpaginated.

113. Nemser, "Art of Frustration," 15.

114. Nemser, "Art of Frustration," 15.

## CONCLUSION

The epigraph is from Hans Haacke and Catherine Lord, "Where the Consciousness Industry Is Concentrated," in *Cultures in Contention,* ed. Douglas Kahn and Diane Neumaier (Seattle, WA: Real Comet Press, 1985), 234.

1. Xerox's sponsorship of *New York Painting and Sculpture: 1940–1970* at the Metropolitan Museum of Art exemplifies this move toward a more distanced patronage coordinated through the museum and disconnected from art production. On this exhibition's commercial entanglements, see Lucy Lippard, "Museo, Museas, Museat," *Hudson Review* 23, no. 1 (Spring 1970): 6–14.

2. Among many artists and critics, *neoliberalism* has become a favored shorthand for the various, and often vaguely defined, failures of contemporary global capitalism. Social geographers have provided some of the most rigorous critiques of the term's increasingly totalized application. For a useful summary of such work, see Clive Barnett, "Public and Markets: What's Wrong with Neoliberalism?," in *The Sage Handbook of Social Geographies,* ed. Susan Smith (London: Sage Publications, 2010), 269–84.

3. The literature on Haacke is now immense, including important texts by Caroline Jones, Benjamin Buchloh, Julia Bryan-Wilson, and Rosalind Deutsche, among many other scholars. The artist's own writings add to this corpus, as do his collaborations with sociologists including Howard Becker and Pierre Bourdieu. For a useful summary of Haacke's attitudes toward corporate museum sponsorship, see Alexander Alberro, ed., *Working Conditions: The Writings of Hans Haacke* (Cambridge, MA: MIT Press, 2016), xxxiv–xi.

4. See Paul Wood and Charles Harrison, eds., *Art in Theory, 1900–1990* (Oxford: Blackwell, 1995), 885–86.

5. Szeemann's own interest in the overlaps between the "consumer and viewer" was also in evidence at a concurrent project at Bern's Gebrüder Loeb AG, for which local contemporary artists

developed avant-garde window displays using products stocked by the department store. Harald Szeemann, "Neue Wege der Kunst-präsentierung," *Werk* 56, no. 10 (1969): 709–10.

6. Quoted in Claudia Di Lecce, "Avant-Garde Marketing: 'When Attitudes Become Form' and Philip Morris's Sponsorship," in *Exhibiting the New Art: "Op Losse Schroeven" and "When Attitudes Become Form" 1969*, ed. Christian Rattemeyer (London: Afterall Books, 2010), 226.

7. Harald Szeemann, "How Does an Exhibition Come into Being?," in *Harald Szeemann: Selected Writings* (Los Angeles: Getty Research Institute, 2018), 35.

8. As Caroline Jones has pointed out, the Kunsthalle Bern had also hosted the *11 Pop Artists* exhibition toured by Philip Morris. Caroline Jones, *The Global Work of Art: World's Fairs, Biennals, and the Aesthetics of Experience* (Chicago: University of Chicago Press, 2016), 175. Szeemann later claimed that Philip Morris did not regard the exhibition as "good publicity." See Beti Žerovc, "Making Things Possible: A Conversation with Harald Szeemann," in *Harald Szeemann: Selected Writings* (Los Angeles: Getty Research Institute, 2018), 385.

9. Institute for Motivational Research, "A Proposal for a Study of the Development of Symbols and Vocabulary to Be Used in Cigarette Advertising and Promotion," April 1965, 2, Ernest Dichter Papers, HML.

10. Jones, *Global Work of Art,* 180.

11. J.T. McKenzie, "Cigarette Advertising Strategy 1971," October 16, 1970, Document No. 2501265730, LTDL.

12. Michael McNay, "When Attitudes Become Form," *The Guardian,* September 1, 1969, 6.

13. Sam Hunter, *Art in Business: The Philip Morris Story* (New York: Harry N. Abrams, 1979), 37–51.

14. *Air: A Philip Morris Exhibition* (Melbourne: Philip Morris Australia, 1970), unpaginated.

15. Scott Cutlip, *The Unseen Power: Public Relations, a History* (Hillsdale, NJ: Lawrence Erlbaum, 1994), 494.

16. These are just some of the promotional phrases used to promote filter technology in the 1960s and 1970s.

17. Szeemann, "How Does an Exhibition Come into Being?," 41.

18. Warren Braren, submission to Federal Trade Commission, November 12, 1970, 10, Document No. T109091692, LTDL.

19. John Larkin, "Time and Place to Draw Breath and Dream," *The Age,* June 17, 1970, 2.

20. Larkin, "Time and Place," 2.

21. "Lucht-Kunst," *De Telegraaf,* April 29, 1971, 4.

22. Hans Haacke, membership form, Box 3, Folder 3–23, Experiments in Art and Technology records, GRI.

23. See *E.A.T. News,* November 1967, 11–12, Box 138, Folder 8, Experiments in Art and Technology records, GRI.

24. Tuchman, *Art and Technology,* 116.

25. The name of the hosting organization is suggestively misidentified in Hans Haacke, "Untitled Talk at Annual Meeting of Intersocietal Color Council, New York, April 1968," in Alberro, *Working Conditions*, 14–25.

26. "1968 Annual Meeting," *Inter-society Color Council News Letter,* November-December 1968, 1.

27. "1968 Annual Meeting," 1.

28. Haacke, "Untitled Talk," 21.

29. John A. Tyson, "Beyond Systems Aesthetics: Politics, Performance and Parasites," in *Hans Haacke: All Connected*, ed. Gary Carrion-Murayari and Massimiliano Gioni (London: Phaidon Press; New York: New Museum, 2019), 260. In an interview with Gioni in the same catalogue, Haacke denies this connection. "In those days, the marketing surveys you mention were unknown to me. Perhaps they did not exist yet" (225).

30. Mary Anne Staniszewski, *The Power of Display: A History of Exhibition Installations at the Museum of Modern Art* (Cambridge, MA: MIT Press, 1998), 285.

31. Christopher Andreae, "Haacke Explains His Astonishing Show," *Christian Science Monitor*, November 24, 1969, 10.

32. Skrebowski has written that this work was, instead, "lost to history because of the already overinflated claims of a nascent information technology sector." Luke Skrebowski, "All Systems Go: Recovering Hans Haacke's Systems Art," *Grey Room* 30 (Winter 2008): 65.

33. Jean Toche to Sylvania Lighting, November 17, 1967, Box 122, Folder 9, Experiments in Art and Technology records, GRI. On GAAG protests, see Julia Bryan-Wilson, *Art Workers: Radical Practice in the Vietnam War Era* (Berkeley: University of California Press, 2009), 184–87.

34. Jean Toche to Sue Edgerton, February 1968, Box 122, Folder 9, Experiments in Art and Technology records, GRI.

35. Quoted in Claudia Di Lecce, "Avant-Garde Marketing: 'When Attitudes Become Form' and Philip Morris's Sponsorship," in Rattemeyer, *Exhibiting the New Art*, 223. Haacke extended this claim in a gallery label for *On Social Grease* (1975) for his 2019 retrospective at the New Museum: "Although not perceived at the time by the public, corporate art collecting and sponsorship of art exhibitions by large corporations developed in the early 1970s at a scale and with an impact hitherto unknown."

36. Sophie Cras, "Art as an Investment and Artistic Shareholding Experiments in the 1960s," *American Art* 27, no. 1 (Spring 2013): 20.

37. Including a revised version of the aforementioned essay, see Sophie Cras, *The Artist as Economist: Art and Capitalism in the 1960s* (New Haven, CT: Yale University Press, 2019). For another fascinating example of these issues operating beyond the conventional bounds of conceptual art, see Joan Kee, "Free Art and a Planned *Giveaway*," *Archives of American Art Journal* 57, no. 1 (Spring 2018): 44–61.

38. Mari Dumett, *Corporate Imaginations: Fluxus Strategies for Living* (Berkeley: University of California Press, 2017), 52.

39. Dumett, *Corporate Imaginations*, 5.

40. Don Celender, *Political Art Movement, Religious Art Movement, Affluent Art Movement, Academic Art Movement, Corporate Art Movement, Cultural Art Movement, Mass Media Art Movement, Organizational Art Movement* (St. Paul, MN: The artist, 1972), unpaginated. Critic Max Kozloff, the catalogue essayist for Philip Morris's *Pop and Op* exhibition, dismissed Celender's project as "lightweight . . . a hook without any bait." See Max Kozloff, "Junk Mail: An Affluent Art Movement," *Art Journal* 33, no. 1 (Autumn 1973): 31.

41. Celender, *Political Art Movement*, unpaginated.

42. Celender, *Political Art Movement*, unpaginated.

43. Celender, *Political Art Movement*, unpaginated.

44. "Biennale of Sydney Cuts Ties with Sponsor Transfield," SBS News, March 7, 2014, www.sbs.com.au/news/biennale-of-sydney-cuts-ties-with-sponsor-transfield.

45. "Sydney: Malcolm Fraser Arrived at the Art Gallery of New South Wales . . .," *Tribune*, Sydney, November 17, 1976, 11.

46. The connection between the Sacklers and OxyContin had come to widespread attention through an in-depth article on the subject in later 2017. See Patrick Radden Keefe, "Empire of Pain," *New Yorker*, October 30, 2017, 34–49.

47. Jillian Sackler quoted in Helen Stoilas, "Nan Goldin Leads Anti-opioid Protest at the Met's Sackler Wing," *Art Newspaper*, March 11, 2018, www.theartnewspaper.com/news/nan-gold-leads-anti-opioid-protest-at-the-met-s-sackler-wing.

48. For a useful account of broader commercial interests behind OxyContin, and the contradictions of Arthur Sackler's own activism against the tobacco industry, see Alan Blum, "Museum Malignancy: What the Sacklers and Philip Morris Have in Common," *Cancer Letter,* October 18, 2019, 10.

49. David Joselit, "Toxic Philanthropy," *October* 170, no. 158 (October 2019): 4.

50. On the activities of Liberate Tate, see Mel Evans, *Artwash: Big Oil and the Arts* (London: Pluto Press, 2015).

51. Alexander Alberro, *Conceptual Art and the Politics of Publicity* (Cambridge, MA: MIT Press, 2003), 2.

52. David Joselit, *Feedback: Television against Democracy* (Cambridge, MA: MIT Press, 2007), xiii.

# ILLUSTRATIONS

# INDEX

Page numbers in *italics* refer to illustrations.

corporations, global orientation of, 2, 7, 9, 10–11, 91, 111, 135. *See also* Turmac

Cor-Ten, 195; architectural uses of, 195–96; Chicago Picasso as first prominent sculptural use of, 197, 202, 204, 206; early sculptural uses of, 284n92; Inland Steel and, 207; Lippincott and, 207, 284n93; neologism, 195; public sculpture's embrace of, 207–8, 284n95; rusty hue, 195–97, 202–4, 208, 282n35; Serra and, 225; U.S. Steel and, 9, 195–96, 199, 207, 208

Council of Europe, 148–49, 274n50

counterculture, 3, 16, 17, 18, 60, 237

Coviello, Peter, 136, 145

Cras, Sophie, 233

Crimp, Douglas, 218, 288n79

Crouwel, Wim, 148, *153, 154, 155,* 156

Crow, Thomas, 256n78; *Modern Art in the Common Culture,* 79, 217, 244n34

cultural capital, 7, 111, 263n2

Daley, Richard J., 199, 202, 206

Darbel, Alain, 140

D'Arcangelo, Allan: Aspen Institute, 256n86; *11 Pop Artists,* 74, 89

Davidson, Bruce, 98–99

Davie, Alan: *Study for BP No. 2,* 267n92

Davis, Mike, 244

Davis, Stuart, 4; Heinz mural, 28–29

DeLap, Tony, 164

Delvaux, Paul, 116

department stores: Abraham & Strauss, 35–36, *36;* Gebrüder Loeb AG, 289–98n5

Dexter, Gail, 162

Diederen, Jef, 152

Dine, Jim, 21, 74, 259n52; *Awl, 75,* 75–76; *Throat,* 76

Dinkeloo, John, 195–96

Disney, 4, 17

disposability, 34–36, 54, 59

Donati, Enrico, 266n78

Dorazio, Piero: *Blera,* 277n15

Dorrance, John, 234

Doss, Erika, 8, 12, 223

Douberley, Amanda, 126

Downtown-Lower Manhattan Association (DLMA), 121, 270n140

Drexler, Arthur, 121, 130–31, 271n165

Dubuffet, Jean, *129;* antiestablishment views of, 128, 129, 270nn152–53; *art brut,* 126, 168; Chase collection, 270n146; *Groupe de quatre arbres,* 91, 120, *121,* 126–30, *128, 129,* 133, 270n148

Duchamp, Marcel, 55

Dumett, Mari, 234

Dunn, William, 70

Dutch Art Foundation, 152

Dutton, Geoffrey, 159

Dzubas, Friedel, 256n86

Eckerstrom, Ralph, 45, 46

Eco, Umberto, 168, 170

Eells, Richard: *Corporation and the Arts,* 15, 245n64; *Corporation Giving in a Free Society,* 14–15

*11 Pop Artists,* 67, 68, 74–86, *75, 77, 79, 85, 87,* 229, 260n70; corporate intervention in, 74, 76–81, 259n53, 259n59, 259n61; corporate social responsibility and, 70, 72; international tour, 81, 259n49, 260nn74–75; Laing's inclusion in, 84, 259n47; reconceptualized as *Pop and Op,* 81, 82, 84, 291n40; references to Philip Morris brands in, 75–76

Elliott, James, 285n5

Eloul, Kosso, 210

environmentalism, 223, 231

Esman, Rosa, 74, 79

Esso, 149, 246n72, 277n8

Europe, economic integration of, 9, 145–149

European Economic Community (EEC), 145, 148, 273n43

European Free Trade Association, 145, 273n43

Ever-Ready Personna, 81, 260n74

Experiments in Art and Technology (E.A.T.), 233, 247n84; Haacke and, 231–22, 290n25; Pepsi Pavilion, Expo '70, 17–20, *19,* 247n95

Expo '70, Osaka: International Sculpture Symposium, 217–18, 226, 287n54, 287n59. *See also* Experiments in Art and Technology

Fair Packaging and Labeling Act, 61

Famous Artists School, 74, 144, 259n44, 273n31

Fedeli, Carlo, 184, 280n82

Federal Trade Commission (FTC), 57, 70, 231, 249n15

Feigen, Richard, 259n47, 261n94

Ferber, Herbert: *Sculpture as Environment,* 5, *6*

Ferron, Marcelle, 152

Fink, Karl, 232

Finn, David, 70, 72, 258n28. *See also* Ruder & Finn

Fisher, Vic, 217, 220, 221

Fladell, Winston, Penette Inc., 34

Fluxus, 233–34

*Fortune,* 57, 92, 98, 172, 209, 212; corporate liberalism, 242–43n16

Foundation for European Culture, 148–49, 273n44, 274n47, 274n50

Franchina, Nino, 170